The Communicator's Handbook:
Techniques and Technology

Second Edition

MAUPIN
HOUSE

The Communicator's Handbook

Copyright © 1990 and 1993
Agricultural Communicators in Education (ACE)

All rights reserved under International
and Pan-American copyright conventions.

Published in the United States by Maupin
House, P.O. Box 90148, Gainesville, FL 32607
1-800-524-0634.

The Communicator's Handbook: Techniques
and Technology/Edited by Patricia Calvert.
 314 p.
 Includes index.
 ISBN 0-929895-01-0: $23.95
 1. Communication—Handbooks,
 manuals, etc. I. Calvert, Patricia, 1936-
P90.C63465 1990
302.2'02—dc20 89-12302
 CIP

 Agricultural Communicators in Education (ACE) is an international association of professionals in land grant universities and related associations who practice in all areas of communications

Design specifications for The Communicator's Handbook

- The main title is 30/30 Eras Book.

- Chapter numbers are 72 point Eras Book.

- The page heading line is 2 points and 56 picas wide.

- The major subheads that appear above the page heading line are set in 12/13 Eras Demi.

- Major subheads are 15/15 Eras Demi with a 1 point line beneath them.

- Secondary subheads are 12/12 Eras Demi.

- Third level set-in subheads are 11/12 Eras Demi.

- The text is set, flush left, to a 17½ pica measure in 11/12 Eras Book.

- Three 17½ pica width columns with 1½ pica gutters occupy the 11" x 8½" page format.

- The page numbers are 12 point Eras Demi and the lower book title identification is in 10 point Eras Medium.

MAUPIN
HOUSE

Second Edition

Introduction

People today live and work in a complex, ever-changing, global environment. In one day's time, you might write a press release on your computer, send it electronically to 10 media outlets, and meet with colleagues from across the nation via audioconference. Then you might deposit your paycheck in the automatic teller machine, preview an educational video taped from a cable TV program, watch the evening news beamed by satellite from the Orient, and chat with your family about the day's busy activities.

Communication is central to every facet of daily life. Personally and professionally you communicate using techniques and technology far different than those used just a few years ago. Interpersonal communication skills are increasingly important to surviving in a fast-paced, modern society. On the job, communication skills are constantly stretched as you target and educate new audiences in new areas with new tools.

The Communicator's Handbook: Techniques and Technology is designed to help you improve both the delivery of your message and its impact. It can also help to make you a more effective, efficient communicator.

As an educational tool, this handbook will help you plan and execute a variety of programs, communicating through print, photographs, exhibits, posters, slide-tape shows, speeches, and on radio and television. Instructions for designing graphics, editing videotape, publicizing events, marketing an organization, and planning crisis communication are other important topics covered in this handbook.

You will also be introduced to up-and-coming electronic technology, such as electronic mail, interactive video, CD-ROM, desktop publishing, and satellite teleconferencing. This new technology has already transformed the field of communication — and the jobs of many professionals.

This book was written, designed, and edited by professionals of the international communications association, Agricultural Communicators in Education (ACE). It is intended to help students, educators, and communications professionals meet many of today's communications challenges.

The Communicator's Handbook is a resource you can use every day. It will improve both your performance as a communicator and the image and impact of the organization you represent.

Patricia Calvert
Coordinator and editor

Acknowledgments

When an association writes a book as comprehensive as this one, many people deserve a note of thanks. First, ACE deeply appreciates the work of the entire staff of the Graphics and Media Center at the Institute of Food and Agricultural Sciences (IFAS), University of Florida. This staff, part of the IFAS Editorial Department, headed by past ACE president Don Springer, was responsible for the book's design, typesetting and layout, as well as many of its photographs and illustrations.

ACE especially recognizes the efforts of Ashley Wood, who coordinated the work and handled the inevitable crises with humor, skill and patience, and of David Morris, who brought his writing skills and common-sense approach to the painstaking task of line editing the entire manuscript.

Special thanks are in order for the ACE pioneers, particularly Hal Taylor, who conceived and developed the first ACE communications handbook over a decade ago. Their dedication and contributions to our professional organization have been countless.

Finally, I express my deep appreciation to the ACE Board of Directors and the officers for their faith, support and counsel in the development and production of this handbook.

Patricia Calvert
November 1989

The Communicator's Handbook: Techniques and Technology

Second Edition
Edited by
Patricia Calvert
Deputy director, communications,
information and technology, USDA
Extension, Washington, D.C.

Other books by
Agricultural Communicators in Education

Clip Art Books 1-6

Contents

Contents

Contents

A universal fact of life is that writing can be difficult for many people, and certainly a challenge for all. A scholar agonizes over a research paper as the publishing deadline nears. A newspaper reporter fills his wastebasket with lead paragraphs while nervously finishing a breaking news story for the next edition. A university news writer scours the campus for information that an important news outlet needs immediately. A housewife searches for the right words in a letter to a family member as the mailing deadline arrives.

Putting together a sentence, paragraph, article, or document that conveys an easily understood message is a worthy achievement. Doing so under time pressure makes the result even more remarkable.

Who is your audience?

Many beginning writers make the mistake of learning too little about their audiences. You will succeed as a writer to the degree that you know your audience's ages, occupations, educational and income levels, limitations, prejudices, interests, and dislikes. Without such information, you are like an inexperienced hiker wandering in a forest of tall redwoods without a compass.

"Readers fail to understand us when we fail to understand them" is a truism worth remembering.

Write for easy reading

Because your goal is to be understood, consider these ideas about easy-to-read writing.

Be conversational. Readers like this style. They don't care if you end a sentence with a preposition. You convey a clear message with common, everyday words. Everybody uses contractions when speaking. Sprinkle them in your written messages and watch your writing spring to life.

Try short, familiar words. Two out of three words in the Gettysburg Address have only one syllable. Only occasionally will longer words serve you better. Language expert Rudolph Flesch uses syllable counts to measure readability. His guide is worth repeating: 100 to 130 syllables per 100 words for easy reading, 131 to 160 for standard reading, 160 and above for difficult reading. Gauge a sample of your own writing. Many writers who do are surprised to learn that they are writing well above the reading capability of many of their audiences.

Use personal words. You'll find a gold mine in "I," "you," "we," and other personal pronouns. Personal words involve readers. Syllable, word, and sentence counts mean little if you aren't personal.

Use short sentences. People find them easier to read. The best average length is 17 words. That doesn't mean you should carefully meter out 17 words for every sentence,

1 The art of good writing

- Common grammatical pitfalls
- Words can't think for you
- Some forget-me-nots

however. Reader boredom will surely set in. It's okay to string out some sentences. Short sentence or long, keep the meaning clear.

Create short paragraphs. Long sentences and long paragraphs are a cure for insomnia. Good writing often comes in neat little paragraphs of two to four sentences.

Don't ask readers to unscramble your ideas. Place thoughts in logical order. State your major point in one sentence. Tell why it's important; then list other appropriate information.

Common grammatical pitfalls

Nobody expects you to know all the rules of grammar. Nonetheless, if you expect others to read what you write and to respect your efforts, you must know some basics. Here are some common misuses of grammar. In each example, the first sentence is incorrect, the second correct.

Inconsistent or mixed tenses. "The farmer seeded oats in three fields and has plowed the back forty." "The farmer seeded oats in three fields and plowed the back forty."

"He is writing for working mothers and presented his information to meet their needs." "He writes for working mothers and presents his information to meet their needs."

"Mary walks outside, then started to weed the flowers." "Mary walked outside and started to weed the flowers."

Dangling modifier. "Coming over the hill, the building was seen." "Coming over the hill, she saw the building."

"To profit from a long meeting, the seats must be comfortable." "To profit from a long meeting, we need comfortable seats."

Repetition. "Market gardeners annually produce tons of fresh produce each year." "Market gardeners produce tons of fresh fruits and vegetables each year."

Redundancy. "Students evaluated the importance of the course." "Students evaluated the course."

"Beautiful hills and valleys add to the beauty of the area." "Hills and valleys make the area more beautiful."

Excess baggage. "The nursery owner blamed low rainfall and a lack of soil moisture for causing the poor landscapes." "The nursery owner blamed the drought for the poor landscapes."

Hem-hawing. "Apparently the test seemed to indicate the new battery was evidently defective at purchase." "The test showed the new battery may have been defective."

Circling. "The project all of the City Council selected was the downtown renovation project." "The City Council selected the downtown renovation project."

Back door approach. "This trip will not cost employees any money." "This trip is free to employees."

Words can't think for you

If words could do our thinking, writing would be simpler. But words are only tools. Used correctly, they work for us. Used incorrectly, they work against us. Remember that most of us will skip over words we don't understand before we will reach for a dictionary.

One of our worst mistakes is using words that contribute nothing materially to our messages. These are lazy words — words that don't pay their way. Examples are forms of "there is." "There has been an increase in the amount of pizza consumed by teenagers" contains several idle or lazy words. Shake out the lazy words and you get: "Teenagers are eating more pizza."

Few writers have sorted out idle words and used the precise words better than Mark Twain, who said that the difference between the right word and almost the right word is the same as the difference between lightning and the lightning bug.

Some forget-me-nots

Be ruthless with your copy. If a word, sentence or paragraph gives no new information, scratch it. Readers demand that you

clarify and simplify, which may not always satisfy your longing to be eloquent.

Send up trial balloons. Let others read your copy. Don't fret if you hear, "I don't quite follow you" or "This needs more work." All writers need thick hides.

Make the declarative statement routine. "The declarative sentence ends in a period." is a declarative sentence.

Be fresh. Don't tell readers something they already know, such as "wrapping up in winter prevents runny noses." They may wonder how many more brilliant thoughts they'll have to endure.

Start well. Because you want to attract readers, make your first two or three sentences count. Give them oomph! Otherwise, readers may yawn and flip on the TV set.

Look it up. In writing, ignorance isn't a sin. Laziness is. Keep a dictionary close by. You will know that "linage" means newspaper advertising space and "lineage" means your family tree.

Engage your readers. Language analysts have found that most people who read would rather be doing something else. One bad paragraph can break the sometimes shaky engagement you have with your readers.

Keep it simple. Avoid excessive mechanical roadblocks that cause readers to back up and restart. Commas, semicolons, and colons should clarify, not confuse.

Trim the fat. Reject such sentence openers as "Needless to say..." and "Hopefully...." It's hard to kick the "unnecessary word" habit, but you can do it. Learn to become aware of obvious trimmers. For example, people don't "scream loudly" or "murmur quietly."

Removing the fog

Wordiness is the bane of many writers. It can't be emphasized enough that trimmed prose is more palatable to readers than the verbose version. To improve wordy sentences study these examples and apply the lessons to your own writing.

"The discussions became quite heated at times, which was an indication that members themselves determined the goals of their club."

Better: "Occasional heated discussions proved that members set their club's goals."

"There are many weaknesses in writing that can be detected if your material is carefully reread."

Better: "Rereading helps you detect your writing weaknesses." Removing the fog leaves a simple seven-word sentence.

"The horticulturist pointed out that the homeowners in his section of town wanted nice, green lawns but weren't willing to apply enough fertilizer needed to reach their goals."

Better: "The horticulturist said many local homeowners won't apply enough fertilizer to have good lawns." This cuts in half a 28-word sentence.

Too many prepositional phrases fog over a sentence, too:

"The essay contest is sponsored locally by the Central Electric Supply Company in cooperation with the Roberts County Extension Office."

Better: "The Central Electric Supply Company and Roberts County Extension Office sponsor the essay contest."

Good transition phrases help to clarify and to show readers the relationship between what they've read and are about to read. Examples are "Later that year," "After the game," "Despite that problem," and "Meanwhile, the other class...."

Rely on active voice sentences

Don't use *passive voice* sentences as your mainstay style. They immediately tag you as a lazy writer. You can spot passive voice simply by watching for "am," "is," "was," "been," "are," "were," and "be." When such words serve as auxiliary verbs — "is featured" or "was liked" — you've got passive voice. Some examples of passive and active voices:

Passive: "An ordinance that extended swimming pool hours on Saturdays was passed

1 The art of good writing

today by the City Council after it was pressured by a group of parents."

Active: "Pressured by parents, the City Council today extended swimming pool hours on Saturdays."

Passive: "A scaled-down highway improvement plan was approved today by the State Legislature."

Active: "The State Legislature today scaled down the highway improvement plan."

Someone wrote that active voice sentences get attention and passive voice sentences get cold shoulders. An exaggeration, perhaps, but the active voice does strengthen writing.

Weak: "A wide range of learning experiences is provided under the guidance of a volunteer 4-H leader."

Strong: "Volunteers guide 4-H members through many learning experiences."

Weak: "The clothing drive for flood victims was conducted by the Business and Professional Women's Club."

Strong: "The Business and Professional Women's Club collected clothing for flood victims."

To improve, read about writing

Practice makes perfect. Well, that's not quite true in writing. No writer ever attains perfection. But gaining experience and reading what experts say can surely help any writer improve.

Publications remain a primary delivery system for information even in an electronic age. Nothing has proven to be more user friendly than well-written, well-designed, and neatly produced publications.

They retain this favored position because there are times when you need to give specific instructions for reaching an objective, provide more details than can be handled easily through other media, or supply an audience with information for future reference.

Publications can accomplish these things with relative speed, comparatively low cost per contact, and the expectation of a good result. Studies show that audience penetration with a message is good and that readership and use of content are high when a publication is provided in response to a request for information.

Planning the publication

Many of the polished publications seen today require a high degree of professional skill in writing, design, and production. It is possible, however, for someone with little experience to do a good job of producing simple publications.

This chapter will acquaint you with the major steps in the process and will provide simple guidelines to help you through them.

When you prepare a publication from a manuscript, you move through these three major stages:

Planning. Consider the purpose, audience, message, and outline of the publication.

Writing. Decide on a basic style for the manuscript, draft it, rewrite it, then edit and polish it.

Production. Determine the format and design, set the manuscript into type, prepare the layout, then print it.

Planning is the thinking-through process that helps you organize your publication. Unfortunately, it is a step that is often passed over lightly or bypassed altogether even though it has been proven to save time and money.

It is the time when you ask yourself four basic questions:

■ Why is a publication needed?

■ Who am I trying to reach?

■ What do I want my audience to learn from the publication?

■ How can I best say what I want them to know?

If you successfully answer each of these questions in the planning stage, you will understand your purpose for the publication, know who the audience is, know what the message is, and have a master plan to follow as you write.

Purpose

Publications are the workhorses of communication, but they may not be the best method to use every time you want to communicate a message. The first step in the planning process should be to determine which channel of communication will do the best job of getting your information to an audience. Several other chapters in this book explain the merits of the various media.

Once you have determined that a publication is right for your use, try to define its purpose on paper. The ability to make the purpose of the publication clear to yourself is a test of whether you will be able to make it clear to your readers.

It is also important to keep the purpose realistic and of manageable size. Don't set out to accomplish more than you comfortably can in the space of the publication. Remember that people say they are more likely to read publications that are short, simple, and to the point.

Audience

A time-honored maxim of communications is, "Know your audience." This emphasizes the need to think carefully about people you want to reach.

2 Publications

To get to know the members of your audience better, set down briefly as much information about them as you can. Include basic points such as their age, sex, occupation, income, and place of residence. Also include how they think and feel and what they may need to know about the subject of your proposed publication. Too often we don't communicate well because we write for ourselves or our coworkers instead of for a clearly defined audience.

Message

Only when you know your audience can you decide what information is essential to achieving your purpose. The basic goal is to keep the message as short as possible without overlooking important facts.

Initially, list all the information your publication *could* cover. Then review the list and remove what your reader doesn't *need* to know or doesn't need to know *right now*. Check the list for points you can assume the reader knows already and cross these off too.

Look at the points remaining and ask yourself what facts or concepts the reader will need to learn in order to understand them. Add these, being sure that each will be clear to the reader as it stands. Missing links in information can play havoc with the ability of the reader to use it.

At this step also consider whether some points you list can be made better with illustrations than with words.

The outline or master plan

A good outline can provide you with a master plan for your publication. While some people have negative feelings about the outlines of their school days, outlining is a vital step in publication planning. You must see the organization of your publication well enough to construct a clear outline if your reader is to see the message clearly too.

Here's what an outline does for you:

- Keeps you organized, which helps your audience follow you better.

- Saves time in writing.

- Helps you stay focused on each point and ensures that you cover the important ones.

- Keeps you from backtracking and from writing aimlessly.

The form of the outline itself is of less importance than having one that is simple and is right for the subject — one that will result in a publication organized from the reader's viewpoint.

The strict rules for outlining learned in school need not be applied to informal publications. Not all sections must be structured the same. It is acceptable, for example, for one section

of the publication to have second-level heading and another to have none. Any section that has one subdivision, however, should also have at least a second one.

Simply put, publications have three basic parts — a beginning, a middle, and an end. Within this simple framework the outline for each may vary, depending on the form you want the publication to take.

The outline may be sequential or chronological — first-this-next-that order. It can be in a cause and effect order — here's-the-problem-here's-what-to-do-and-here's-how-to-do-it order. It can also be arranged in order of importance — most-important-point-to-least-important-point, or vice versa.

Writing the publication

As you draft your manuscript, keep in mind that you are writing to be read. Your goal for the manuscript should be clear, simple, easy-to-read writing. Strive for an easy, conversational tone to help achieve this.

Often we hesitate to write in simple language because we think we may lose our audience. Research shows, however, that with well-written materials just the opposite occurs. As readability levels go down, interest and comprehension go up for all groups. It is not simplicity that turns off the audience, but rather it is finding too little new information.

As an added point in favor of simplicity in writing, remember that such critically acclaimed and popular writers as John Steinbeck and Ernest Hemingway wrote on the fourth- and fifth-grade levels.

Guides to simple writing

Sometimes we don't simplify our writing because we aren't sure how to go about it. These techniques may help you:

■ Keep sentences short. While sentences should vary in length for the sake of variety and a natural rhythm, the average length should be only about 15 words.

■ Work for greater clarity through the use of exact words.

■ Choose simple forms over complex. A complex form is often important to clear expression, but in most cases complex ideas should be presented in simple terms. If complex or technical words must be used, find a way to explain them.

■ Prefer the familiar word. Astute writers draw on large vocabularies only to give exact meaning to their work, never to impress.

■ Avoid unnecessary words. Usually you can cut your work in half without affecting meaning and understanding. The "deadwood" can be edited out as you work toward a final draft.

■ Use active verbs. They make your writing more readable by making it more interesting, livelier, and shorter.

Balanced treatment

As you write, be aware of the need to give fair, accurate, and balanced treatment of the sexes and minorities. Unless the information is specific to one sex or group, keep several guidelines in mind.

■ Avoid man-words where substitutes can be used without making your writing awkward. For example, use *synthetic* instead of *manmade, human beings* instead of *mankind,* and *salespeople* instead of *salesmen.*

■ Specify gender only where it serves a legitimate purpose. Rather than contend with the *he/she* or *him/her* dilemma, recast a sentence using the plural pronouns *they* or *them.*

■ Treat both sexes as full participants in the action.

■ Use job titles that fit both sexes equally well.

■ Where illustrations show people in action, show them in non-stereotyped roles.

■ Avoid using singular male pronouns as universal pronouns. They have traditionally served in English to refer to either sex, but that usage is no longer accepted.

For a thorough discussion of effective writing, see Chapters 1, 3, and 5.

Producing the publication

Production of the publication encompasses the work that takes place after the manuscript is completed. It includes deciding on a format, setting the manuscript into type, designing the pages and laying them out, and printing the publication from the completed pages.

Format

Format refers to the finished size of the publication and the number of columns per page. It also has to do with the typeface and paper used, the method of binding used, and the overall look of the publication.

The finished size is governed by the content and the equipment on which the publication will be printed.

■ Is it to be primarily text or will it include illustrations that need special space consideration?

■ How many pages will it have?

■ Will it be delivered to the reader as a handout, sent in an envelope, or treated as a self-mailer?

In printing terms, a sheet of paper is different from a page. A sheet is a piece of paper that has two sides when not folded. A page is one side of a piece of paper. Therefore, a sheet of paper has two pages when not folded, and four pages when it is folded once.

An 8½" by 11" sheet of paper is very functional, and many publications are printed on this size. Sheets are usually flat, though they can be folded in half to make 5½" by 8½" pages. Under some circumstances a 9" by 12" sheet is folded to create a 6" by 9" finished publication or folded into thirds to form a 4" by 9" finished publication.

Depending on the size paper you select, you will usually use one, two, or three columns per page. An 8½" by 11" page can handle any of these choices, but you should avoid a single column on this size page because the lines of text would be too wide to be easily followed by the reader's eye. If the paper is folded to become a 5½" by 8" page, however, a single column could be the best solution.

Design

The quality of the information and clarity of presentation are of first importance in a publication. However, a well written and well edited publication is improved by good design. Problems with design often arise because the producer does not have a clear plan or becomes too ambitious.

Simplicity and consistency are keys to achieving easy-to-read pages that will attract and hold the reader's attention.

Designing a publication is like most things — there's a right way and a wrong way to do it.

Letting each page take its own shape and form is the wrong way. Giving each page a similar structure so that there is a sense of cohesion and character is the right way.

Grids

The use of a design tool called a *grid* can help achieve the simplicity and consistency that are important. It can also save time and money, and take the guesswork out of how your publication will look.

What is a grid? It's a means of organizing material using a pattern of horizontal and vertical lines that divide a page into uniform sections called modules. Text and illustrations are fitted into these sections. The modules remain the same from page to page, making the layout of the publication consistent from one page to another.

		MASTHEAD
TEXT	TEXT	TEXT
OPTIONAL ILLUSTRATIONS		OPTIONAL PHOTOGRAPHS

Designing each page in a similar format gives your publication a sense of cohesion.

Professional designers find that grids aid in the creative process and save time. Grids can also help the amateur more quickly achieve a neatly designed publication with a professional touch.

Standard graph paper can be used as a basic sheet on which to construct a grid.

Keep in mind that the more modules in the grid, the greater your freedom in design. The larger the modules, the less freedom you have in working within them.

Visualization

Earlier in the planning process you considered the possibility of illustrations for the publication. In the design and layout steps, however, you get down to the basics of visualizing specific points.

Using illustrations where possible often helps get your message across to the reader. Never add illustrations simply to "dress up" the publication — good visuals are always an integral part of the message itself.

The printing method you choose and the graphic skills or resources you have will influence the type of illustrations you use. Simple line drawings, charts, and graphs can be used with almost any printing method. They also can be produced faster with less expense than photographs.

You can gather drawings from other publications or from commercial collections of ready-to-use drawings such as the *Ace Clip Art Book Six*, published and sold by Interstate Printers & Publishers, Inc., Jackson and Van Buren, Danville, Illinois 61832-0594. You may also want to check an art supply store for other available clip art books. When you use art that is not original, however, be sure to observe all copyright rules.

Charts or graphs should be simple. If you produce them yourself, you will need to take pains to see that lines are straight and letters are properly spaced.

Even though equipment and staff constraints may dictate a simple approach to illustrating your publication, you can still display some parts of it in a different way to achieve a stronger visual sense.

One section of the text, for example, may lend itself to being "boxed" as a separate item. Simply set the type a bit narrower than the rest of the text, add a heading and place a rule around the information. Lists often work well in boxes.

Another section might be handled as a short article, called a *sidebar*, which is related to the whole but displayed under a separate title. A general publication on gardening, for example, might include a sidebar on annuals that perform best in your area.

In summary, here are six basic design pointers to guide you:

■ Keep it simple, clean, and functional.

■ Remember the audience you are to reach, the content of the publication, and how the publication is to be made available.

■ Aim for a design that you or your staff have the ability to achieve.

■ Know the requirements of the printing equipment you'll use and stay within them.

■ Limit the number of typefaces to avoid clutter. Your typesetter or your desktop publishing system may make many available, but one face for the text and one face in varying sizes for headings is a good standard to follow.

■ Be consistent within the publication in column width, margins, spacing, headings, and illustration labels.

Setting type

A few fundamentals about type may be useful to you in preparing your manuscript for printing whether you use in-house equipment or purchase type from a commercial typesetter.

The different types available are called "faces" and usually come in a range of sizes from 6 to 72 points (72 points equals an inch) and with a complete font in each size. A *font* is a full set of characters in any one size and style of type.

There is a wide array of typefaces today, each with individual characteristics that influence its readability and legibility.

Classes of type

Type falls into classifications such as *oldstyle, modern, sans serif, square serif,* and *script*. The two classifications that may be most useful to you in publication making will be modern and sans serif.

Oldstyle and modern typefaces are based on ancient Roman inscriptions. They have endured over the centuries since they were designed, probably because they have a classic quality and high legibility. These typefaces are designed with a distinct contrast between thick and thin strokes of the letters. Letters also have *serifs,* thin "feet" or "tails," that finish the strokes. Their open, round design also adds to their readability. As a result they are a good choice for text.

The sans serif classification includes contemporary faces, many of which came into vogue in the '70s. They have remained popular and

successful for use in headings, smaller blocks of reading matter, and for posters and advertising. The letters have a clean, modern look with no serifs and little contrast in the thick and thin strokes of the letters.

While other classes of type have areas of special use, they are not good "book" faces and should be avoided in publications. Script, for example, is designed to look like handwriting. While it is traditionally used for formal invitations and announcements, the letters have little contrast in strokes and no serifs and seem to run together. Text letters such as Old English are designed to approximate the hand lettering of the early illuminated manuscripts. They may be used successfully in diplomas, certificates and religious documents, but are not suitable for the text of publications.

Some typefaces, particularly those widely used, have many variations in weight and style that together make up a "family" of type. For example, Helvetica, a popular sans serif face, may have light, medium, bold and extra bold versions. There usually is an italic version and possibly expanded and condensed versions.

With these variations plus a range of available sizes you can prepare a publication that uses only one type face, yet has the variety in weight and style that may be needed to set off content effectively. If you want the variety of a second face, it could be used for headings.

A roman face, for example, can be used for the body of the text to provide good readability and legibility. A larger, bolder sans serif face might be used for contrast and good visibility in the headings.

Methods of producing type

There are several methods of producing type. The three that may be most available to you are *typewriter* or strike-on composition, *photoelectronic typesetting*, and *computerized desktop publishing* systems.

Standard correcting electric typewriters with or without memory can be used as simple typesetters to provide clean, even text or to prepare stencils for mimeographing. In combination with neatly applied press-on type or machine headline lettering to provide

contrasting type in larger sizes for headings, the result can be quite acceptable. You may also want to investigate the possibility of buying headline lettering from a local typographer or art supply store that provides this service.

Standard correcting electrical typewriters can be used as simple typesetters to provide clear, even text or to prepare stencils for mimeographing.

Phototypesetting systems make use of three elements to produce type: a master character image, a light source, and a photo- or light-sensitive material.

Hh	**Hh**	**Hh**	*Hh*
Light	Medium	Bold	Italic

While some offices use small phototypesetting systems for in-house work, the larger, more powerful systems are with commercial typesetting houses.

Desktop publishing exploded on the scene in the late '80s, providing the capability of using office computers to create camera-ready pages for printing. The integral parts of these systems are a personal computer with a hard disk drive, word processing software with page layout capability, and a laser printer.

For an in-depth discussion of desktop publishing equipment and guidelines for using it to produce publication pages, see Chapter 15.

Guides for commercial typesetting

If you are not able to typeset your publication copy in your own office, you may find these pointers helpful in preparing your manuscript for a commercial typesetter.

■ Type on standard 8½" x 11" white paper of good quality.

■ Double-space the copy and allow margins of at least 1¼" all around. Be sure to keep a copy in case the original is lost.

■ Do not underline words in your manuscript for emphasis unless you want them set in italic type. If you want to emphasize a word, draw a wavy line under the word or words and mark "bf" in the margin. It will then be set in boldface type for emphasis.

■ Identify each manuscript page at the top with the title and page number.

■ Number each sheet consecutively. After the last line on the last page, type "end."

■ Make any corrections after the manuscript is typed above the line and in ink.

If you are unable to typeset your publication in your own office, a commerical typesetter is the next option.

To keep the cost of commercial type as low as possible, edit your manuscript carefully and double-check it before it goes to the typesetter. All facts and all spelling, punctuation, and capitalization should be double-checked before it leaves you. Typesetters must set copy as it is sent to them even though they may suspect that something they see is incorrect. Corrections can be costly.

You will need to inform the typesetter about the face and size type you wish to use, the amount of leading (space) you want between lines of type, the width you want the lines to be, how paragraphs are to be indented, and other points. These instructions are marked on the manuscript in a process called *specifying the type.*

Basic formats for type

There are several basic formats for setting type. For example, you can set the copy so that it is justified (straight or "flush") on both the right and left sides. Or you can set the type so that it is flush on the left and "ragged" (uneven) on the right.

Both styles usually have indented paragraphs and use hyphenation as needed. Either roman or sans serif typefaces are used. Headings may be centered or may start at the left margin (flush left).

Check with your typesetter for instructions on how to mark the type specifications for the style you want.

Layouts

If a commercial printer is setting your type and laying out pages for you, all you need to supply is the copy, any illustrations, and full-scale rough drawings (dummies) of how you want the pages to look.

If you are producing finished pages on a desktop publishing system, you will need only to give them to the printer numbered in the order in which they are to appear.

If neither of these routes is available to you, the next step in the production process is to produce neatly prepared pages from which the publication can be printed.

Offset printing or copier layout

When you print by the offset method or electrostatic copier you will need to prepare a layout that is ready to be used exactly as is to make a printing plate or copy. This involves deciding precisely where you want type, headings, and illustrations to go and pasting up your material, properly aligned on a sheet of white paper just as you want it to appear in the printed publication.

Artistic ability and special training are helpful but not essential to this process. Organization, neatness, a "good eye," and the tools to ensure straight lines are essential.

A T-square and triangle are good tools for aligning (keylining) your copy. They should be used on a flat, straight-edged table. An alternative to these tools is a clear plastic ruler with crosshatch markings; when you place the ruler over your copy you can see through it and align the copy with the markings.

Rubber cement and hot wax give you a smooth, wrinkle-free paste-up and allow you to move copy successfully once you have pasted it down. Art supply shops have waxers that can be used to apply a coat of wax to the back of your paper. The wax then holds the copy in place on the layout.

For simple publications, clear plastic (matte finish) tape may work equally well and is easier for many people to handle. Of course, you must be careful to use it only on the edges of the paper, not over the type.

Spacing and margins

Consistency is important in the spacing and margins of the publication not only for appearance but for successful printing.

As a rule of thumb, the widest margin is always at the bottom of the page. Side and top margins may be alike, or the top margin may be a bit wider than the side margins. On facing pages, the inside margins (called the gutter) are narrower.

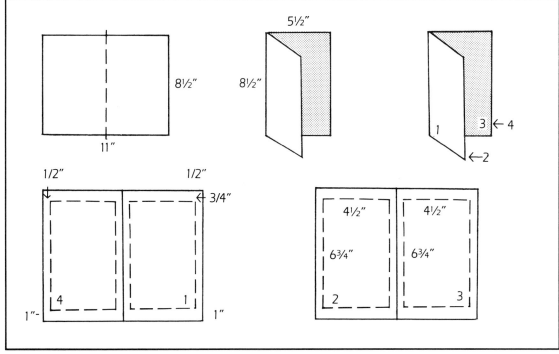

Sample publication layout for an 8½" x 11" sheet show paging and suggested margins.

If you produce a four-page publication from an 8½" x 11" sheet folded, the finished size of the publication will be 5½" x 8½". You would treat the front and back pages (pages 1 and 4) as single pages and the inside pages (pages 2 and 3) as facing pages.

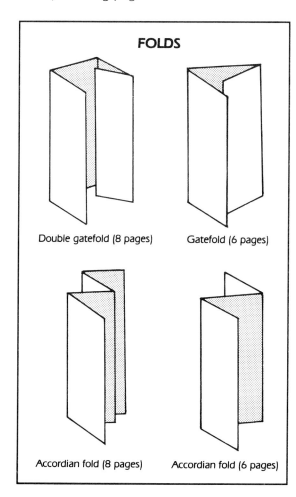

FOLDS

Double gatefold (8 pages) Gatefold (6 pages)

Accordian fold (8 pages) Accordian fold (6 pages)

The margins for pages 2 and 3 could be ½" at the inside edges (gutter), ¾" at the top, ½" on the outside, and 1" at the bottom. All type and illustrations would be within an image area 4½" wide x 6¾" deep — proportionately, the same shape as the full page.

On pages 1 and 4 the outside margins could be ½", the bottom margin, 1M, and the top margin, ¾". The top margin on page 1 might appear larger because you probably would use larger type for the title of the publication and allow extra space around it.

If your type is prepared on a desktop publishing system or by a commercial printer, larger or contrasting headings can be created as a part of the typesetting process. If you rely on a typewriter, you will have to achieve these qualities by using all capitals, underlining the heads, or both.

A better solution might be to use rub-off letters available in art supply stores, or machine lettering if such a system is available to you.

If your illustrations are black-and-white drawings (line drawings), they may be cut and pasted on the layout sheet or drawn directly on the sheet.

Photographs are not pasted on the layout, but the space they are to occupy must be carefully indicated. Label the photos on the back to correspond with the space assigned so that the printer can match up picture with place. Do not write on the back of the photo itself

because this could damage the emulsion in a way that would show in the printed publication.

If you produce publications often, you may want to investigate courses in your community that cover the basics of design and layout. Chapter 6 also provides important information to guide you in some of these areas, as do a number of publications listed in the reference section.

Layouts for mimeographing

If you will be using a mimeograph machine to print your publication and you have an electronic stencil maker available, you may prepare the layout much as you would for offset printing. The electronic stencil maker scans each page and reproduces the light and dark areas on the stencil.

If you do not have such a machine, you will need to use a different approach to preparing your layout. Use a typewriter to cut the stencil, typing the copy exactly where and how you want it to appear on the page. You can either type in the headings or, with the use of a stylus and lettering guide available at a mimeograph or art supply shop, you can create larger, bolder headings for contrast.

Consult your mimeograph supplier for pointers on the most effective use of the equipment.

Printing the publication

The biggest expense in production is the cost of printing. You will want to know enough about the more frequently used processes to make an informed decision on the system to use (when there is a choice).

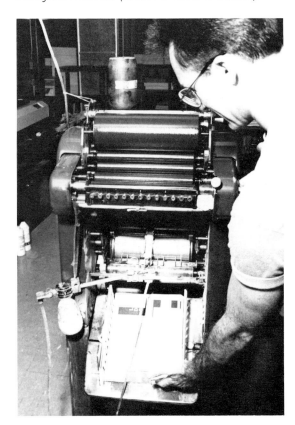

Offset presses can produce thousands of impressions per hour.

The method most readily available probably will be offset printing, electrostatic copying, or mimeographing.

Offset presses

There are many types of offset presses, ranging from simple office duplicators to sophisticated machines that can handle multiple colors and produce thousands of impressions per hour. All offset presses have inking and dampening systems and three printing cylinders — the plate, blanket, and impression cylinders. The system operates on the principle that oil and water don't mix. The flexible plate with the image to be printed is clamped to the plate cylinder. When this cylinder rotates, it comes in contact with the dampening rollers, then the inking rollers. The dampeners wet the plate so the non-printing area will repel ink. The inked image is then

The preparation of plates for offset presses includes "stripping" negatives by an offset photographer.

The offset method requires minimal preparation time including touch-ups.

transferred to the blanket cylinder, which "offsets" the image onto paper as it passes between the blanket and impression cylinders.

The offset method requires minimal preparation time, is adjustable to allow good alignment (register) of materials, is flexible enough to handle a wide range of papers, and can print photographs.

Copiers and duplicators

Copying and duplication methods are technically classed as "reprography." Copiers, which have become indispensable to offices everywhere, offer fast, convenient, and economical means of making multiple copies of a wide range of documents. They are used extensively by in-house printing departments and quick printing shops.

Since 1960 the xerographic method of copying has dominated the copier scene. This method is an electrophotographic one, based on the electrostatic transfer of toner to and from a charged photoconductor surface.

These copiers use electrophotographic coatings to produce the images in the copier. Such materials have the property of holding an electrostatic charge in the dark and losing the charge when exposed to light reflected from the white areas of an original layout. The image areas that remain charged are developed with an oppositely charged dry powder or liquid toner which is then fixed to paper by heat, pressure, or solvent vapor.

Copying and duplication methods offer fast, convenient, and economical means of making multiple copies of a wide range of documents.

Another important piece of equipment in this category is the offset duplicator. These small

offset presses produce good copies quickly. They are ideal for producing a wide variety of materials, including simple publications, at low cost and with a minimum of preparation.

Printing by mimeograph

The mimeograph machine is also classified as a duplicator. However, it uses a stencil made of thin, tough paper with a waxy coating that is "cut" using a typewriter.

The stencil is fastened to the outside of a duplicator cylinder. Ink from inside the cylinder is pressed on the cylinder surface. As the paper moves through the machine it comes into contact with the stencil, and an image is transferred from stencil to paper.

While many improvements have been made in mimeograph machines over time, the quality of the products they print, even under the best circumstances, cannot compare with those from offset machines or electrostatic copiers.

Paper and ink

Selecting inks and papers is similar to buying paint in a paint store. The choices seem almost endless.

Papers are sold and labeled by weight and type — 60-pound offset, for example, or 20-pound bond. At the economical end of the line are newsprint-like papers. Newsprint

itself, however, can be used only on a special printing press called a web press. At the expensive end of the line is a wide variety of special paper stocks with many different finishes.

The basic decision on ink is whether to use one or more colors. In printing terms, *single color* means that only one color ink is used throughout the publication. It can be black or some other color, though black or very dark colors are the most readable.

Selecting inks and papers is essential in the final stages of the printing process.

Process color is used to reproduce color photographs. This is an expensive process and also requires sophisticated printing equipment.

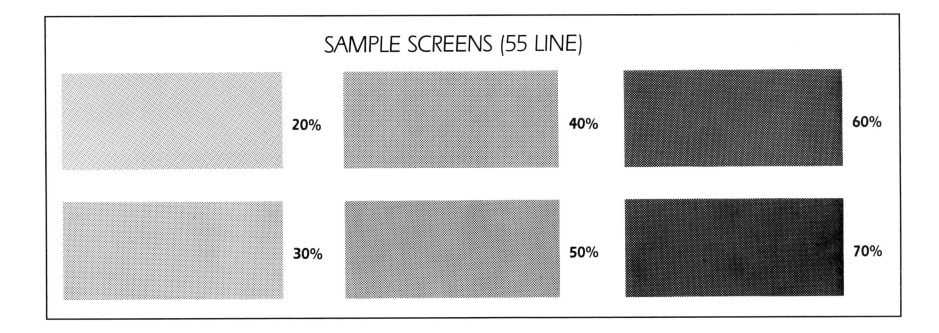

SAMPLE SCREENS (55 LINE)

20% 40% 60%

30% 50% 70%

You can create the illusion that more than one color of ink has been used by screening the single ink color to create several tones of the one color. If you print by offset, the printer can place a Benday screen in front of your artwork when the printing plate is made. This screen

has a dot pattern that represents a percentage of the darkness of the original artwork that you want. You can achieve this same effect yourself by using rub-off pattern sheets when you prepare your art.

Consult your printer or supplier about papers and inks for the publication you plan, taking into account the equipment on which it will be printed. From their swatch books, you can select from dozens of choices the paper and ink color that best suits your publication and your budget.

■ **Some basics**

News articles written by communicators at non-profit agencies, universities, or public relations firms face special challenges. Those writers know that preparing good articles does not by itself assure use by major dailies. Big papers depend less on "stringers" and "canned" news and more on their own reporters and news wire services.

Electronic delivery makes a difference with some editors, however. Many agency, university, and organization news gatherers are using rapid delivery technology to reach the pages of big dailies, wire services, and some magazines. Some smaller weeklies may even use electronic delivery to minimize typing or keystroking. Weekly editors usually invite news from sources other than their own staffs.

Some basics

What is news? Many definitions exist, but Mitchell Charnley's in *Reporting* are among the better ones: "News is tomorrow's history done up in today's neat package. . . . News is the best record we have of the incredible meanness and the magnificent courage of man. . . . News is the timely, concise, and accurate report of an event; it is not the event itself."

News editors consider an item news if it is timely, has local interest, carries a sense of importance, involves conflict, is about progress (or lack of it), is unusual, or contains a human interest appeal. For a fuller discussion of news traits, consult Chapter 5, "Writing skills short course."

The lead. Learning to write a lead is important. Practice writing leads that use striking statements, quotations, questions, and other attention-getters. Readers sense enthusiasm in a writer and react accordingly.

After writing a one- or two-sentence lead, expand your article. Add facts or statements in descending order of interest and importance. This classic, inverted triangle news writing format is still the standard.

Be local. Editors may reject articles lacking local interest or impact. Almost any story idea you have can be localized, but it takes a little digging sometimes. Try to use local names, no matter what the topic. For example, let's say your subject is a new business marketing approach that is sweeping the country. An article about a local business person who uses the strategy to improve earnings and who reveals his or her "secrets" would please most editors.

Be correct. Get the facts and spell them correctly. Nothing is so embarrassing as an agency or organization release with poor spelling or an unchecked fact. If you have to guess on a name or a fact, hold the item until you're sure.

Be neat. Submit "clean" copy. You have no excuse for sending marked up copy to an editor, especially if you use word processing. Correcting copy on computers is a snap.

Write tight. Before mailing the article, apply the imaginary scissors test: Will it make sense

Be local. Be correct. Be neat. News editors consider an item news if it meets this and other criteria.

if it is cut from the bottom? Make sure the answer is yes.

Stay in touch. Maintaining good relationships with editors and reporters is important. Visit editors to learn what they want and when they want it.

Advance and follow-up stories

Editors label news stories and features by several names: advance, follow-up, color, sidebar, interpretive, descriptive, and investigative. You could think of others. The advance and follow-up probably head your list.

Good advances and follow-ups take work and sometimes imagination. It is easy to give time, place, speakers, and topics in an advance and rely on readers to supply the interest. You can't afford to rely on your readers, however. A good advance has a built-in interest factor. Check these examples:

First lead — A meeting on crop marketing outlooks will be held Wednesday at 8 p.m. at Gordon High School. Interested parties are invited.

Second lead — Skidding commodity markets may attract several producers and local business people to Gordon High School Wednesday, when university economists peek into the future. The meeting starts at 8 p.m.

That's more like it. Both leads give facts, but only the second gives a *reason* for producers

and local business people to attend. Stories about meetings need a "why" angle.

The educational payoff of a meeting may be in the follow-up article. You can remind those who attended of the highlights, reinforcing the learning process. A follow-up also reaches people who did not attend the marketing outlook meeting, the majority of almost any community.

Did the economists predict better markets? Or did they see more of the same? You owe it to the editor to follow through on coverage. By printing an advance, the editor saw this as a newsworthy event deserving additional coverage.

Don't start a follow-up article with attendance figures, note that "an interesting time was had by all," or list speakers and their subjects.

Features and columns

Features usually deal with people. They have a touch of the unusual, the unknown, or the unrecognized. These articles are excellent teaching tools when they focus on specific, but unique achievements or events.

Columns, on the other hand, are a "journalist hybrid" — part article and part feature. They usually consist of reading material topped by a readily identifiable "standing head."

The feature. Look for people with interesting work or hobbies who are willing to talk. Their

enthusiasm will shine through their words and will make your feature sparkle. Use quotations with quotation marks. They dress up even a modest feature.

Interviews are key to features. Questions built around "how" or "why" attract better responses than do questions requiring only a "yes" or "no" answer. Stay on the subject or you'll wind up with more notes than you can possibly use. Search for human interest angles in feature writing. Nothing stirs heartstrings quite so much. Probe beneath the surface. A writer once interviewing a couple asked, as an afterthought, about their children. Imagine her astonishment when she learned that all eight children had graduated from the same university. That made the story.

The column. The column can cover several short items or only one subject. Use the arrangement that seems to work for you. Editors generally have only one major requirement of a column — that it attract readers and keep a following in the paper. If readers ask for it when the editor goes a week without using it, the column has a home. One easy way to build readership is by printing names. Use them naturally so they fit in with the flow.

A column is a place for opinions. Most columnists can give personal views with no constraints except for the laws of libel, the dictates of good taste, and the willingness of the editor to print them. Educators, science

writers and public relations professionals, however, have much less freedom in column-writing.

Writing a weekly column is a commitment. The well can run dry. You may recognize at 2 p.m. on Monday that the column must be in the hands of the editors just two hours later, and you haven't written the first word. Realize your commitment before you agree to write a regular column.

To help prime your creative pump, keep a folder of ideas. File questions you get daily. Cut out articles. The contents of a new publication or a research result may deserve attention. Read unusual publications that deal with topics you don't normally bother with. Sometimes ideas come from strange sources.

Write your column as though you are writing a letter to a good friend or a favorite aunt. This will give it personality.

Don't overlook fillers

Most newspapers carry small items at the bottom of some news columns. Editors call them "fillers." Although not related to other items in the column, fillers serve a vital role. Page paste-up workers don't have to scurry for type to fill space that scheduled news items didn't occupy.

Newspaper syndication services, commercial concerns and public relations and information and education offices provide fillers. Brief sets

of facts about programs and people in your organization make excellent fillers.

Editors like photographs

Many editors want photographs with articles. Photos seem to enhance readership. Check the latest edition of your hometown newspaper for the number of staff-written stories and wire service articles accompanied by photos. Whether they accompany a story or stand alone, photos with a strong human angle get the most attention in the newsroom. A photo must also pass the technical test with an editor. It must be clear and sharply focused with good contrast.

The news photo is effervescent. It is a hot potato today, a cold cucumber tomorrow. The feature picture, on the other hand, is a slow burner. The editor can use it tomorrow or next week without detracting from its significance.

Tailor-made and exclusive

You probably send news items to all magazines in your area. Yet, special occasions may dictate you send to just one magazine. This may be one that demands exclusivity. The key is learning what its editor wants.

If you plan to target an item to a certain editor, check in by telephone or through a personal visit first. The editor may suggest length and a story slant. That could save you

the frustration of producing an article containing many unwanted words.

Some information offices mail out "media alerts" to call attention to a possible news story or to an upcoming event. If the idea of a "tip sheet" appeals to you, always include the names and phone number of persons to contact.

Whatever you can do to maintain contact with editors, do it. Editors may accept more items or suggestions from people they're in frequent contact with.

Remember that you do not need to be a subject matter authority to produce an informative article. Don't let your lack of knowledge about a particular subject keep you from writing about it. Let your readers learn as you do.

When you use statistics, make sure they are correct. And then state them simply: "Three out of four people" is better than "74.6 percent of the population."

How to help a reporter get the story

Reporters are often imagined as all-seeing, all-knowing people who have a spider-web of informants keeping them apprised of every new development. The truth is not quite that glamorous, but the best reporters do have networks of sources that tip them to good stories.

3 Writing for newspapers and magazines

■ How to help a
reporter get the
story

You can be one of those sources by under-standing how the media works. As a communicator for a non-profit organization, you probably often function as a news middleman or liaison between your institution and the media.

Many reporters grow to rely upon credible communicators at universities and non-profit agencies almost like field correspondents. They count on their sources to keep them abreast of the latest trends and steer them to front-page stories. But the operative word here is credible.

How do you gain credibility with the media? First, by understanding what makes news. Second, by knowing what the media needs to deliver news to the public. And third, by using your imagination and creativity to find new ways of ensuring that the media knows about your organization.

Before establishing contacts with the media, it's also smart to be a good reporter within your own organization. Find out what kind of media profile your organization would like to pursue. What areas does the organization wish to highlight? Are members willing and able to be available to the press? How would the organization deal with the possibility of negative stories?

After you devise a plan for dealing with the media, you can develop ways to spread the word about your organization. Writing a news release and sending it to newspapers is still

the most effective way of plugging into the news network.

As stated before, computers link universities, public relations firms, and non-profit agencies to news associations such as the Associated Press. Since the Associated Press serves most newspapers, television, and radio stations, the wire service offers the most convenient and effective route to newspaper front pages and newscasts. But there are other ways of stimulating media interest that are often overlooked or underestimated. Here's a list designed to win you a special place in a reporter's Rolodex:

Know your media gatekeepers. Know the editors, reporters, and news directors in your area. Read the newspapers, call newsrooms, and consult media directories to learn the reporters, editors, and news directors most likely to be interested in your organization. Remember to include reporters from cable television stations, newspaper and television editorial writers, and newspaper columnists. Some institutions hire a newspaper clipping service to clip articles mentioning their organization, which is a good way to learn the state and national reporters covering your organization. A clipping service can also help you gauge the effectiveness of news releases.

Know who you are. You must know how to introduce your organization to the media. Don't assume that a reporter, editor, or news director knows enough about your organization. Send introductory letters accompanied by

a business card and a brochure, pamphlet or magazine describing your organization. One non-profit organization created a "Facts-At-A-Glance" sheet that describes the organization's mission to new reporters. Other groups have drafted telephone directories listing organization members who are willing to serve as experts for the media. Tools like these serve as ice-breakers with new members of the media and updates for experienced reporters.

Respond promptly. Know the needs of the media. Answer all telephone calls promptly and know the reporter's deadline. More important, help him meet it. All reporters are attracted to a good story, but each has somewhat different ways of covering it. A newspaper or magazine reporter will generally interview sources in person or on the telephone, looking for photographic possibilities or statistics for an eye-catching piece of graphic art.

Television reporters believe the best stories have strong visuals that grab and hold a viewer's interest. With a camera crew in tow, a television reporter is attracted to activities that make exciting or interesting footage and interview subjects who talk in clear, concise language. Radio reporters, too, rely on lively interviews to add color to their stories.

Know how to brief the media. The best way to be prepared for an onslaught of media interest is to have a written news release ready to give or send to reporters. That way, reporters can refer to the release when they

■ How to help a
reporter get the
story

Writing for newspapers
and magazines 3

are back at their keyboards. A written release ensures that your organization's view or version of events is clearly stated. Some organizations also offer a videotaped version of their news release to broadcast reporters. Others create "press packets" that include photographs, graphs, diagrams, and even artwork to accompany a news release. Aside from news releases, some institutions publish news tip sheets, which suggest ideas for feature stories to the media.

Be aware of trends and experts. Reporters have an endless need for experts able to answer their questions at a moment's notice, especially for in-depth and feature stories. Cultivate a reputation as a communicator who has access to the experts and reporters will always know your telephone number.

For example, a flurry of articles about pesticides may prompt reporters to take a renewed interest in biological controls or natural alternatives to chemicals. Communicators at many universities have steered reporters to biocontrol experts, who have been quoted in articles across the country.

The best communicators know how to spot trends in the making. Better yet, they know how to generate compelling story ideas that showcase the expertise of their organization's members.

Know how and when to hold a news conference. The news conference is a tool for making news. The best time for a news conference is around 10:00 a.m., which is

early enough to meet the deadlines of broadcast reporters and reporters from afternoon newspapers. But it's not too early for reporters for morning newspapers, who work late and don't usually arrive in their offices before 10:00 a.m. Make sure that chairs, handouts or press packets are available for every reporter.

At many news conferences, the people meeting the media leave too early, before reporters have had enough time to digest their press packets and ask all their questions. A good news conference leaves reporters feeling stuffed with information and satisfied they will be able to write their stories with confidence. Don't leave them hungry for more.

Know all the ways to reach the media. Don't overlook opinion columns and letters to the editor as an effective way of publicizing your organization's views on a given issue. By the same token, also explore opportunities to appear or to create cable television shows or radio shows about your organization. This is a non-traditional, but still very effective way to win column inches.

The care and handling of reporters

Much of successful writing for newspapers and magazines hinges on personal interaction between you and the editor. Many people approach a meeting with a reporter with all the trepidation they reserve for an encounter with their dentist. But an interview with a reporter doesn't have to be a messy,

painful affair, not if you know some of the of following Do's and Don'ts for dealing with the media:

■ Don't ask a reporter to go off-the-record. Requesting a reporter to withhold information is a very risky proposition that can easily backfire. Assume the reporter is going to quote everything that is said and make sure everyone knows that in advance.

■ Don't ask a reporter for a copy of his story in advance. Some reporters will be insulted by this. What you can diplomatically suggest is that the subject of an interview would be happy to help the reporter if he wants to later check his facts or ask any additional questions. Give the reporter business and even home telephone numbers, so that he can call back later.

■ Don't assume the reporter is an expert. Start off simply with the basic premise of the story and gradually add on layers of information.

■ Do treat the reporter with courtesy. It sounds corny and obvious, but manners go a long way with the media. Keep appointments with reporters and make them feel welcome. If a member of your organization grants an interview to a reporter, he should try to be as forthcoming and informative as possible.

■ Do ask the reporter about his story. Find out what angles he's trying to pursue and what visuals would enhance his article or

broadcast feature. Be willing to help a reporter reach and set up interviews with people in your organization.

■ Do keep in contact with the media. But don't harass reporters with meaningless, "What can I do for you today?" telephone calls or visits. Cultivate a reputation that tells a reporter a compelling news story is waiting every time you call.

- Know your audience
- Define your purpose
- Find out if anybody's reading

Newsletters 4

A newsletter can be a wonderful means of communication. Research consistently shows people like newsletters. People like to get timely information specifically tailored to their interests that is quick and easy to read.

But a newsletter must be read before it can communicate. It can't get thrown away before it is opened or banished forever to the to-be-read-tomorrow pile.

You want your newsletter to be a vital piece of communication that people look forward to receiving. This only happens through planning and commitment.

Know your audience

The first step in planning a newsletter is too often overlooked: Know your audience. Who are they exactly? What are they interested in? What do they have in common? What can your newsletter do for them?

The audience can be quite diverse demographically but it has to have some commonality addressed with your newsletter.

For example, you might want to develop a newsletter for hospital volunteers or for farmers learning to use computers. The audience for a nationally distributed newsletter called "The Sproutletter" is people who like to eat sprouts. That's how specialized an audience can be.

If your audience is already defined for you — such as clients for your business or members of a certain organization — then you need to make sure you know what they are interested in. Find out. Meet with a few of them or send out a short questionnaire.

Define your purpose

After you have defined your audience, the next thing to do is define your purpose. The same rule applies: Be specific.

For example, say your audience is people who do crafts for pay. The purpose of your newsletter might be to help them market those crafts. You will include information about upcoming craft shows and pass along tips from successful artisans.

Or your audience might be people who home-can food. Your purpose is to keep them informed of the latest research on safe home-canning procedures, what's new in equipment, and recipes considered safe.

The more specific your purpose, the easier it will be to prepare your newsletter. Your mind becomes tuned in to bits of information that could make good articles. Make note of these in a file. Each time you go to put the newsletter together, all you have to do is dig in that file for the material you need.

Find out if anybody's reading

Even though you may be armed with a clear-cut audience and purpose, you're still not ready to launch a new newsletter until you have figured out an evaluation plan. You need to find out if anybody out there is reading you. Coming up with a plan before you start publishing will help assure that you stick to your audience and purpose without getting off track.

There are three levels of evaluation. Come up with a plan for all three.

Level 1: Get feedback on a regular basis

Write at least one article per issue that calls for some response from the reader. Examples might be:

- Include an order blank and ask readers to send in the names of acquaintances who might like to receive the newsletter.

- Publicize a publication you have in quantity and see how many requests you get because of the article.

- Solicit questions from readers and include question-and-answer articles in the newsletter.

An enterprising family economics specialist in Missouri started a newsletter called "Beginnings" for newly married couples to help them get their financial feet on the

ground. One issue included this article:

What do "you" do?

How do the two of you handle money and bills? Are you happy with your present system? If you would like to share your system with others, drop me a line or call — I'll include it in next month's "Beginnings."

In an issue of the national newsletter "Communications Concepts," the author asked for readers to send in puns so he could give "fun in the pun awards" to the worst and best puns sent in.

Level 2: Do a survey

Do this once a year. Ask what the readers read and don't read, like and don't like about your newsletter. Use this information to improve your newsletter.

You'll waste your time, though, if you don't design the survey the right way. There's an art to doing it. Here are a few tips:

■ Ask only what you want to know and nothing extra.

■ Keep the survey form as short as possible — no more than one 8½" x 11" inch sheet. The back of a postcard is best.

■ Make it easy for people to return. Include a self-addressed, stamped envelope. A self-addressed, stamped postcard has

advantages because it can be inserted in one of your issues.

■ People are turned off by questions on age and income. If this information is vital to you, don't ask it first. Let them warm up to your survey first. Then when you do ask it, provide ranges, such as an age between 30 and 39 or an income less than $30,000 per year.

You don't have to ask everybody. If you have a random sample, you can extrapolate the results to the whole population. Pick every tenth name from your mailing list, for example.

It's also essential to do a dry-run before committing your survey to the mail. Test the survey on a handful of people to make sure your questions are understandable.

Level 3: Find out if anybody is doing something different because of your newsletter

This is the most difficult level of evaluation. It has to be carefully orchestrated. Figure out *one* thing you want to campaign for in your newsletter. And then quickly find out if your campaigning did any good. Here are the steps:

■ Promote something. You may want to use two or three or more issues to do this.

■ Find out if anybody is doing it because of your newsletter.

■ Remember to find out fast. They may start doing it. But they'll forget they got the idea from your newsletter unless you time your evaluation and the campaign close together. Ideally, the timing should be within 30 days of the end of your campaign — or certainly within three months. For efficiency's sake you may want to include this evaluation in with your yearly survey.

What you choose to campaign for depends on your audience and purpose. If your audience is the newly married and your purpose is to help them get off to a good start financially, you might want to campaign for them to set up a budget.

You might want to campaign to help weight watchers keep off weight, smokers to stop smoking or farmers to adopt certain soil conservation practices. A hospital employee newsletter conducted a campaign to promote courtesy in elevators. Whatever it is, if you find that people have changed their lives because of your newsletter, that's quite an accomplishment. Those kinds of results might help you get a raise or more subscribers. Either way, you've set yourself up for newsletter stardom.

Market your newsletter

The next plan you need to devise is how to market your newsletter. An effective way to do this is through direct mail marketing. Thus, you need mailing lists. If your chosen audience belongs to organizations whose mailing lists you can get hold of, you are all set. But if you

are trying to reach an audience whose members are not already organized in some manner, then you have your work cut out for you.

Here are some tips to help you get a mailing list started:

■ Get publicity in publications that reach your audience. If you can get this free, great. If not, you might have to buy some advertising space. Classified ads are less expensive than display ads and may yield a substantial number of names for you.

■ Put coupons in each issue of your newsletter asking readers to send names of friends or relatives who might be interested in subscribing.

■ Check with key people who have contact with the audience you're after. See if they would be willing to help you come up with names and addresses. For example, for the "Beginnings" newsletter for young married couples, the author went to ministers requesting names.

Once you have a mailing list, then you can proceed to promote your newsletter and urge subscription. Design a direct mail flier and cover letter that explain to the reader what he or she will gain from your newsletter. Answer this age-old question for the reader, "What's in it for me?" Here's a formula you may want to follow as you write your copy:

■ Promise a benefit.

■ Tell readers what they will get. Tantalize them.

■ Back up your statements with proof.

■ Rephrase the strongest benefit in the closing.

■ Incite action NOW.

Ideally, your direct mail marketing packet should include:

■ A cover letter.

■ A direct mail flier.

■ A postage-paid, self-addressed subscription card.

■ A sample issue of the newsletter.

If your newsletter has been available for a while and you are seeking more subscribers with your direct mail campaign, then you can incorporate the technique of the testimonial. Find out from readers what they have gained from your newsletter. If you have done a good job of evaluating, you should have these kinds of quotes already in your files. Include these quotes in your direct mail flier design.

Start your newsletter

O kay, you know your audience and have a clear-cut purpose. You have thought through an evaluation and marketing plan. Now, how do you organize the newsletter and write it?

The most efficient approach to the organization of a newsletter borrows from both the newspaper world and the magazine world. You borrow from the newspaper world the news approach to determine the prominence of your articles. Your best, most timely, and important article goes first. The rest of the articles follow.

You borrow from the magazine world the technique of departmentalization. That is, you put certain kinds of information under predetermined headings. For example, in "The Newsletter on Newsletters," the author has a department called "Newsletter Reviews." In it he tells of new newsletters, their audience, purpose, format, and subscription information.

Other examples of departments might include question-and-answer columns, employee of the month personality profiles or guest columnists. You will determine your departments based on the audience and purpose of your newsletter.

The department technique makes your newsletter easier and quicker to read. Departments also help you assemble your newsletter. You know exactly where to put certain bits of information without having to reinvent the wheel each issue.

Write about the right stuff

Write about what your audience wants and needs to know. Think about these five needs that everybody has:

People like recognition. Use names in your newsletter. People like to read about themselves first, then about people they know and finally about people who are famous. Take advantage of that need. Incorporate names whenever you can. Offer examples of how real people do the things you wish to promote in your newsletter.

A textile specialist in Missouri, for example, did a newsletter for professional seamstresses. In each issue she used the name of someone who had asked her a question or who had provided her with a valuable tip.

A livestock specialist used the same technique. He would find farmers doing the kind of practices he wanted to promote and then used their names in his newsletter.

People like to increase their wealth and save money. No matter what your audience or purpose, there has to be some economic angle to your newsletter. At least one reference in each issue should help people save or make money.

People like to feel safe, secure, and healthy. Include safety or health information in an article or have a department on tips. People seem to be more conscious than ever of safety and health.

People like to save time. Just about everyone has far more to do than there are hours in the day. This is true especially of newsletter audiences. That's why they subscribe to newsletters. Easy-to-read tips on saving time can endear your newsletter to your readers.

People like to have fun. When authors approach their newsletter as a means to communicate with a friend, they are more likely to write better copy and be read more. If you can bring a smile to someone's face, you've won a friend. Add a little humor to your newsletter. Write a clever headline. Include a poke-fun department. Pass on a funny situation that someone solved successfully.

One administrator wrote a newsletter for his staff and regularly included a "Turkey of the Month" department in which he admitted some error or boo-boo he had made. This endeared him to his readers.

The name of the employee newsletter for San Diego's Sea World is "The Whale Street Journal." A dairy specialist titled his newsletter "No Bull — Udder Facts."

A livestock specialist would add a quote at the end of his newsletter as a filler. But instead of using one of those innocuous anonymous quotes, he always quoted a real person from a joke made over coffee at the small town restaurant where he would frequently gather with farmers.

A newsletter without photographs can still look uncluttered and present information in a graphically pleasing way.

- Write to be read fast
- Struggle for good headlines
- Develop a style

Write to be read fast

People want newsletters to be a quick read. They want to be able to grasp the information you have presented quickly, so write your articles with this in mind.

Start off with a bang. Don't beat around the bush. Get to the point. Newsletter articles don't need flowery introductions. So borrow the concise writing style of newspaper journalism.

Use the more familiar and shorter word. Write to express, not impress. Why say "utilize" when "use" will do?

Write at a level slightly below what your audience is capable of reading. Readers appreciate this because reading goes faster, and this saves them time. Even such stellar publications as the Wall Street Journal don't exceed a high school reading level. Take the fog out of your writing by keeping your sentences short and cutting down on the number of words with three or more syllables.

Write the way you talk. Keep your style informal. After all, this is a letter.

Edit your copy. Let it sit at least 24 hours and then go back and get rid of verbiage and clean up the text for clarity. If possible, have at least one other person edit the copy for you. It's difficult to be your own editor.

The most important part of your article is the first sentence. After you have written the first draft of the article, go back and make sure the first sentence grabs attention.

Even more important than the first sentence is the headline. Headlines can make or break your newsletter. What do people do when they scan a publication? They read the headlines. That determines what they will read — if they read anything.

Struggle for good headlines

Writing good headlines can be a struggle. It often takes more time than writing the article. But what you'll find is that as you write the headline, you cut through to the essence of the article. Authors often go back and rewrite the first part of their article to match the good headline they have come up with. Headline writing helps you make the point as concisely as you can. Here are a few rules for good headline writing:

Use action verbs. Verbs like "grab," "strike," "stir" and "build" are all verbs that imply action. Stay away from static verbs like "is" and "are." A headline is even duller if it does not include a verb at all. These headlines are called "label headlines" and can be deadly unless they are used in combination with an accompanying headline, often in smaller type, that includes a verb.

Poor: Annual Meeting News

Better: Plot Your Way to Portland for Annual Meeting

Keep the verbs in present tense. This is the style readers are used to in newspapers. Present tense usually takes up less precious space, too.

Get to the point. Tell what the article is about. Be clever if you wish. But don't deceive the reader as to the point of the article. For example, the headline for an article on how to write a good, concise resume was titled, "Don't let a resume cramp your file." This is a clever play on words but still told what the article was about.

Develop a style

To make your writing easier, you need to establish certain guidelines, known in the publishing business as style. This means that you always do certain things the same way so you don't have to re-think how to do them. Your style includes such things as peoples' titles, for example. On first reference your source may be John Smith; and on second reference, Mr. Smith or Smith. You may want to refer to all women with the title of Ms. Or you may want to leave off titles altogether. There's no right or wrong about any of these choices. Just decide and then stick with it. This also makes your writing easier to read. The reader subconsciously picks up on your style and doesn't get confused.

Besides titles you may also want to make decisions about how to write numerals and how to designate states.

If you don't want to make all these decisions yourself, just adopt the style of somebody else. A popular style guide is *The Associated Press Stylebook and Libel Manual.* Another popular one is *The Washington Post Deskbook on Style.* Many newspapers use these style books. Both of these are readily available at bookstores or can easily be ordered.

There will be other things particular to your newsletter not covered in a standard style book. So create your own supplement. In it might be such things as what acronyms you don't spell out and how you refer to an organization on second reference. For example, the University of Missouri has a supplemental style book in which the rules on second reference to the university are clarified: Either use MU or Mizzou.

Design a winner

How a newsletter looks is important. A well-designed newsletter will draw readers to it. The design elements in a newsletter include the nameplate, text, headlines, departments, charts and graphs, art and photographs, color, and the masthead. All work together to give a newsletter a distinctive and unified look. All contribute to helping the newsletter be easy to read and full of useful information.

Nameplate

The nameplate is where the name of the newsletter is. It's usually at the top of the first page of the newsletter. But it doesn't necessarily have to be at the top. It can also be along the side, in the middle, or at the bottom.

The lively design of this newsletter moves your eye around the page. Note the integration of the words and the visuals.

The nameplate is sometimes called the masthead. This is a misnomer. The correct terminology is nameplate or flag.

The nameplate consists of the name, the subtitle, the origin of the newsletter, and the date.

— **NAME**

— **SUBTITLE / ORIGIN**

— **DATE**

Name. Avoid names like "Newsletter" and "Update." They are tired titles. Think of something else. For example, the name of an employee newsletter for a shoe manufacturer is "The Inner Sole."

The name should be bold and dominate the page. The name should be one or two words.

Subtitle. Have a subtitle to explain more about the name. For example, one newsletter is called "Silver Threads," and its subtitle is "News for Senior Citizens." Subtitles help clarify who the audience is.

Origin. It should be perfectly clear where the newsletter is coming from. Who is putting it out and what is the address? Address and subscription information can be saved for the masthead. But always include who is responsible for the newsletter in the nameplate.

Date. Newsletters must be dated. Some authors also like to keep track of volume numbers for ease in binding later.

If you can't afford to get your newsletter printed so it looks professionally done, at least try to get your nameplate printed. Seek professional help with the design of the nameplate. Then, you can duplicate the body of the newsletter on whatever equipment you have available.

The cost for all this would be relatively minor compared to the benefits of a better looking newsletter.

Text

Two decisions need to be made. What style and size for the type? And how many columns?

Most newsletters are now done with computer equipment that can mimic any type style previously reserved only for those who could afford typesetting.

If you use Pagemaker software with a Macintosh computer or anything similar, it is best to stick with a typeface similar to what you see in newspapers or magazines.

If you just have word processing capabilities with your computer, then by all means use a letter-quality printer and not one that yields an obvious dot pattern. That type style is just too hard to read.

If you just have a typewriter, then be sure to use a carbon or film ribbon — and not a cloth ribbon — for a crisper and more professional look.

Use only one type style and size for your newsletter. A professional designer can manage to mix type styles and sizes and make a newsletter look good. But it's difficult to do this unless you have that expertise. To simplify your life, stick with one.

Now, you need to decide how many columns and how wide they should be. One choice is to have one column go clear across the page. Some well done and expensive national newsletters are done this way. This format makes a newsletter easy to put together, particularly if you only have a typewriter or word processing equipment at your disposal.

But the wider the line of type, the bigger the typeface has to be. It should be pica size if you're using a typewriter and either 10 or 11 points high if you're having it typeset. Also, make sure there are ample margins on both sides so the eye doesn't have to travel too far. "The Newsletter on Newsletters" is done in a one-column format and has an inch margin on both sides.

Important decisions in designing the newsletter are what size and style of type to use and how many columns.

An alternative to the one-column centered across the page is the one-column that extends across two-thirds of the page leaving the other third for headlines. This format shortens the distance the eye has to travel so you can get by with a little smaller type size.

Other alternatives are two-column, three-column, four-column, or even more. See the illustration for guidelines on margins. When you use more than one column, you want to make sure that the space in between the columns is not too large so that it creates a river of space that's not pleasing to look at. Again, get ideas from well-designed magazines and newspapers.

Size of columns

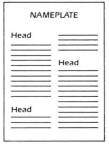

1 column with headline above text

 column = 36 picas or 6 inches

2 columns

 columns = 20 picas or 2-3/16 inches

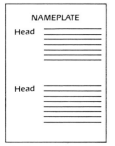

1 column with headline beside text

 column = 24 picas or 4 inches

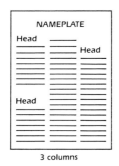

3 columns

 columns = 13 picas or 3-5/16 inches

Margins
- 5/16 or 2 picas between columns
- 13/16 or 5 picas on left and right sides
- 11/16 or 4 picas on top and bottom

Nameplate
- Allow at 1½ to 2 inches

Borders
- Subtract at least 1 pica or 3/16 inch from each side of layout to allow room for rules

EXAMPLES

2 COLUMN

4 COLUMN

Headlines

In the writing section you were told to make headlines lively. Follow that up with your design. Set it up so the headlines are bold and eye-catching.

If all you have is a typewriter or word processing equipment, then underline or boldface the headlines.

If you have more sophisticated equipment or can afford typesetting, then make the headlines in a larger, bolder type than the text.

Give the best articles the biggest headlines. When you look at a newspaper, the most important stories have the biggest headlines. Follow suit with your newsletter.

Departments

Most newsletters have departments, or sections, where types of stories are grouped. It makes them easier to produce and

read. To be effective the departments need to appear in the same place and look the same. A department can be as simple as a table of contents box luring readers to turn pages or a calendar of upcoming dates. An employee newsletter for an oil company has a question-and-answer department called appropriately "The Pipeline." To help the reader, always put departments in the same place from issue to issue.

Charts and graphs

Charts and graphs can be a way to boil down complicated information, so they are naturals for the quick-read format of a newsletter. The secret to doing charts and

Charts don't have to be dull. They simplify, unify, and graphically explain complex subjects.

graphs well is to make them readily understandable. Have all the information right there and not buried in the text so the reader must move back and forth. This can be so confusing that the reader will give up. See the illustration for examples of good charts.

Art and photographs

Art and photographs can add interest to your newsletter and help draw in the reader. But they have to help communicate your message otherwise there is no point in using them. Too often pieces of artwork are just stuck in to take up space.

Both art and photographs have to be well done or they do more harm than good. If the photo is blurry and you can't identify the people in it, don't use it. It will make your whole newsletter look bad.

If possible, hire a professional photographer to take pictures for you. Sometimes this can be done for relatively little money. Good, crisp photographs can do wonders for your newsletter.

If you use a photograph, be sure to have a cutline or caption underneath. This explains what's going on in the photo. Well written cutlines can entice the reader to read the whole article. If the photo is just a facial shot of someone, commonly called a mug shot, have the person's name printed underneath

This newsletter shows a strong sense of user-friendly design.

the photo. Don't assume that everybody reading your newsletter knows who that person is.

Original art may be difficult and expensive to obtain depending on your access to commercial artists. However, there are ample choices of clip art books for sale. Unfortunately, much of the art in them may be overused and outdated. Using it in your newsletter may detract from its appearance. So if you use it, use it sparingly and only to help you communicate your message.

Color

There are two things to consider with color in a newsletter. One is the color of paper in combination with the color of ink. The other is: Should you introduce a second color of ink, also known as spot color?

The most readable combination of colors is black ink on white paper. So if you vary from that, stay as close to white with your paper as you can and as close to black with your ink as you can. The darker the paper and the less black the ink, the more you compromise the readability of your newsletter.

Black and white are the best colors to use if you have photographs in your newsletter, too. It can be quite disconcerting to look at blue or green people in photographs.

Spot color can add distinction to your newsletter. One other color in addition to your black can brighten up the pages. Two colors beyond black can add even more excitement. However, the cost goes up with each additional color. And, unless you are a trained artist, using two colors can be overwhelming. The ideal combination for most newsletters is black on white with one spot color.

The major rule to guide you with the use of your spot color is restraint. The price is the same whether you use a lot of it or a little of it. But it's best to use only a little.

Some suggested places to use spot color:

- In the nameplate. Some people have their nameplate only printed in quantity in one color. Then they duplicate their newsletter on those pre-printed sheets with the equipment in their office. They find this saves money.

- In large initial letters. One common design technique popular now is to make the first letter of an article extra large.

- In blurbs. These are short provocative quotes pulled out from the article and set in a slightly larger type. Blurbs help break up a long article.

- In bars across the tops of pages. Don't use the spot color in your headlines. This would be an example of overuse of spot color that takes away from its effectiveness.

Masthead

If your newsletter is written and put together by one person, it's probably not necessary to have a masthead. But if there are a variety of contributors or if the newsletter can only be obtained through subscription, there is a need for a place in the newsletter to provide all this information. This is where a masthead can be useful. Pack it full of the details, and always put it in the same place for each issue of your newsletter. Some people like to put these at the bottom of page two. Others like to put them on the back of a four-page newsletter.

A typical masthead includes a miniature version of your nameplate for a unified look to your newsletter and this information:

- Authors and contributors.

- Address, phone number, and place of origin of the newsletter.

- Date and volume number.

- Subscription information.

Putting together a newsletter can be a gratifying experience. Readers like newsletters. They appreciate getting timely information in an easy-to-read manner. Once a routine is established, putting together a newsletter can be done in a relatively short period of time.

But like anything, to be done well, a newsletter takes dedication to excellence. Readers have to know they can rely on the information in it.

With these tips and some commitment to excellence, you are on your way to making a difference in people's lives with your newsletter.

- Lesson 1: What is news?
- Lesson 2: How do you report news?

Writing skills short course 5

Lesson 1: What is news?

News is a report of something new.

News depends upon:

Timeliness. Immediate or near the present— the first reason for a news story. Without timeliness a news story is either history or prediction.

Proximity. Close physically and/or psychologically to the audience and point of publication or broadcast. Editors prefer "local" stories.

Importance. How "big" and important is the idea, event, situation, or person.

News involves at least one of these factors:

Conflict. All kinds of struggles: man versus his environment, man versus man, etc.

Progress. Improvements made by man: research developments, better production methods, education, new equipment, improvements in living standards, human relations, etc.

Unusualness. Rare, odd and sometimes unforeseen ideas, events or situations.

Human interest. Ideas, events, or situations which touch human emotions. Human interest events may only arouse casual curiosity, but they may incite anger or fear or elicit joy, sadness, compassion, or some other feeling.

Lesson 2: How do you report news?

Use the 5 Ws and an H!

<u>Who</u>? Who said it? Who is it about?

<u>What</u>? What happened? Importance counts.

<u>Where</u>? Where did it happen? Remember proximity makes it news.

<u>When</u>? When did it happen? Remember timeliness.

<u>Why</u>? Why is it important? Remember policy.

<u>How</u>? How did it happen? Was there anything unusual about it?

Make it readable

The best way to improve your writing readability is to use:

Short sentences. This is the best single technique and the easiest. For today's mass audiences, news stories averaging between 15 to 20 words per sentence are considered easy reading. Sentences longer than 30 words may be hard to understand.

Short paragraphs. Keep paragraphs short. And vary their length from one word to five average sentences. Remember, a 100-word paragraph looks quite long in a narrow newspaper column. Editors don't like them. Neither do readers.

Easy words. Use short, simple words in place of longer, many-syllable words with the same meaning. When a technical or difficult word must be used, explain it as simply as possible.

Personal words. Words like "you," "we," a person's name, direct quote, etc., give your copy more human interest. Admittedly, this kind of personalization is more often used in *feature* rather than *hard news* stories. But it is still a good technique for holding reader interest.

Active verbs. Action verbs keep a story moving and grab the reader more than "to be" verbs that show little action.

Get to the point...fast!

Put the most important points first.

Most people whiz through newspapers, reading headlines and maybe the first paragraph or two of stories that catch their eye. So, get your important facts into the first paragraph; the first sentence is even better.

Editors chop stories to make them fit available space — usually from the bottom. So if you've got something essential to the story at the bottom of your copy, it might not make it into print. News writers usually use the inverted pyramid style, that is,

placing the most important fact first;
second most important fact next;
and so on, down to the
least important.

Lesson 3: Style

<u>Put one or more easy words in each blank.</u> (Possible answers follow.)

Complex words. Sometimes two simple words are better than one complex word.

deficiency _____ remainder _____

equivalent to _____ approximately _____

construct _____ illustrate _____

insufficient _____ beneficial _____

Empty phrases. Rid your writing of these tired cliches.

so as to allow _____ keep in mind _____

make plans for _____ adjacent to _____

in order to _____ at the present time _____

disposed of on the market _____

list a description of _____

are suspected of having _____

it is advisable to begin _____

more uniformly shaped _____

with the exception of _____

Complex words:(Answers)

deficiency — shortage, lack

remainder — what's left, rest

equivalent to — equal to, same as

approximately — almost, about

construct — build

illustrate — show

insufficient — not enough

beneficial — helpful, good

Empty phrases: (Answers)

so as to allow — to allow

keep in mind — remember

make plans for — plan

adjacent to — next to, beside

in order to — to

at the present time — now

disposed of on the market — sold

list a description of — describe

are suspected of having — might have

it is advisable to begin — begin

more uniformly shaped — alike

with the exception of — except

- **Lesson 4: Write a better sentence**

Polish your style

There's always a better way to write it. Any time you rewrite something, you will probably improve it. See the shaded area (page 34), try your hand at simplifying words and phrases.

Lesson 4: Write a better sentence

When you rewrite, try to shorten sentences and give them more action. In doing so, consider the context of your article. You may have a different "answer" than we do for the following because you thought of the sentence in a different context than we did. That doesn't mean you're wrong. But your sentence should be easier to read than the original. And it should contain an active verb if possible.

Active verbs show action. You can find good examples on sports pages (hit, smashed, ran, booted) and in recipes (mix, stir, baste, whip).

Rewrite the following sentences, simplifying them and using action verbs where possible. Answers follow.

Example: Poor: Your consumption of milk should be a quart daily.

Better: Drink a quart of milk daily.

Poor: Strict adherence must be given to safety precautions when using these insecticides.

Better:

Poor: Elimination of these pests calls for a strict insect control program.

Better:

Poor: The right fertilizer must be used for high corn yields.

Better:

Poor: Each pint carton should be labeled, and this label must be recorded on the information sheet for the laboratory.

Better:

Poor: Evaporation of liquid takes place.

Better:

Poor: When an application of wax is made to this surface a brilliance is imparted to it.

Better:

Poor: When application of pressure is employed by the operator, the machine is activated.

Better:

Possible answers

Poor: Strict adherence must be given to safety precautions when using these insecticides.

Better: Follow safety precautions when using these insecticides.

Poor: Elimination of these pests calls for a strict insect control program.

Better: Follow a strict control program to eliminate these pests.

Poor: The right fertilizer must be used for high corn yields.

Better: Use the right fertilizer for high corn yields.

Poor: Each pint carton should be labeled, and this label must be recorded on the information sheet for the laboratory.

Better: Label each pint carton and record on the laboratory information sheet.

Poor: Evaporation of liquid takes place.

Better: It dries.

Poor: When an application of wax is made to this surface, a brilliance is imparted to it.

Better: It shines when waxed.

Poor: When application of pressure is employed, the machine is activated.

Better: Push to start.

Lesson 5: Getting the facts

When writing a news story, make sure you have all the pertinent facts and that they are accurate. Think back to who, what, where, when, why, and how. Most news stories contain all of these. Sometimes you can omit one or more, such as why or how, if they are implied or already understood by your audience.

In the beginning...

The most important part of a news story is the first paragraph, the *lead*. It should contain the most important information in the story. Consider *who, what, when, where, why,* and *how* when writing that first paragraph. Most leads contain more than one of these. Below are some examples of leads that feature at least one of the five Ws or the H in each, followed by one that contains all six elements.

Who: *Dr. Norman E. Borlaug, 1970 Nobel Peace Prize winner,* will speak here Tuesday at the Memorial Union.

Why: *To help more computer users boost their efficiency,* the community college will be expanding the Computer Literacy Program.

How: *Cooking meats in bags made of recycled paper* can be toxic, warns a home economist.

What: *Changing federal regulations in home health care* are opening up new business opportunities in the Southeast.

When: *May 6 is the deadline* for Midtown's summer Little League baseball program, Columbia County Parks and Recreation officials announced today.

Where: *From an oat field in Berrien County, Michigan,* the cereal leaf beetle has spread *throughout most of the grain producing areas of the Midwest.*

Who, What, When, Where, Why, and How:

 (who) (how)
Midcity Mayor Georgia Smith announced her
 (what) (when)
candidacy for governor Wednesday at a news
 (where) (why)
conference in City Hall saying she was "tired

of old guard politics running the state."

Lesson 6: You're on your own

Okay, you've got the basics. Now write a news story from the facts given below. Remember, use short sentences, short paragraphs, and get to the point fast. Write for your local newspaper.

Think! What is most important to readers in your town: who, what, when, where, why, or how? Do not go on until you have written your story.

1. John R. Roberts is mayor of Metropolis.

2. The National Mayoral Association's (NMA) annual conference will be held next week.

3. Mayor Roberts will attend the National Mayoral Association's conference to report on the really neat utilities plan that your town has.

4. There are 2,300 members in NMA.

5. The utilities plan reduced your town's use of electricity by 50 percent last year.

6. The plan employs the use of solar collectors.

7. The NMA's conference is being held in Washington, D.C.

8. I. M. Incumbent is the president of the National Mayoral Association. He personally invited Mayor Roberts to the conference to talk about his plan on Thursday.

■ **Lesson 6: You're on your own**

NEWS RELEASE HEADING

(Name and address of your organization)

Contact: (Name)
 (Phone) (Date)

RELEASE: Immediate

Roberts to report
on utilities plan
at mayors' conference

Mayor John R. Roberts will report on the Metropolis utilities plan at the National Mayoral Association's (NMA) annual conference Thursday in Washington, D.C.

Mayor Roberts was personally invited to make the presentation by I. M. Incumbent, president of the 2,300-member NMA.

The Metropolis utilities plan, which employs the use of solar collectors, reduced the city's use of electricity by 50 percent last year.

Now remember what we said about the inverted pyramid. Decide which things are most important; then get them into the story as quickly as possible. After you do your story, check your version with ours on this page.

Note the release format. The information at the top should show the editor where the release came from and where more information can be obtained. Leave two to three inches at the top for the editor to mark the copy for a headline, or size of type, etc. Double or triple space the copy.

The most important facts in this story are *who* (Mayor Roberts) and *what* that person is going to do. This information should be in the first paragraph of your story.

Essentially, the information in our second and third paragraphs embellishes what appears in the first. You could reverse paragraphs two and three without being wrong. The main thing is to get all the essential information into your story and to get to the point as quickly as possible.

One other note: You'll notice we eliminated "really neat" from the description of the utilities plan. Expressing such an opinion is editorializing and is proper in a news story only when the comment can be attributed to someone, preferably via a direct quote. As you read the news stories in this book or in newspapers, note the attribution ("Roberts said," "she claimed," etc.). A story containing editorial comments without attribution should never appear in a newspaper unless: (a) it's in a column (then the information can be directly attributed to the author of the column) or (b) it's on the editorial page (when the information is labeled as an editorial).

The meeting story

Routine meeting stories are easy to do, once you get the hang of it. You mainly need to get who, what, when, where, why, and how down on paper in a neat fashion so your prospective meeting goer gets the message.

5 Writing skills short course

Try your hand at writing a routine meeting story from the following. Our version follows. Note: For the purpose of this exercise, you may save time by just inserting the words "program details" in your story where the information in No. 7 should appear.

1. The annual meeting of the Missouri Association of Consumers will be held Saturday (March 4).

2. This is a public meeting.

3. Registration is 9-9:30 a.m.

4. Registration is at the Flaming Pit Restaurant.

5. Cost of registration is $6.00. (That includes a noon lunch.)

6. At the meeting, media representatives will comment on their investigative reporting of consumer fraud.

7. The program is as follows: 9:30 a.m. — Panel on "Investigative Reporting in the Consumer Interest" moderated by Don Keough, Capital City correspondent for the *Columbia Daily Tribune.* Panel members will include media representatives from Missouri's major metropolitan areas.

Noon — Luncheon address on legislative action by James L. Sullivan, director, Department of Consumer Affairs, Regulation and Licensing. After the address will be a presentation of the annual "Friend of the Consumer" award. Last year's award went to James Mulvaney, then chairman of the Missouri Public Service Commission.

1:15 p.m. — Panel on "The Media's Responsibility to the Consumer." Panel moderator is Roy Fisher, dean of the University of Missouri-Columbia School of Journalism. Panel members are news and editorial writers and broadcasters, who will comment and then respond to consumers' questions.

8. The source of all this information is Mrs. Carolyn Leuthold, arrangements chairperson. She says, "It's a public meeting, and anyone who registers will have a chance to confront media representatives on consumer issues." She also says that anyone who wants to make an advance registration for the sessions can do so by writing to the Missouri Association of Consumers, Post Office Box 2353, Jefferson City, Missouri 65101, or by contacting her at 1501 Ross Street, Columbia, 65201 (Phone: 449-1358).

Joseph J. Marks
News Director

IMMEDIATE RELEASE
Mailed February 22

Media to rap
with consumers
on Saturday

COLUMBIA, Mo.— Media representatives will comment on their investigative reporting of consumer fraud, Saturday (March 4), at the annual meeting of the Missouri Association of Consumers.

"It's a public meeting, and anyone who registers will have a chance to confront media representatives on consumer issues," said Mrs. Carolyn Leuthold, arrangements chairperson.

Registration is 9:00-9:30 a.m. at the Flaming Pit Restaurant. Cost: $6.00 for registration and a noon lunch.

Lesson 6: You're on your own

The program starts at 9:30 with a panel on "Investigative Reporting in the Consumer Interest" moderated by Don Keough, Capitol City correspondent for the *Columbia Daily Tribune*. Panel members will include media representatives from Missouri's major metropolitan areas.

The luncheon address on legislative action will be delivered by James L. Sullivan, director, Department of Consumer Affairs, Regulation and Licensing.

Following his address will be a presentation of the annual "Friend of the Consumer" award. Last year's award went to James Mulvaney, then chairman of the Missouri Public Service Commission.

At 1:15 p.m., Roy Fisher, dean of the University of Missouri-Columbia School of Journalism, will moderate a panel on "The Media's Responsibility to the Consumer." News and editorial writers and broadcasters will comment, then respond to consumers' questions.

Advance registration for the sessions can be made through the Missouri Association of Consumers, Post Office Box 2353, Jefferson City, Missouri 65101, or by contacting Mrs. Leuthold, 1501 Ross Street, Columbia, 65201 (Phone: 449-1358).

Note: In our meeting story, we include important news elements in the first paragraph, then add details. Only the most interested persons will read beyond the first paragraph or even beyond the headline. By the way, it's not a bad idea to put a headline on your story when you submit it. Headline writers will probably have to change the headline to suit the space available, but including a tentative one is a quick way to tell the editor the essence of your story.

The award story

Names make news. And everyone likes a winner. Put those two cliches together, and you have the award story.

These stories are quite easy to do. Once you figure out the system, you can literally "fill in the blanks" and do your own.

Check the following samples. With a few modifications, you can adapt the same format to almost any award story.

Morris named
(last name)
scholarship winner

MIDTOWN, Mo. — Patty Morris,
(name of winner)
Vandalia, has been named winner
(hometown)
of the Dennis Gallup 4-H Memorial Scholarship, Morris, daughter of Mr. and
(winners last name)
Mrs. Kenneth P. Morris, Route 2, was
(parents names and address)
presented the scholarship, Wednesday, May
(day & date)
20, by the Missouri 4-H Foundation.

The scholarship was presented for her 4-H and community activities over the last eight
(reasons)
years.

The rest of the story includes details of the winner's accomplishments and, perhaps, comments from the recipient on how the scholarship will be used.

(Name of County) County Scouts
Win State Awards

MIDTOWN, Mo.—(Number, county) youths were among 124 Great River Council boy scouts presented Eagle Scout awards (Day, date and place)

Then, list the award winners, along with their ages, their parents' names (if you have them) and their addresses. Generally, it is best to list each person in a separate paragraph. However, if you have more than one winner from the same town, you can put two or three in the same paragraph, providing this doesn't make the paragraph too long. It's a good idea to underline the names of towns to help the editor localize the story. For example:

Area award winners were:

John Jones, 16, son of Mr. and Mrs. T. Alvin Jones, 112 West North St., Oakdale.

Don and Ron Davis, both 15, sons of Mrs. D. R. Davis, 112 Woods St.; and Anthony Rossi, 15, son of Dr. and Mrs. Elvin Rossi, 112 North West St., Firdale.

"The Eagle Scout Award is presented to fewer than one percent of Missouri's boy scouts each year," said H. H. Schwarts, Great River Council leader. "To win the award," he said, "the scout must have earned 24 merit badges, completed a community service project, spent at least three years in scouting, and performed in a leadership capacity for at least six months."

The "How to do it" story

Let's say you have a job like that of an extension specialist or some other community service person. You want to provide information in an appealing form.

First, let's see if it's appropriate to use the mass media to do this.

Think of your audience. If only a few people will be interested, you might just as well send them a letter, call them on the phone, or have them come over to your house. If the audience is larger than that — one that can be served by mass media — then you'll want to write a "how to do it" story.

Next, consider what you want to tell this audience and how you can make the information appealing. Will this information save the readers time or money or make them happier or sexier?

Then figure out how to address your audience as personally as possible. "You can save money by..." "Do-it-yourself auto mechanics can save time by..."

In the following example, an engineer is quoted. You could quote yourself if you're an authority. It is important that you attribute the information to a person, agency, etc., to give the information credibility.

Remember, be direct, personal, and appealing.

Insulate that
water heater;
save $15 - $30

BILLINGS, MT. — You can save $15 to $30 a year by putting a couple of inches of insulation around your hot water heater, claims Richard Phillips, University of Montana agricultural engineer.

"Most heaters have only about one inch of glass fiber insulation in their walls," says Phillips. "That's not enough to keep some of the heat in the tank from escaping."

Phillips recommends insulating with two- to four-inch-thick unfaced glass fiber bats and securing them to the tank with tape or string.

"Insulation should be held in place firmly but not compressed when installed," he says.

Montana State University studies show that two inches of insulation will save about $25 a year on an 80-gallon tank; 4 inches, over $30. Savings will run $15 to $20 annually if you put two or three inches of insulation around a 40-gallon tank, says Phillips.

Lesson 7: Be your own editor

Check your copy closely before you finally submit it for publication. If possible, have someone else check it, too.

Below are listed some common grammatical mistakes. You can avoid most of these by following the KISS formula: "Keep It Simple, Stupid!" The less flowery the language and the more straightforward, the more likely you'll communicate effectively. And that's what this course is all about.

Common grammatical mistakes

Too many prepositional phrases. Don't avoid these phrases completely; just remember too many make reading difficult.

Bad: The sales meeting was conducted by the sales manager of the company in the conference room.

Better: The company's sales manager conducted the sales meeting in the conference room.

Mixed tenses.
Wrong: He walked the dog and works with the horses.

Right: He walked the dog and worked with the horses. Or: He walks the dog and works with the horses.

Wrong: The women cleared their tables, grabbed their coats, and were going home.

Right: The women cleared their tables, grabbed their coats, and went home.

Dangling modifiers.
Wrong: Walking through the rows, the potato bushes nearly filled the rows.

Right: Walking through the rows, I noticed the potato bushes nearly filled the rows.

Wrong: To benefit fully from a long concert, the seats must be comfortable.

Right: To benefit fully from a long concert, you must have a comfortable seat.

Redundancy.
Wrong: Mary was wearing the same identical hat as Sue.

Right: Mary's hat was identical to Sue's.

Wrong: The two agencies cooperated together for a period of two weeks.

Right: The two agencies cooperated for two weeks.

Non-agreement. This can be tricky. To check, think: "Which one has correct noun-verb agreement?

Wrong: A bowl of apples, peaches, and bananas make a nice centerpiece.

Right: A bowl of apples, peaches, and bananas makes a nice centerpiece.

Wrong: Which one of the following sentences have correct noun-verb agreement?

Right: Which one of the following sentences has correct noun-verb agreement?

Careless repetition.
Wrong: You want to emphasize a point, so you repeat it, using different words for emphasis.

Right: You want to emphasize a point, so you repeat it using different words.

Mixed construction or faulty parallelism.
Check for this in a series with elements compared and contrasted.

Wrong: We were told to write in ink, that we should use only one side of the paper, and we should endorse our papers properly.

Right: We were told to write in ink, to use only one side of the paper, and to endorse our papers properly.

Lesson 8: Writing features

A good feature writer is imaginative, curious, nosey, attentive, unconventional, witty, and is usually not above "borrowing" a good writing idea from someone else.

He or she does a good job of digging out information, then is clever enough to twist even dull data into interesting and sometimes amusing prose.

5 Writing skills short course

What is a feature?

A feature differs from straight news in one respect — its intent. A news story provides information about an event, idea, or situation. The feature does a bit more. It may also interpret or add depth and color to the news, instruct, or entertain.

How to write it

The feature doesn't usually follow the inverted pyramid style of the news story. In fact, the hard news story lead based on one of the five Ws (who, what, when, where, why) or the H (how) is seldom appropriate for a feature story. The feature lead "sets the stage" for the story and generally cannot stand alone. A feature lead must interest the reader. It's the "grabber" that gets the reader into the story and keeps him or her going.

Many rules for news writing do apply to feature writing: short sentences, easy words, personal words, active verbs. But feature stories can be more fun to write, because you can be more creative.

When the feature?

A feature is a better alternative than a news story when you want to accomplish one of the purposes cited above. When educational material is hard to swallow, a feature can be the "spoonful of sugar that helps the

medicine go down." Remember, features are generally longer than news stories. Make sure the editor will give you the space for one before you write it.

What makes a feature go?

"Easy" writing makes for easy reading. That means short sentences, simple words, active verbs, and personal words, plus:

Transitions: So the article always keeps moving forward. They are used to add to, illustrate or extend a point.

They usually begin with words like "and," "furthermore," "also," "or," "nor," "moreover," "along with," etc.

They summarize: "at last," "so," "finally," "all in all," etc.

They link cause and effect: "as a result," "that produced," "consequently," etc.

They refer back: "they," "those," "these," "that," "few," "who," "whom," "except for," etc.

They restrict and qualify: "provided," "but," "however," "in case," "unless," "only if," etc.

Interest-building devices: Personalize the people you are writing about and what they are doing; quotes; human interest.

"Kicker":While the lead or "grabber" at the beginning gets the reader into a story, the kicker at the end of a feature should have a punchline that helps the reader remember the story.

Test your features

Write features and get opinions from others, especially editors. Check the feature below for style and feature writing devices.

> She "saw"
> the way
>
> Barbara Snell, 8, awoke in her back bedroom with the heavy smell of smoke around her. She knew she could find her way to safety. But could her mother and brother?
>
> Barbara awakened her 12-year-old brother, Paul. Then she hurried through the dense smoke to her mother's bedroom, keeping her brother close to her side.
>
> Mrs. Snell roused herself, groggy from the smoke. She started for the door she thought led outside. It was the door to the bathroom.
>
> "This way," cried Barbara, as she led her mother and brother to safety.
>
> She had no trouble finding her way. Barbara Snell is blind.

The feature thinking/writing process

Feature stories start in the mind. You have something you want to tell others. You would like to make it at least as interesting to your readers as it is to you.

Imagine this. You are asked to teach feature writing to extension home economists, or another group of people with little or no formal background in writing. You want to give them some personal examples close to their field. You begin searching through their regularly produced newsletters that they have brought to class as examples.

Mostly you find straight information summarized from university or agency publications. Then up pops an item that hits your eye immediately. My goodness! There are human interest words like "I" and "my" in the item. You know instantly that a feature can't be far away.

Study the original newsletter item followed by a "P.S." of additional information gathered from a safety specialist. After you read the material in the box, look at some of the alternate leads that can be developed for writing the feature story. The end product follows. No Pulitzer Prize winner, to be sure, but it has more effect on readers than a straightforward, "You-should-be-careful-of-kitchen-fires-because" story.

(Original newsletter item...)

I'm reluctant to admit it, but last Thursday I had my first kitchen fire. While the fire was small and easily extinguished, the experience was frightening and certainly carried several messages that we all know well and need to review for our own safety. Of course, one is controlling heat and keeping a check on the cooking process. When attention is diverted, it may be only for a moment, but that moment can be disastrous.

In my experience, I was amazed at the voluminous amount of smoke from three strips of bacon. I made the error of removing the lid and, believe me, the smoke was excruciating and promptly resulted in a coughing siege and irritation in the throat.

I could go on, but I did want to share some of the experience as a reminder to us that a home safety program can be an important part of our total housing program. Dave Baker, extension agricultural engineer and safety specialist, is an excellent resource person. I was interested that he indicated there was no good method of putting out a fire such as mine, but had I carried the skillet with the lid on to the out-of-doors, I would have had less of a smoke problem.

> From: Lois M. Deneke
> State housing and interior
> design specialist
> Lincoln University

P.S. Dave Baker says the best bet for keeping kitchen fires from getting out of control is to have a multi-purpose or chemical extinguisher handy. Baking soda works, too, especially on grease fires. If a fire occurs in a pan, says Dave, put the lid on. If a fire starts in the oven, close the oven door, and turn off the gas or electricity. Open a door or window, and use a fan to draw smoke out of the house. The vent fan above the stove can be helpful, too. Act fast and, above all, don't panic.

Now, here are some alternate leads from the above.

They say nothing teaches like experience.

But in Lois Deneke's case, the lesson was almost too hot to handle.

or

It's amazing what three strips in the kitchen will do, especially if the strips are bacon — and they catch on fire. It all began when...

Now observe the original information in the form of a new feature article:

5 Writing skills short course

Homemaker has hot time

Lois Deneke had a hot time in her kitchen last week.

She was pretty "smoked up" at what happened then. But now she's cool and ready to share her experience with those who suddenly find themselves in a spot too hot to handle.

You see, Lois is a state housing and interior design specialist with Lincoln University. One of her jobs is to design homes to be safe and convenient. But she got a firsthand lesson in safety last Thursday when she experienced her first kitchen fire.

"The fire was small and easily extinguished," she said.

"But I was amazed at the amount of smoke from three strips of bacon!"

"I made the error of removing the lid and, believe me, the smoke was awful! I ended up having a coughing siege and a sore throat."

Because of what happened, Lois contacted Dave Baker, extension agricultural engineer and safety specialist at the University of Missouri-Columbia, to find out the best way to handle kitchen fires.

"I was interested to learn that there was no good method of putting out a fire such as mine," said Lois. "But had I carried the skillet with the lid on out-of-doors, I could have had less of a smoke problem."

She said Dave Baker's advice is:

—Keep a multi-purpose dry chemical fire extinguisher handy (or at least a good supply of baking soda).

—If fire starts in a pan, put the lid on if you can.

—If the fire is in the oven, shut the door, and shut off the gas or electricity.

—Take care of the smoke.

"You'll just have to fan it out," Dave told Lois.

"You can do that by opening a door or window and using a fan to draw the smoke out of the house. The vent fan above the stove can help remove smoke, too."

Dave said it's important to act fast and not to panic.

In other words...in case of fire, stay cool!

Lesson 9: Keep on writing!

The best way to test your skill as a feature writer is to write feature stories. Then get opinions from readers and writers. Note the writing techniques used in the following.

He hob nobs
with the best
of corn 'n cobs

COLUMBIA, Mo. — If you'd like to hobnob with corncobs, or find the world's toughest cornstalk, or breed your own corn hybrid, see Marcus Zuber.

The University of Missouri-Columbia agronomy professor, one of the world's leading corn breeders, has just added four more inbred lines to his list of "specialty corns."

That gives him 43 lines. Count 'em...43.

One of his earlier lines, Mo17, is the parent of corn hybrids that account for one-seventh of all the corn grown in the United States.

Geneticists say developing hybrids is child's play compared to developing an inbred line. Inbred lines are the basic blocks from which breeders build better plants.

Of Zuber's 43 lines, 30 are "specialty corns."

Some are high in lysine, the amino acid essential for animal and human growth.

Some are high in amylose, the starch used for making film and similar products.

Some are "high waxy types," and contain a paste used in making adhesives.

Some are known for their stalk strength. Since 1960, Zuber has more than doubled the stalk strength of some of his corn hybrids, making them more resistant to lodging — so they won't topple and fall in bad weather. That lodging resistance could save farmers up to 25 percent in yield losses in some years.

And some of Zuber's corn gets puffed by millions each year.

It ends up as corncob pipes.

See, all the corncob pipes in the world are produced in three factories in Missouri —two in Washington and one in St. Clair. They produce 25 to 30 million pipes annually, most from corn known for its cobs.

Zuber developed seven inbred lines and four hybrids especially for this industry.

"The pipe people like cobs with a minimum diameter of 1⅞ inch that have enough wood tissue to make a bowl," said Zuber. "They also want that wood free from fractures so it doesn't crack."

What with all the corn lines and hybrids he's developed and all the uses of corn, Marc Zuber's research touches millions of humans and animals each day.

And that's no pipe dream!

Graphic design 6

Long before the intricacies of modern language evolved, graphics were the key element in communication. Visual symbols were fundamental to man's understanding of a message. When words failed, pictures would communicate. In fact, such visual symbols became the basis for written language. Letters of the earliest alphabets were nothing more than symbols conveying a concept understood by the reader.

Letters are nothing more than symbols conveying concepts.

The use of graphics can make your presentation more attractive, clarify your message, and extend retention.

Much has been written on the impact of graphics on the evolution of man and his ability to communicate effectively. As important as it seems in a historical context, graphic design is every bit as important today. Visual elements show us how to open packages, how to wash clothes, and how to assemble goods. Graphics tell us which doors to enter and where to exit. Imagine driving a car without the help of graphics. Everything from which gear you're using, where to turn, and when to stop is communicated graphically.

If your goal is to communicate successfully, an understanding of the principles of graphic design is helpful. Whether you are writing a newsletter, designing a magazine, laying out a newspaper ad, making a poster, or delivering a speech, the use of graphics can make the difference in your effectiveness. Graphics can make your "package" more attractive, clarify your message, and extend retention by your audience. This happens only when design principles are understood and followed, however. Bad graphics can have just as much impact, though it won't necessarily be a favorable impact.

Students of graphic design, even those blessed with abundant talent, spend years perfecting their skills. This chapter will not impose unrealistic goals on those who protest "I can't draw a straight line even with a ruler." You won't have to struggle with tasks for which you lack aptitude. You simply need to understand, remember, and implement the principles if you want graphics to enhance your message.

The design process

Keep it simple

As with other communication professionals, a graphic designer begins by asking specific questions. What do I have to say and who needs to hear it? When objectives are clearly understood, you can focus on solutions. Whatever the message might be, and whomever the audience might be, the visual

6 Graphic design

must support and clarify that message. It doesn't matter which medium is used to convey the message. The principles remain the same.

Consider your audience carefully. Accommodate any peculiarities they present to you. Let's assume that you're designing a newsletter. If your audience is younger, the use of visuals increases your chances of delivering a message to this group not usually fond of extensive reading. If you're addressing retirees, you'll want to consider larger type to compensate for poorer vision. If you wish to reach scientists, graphs conveying data are useful. Though these approaches seem obvious, they are too often overlooked.

Learn from good examples

So you don't know where to begin? Look around you. What advertisements catch your attention in the magazines you read? What visual image remains clear in your mind from this morning's paper? Which poster stands out on a bulletin board? Study such examples of effective use of graphics. You can learn so much by observing techniques and solutions employed by others.

Your overall design and your use of visuals must not be complicated. The competition for the eye's attention is fierce. If your design and your visuals are clean, simple, clearly stated, and harmonious with the message, then you're helping your audience. You must assume that your audience doesn't understand what you're saying. You might as well assume,

too, that your audience won't be generous in giving you time to say much. Keep everything very simple. Don't use visuals for mere adornment. Make them work for you. Don't overdo it, either. If one visual works in relating the message, you don't need more.

You'll notice how simplicity prevails. The poster with few words, well-placed and readable type, and with one strong, supportive visual is the one that works. The page that makes nice use of space, headlines and sub-heads, without too much text crammed into it, is the one you stop to read.

Start paying attention to such things and you'll see the style of good graphic designers. A casual observer or reader seldom realizes how much thought and planning goes into the design of a printed piece or into the graphics flashed on a television screen. The style is intended to catch your attention, clearly state a message, and to have that message retained. That's the style you need to

Learn from good examples. Look around you. Start paying attention to graphic designs in magazines, television, posters, billboards, etc.

achieve. With a planned, balanced use of space, good selection of type, and clearly understood visuals supporting the message, your style can be effective.

Beginning to take shape

One of the design standards we need to understand first is the actual layout of a page. What determines the actual format of your page design? The problem is the allocation of space to the elements you wish to include. It's very much the same problem that you face when you begin placing furniture in an empty room.

Begin with a plan or a format. In designing newsletters and other printed materials, you'll want to know that there are industry standards when it comes to sheet sizes. For economic reasons, standard page sizes exist worldwide. The paper mills and the manufacturers of printing and copying equipment have made the 8½" x 11" page a universal common denominator. Even computer paper follows this standard. Though less common, 8½" x 14", or legal sheets, are also readily available. The other standard sheet, 11" x 17", is really just a way to get four pages of 8½" x 11" on a single sheet folded in half. There is no reason to fret about such limited standards when designing your piece. Save yourself money and aggravation and do your design with those sizes as your standard. They are still very flexible and workable sizes.

Accordingly, let's consider designing a page to be printed on an 8½" x 11" sheet. What

format are we going to follow? The concept of columns of type (as in a newspaper) instead of words all the way across the page (as in a letter) serves many useful purposes. Of course you can get more words on a page this way. The best reason, however, is that your audience is benefitted with quicker and easier reading. (Remember, that should always be one of your objectives. Make things easier for your audience.) Research reveals that people read faster and retain more when reading from columns. The eye doesn't have to scan all the way across the page for every line down the page.

Decide which column format best fits your graphic needs.

Consider the equipment you use. Other factors need to be considered in determining a format. If columns are going to be used, are there going to be two columns or three columns on a page? You need to consider the source of your typed columns. Are you using a typewriter, your computer, or purchasing commercially set type? What are your limiting factors? Don't design beyond your capabilities. Even if you have nothing more than a typewriter, chances are you have access to a copier that enlarges and reduces. Don't feel limited. (A copier is also a good solution for making your type darker if your printer or typewriter comes out too light.)

A two-column page is an easy format to work with but three columns give you a little more flexibility in your design. (More than three columns on an 8½" x 11" sheet probably won't give you enough column width to have many words per line. That would probably hamper your reader. You don't want that.)

Putting your ideas on paper

Your tools. Nothing short of actually performing the task can convince you that you can do it. There are plenty of sophisticated tools for the graphic designer. Unless you plan to design a lot of material, you don't need to spend much money to get the job done right. If you don't have a drafting table, use a desk top, dining table, or an old door set up as a table. You'll need a T-square, a triangle, a ruler, some scissors or a knife blade, masking tape,

6 Graphic design

and rubber cement. A visit to an art supply store will acquaint you with much better tools to use, of course, but you can get by with these. Drawing pens and pencils will also be used.

Your T-square is placed on the left or right of your table, opposite the hand with which you draw. Tape your sheet down on the table making sure the top edge of the sheet is parallel with the T-square. You only need to tape down the corners of the sheet to keep it in place. Your triangle is to draw vertical lines and angles. Designers learn quickly not to use

You'll need a T-square, a triangle, a ruler, scissors, rubber cement, a drawing board (or something like it) and masking tape.

the T-square or triangle as a cutting edge. Nicks prevent you from making clean, straight lines. Also, always keep these tools clean on both sides. If you use your triangle or T-square for doing ink lines, place some masking tape just in from the edge around all sides of the triangle and under the T-square. By placing the taped side down, the triangle is elevated enough to keep ink from smearing or running.

Establish margins on all four sides of your page. Allowing at least a 1" margin all around will usually be a safe solution. A cramped page is not an inviting one. Also, printing limitations usually require specific minimum margins. Know these things before you start.

Design the format. Now let's design a three-column newsletter format. A designer begins making his layout as a rough pencil sketch to show where each column, each headline, each visual, etc., should fit. Mark your margins first. Within that space you'll "package" your message. With a 1" margin on each side, we have 6½" across within which we'll work. We can make three 2" columns with a ¼" space separating each column. Pencil these in to establish a grid which allows your eye to visualize space available.

Having done this, you now have a basic pattern to use. This grid will be the basis for every page for the particular job at hand. This consistency gives your newsletter, or whatever the assignment might be, its unity. Now you can have the manuscript set in type. Our grid tells us we want the words to be set in columns that are 2" wide.

Typefaces

I've seen that face before

To the uninitiated, the world of typefaces may seem overwhelming. It's not. It's true that there are hundreds of styles of type. They all have different names, come in different sizes, and can be bold, light, or medium. But the distinctions are actually subtle. All typefaces can be classified into two basic groups: serif and sans serif. A third group is decorative type. They are, as the name implies, used more for ornament and novelty and have

A serif type refers to letters which have small horizontal parts attached to the top and bottom of the letters.

relatively little application. Decorative types might be used on certificates, for instance, but are generally harder to read.

Serif and sans serif. A serif type refers to letters which have small horizontal parts attached to the top and bottom of the letters. Frequently called flags and feet, these serifs, or horizontal edges on letters, are the feature which distinguish a typeface from the sans serif (without serifs) group.

In ancient Rome, when letters were commonly chiseled into walls of buildings, the straight-edged letters often resulted in cracks and fissures developing in the wall. To avoid that problem, they began putting horizontal edges on the top and bottom of the vertical lines forming the letters. Rounding off the letter in this way changed the direction of the stress, eliminated cracks, and introduced the concept of a serif typeface to western civilization.

Though considerable research has been done on the merits of serif versus sans serif type, most of it is contradictory. No definitive study prevails. The selection of one over another is usually arbitrary and the result of individual preference.

Are you my type?

Type selection. Individual preference doesn't mean you can select any typeface for any function and be effective. Common sense should help you. Study various typefaces in magazines and other printed pieces. Each typeface has its own personality. Some are

formal, some whimsical, and some are easier to read. Consider your message and your audience and select a typeface that suits each. A helpful lesson can be learned from studying the various typefaces used by corporations for their logos or trademarks. Graphic designers carefully select a type that reflects the image a corporation wishes to project. You can do the same thing when selecting a typeface.

Keep it simple with type, too. You'll want to use an easily read typeface for the body copy, or the bulk of your text. Don't change typefaces within your text. If emphasis on a particular word is needed, bold or italicized letters may be used, but make these exceptions sparingly. Your headings, subheads, and captions under photos or illustrations ought to contrast with the body copy. Do this by using a bolder face of the same type, by using a larger size, by using sans serif type for text and a serif type for the headings, or some similar scheme. Be aware that using all uppercase (capital) letters is very difficult to read. Avoid that syndrome. More than anything, you must remember to keep it all simple, clean, and clear. A page with a mixture of types is cluttered and ends up competing with or distracting from your message.

Visuals and spacing

Learning to conquer space

The spacing between letters, between lines, and between text and headlines is also an important consideration. In most cases,

Be sure you think about the spacing between letters, lines, text, visuals and headlines. Good use of space allows your message to "breathe."

technology controls those factors for you. Whether you're using a personal computer, a typewriter, or purchasing type from a professional typesetter, you want to think about how you space the elements. Good use of space allows your message to "breathe" and usually makes reading easier. However, be careful that you don't put too much space between a visual and its caption, or between a subhead and the text relating to it. Make sure your reader knows which elements relate to what. As unscientific as it sounds, your eye can usually tell you whether you are using space wisely.

If you are using hand-set letters, such as transfer type available at office supply and art stores, you need to know that not all letters and numbers require the same space between them. In fact, it looks awkward and is less readable if exactly the same space is used between each letter. The shape of the letters dictates how you space them. For instance, the parallel lines in an uppercase A and an uppercase W require that they be placed closer together when in sequence. The same concept applies when lettering by hand.

Keep it simple with computers, too. As mentioned earlier, the use of personal computers has minimized the problems one

Don't give in to the temptation to use all the typefaces, borders, and symbols available on your computer.

encounters when determining appropriate space between letters. The computer, however, doesn't solve all of the design problems. In fact, the advent of desktop publishing systems makes it even more important to understand the basic principles of graphic design. Now that more people have access to systems that set type in many different faces, that create borders and symbols, etc., the tendency is to use them all at once. There is probably an application for every feature a system can do; otherwise it wouldn't be included. Don't give in to the temptation to use it all on the same page, or in the same newsletter. Remember that initially your reader needs to be attracted to the piece. The same reader needs to be able to comprehend your message without having to weave in and out of a catalog of computer tricks.

A picture's worth a thousand words

Take time to select a good visual that supports your text. If the reader isn't helped by using the visual, you may be better off using blank space (also called white space or negative space).

Illustrations. If you have drawing skills, do a clean, simple line drawing to illustrate a point. If you're designing something for a church, social group, or your business, you might find someone else who can draw and is willing to help you. The value of original art is that you can make it exactly the size of the space you wish to fill and you need only include that which clearly supports your text.

Photos. If a good photo exists, use it. A frequently used trick of graphic designers is to set up or stage a pose demonstrating a process or concept and to take a Polaroid photo of it. By placing tracing paper over the photo, you can trace the outline of the important components of the photo and eliminate what isn't needed. You end up with a line drawing that will reproduce nicely when your piece is printed. This tracing technique also solves the problem of a photo that won't reproduce well because it's too dark or lacks contrast, for example.

Reproducing a photo in a printed document introduces several new challenges to consider. It costs more than a line drawing, for instance, and requires some extra work in the layout stages. Also, a photo won't always reproduce well on a copy machine. Color photos are much more expensive and require technical knowledge beyond the focus of this chapter.

There's reason to use a good photo, though, if a good one exists and helps clarify your message. If the subject of the photo is in focus, if it has good contrast (sufficient distinctions between the blacks, the grays, and the whites), and helps the reader understand, it will work for you. Details for accommodating a photo into your brochure or newsletter will be discussed later.

Clip-art. There are good sources of clip-art for sale which provide you with reproducible illustrations in a wide variety of topics. For that matter, you can cut out art from a number of

sources. Do not use art from a copyrighted work, however, without the publisher's permission. Many useful drawings such as famous landmarks or historical figures appear in old books printed so long ago that the copyrights have expired. Such works in the public domain are free to use. It might be worth a visit to your public library to photocopy drawings from an old reference book. Most U.S. government publications are not copyrighted and have good illustrations.

There are good sources of clip-art in most government publications and in old books whose copyrights have expired.

Remember, above all, that the visual has to help the reader understand your message. Don't use one just to have one. Make it work for you. Don't overdo it, either. Whether it's a photo, a drawing, a graph or chart, or just a subhead with large decorative type, don't junk up your design with overkill.

The layout process

A "fitting" occasion

Now comes the fun part. With a format established, with type set, and good visuals, you can now fit the pieces together. All of the earlier work is just to prepare you for the final step in conceiving how your finished piece will look. You'll want to experiment with all of the elements before you decide, so make photocopies of everything to play with and save your good drawings, photos, and type for the final layout.

Cut your type into columns. Your headlines and subheadings should be larger and can be cut into words or phrases. By moving the columns of type on the grids of your layout sheet, you'll determine how much space your message requires.

Your headlines deserve more space. Experiment with several options. Leave open space above it or beside it; move it to the left margin or to the right. Take advantage of the opportunities that three columns give you. Your headline might work in one column. You can extend it across two or all three columns.

What looks interesting? What attracts the reader? Also consider which visuals relate to text on that page. What size do you want the visual to be? Where do you place the visual? Though illustrations and photos need to be closely situated to the text they support, it's more important to consider how balanced the page looks. You can always relate visuals to text by using Figure 1, Figure 2, and so on, in the caption to the visual and then refer to that figure number in the text itself.

Balance. In attempting to achieve balance in your design, you must realize that elements such as illustrations, photos, and headlines, by their size and boldness, will carry more "weight" than the rest of the text. This means that the eye is more readily attracted to that space by its dominance. You achieve a balanced look by spacing these elements with careful consideration of their relationship with everything else on the page. Imagine your page as a plane balanced on a central point.

As you place a bold heading in one corner, for instance, the opposite corner will need something to balance that weight or dominance. Don't always think that symmetry is the solution to balance. It isn't. All of the visuals could be placed in one column and still have a balanced look.

It's important in laying out consecutive pages in a newsletter, brochure, etc., that you consider the balance on one page with the balance on the page opposite it. A reader sees both pages at once when looking at an

opened magazine. That whole look must be balanced to be attractive.

Don't forget that blank space can be visually useful in creating balance. The contrast of small type surrounded by white space is going to draw attention to that space, for example. Don't be afraid of leaving blank space if it helps to balance everything. Your eye is a good judge of what is visually interesting and exciting. Experiment. Notice what designers do in popular magazines. The pages of this handbook also demonstrate balanced design and might give you some ideas.

Nothing usually happens by chance with good graphic design. Balance is planned and the elements are ordered carefully and intentionally. Use logical order to bring the reader's attention to information in proper sequences. By leading your reader's eye from point to point in an orderly sequence, you'll help the reader's comprehension and encourage retention. Don't disrupt or confuse the flow of information by using poor design.

Mock-up or dummy. When your design looks right to your eye, tape all of the elements on your grid sheet. It doesn't need to be precise. It will show you if sections of the text need to be shortened or expanded. It will show you if you need to enlarge or reduce your visual. It will also serve as a good model to submit to anyone who needs to approve your concept. It also enables your printer to estimate production costs for you. This step is called your mock-up or dummy.

Put that dummy to work

Using your dummy as a guide, you are now ready to make a final paste-up. In commercial printing, this final paste-up is photographed to make the plates for the offset printing press. This is also called a camera-ready layout. At this stage everything must be neat and precise. Trim your columns of type and headings closely and carefully. Using the same grid as your dummy, your type and drawings will be secured by using a thin coat of rubber cement on the back side of the type. Some designers use tweezers or an X-acto knife to lift the cemented type into place. Secure it into the position indicated by your dummy. Avoid smearing and smudging. You must be neat. Rubber cement is usually easy to clean up and allows you to move the type around after you put into place. Use your T-square and triangle to make certain the columns are within the designated grids and that the type is aligned. Use a cover sheet of tracing paper to press everything neatly in place.

You can't be too careful at this stage of your production. The way it ends up on your layout sheet is the way it is going to print. Designers use light blue non-photo pencils, available from art and office supply stores, to establish guidelines within which they can work. The pencils are called non-photo because their light markings are not perceived by the camera when the printer begins production. Any other marks on your layout, however, will be reproduced. Be careful!

Working with photos in the layout

If you're using photographs or drawings that need to be enlarged or reduced from what is available, there are some steps you should take. Remember that you want the photo to help the reader understand the point you're demonstrating. The photo must clearly show what is needed for the reader to comprehend. There may be other aspects of the photograph you would prefer to eliminate. There may only be one segment of the photo that relates to your message. Designers use cropping in these situations.

Cropping photos. To crop a photo means to zero in on your subject and eliminate what

To help you decide how to crop photos, make two L-shaped pieces of cardboard to use as frames.

isn't needed. Make two L-shaped pieces of cardboard to use as frames around the photo. Move them in and out until you get just the portion of the photo that you want. In the margins of the photo, mark lines where you want the photo cropped horizontally and vertically. This achieves the same effect as taking the scissors to everything you don't want without actually cutting your photograph. You must realize that the shape of the photo after cropping is the space you must allow in your layout.

Sizing photos. You'll probably need to know how to enlarge or reduce the size of the photo, also. It's seldom when an available photo or art exists in exactly the size you ultimately need. There are tools such as proportion scales which help you figure what percentage the enlargement or reduction will be. They are inexpensive and readily available at art supply stores. However, as long as you understand how shapes change proportionately, you can get by without this purchase.

To illustrate this concept, consider that you have a photo that you've cropped to a width of 3¼" and a 2" height. The space that you have allowed for the photo in your layout is 6½" wide. You will be enlarging the photo to twice its original size. You must realize that when you make that photo twice as wide, you are automatically making it twice as high. Accordingly, you must make your space available in the layout to fit both dimensions. This process is called scaling. The formula is simply the ratio that follows:

If you have trouble with algebra, you can draw your own diagonal scale illustrated above.

$$\frac{\text{original height}}{\text{original width}} \times \frac{\text{adjusted height}}{\text{adjusted width}}$$

Measure the width and height of your original image. Draw a box with those dimensions. Extend a diagonal line from the lower left corner through the upper right corner. Determine which is the critical dimension according to your layout space requirements. It doesn't matter if it's width or height. Let's use the earlier example. Your original image is 3¼" wide. You want to enlarge it to 6½" wide. Extend the base line of your diagonal scale to the 6½" mark. If you draw a perpendicular line up from that 6½" mark, the point where it intersects the diagonal line will tell you what the enlarged height will be. The distance from your base line to the diagonal is the enlarged height. The same principle will tell you reduced heights or widths.

Confusing? It shouldn't be. Don't hesitate to check with your printer for help. As long as you explain what you want, the printer will help you get it right.

Halftones. There is one other point to make about preparing a camera-ready layout that involves a photo. Recall that the photo will cost extra to reproduce in your printed piece. That is because it will require a special negative to be developed by the printer. Because of the variations of gray tones in a photo, unlike the stark blacks and whites of your type and line drawings, the image is converted to a series of dots in a tightly spaced pattern. This is called a halftone negative. Look at a photo in your local newspaper and you'll see that it's a dot pattern.

In order for the printer to reproduce the photo accurately showing the range of gray tones, a halftone negative must be made. When you make your camera-ready layout, you will not be gluing the actual photo down on your

layout sheet. You will indicate the space where the photo is to go by using a solid box in that space. Professionals use rubylith, a red adhesive film, that can be trimmed right into the space where your photo will go. When your camera-ready layout is processed by the printer, the negative will show a transparent window where the rubylith was. A halftone negative of your cropped photo is made to the size you've indicated it should be. The halftone negative is then placed into that window. Your photo is printed reasonably close to the quality of your original.

Because of the variations of gray tones in a photo, the image is converted to a series of dots in a tightly spaced pattern called a halftone.

More details

Any other directions you may have for the printer should be written down and securely attached to your camera-ready layout. Discuss all of your requirements extensively with the printer. Don't hesitate to seek advice on paper and ink combinations.

Papers and inks. Paper selection can be tricky. There are many colors, many finishes, and many weights to consider. Few selections will work for any given application. If you intend to mail your printed document, don't forget that more weight means more postage. It is useful, once again, to rely on the professional to help you make a decision. If your application and your budget are understood, it's easier for professionals to give good advice.

What about ink colors? It must contrast with the paper. But don't overdo it. Your message, your visuals, your audience, and your budget need to be considered. You might like the color of a particular green ink. Is it readable? Does it suit your content? If there is a photo of ground beef, for example, do you want it to be green? Use common sense.

Photos actually reproduce best when using black ink on white paper. The darker the ink and the lighter the paper, the better your grey tones will reproduce. Unless your intention is to be outrageous, you are better off trying to be tasteful.

Summary

It happened by design

To repeat an earlier premise, graphic designers spend years perfecting their skills. The best are formally trained for four or five years and have many years of professional experience. You won't achieve that level from this chapter alone.

The concepts are not hard to understand, though. Use common sense. Consider your message and your audience. Keep everything simple. Know that the eye is attracted to balance and order. Any visual element needs to be a strong image clearly related to your message.

Though we've concentrated on printed materials for use in a newsletter, the basic principles apply to other designs. A hand-drawn poster requires the same evolution of thought. A color slide relies on the same concepts to be effective. It's all related to how visual elements can help you communicate.

A great way to learn is to be aware of what works in commercial advertising. The next time you look through a magazine, pay attention to the clever ads and how they handle space. What visual elements are effective? Try these tactics on your own work. If you're not satisfied with your first effort, don't worry. You learn more with each effort.

Exhibit design and production 7

E xhibits are a way of communicating messages to large audiences. Exhibits provide opportunities for the communicator to interact with the device and the audience. If properly handled, they can be easily updated and used over and over again. There are transportation and assembly problems that must be faced with each presentation, but these are outweighed by the opportunity to present messages to large audiences at events such as mall and trade shows, festivals, fairs, and conferences.

Exhibits are constructed from a large variety of materials. You should consider ease of handling, durability, and attractiveness when constructing an exhibit.

Exhibits can include many different devices: print, illustration, photography, film, television, computers, interactive video, and others. Consider the appropriateness of each for your audience.

Most communication devices follow a set pattern, A to B to C, when presenting messages. Exhibits allow the viewer to begin anywhere and spend more time with whatever elements are the most interesting.

Information must be condensed for exhibit presentation since most viewers spend only a few seconds to several minutes in viewing exhibit information. If after a first quick look at an exhibit, the viewers are not aroused by some interesting item or items, they may move on to something else.

Exhibits are often staffed. Instead of offering only passive information, individuals can be assigned to the exhibit to provide additional information about the subject, answer questions, or hand out materials. Even when a passive exhibit is in use, someone must continually attend to its appearance.

In this new age of electronic media, attention spans are much shorter. We are in the midst of an information explosion, competing with many other forms of communication for the viewer's attention. The competition is bigger, brighter, more animated, and more colorful than ever. If an exhibit is to be effective, it must be well planned, visually exciting and attractive, but condensed and direct. Only then can it compete effectively for the viewer's attention.

Planning your exhibit

Purpose

T he purpose for your exhibit is usually decided before the communication device is selected. Decide if the purpose is to teach, show relationships, or promote. If the device is to be an effective communication tool, one must closely examine the purpose for communicating.

If an educational exhibit is to be effective, it must convey to the viewers something they didn't know before viewing the exhibit. You may wish to modify their behavior in some way, or influence their attitudes or beliefs. Decide if you want them to take specific action, change opinions, or just be aware of some new information.

Subject

S elect a subject that has personal appeal to a large portion of your audience. Timing is also essential. For instance, a vegetable variety exhibit would interest more people before spring planting time than it would in the fall.

Choose a subject that is specific. A broad subject will be harder for you to cover adequately and more difficult for your viewers to comprehend. A simple subject is easier to design, particularly if you limit the number of main points to three or four.

Be sure to include only material that provides a real contribution toward your purpose. Look critically at the information as your viewers will see it. Emphasize the main points of your subject and eliminate the details. Detailed information can be printed in a handout, or you may provide an address or a telephone number.

Audience

D ecide exactly who your audience will be. Many of the decisions involving design will be affected by the age, background, educational level, and lifestyle of your audience.

7 Exhibit design and production

Change your methods as your audience changes. Consider a different means of presenting information to younger groups than you would to older, more conservative individuals. Bright colors, large graphics, and more hands-on materials may work better for younger audiences. Adults may prefer a more straightforward presentation. Generally, you can find several people who identify with a specified audience, and you can ask them for opinions on your design ideas before you go on.

Consider the location(s) where the exhibit will be displayed. What kinds of people will be there? What are their interests? How familiar will they be with the information covered in your exhibit? What can your exhibit do for them?

Exhibit devices

Exhibits are intended to be different from newspapers, bulletins, and magazines. Messages should be conveyed in a *visual* manner. Use less copy. Viewers will not spend time reading large blocks of copy in exhibits. Consider handouts or a more visual means of conveying this information.

Live or real objects. Because of the convenience of obtaining, mounting, and displaying visual representations, we often overlook the possibility of using real objects. Live animals always attract attention. Plants or other real objects are usually superior visuals if we can use them.

Models. Whenever the size or visual limitations of a live or real object are prohibitive, a model may be helpful. A model can provide a miniaturization of a much larger object, or an enlarged version of a smaller object. A model allows the viewers to focus on the important parts by eliminating unnecessary details or visual obstructions.

Photographs. Photo enlargements provide a realistic look at an object or a situation. The photos should eliminate distractions and irrelevant details and zero in on the areas that support the message to be communicated. This medium can condense large objects or enlarge small ones. Avoid having many small photos; use fewer but larger prints. Use a mix of sizes for added design appeal.

Projected images. Motion pictures, slides, filmstrips, overhead transparencies, and television can be useful as exhibit visuals. Common sense must keep the designer from expecting the audience to spend much time viewing this type of visual. Just because the pictures are moving or changing, or they are accompanied by sound, doesn't guarantee that viewers will spend much more time watching. Unless they have a strong interest in your subject, you can expect them to give your exhibit only two or three minutes at the most.

An important consideration relating to projected images is image size. While it may be desirable to have a large image, you'll find that the larger the image size, the less brilliant

Tell the story with visuals. The exhibit on the left has too much copy, not enough visuals.

it becomes. Since exhibits are usually displayed in well-lighted areas, it's normal for the image on the screen to look weak unless it's kept fairly small (no larger than 18 inches), or unless you provide a canopy to eliminate the ambient light.

Computers. Using computers in an exhibit can add to the interest level. They can be programmed to demonstrate or teach certain parts of the exhibit, construct models, or show diagrams and graphs. Some programs can solicit a yes/no answer or lead viewers through a set of questions.

Computers attract attention, but may also narrow the audience since fewer viewers can work on keyboards or respond to monitors.

Illustrations. Again, knowing your audience is essential. Using this device, the creator can completely eliminate unwanted detail,

In addition to the usual visuals, large or unusual letters, words, shapes, and designs can assist in attracting attention and communicating a message.

exaggerate portions to provide emphasis, and communicate a message in its most basic form. While the appearance should be attractive, it's not necessary for the illustration to appear as a beautiful work of art. It may complement a headline or body copy, or stand alone to create its own message.

Graphics. Charts and graphs can be helpful visuals in showing changes, relationships, and differences. Be sure to choose the appropriate type of graph for your message, and keep it simple in design.

Other graphic visuals include large or unusual letters, words, shapes, and design patterns that assist in attracting attention and communicating a message.

Exhibit design and construction

E xhibit design organizes the basic shapes formed by the visuals, the copy, and the unused portion of the background (negative space) into an interesting and balanced unit. In such an arrangement, the elements themselves are subordinate to an overall unifying plan. This plan should be pleasing to the eye, yet simple in concept, and it should enhance the communication of the message.

Exhibit design and the message should be in balance. While an exhibit designer is interested in an aesthetically pleasing display, the most important point is to communicate. All elements should contribute to an overall design and message.

Consider traffic flow and viewing distance. With large lettering and visuals, you can increase legibility and attract attention at a greater distance.

You as the designer should have some knowledge about where the exhibit will be located. The theme of the event and the nature of the exhibit location will affect design. The designer should consider assigned space, lighting, traffic flow, and viewing distance.

Stage 1: Information gathering

T he exhibit designing process begins by gathering relevant facts and conditions, or limitations about the exhibit: its purpose, the subject, the audience, its location, and the resources you have to work with. Write them down. You usually begin with much more subject matter than a simple, direct design will allow. Organize it into some logical order so that the viewers can follow easily. This information is boiled down into simple phrases or brief statements. Don't hesitate to delete information of lesser importance.

Make several attempts to create a short, catchy title that identifies the exhibit and gets

viewers involved. Use the verb in the active form, and be sure the audience can relate to and be invited by the title.

Stage 2: Organization

After you've condensed the subject matter into simple phrases or statements, you must then consider the opportunities to support, clarify, or explain them with visuals. Jot these ideas down on paper. Consider a variety of approaches for each visual, but aim for visual ideas that are simple and to the point.

Say, for instance, that your exhibit would benefit from a visual that relates to horses. List a number of alternatives: a group of horses, one horse, half a horse, a horse's head, a horse's hoof, a horseshoe, a bridle, a saddle, a riding boot; the list can go on.

Now put yourself in the place of your viewers. Which visual alternative is most appealing? Which best communicates your message? Which is the least complicated?

Stage 3: Visualization

At this point you begin to visualize how some of these elements relate and fit together. Sketch out your ideas, using pencils and markers. Asymmetrical, or informal, balance is usually more interesting than symmetrical, or formal, balance. Group your visuals and copy together to make points. Don't try to space them out over the entire background. Allow areas of negative space

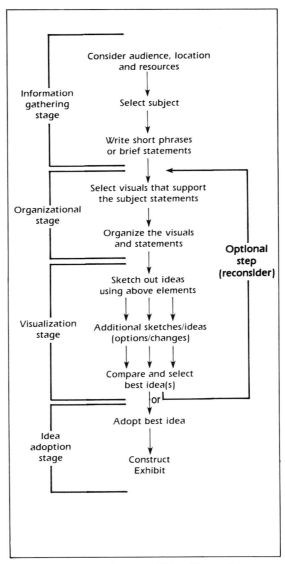

Though the design of every exhibit will vary, this model may be useful during the planning process.

around groupings. The exhibit will look less crowded and negative space will tend to highlight the visual groupings. An exhibit, as does the printed page, usually reads left to right and top to bottom.

Now that you've sketched out a number of ideas, compare and select the sketches you like best and are the most effective. If you reach a point where you've run out of ideas, stop and come back to the project at another time. Ask others for their opinion. It's easier to change at this point than halfway through construction.

Stage 4: Idea adoption

You may need to allow more time for digestion, and you may have to repeat these steps, or parts of them, several times before everything falls into place. When you feel your ideas effectively communicate your message — with design elements united into a simple, pleasing unit — then you're ready for adoption. Now you may move toward constructing the exhibit, using the ideas you've adopted.

Attention-getters

A good design unites the various elements in such a way that the overall appearance is attractive, inviting, and worthy of attention. If the viewers don't bother to look at it, they won't get your message. A good choice of visuals can be interesting, but coupled with one or more "attractants," your exhibit can draw considerable attention.

Size. Keep your visuals and lettering large. If your entire exhibit is small, then you must limit your selections in order to keep them as large as possible. If surrounding exhibits have ½" lettering, you have a considerable advantage if you use 1" or 2" lettering. This may also require that you use much less copy.

Shape. Many exhibits appear to use only square or rectangular shapes. The use of a round, oval, or other unusual shape can draw attention. Backgrounds need not always have horizontal and vertical lines, even though they are convenient. Try to use the third dimension in your design. By mounting a two-dimensional object like a photograph on a thick mat or foam board, and then placing it on the exhibit surface, your image will appear elevated from the background.

Texture. If most parts of your exhibit have smooth surfaces, it may be advantageous to add a rough or textured area. This is easily accomplished with rough wood, corrugated paper, burlap fabric, and the like. You can even give this effect by partially painting an area with aerosol spray or a paint roller, or by striping with a brush or felt-tip marker.

Color. Be cautious with colors. Extremely bright background colors will detract from the visuals and other exhibit elements. Usually a continuous soft background color and one or two other brighter colors for lettering or grouping visuals are adequate. Bright colors can attract attention or draw interest to certain areas of the exhibit, but be careful how colors are combined and used.

Motion. Motors of many varieties can be used to achieve animation. These can be purchased at an electric supply center. Live animals also provide motion and usually get considerable attention when they are part of an exhibit.

All straight lines, rectangles and smooth finish.

Texture adds interest and the oval draws attention.

Lettering is too small.

Larger letters draw more attention.

Visuals alone are attractive, but size, shape and texture can also increase the attention-getting capacity of an exhibit.

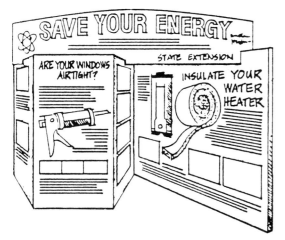

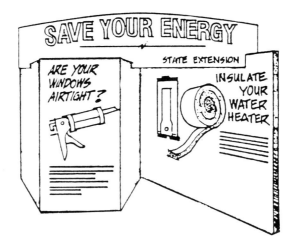

The design should be basically simple, with few elements and much negative space. The exhibit on the left is too crowded.

Light. Make sure your exhibit is lighted well with about 150 watts per 4' x 4' area. While floodlights are used to light broad exhibit areas, intense spotlights can draw attention to specific exhibit areas.

Moving, flashing, and blinking lights can attract attention, but common sense must dictate their intensity. Incandescent lighting intensity can be reduced by using lower wattage bulbs or a rheostat.

Exhibit design tips

Consider the following suggestions any time you are working your way through the exhibit design process.

Be sure the design is basically simple, with few elements and much negative

space. The most common error of exhibit design is too many elements or too much copy. Such designs can be difficult to comprehend and may give the viewer the impression of being cluttered.

Make certain that the exhibit "reads" well — left to right, top to bottom. The title, the visuals, the copy, and the overall design should have an obvious message, with all the elements contributing to its communication. Does the exhibit accomplish the purpose that was intended?

Put yourself in the position of one viewer from your specified audience. Imagine the exhibit in its intended location. Is there a strong attention-getter? Does the message come through loud and clear? Is that message positive and worth your time?

Exhibit backgrounds

Exhibits made of metal and plastic supports, with cloth or other backgrounds, can be purchased from a number of exhibit companies. Instead of constructing your exhibits, you may want to purchase your exhibit and then design and mount your visuals on these boards. Most companies make a lightweight, strong, and attractive display background that either comes with a carrying case or will collapse to a manageable size. Cost can be prohibitive. Contact an office supply store for catalogues and prices.

If you cannot purchase an existing exhibit, construct your own. Look at the following for construction tips and materials.

A wide variety of materials is available for use as exhibit backdrops. Before selecting one, you should answer some basic questions concerning the exhibit.

- What will be the final size of the backdrop?
- How small must it be packaged for transport and storage?
- How heavy will it be?
- How sturdy and durable must it be?
- How easily can visuals be mounted on it?
- What color should it be?
- What are the necessary resources, such as initial cost and time preparation?
- How often will it be used?

■ Exhibit backgrounds

Here are some commonly used materials:

Plywood, available in ¼", ⅜", and ½" thick, 4' x 8' sheets — heavy in weight.

Masonite, ⅛" and ¼" thick, 4' x 8' sheets — heavy in weight.

Plywood paneling, 3/16" thick, 4' x 8' sheets — moderate in weight and sturdy.

Styrene and urethane foam, ½", 1", and 2" thick, 4' x 8' sheets — very light.

Foam board, ¼" and ½" thick, 4' x 8' sheets — very light and good as a surface.

Corrugated cardboard, various sizes — very light, but surface must be coated.

Posterboard, 14 and 28 ply, 28" x 44" and 30" x 40" — light and good as a surface.

Other wood, paper, plastic, and cloth materials are available. The preceding list includes those that are most widely used.

The requirements of your exhibit will guide your choice of materials. Limited storage space and smaller auto sizes increase the necessity for designing exhibits that are lightweight and can be squeezed into smaller packages. Foam board is a lightweight product that can be folded to pack into corrugated cartons or envelopes for easy transport and storage.

Lightweight paper and foam products can be easily used as backgrounds for tabletop

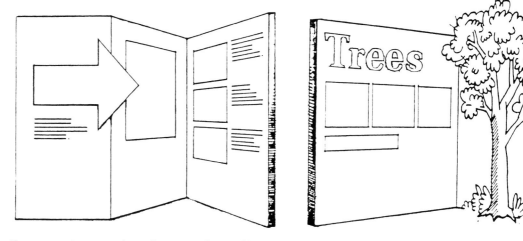

Because most structured panels are manufactured in rectangular sheets, it is common to see exhibits with horizontal and vertical lines. Any effort to break up this horizontal and vertical effect, such as the panel on the right, should increase audience interest.

displays. They need additional support or framing when used on a larger scale.

Large, free-standing exhibit backgrounds may be constructed with any of the aforementioned materials, provided they are adequately supported. Plywood is sturdy when framed with 1" x 3" pine lumber, and sections can be coupled together with bolts through the framing. The reverse side (non-grooved) of plywood paneling makes a good surface. The grain can be filled, or simply sanded and painted with several coats. The plywood may also be finished with formica.

Lettering

Lettering brushes can create fine letters if you've developed the skill or can hire a

professional. But often the available resources are prohibitive in costs or availability of skill. Tempera poster paints are easy to use and although they dry quickly, they are not waterproof. Poster paints are available that dry quickly and will withstand some weathering. Sign enamels are weatherproof and durable, but they have a glossy finish and need 24 hours to dry.

Speedball pens are more easily mastered than the lettering brush. These inexpensive pens work with many kinds of inks.

Art supply stores and office supply stores offer an assortment of lettering. Transfer lettering, block or cut out letters, and stencils are available. Lettering machines are available that will create lines of type for titles. Placement

7 Exhibit design and production

and spacing of letters that make words, and words that make lines of type require a certain amount of skill and time. Practice and take time to make titles and copy look good.

Exhibit titles should have letters at least three inches in height, and a line thickness roughly one-sixth the height of the letters. Larger sizes are usually preferable. The lettering size in the copy of an exhibit should be no smaller than one inch tall.

Lettering visibility is affected by:

Size. Use lettering that is as large as possible.

Line thickness. The boldness of the lines that form the letters should approximate one-sixth the letter height.

Style. Choose a style that is bold, easily read, and not too fancy.

Contrast. The letters shouldn't blend into the background. Use light-colored letters on a dark background and dark-colored letters on a light background.

Working an exhibit

Many public exhibition areas become cluttered with disposable food and drink containers, handout literature, etc. Be sure that someone has the responsibility for keeping your exhibit working and the immediate area neat and clean.

Exhibits need attention in other ways also. Lightweight exhibits can be bumped out of

alignment, and display materials that are handled often need to be repositioned. Handout leaflets should be kept in neat stacks and the supply replenished as needed.

Individuals assigned to work an exhibit should be prepared to answer questions concerning the exhibit subject and to provide information about the sponsoring organization. They should also be able to give food, drink, and restroom information. It's often appropriate to have reference materials available to assist them in answering the harder or more technical questions. A pencil and pad should be kept handy so that requests that can't be filled immediately can be recorded.

Persons who work an exhibit should be neat and well-groomed, appropriately dressed, and properly identified with a name tag or other means. They should greet viewers, help them make new friends, and answer their questions. This responsibility is demanding, requiring many hours of standing, while looking enthusiastic and fresh. Plan to enlist plenty of help.

There are several reasons for having individuals work an exhibit. Keeping the exhibit working and the surrounding area neat and clean are the minimum requirements.

Summary

■ Remember that onlookers usually view an exhibit for only a short time — from several seconds to several minutes.

■ You must have an attention-getter and a quickly understood message in your exhibit.

■ Decide first on your purpose, subject, and audience; then design the exhibit with those things in mind.

■ Do a good editing job, allowing only the most relevant points as part of the message.

■ Tell your story visually.

■ Leave plenty of space in your exhibit; it shouldn't have that discouraging, crowded look.

■ Select appropriate materials. It may be necessary to pack your exhibit in a convenient, transportable package, which must be reasonably lightweight.

■ Keep the lettering to a minimum in quantity, and large in size.

■ Have the display set up on time. Keep it looking good throughout the showing.

■ Make sure persons working the exhibit are neat and well-groomed, enthusiastic, and above all, interested and helpful.

- **What and who**
- **Word choice**
- **The visual**

Posters 8

Posters are a common, and often inexpensive, device used for publicity and advertising purposes. They can be ideal for publicizing events such as meetings, shows, contests, dances, picnics, and public sales. They might also be used to promote a political candidate, educational idea, or to advertise products or services.

Posters differ from flip charts, flash cards, and other teaching aids in that each poster must stand alone without a person to call attention to it, identify its purpose, or stimulate onlookers into further action.

Most people glance at a poster only long enough to identify it. They are more likely to get the complete message of the poster if it is graphically exciting or deals with a subject that interests them.

Posters are normally produced on paper or posterboard, but can take other forms such as promotions printed on trucks, billboards, T-shirts, and bumper stickers. The form your poster takes should depend upon the audience and the most effective way of reaching that audience.

What and who

You should begin by deciding exactly who you wish to reach and what you want to say. Write these ideas on paper, and continue to search for the best possible words and images to express your ideas clearly, simply, and precisely.

Consider the message your poster will deliver from the audience's point of view. What is the age, education level, and background of your audience? Is your choice of words and visuals appropriate for this group? Will the poster capture their interest? An understanding of the audience will also help in making design decisions regarding the color, type face, visual, and basic layout.

Word choice

The message your poster delivers will often depend on the words you choose. During the planning stage, jot down words and phrases, and make rough sketches that also help describe or clarify the message. Begin to visualize and arrange these elements in a logical order.

Select the most important words and pencil them into a rough layout in large letters. This title, with an accompanying visual, may serve as an effective attention-getter. If needed, use smaller-sized lettering (body copy) to explain details of your poster's overall message.

Now rethink what you've done in planning so far. Did you select the key words from the audience's point of view? How well do the words relate to the visual to deliver the message?

The visual

The visual (illustration, chart, photograph, etc.) is most often an essential element in the poster. Try to develop an idea that will appeal to your selected audience. Explore various approaches for the visual, but aim for one that is simple, compelling, and to the point. The visual must reinforce the message, or better yet, carry the message.

If the message you've selected for your poster relates to vegetable gardening, you can list a number of visual approaches: an entire garden, one row of plants, a group of plants, one plant, an array of vegetables, one vegetable, a slice of vegetable, a jar of canned vegetables, a hoe or cultivator, a person holding a vegetable, an expression of satisfaction on a person's face. Your list can go on.

Now put yourself in the place of the viewer. Which idea best communicates the message? Which is most appealing? Which of these ideas can you execute without risking confusion? Which visual idea has greater potential as an interesting shape (design element) in adding impact and drawing the attention of the audience? Seek a simple solution to these questions.

A basic poster design often uses a single visual, contributing to the attention-getting ability of the poster and to the communication of your message. Therefore, the final choice and approach of the visual is critical to the effectiveness of the poster.

8 Posters

Layout and design

G ood poster design organizes the basic shapes formed by the title, the visual, the body copy, and the balanced unit. This basic arrangement should enhance the communication of the message, be simple in design, and please the eye.

One effective approach to poster layout and design is to use a short title, with large letters, along with a simple illustration. Other necessary details may appear in smaller-sized body copy. The title and illustration grab the viewers' attention and lure them in to study the details more closely.

Design guidelines

K eep the *message* foremost in your mind throughout the project. One to five key words should appear in large type and be legible at a distance. These words should suggest your message and have impact upon the audience.

There is no single design formula that will guarantee your success. Many rules have proven effective over time, but some of them can be broken, for good reasons, and an effective design can still be achieved.

■ The major *design elements* are the blocks of space occupied by the title, the visual, and the body copy. It is easier to plan a successful design with three elements than it is with many elements. One of the elements should be noticeably larger than the others. This contrast in size adds interest to the design.

Poster design elements are more effective when *grouped* than when spaced over the entire poster area. Therefore, you should try to avoid creating multiple elements. For instance, three words of a title might be printed in a design with the words tightly fitted together, and they might appear as a single element. Another treatment is to space the three words so they appear as three separate elements. These three elements along with a visual and a block of body copy would total five elements.

■ Leave plenty of *space* between and around most elements, with extra space along the edges of the poster. Avoid the look of crowding.

Allow for several fairly *large areas* of unused or open space. A design begins to look crowded when the open space areas fall below 20 percent of the total area. Many successful posters have 30 to 40 percent of the area in open space.

■ The *configuration* of the open space is just as important to the impact of the basic design as the shapes formed by the lettering and visuals. It usually is desirable

Layout and Design

A. B. C.
Workshop
October 13
1-5:00 PM
Kres
Plaza

Layout and Design

A. B. C.
Workshop
October 13
1-5:00 PM
Kres
Plaza

Key elements of design are: 1) the illustration, 2) the title, 3) body copy, and 4) open space.

to have various sizes and shapes of open space.

■ *Balance,* or the relative "weight" of the visual elements, is an important part of poster design. If a large element appears on one side of a design, two or more smaller elements can be placed on the other side to achieve balance. While it usually is undesirable to scatter the elements evenly over the entire poster area, it usually is ineffective, also, to crowd all elements into one end or one corner of the area.

Balance is necessary to design, but it is often less effective if achieved by centering all elements on the poster. This would be formal balance. Asymmetrical, or *informal,* balance usually is more interesting, more fun to work with, and more challenging than symmetrical balance. Informal balance is less static and monotonous; it suggests movement.

■ In a superior design, either the visual or the lettering *dominates,* rather than having an equal division between the two. A design with the visual occupying more area than the lettering can grab a lot of attention, but be sure that the visual supports the message. People often resent tricky visuals or misleading words that do not support the overall message.

■ Horizontal lettering is normal. Vertical lettering is difficult to read and is not recommended. Therefore, most poster elements appear in the horizontal position.

A large *vertical* line or illustration, though, can attract the viewer's eye and become a pleasing design element. This is true also of angular lines and shapes that contrast to the rectangular edges of the usual poster format.

Lines create *direction, flow,* and cause eye movement. The juncture, real or imagined, of two or more lines can easily become a focal point or center of interest within a design. This means that as you become more adept at using lines and direction, you have increasing control over the viewer's eye movement.

■ An effective poster has a strong *center of interest* at the words or illustration that identifies and introduces your message. This reinforces the idea that communicating the message is your main goal.

The center of interest usually is more effective if it is placed *one-third* of the distance up, down, or in from either edge of your poster. Avoid placing it in the geometric center of the poster area, too close to the edge, or cramming it into a corner.

■ Designing is easier when the *body copy* is short and to the point. Edit and present the

The three posters shown are equally effective combinations of design elements. Possibilities for additional combinations are almost limitless.

message so it appears in a relatively small area. Consider with care the information presented there. You cannot overlook certain necessary facts, such as time and place, but an excess of body copy requires very small lettering or uses too much space. Editing keeps posters from looking crowded.

■ Be certain that the choice of *color* does not detract from the message and is acceptable to your selected audience. A related color plan, one that uses colors lying next to each other on a color wheel, is a conservative, safe approach and seldom jeopardizes a design. Certain designs and specific

PROBLEM SOLVING
New Techniques

April 1, 1999
Honea Path
Megatorium

Leave plenty of open space around design elements.

audiences, of course, might benefit from the addition of a brighter, contrasting color. Older people might prefer a more conservative color plan, while teenagers like bold, contrasting, and even vibrating colors.

Legibility

The main goal of many design decisions is legibility. Messages are unclear when words are difficult to read or a visual is complicated and confusing. An audience seldom bothers to look at a poster that requires much effort to read.

A number of factors influence legibility.

Size. Letters and illustrations must be large enough to be easily recognized. A large poster, 22 x 28 inches, should have the title printed in letters that are 2 to 4 inches high. A smaller format, say 14 x 18 inches, should have title letters 1½ to 3 inches high. Body copy often is printed in letters that are one-fourth to one-third the height of the title.

Contrast. Contrast refers to the relative lightness or darkness of the elements and the background they are on. Maximum contrast is black on white or white on black. This is tiring on the eyes when used in excess. Minimum contrast, such as pale yellow letters on a white background, is difficult to read. A combination just short of maximum contrast is desirable. This might include black or brown letters on a yellow paper, white or pale yellow letters on medium to dark (but not black)

colors, or red letters on a beige or sand-colored background.

Style. This pertains to the character or tone of the graphics. Some lettering styles, such as Helvetica or Franklin Gothic are very easily read. Ornate or overly fancy styles are hard to read. A visual also can be too detailed, causing confusion for viewers. Try to select styles of lettering and visuals that are simple, handsome, and will enhance the message.

Line thickness. Line thickness for letters must be reasonably bold for good legibility. Ideal line thickness is roughly one-sixth the height of the letter. A 3 inch high letter with a line thickness of one-sixteenth of an inch is not very visible. A 3 inch high letter with a line thickness of one-half inch (one-sixth of letter height), on the other hand, is legible at 80 to 90 feet. Fairly bold line thickness is also necessary for illustrations to be readily visible.

Materials

Poster messages appear on a wide variety of surfaces. If you intend to use ink or paint for the lettering or visual, you should select a paper or cardstock that has a smooth, hard finish. This finish is less absorbent and allows you to produce sharp, crisp lines.

Heavy printing paper, coverstock paper, and poster paper are sometimes used for posters. Cardboard suitable for poster production is available under a variety of names. Commonly used materials are bristol board, railroad

board, show-card, illustration board, and posterboard. They vary in thicknesses, in overall size, in hardness of finish, and in price. Compare the available products and examine them closely. Select the material that best suits your project and your budget.

Lettering and visuals may be produced on the poster material with ink or paint, or may be glued to the poster surface. Felt tipped markers may be used, but be sure to select those with permanent ink. Other inks, such as India ink, may be applied with a metal tipped pen or a brush. Different kinds of paints are available, but tempera poster inks are the easiest to use, and they clean up with water.

Letters that are commercially available include rub-down transfer letters and pressure-sensitive paper or vinyl letters. They are expensive and time consuming to apply, but are very precise, clean letters.

The basic design should be simple. Limit the number of design elements. Leave lots of room at the margins, and some larger areas of open space within the design. The most common mistake in poster design is using too many elements and scattering them over the entire poster area. This gives the viewer the impression that the poster is cluttered and difficult to comprehend.

Always keep the message and the intended audience in mind. You must communicate in order to succeed.

Stencil guides may be used to outline the letter shapes on your poster. Be sure to fill in the letters where the centers are attached to the rest of the stencil.

Showing

You've done your best to create a good poster, so how and where you display it should be just as important. Even an excellent poster can be ineffective if displayed under poor conditions. Think of the places that your audience might congregate or pass idle time.

Place the poster where it is highly visible and not lost in a confusion of competitive clutter. Attach the poster securely, so it cannot slide, fall, or wrinkle. It should be at eye level or above, and on a pleasant looking bulletin board, wall, or other backdrop.

The poster should be seen in adequate lighting. Fluorescent lighting will influence the color scheme, and the poster could appear much different than when viewed under incandescent lighting.

Elements of design are most effective when grouped than when spaced over the entire poster area.

Lines or shapes can direct eye movement to a focal point.

Balance is a necessary design element. Balance may be symmetrical (left) or asymmetrical (right). Often asymmetrical balance is more visually interesting.

One to three weeks is usually adequate lead time for posters to advertise an event. Check on their condition several times throughout this period to assure they remain in top condition and maintain an acceptable appearance.

Summary

People often just glance at posters. They will investigate further only if an easily comprehended message appeals to their interest. You must carefully select the key words and/or visual to grab their attention and communicate the message.

Good design organizes the elements into an interesting and balanced unit. Effective posters are not only pleasing to the eye, but present a bold, clear message.

Photography 9

In the hands of a creative photographer, a camera can make time stand still. It captures activities you want to remember, programs you need to document, and people you never want to forget.

This chapter is written for the person who wants to communicate with photos. It will cover selecting a camera that's just right for you, adjusting the camera, making your pictures more enjoyable and informative, employing special photographic techniques, and buying and using camera accessories.

A camera is an important tool for communicators. But don't forget that the photographer, not the camera, is the most important instrument for taking good pictures.

With creativity and determination, you can take exciting photographs with only a simple and relatively inexpensive camera. Properly selected equipment will allow you to concen-

You should select a camera and accessories based on how you plan to use the pictures you take.

trate on taking pictures that convey a clear message instead of fumbling with the camera mechanics.

Selecting the camera

At long last, advanced camera technology allows the photographer to focus on picture composition instead of camera gear. Today's amateur photographer can choose between a simple, relatively inexpensive camera which consistently delivers correctly exposed, adequate pictures, or a more complex, adjustable camera offering full control over every factor.

No camera is perfect for every purpose. You must decide what advantages, such as simplicity, you are willing to trade for others, such as versatility.

Your choice should depend on the kinds of pictures you will take and how often you will be using the camera. If you need enlargements for public displays, you should select a camera different from one you would use to take snapshots for an office report.

Also, consider how many people will use the camera and how much they know about them in general. If the camera will be used by several people who have little photographic background, select a simple and durable model. Extra features add flexibility, but only if you know how to use them.

A variety of picture formats is available to the photographer.

Camera classifications

Cameras are classified by format, which determines the size and shape of image produced on the film. All cameras will take prints and slides, depending on the type of film you use. How you intend to use the pictures will determine which format you need.

Inexpensive 110 and 126 cartridge-loading cameras can produce snapshots or color slides for the beginner. However, as 35mm cameras have become simpler and cheaper, these older cartridge cameras are not as popular. The quality of enlargements from these cameras, especially the 110, is often unacceptable for most serious uses.

9 Photography

The 35mm camera is the nearest thing available to an all-purpose camera. It's the most popular choice for color slides. Black-and-white or color negatives from this format can usually be enlarged to 8" x 10".

The new generation of compact 35mm cameras offers features to suit almost every need and pocketbook. There is even the "disposable" one-time use camera which costs only slightly more than a roll of film. With a price tag less than $10, these cameras are ideal for teaching photographic composition to youngsters.

A variety of disposable cameras is excellent for teaching basic photography.

The family of compact cameras usually has automatic exposure settings, built-in flash and a focal range from six feet to infinity. As the price tag climbs above $100, the cameras may offer zoom, close-ups, and special focus controls. Usually, these cameras do not have removable lenses, time exposure, or manual override features. For this control, you still need to consider an adjustable camera. If you are using an automatic camera, skip to the section on composition, "Creating pictures with impact."

If you want to step beyond the typical into the extraordinary, you probably will use a fully adjustable 35mm camera. These cameras allow the photographer to view the picture through the lens for better composition control, especially with close-up photography. In addition, you can remove and replace the lens with specialty lenses and adjust the shutter opening and speed for full control of depth of focus and stop action.

Professional photographers making pictures for publications or exhibits use a larger format camera, such as a 120, which makes a negative 2¼" x 2¼". This camera is not much larger than a 35mm, yet produces a negative nearly twice as large. Large negatives make sharper enlargements.

2¼ × 2¼

Professional photographers prefer large format cameras because of the clear sharp negatives they produce.

Recent improvements in instant picture cameras have increased their popularity. However, many experienced newspaper and publication editors won't use instant photographs because the lenses in these cameras are often too inferior to produce sharp pictures. The layers of color emulsion in instant color prints keep the edges of objects in the picture from looking sharp and crisp. If your newspaper prints a black-and-white picture from an instant color print, don't be surprised if the faces appear much darker than normal.

Viewing systems

Cameras are also classified by the viewing system, usually twin lens reflex; viewfinder; or single lens reflex.

Twin lens reflex. The twin lens reflex camera has two lenses, one directly above the other. The word "reflex" indicates that you view the image from a mirror inside the camera. The top lens is used for viewing and focusing,

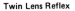

Twin Lens Reflex

The twin lens reflex is an older style format which is bulky but can provide excellent photographs.

while the lower lens takes the pictures. This camera is excellent for general print photography but is not good for close-ups.

Viewfinder. The viewfinder camera has a window built into the top of the camera to allow you to compose your picture.

It is excellent for general photography of scenery and people, but isn't well suited to extreme close-ups because of parallax problems. Most inexpensive 35mm cameras use this viewing system.

Viewfinder

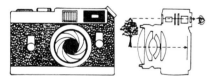

Single lens reflex. If you plan to take many close-ups, or if you plan to use a wide-angle or telephoto lens, the single lens reflex is the most convenient viewing system. The photographer views the image directly through the lens by means of a hinged mirror behind the

Single Lens Reflex

lens. This system also makes it easier to focus and frame pictures when using a telephoto lens.

Single lens reflex cameras are available in most film sizes. Because they are more complex than other viewing systems, they are considerably more expensive.

Camera features

Once you have selected the format and viewing system, you'll find a variety of features on the cameras in the category you have selected. Each camera has a slightly different technique for focusing, adjusting the exposure, and loading the film. With practice you can usually adapt to any system.

There are, however, a few features you'll want to consider carefully. These include interchangeable lenses, a built-in exposure meter, and automatic exposure control.

Interchangeable lenses. This feature allows you to replace the normal lens with a specialty lens, such as wide-angle or a telephoto. Nearly all cameras selling for $200 or more have this capability. It's a valuable feature which allows you to expand your photographic system as your needs and finances dictate.

Lens speed. There can also be some variation in the normal lens you buy with your camera. For example, one option may be a 50mm, f/2, while the other choice may be a 50mm, f/1.4. The f-number in the lens description tells you how wide the lens will open on its largest setting. In this example, the f/1.4 will let in more light and is referred to as a faster lens. (See section on f-stops.)

Some people believe that since the faster lens costs more, it's a better lens. This is generally not true. In fact, the f/2 lens will usually produce a sharper image in all but the poorest lighting conditions. Unless you are interested in doing much low-light photography, you can save money buying the slower lens, in this example, the f/2.

Built-in exposure meter. Built-in meters have made handheld meters a thing of the past for most amateurs. Meters on most single lens reflex cameras read directly through the camera's lens.

To set the correct exposure, look through the viewfinder and adjust the shutter speed or lens opening until the needle lines up on a certain mark.

Some meters measure only a small portion of the subject being photographed, while others measure the entire picture area. Either system works well when you master its use. Through-the-lens meters are especially useful when taking close-up pictures and when using telephoto lenses.

Automatic exposure control. Automatic exposure cameras are quite popular. They are convenient and usually produce acceptable pictures in standard conditions. However, automatic cameras can also produce poor photographs if you don't understand their limitations. (See section on exposure.)

If you decide to buy a fully automatic camera, be sure it also provides manual controls so you can still use the camera when the meter malfunctions or when the batteries are dead. Many automatic cameras use an electronic rather than a mechanical shutter, so they depend entirely on batteries.

You might also want to find out how much the replacement batteries cost. They can be expensive. If you do select an automatic camera, avoid using it in extreme cold and always carry a spare battery.

Selecting the film

The film you select will depend on the kind of pictures you want to take. Before you buy your film, decide whether you want prints or slides, color or black-and-white. You should also be aware of the lighting conditions — indoors, flash, or outdoors.

If you need black-and-white prints, use black-and-white negative film such as Plus-X or Tri-X. If you want color photographs, you must use color print film which always carries the word "color" in the name such as Kodacolor II. If you want color slides, look for the word "chrome" such as in Kodachrome or Ektachrome.

Sensitivity to light

Once you decide on the type of film you need, you must decide how sensitive the film should be to light. If you are taking pictures indoors without a flash or outdoors in the evening, you won't have much light. Conversely, a sunny day by the lake will be very bright. To accommodate such different conditions, film is rated with a number that indicates its speed. On some films, this number is an ISO (International Standards Organization); on other films, it is an E.I. (Exposure Index).

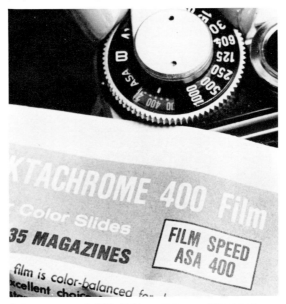

Set your camera's ASA dial to match your film speed, and don't change it until you change film.

For example, Plus-X has an ISO of 125. The newer T-MAX has an E.I. of 100, 400, or P3200. It makes no difference whether the rating is an ISO or an E.I. It's the number that is important. This number should be set on your camera when the film is loaded. Most 35mm film cassettes today have a bar code printed on them. This bar code is read by many newer 35mm cameras and the film speed is automatically set.

Films with higher ISO ratings can sometimes look fuzzy, even though pictures may be in perfect focus. If you're taking pictures in bright sunlight or with an electronic flash, you won't need a highly sensitive film, so try to use a film with a lower ISO rating for a finer grained picture.

If you use color film, you must also take into account the type of light which will illuminate your picture. Most color films are balanced for daylight, which includes light from an electronic flash. You will get greenish pictures by using daylight film with common fluorescent light and a reddish-yellow cast by using daylight film with incandescent light. This off-colored cast can be reduced by using an electronic flash or a corrective filter.

Read the instructions

Film instructions are too often dropped into the nearest trash can without so much as a glance. But if you'll take a few minutes to read them, you'll probably take better pictures.

The instructions will tell you the film's ISO rating. By setting the camera's ISO dial, you're telling the camera how sensitive the film is to light. Once you set the ISO on your camera, don't change it until you load it with another roll of film.

The row of sketches on the instruction sheet tells you approximate exposure settings for different conditions. If your camera doesn't have a built-in meter, cut out the diagram and tape it across the back of your camera. This helps you expose correctly and also reminds you what kind of film you are using.

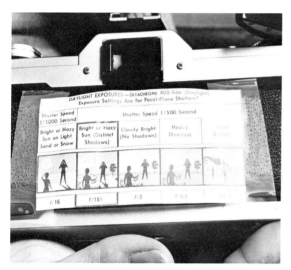

If your camera doesn't have a built-in light meter, tape the exposure guide from the instruction sheet on the back of your camera.

The instruction sheet also explains how to take flash shots and difficult or unusual scenes, such as a stage show. If you use the film under unusual light conditions, it will tell you which filter to use.

Finally, the instructions urge you to keep film out of hot places, especially the glove box or window of your car. Film is sensitive to heat

and light, and a few hours in the car can ruin your pictures.

Because film is sensitive to heat, don't buy out-of-date film. While the film may still be good after the expiration date, its quality may decline. Your time is more valuable than the few cents you may save on expired film.

For short-term storage, refrigerate unopened film in moisture-proof plastic bags. Keep it in the door of the refrigerator away from spills. Before using the film, let it sit at room temperature for at least three hours before opening the box.

Taking pictures

How to hold the camera

The quickest way to assure sharp, clear pictures is to hold your camera correctly. Practice with an unloaded camera and hold it as if you're taking a picture. If you feel unsteady, you're probably holding the camera wrong.

Often people hold the camera along the edges and stick their elbows out. They put their feet together, lock their knees, and hold their breath before jerking the camera lever. This moves the camera every time, causing a blurred picture or cutting off heads. No wonder leading processors say that 90 percent of the bad pictures they process are due to one problem alone — camera movement.

Steady your camera by becoming a human tripod. Use your left hand as the tripod base; hold the camera as if it had been dropped into your hand. Wrap your thumb and forefinger around the lens with the base of the camera resting on the palm of your left hand. Rest the base on the palm of your right hand if you're left-handed and it feels more comfortable.

Always support the camera in the palm of your left hand, with the thumb and index or middle finger on the focusing grip of the lens. This gives the camera firmer support.

To complete the tripod, move the camera up to your eye and let it rest on your cheekbone and nose. Operate the shutter release and the film advance with your right hand. This stance automatically pulls both elbows close to your body away from bumps. In this position, it's only natural to spread your feet apart and relax your legs.

If you want to take a vertical picture, turn the

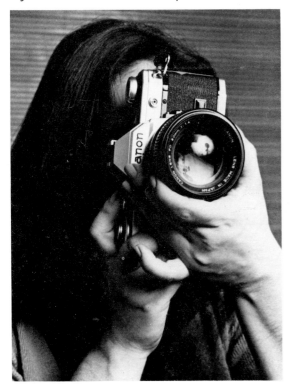

For vertical shots, turn the camera, with the camera lens resting in the palm of your left hand and your right elbow still against your side.

camera in your hand with the film advance lever down, not up. This keeps your elbows at your sides where they belong. Holding the camera in this manner allows you to support most of its weight on the palm of your left hand, leaving your other hand free to push the shutter release button and operate the film advance.

For extra support you can lean against a tree or a building. If you use a car for support, turn the engine off. You don't need the extra vibrations.

Frame your picture carefully in the viewfinder, and you are ready to shoot. Relax. Keep both eyes open when you look through the viewfinder.

Just before you snap the picture, take a breath and then let it out. Yes, let it out, don't hold it in. This is much more relaxing than trying to tighten your chest enough to keep the air in.

As you release the shutter, keep a firm grip on the camera body. Move only your index finger in a slow, squeezing motion. Have someone stand in front of your unloaded camera as you practice taking pictures to tell you if you are jerking the camera.

If camera movement blurs your pictures, try resting your chin on top of your left-hand palm. This might feel a little ridiculous at first, but you'll soon see how much steadier it makes your hands.

Adjusting the camera

Before you can take a picture with an adjustable camera, you have to adjust the size of the lens opening (the f-stop) and the amount of time the lens will be open (the shutter speed). These two settings regulate how much light hits the film. Most adjustable cameras have a built-in exposure meter with an indicator that you can see in the viewfinder. It tells you when the combination of these two settings is correct.

Usually photographers start by selecting a shutter speed. With a normal focal length lens, most photographers will start with a 1/125 shutter speed for photographing inanimate objects.

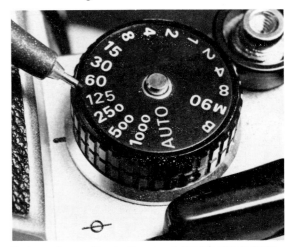

Each number on the shutter speed dial is twice as large as the number on one side and one-half as large as the number on the other side. These are fractions with the numerator (1/) left off. A 250 setting lets light pass through the lens twice as long as a 500 setting.

After setting the shutter speed, set the lens opening. The indicator in the viewfinder will tell you a number to set on your lens, or it will tell you when the setting is correct by matching two needles.

Shutter speeds and f-stops. If you look carefully at the shutter speed dial, you'll notice that each number is about twice as big as the number on one side and half as big as the number on the other side. Since these are fractions of a second with the numerator (1/) left off, it's easy to realize that a 250 setting lets light pass through the lens twice as long as a 500 setting and one-half as long as a 125 setting.

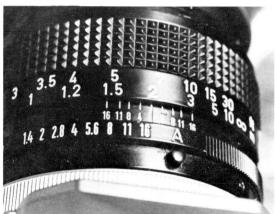

The lens-opening numbers follow the same principles as the shutter speed dial. The larger numbers let in less light and each opening is one-half as large as the one before it.

The same general principle applies to the numbers on the lens barrel. Think of these numbers of fractions with the 1/ left off. This will help you remember that f/16 is a much

smaller lens opening than f/1.4. The problem with thinking of them as fractions is in the math — f/11 doesn't seem to be twice the size of f/16, but it is. This is because the lens opening numbers refer to the diameter of the circular lens opening divided into the distance from the lens to film plane.

Rather than figuring the math, just remember that the lens opening ring is set up exactly like the shutter speed dial. An f/11 lens opening lets in twice as much light as an f/16 and one-half as much light as an f/8.

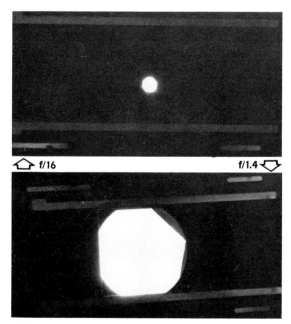

Think of the f-number as a fraction with the 1/ left off. This will help you remember that f/16 is a much smaller lens opening than f/1.14.

This makes changes in the camera setting very simple. Say you are taking pictures at 1/60 and f/8. Suddenly you need to change to a 1/250 to stop action. You have cut the length of time the light can pass through the lens in half two times or two stops. To get the same total exposure, you need to double the size of the lens opening two times, so you move the lens opening from an f/8 to an f/4.

Of course, you don't always have to use a fast shutter speed to show action. A slow shutter speed, causing a blur on part of your picture, is often much more effective.

EQUIVALENT LIGHT SETTINGS

Length of Time _____ ___ _ _ _

Shutter speed 1/30 1/60 1/125 1/250 1/500 1/1000

f/stop f/11 f/8 f/5.6 f/4 f/2.8 f/2

Size of opening

9 Photography

Depth of field. But what about lens openings? Are there other reasons to change them besides when you need to compensate for changing shutter speeds?

Let's think of an example that works in everyday life. If you see a child squinting to see the chalkboard, you would know the child is having trouble focusing and probably needs glasses. By squinting, the child is covering part of the pupil and thereby cutting down on the amount of light entering the eye, making more things appear to be in focus.

To put this in photographic terms, if you can make the camera "squint" by using a smaller lens opening, the area which is in sharp focus gets larger. Photographers say, "The depth of field increases."

If you are taking a picture of a man vaccinating an animal, you may want both the needle and the man's face to be in focus. That's no problem if both are about the same distance from your camera. More likely though, the needle is closer to the camera than his face is. Then you need sharpness not just at one distance but through a range of distance, from five to seven feet or more. You gain this depth of field by using a small lens opening, or f-stop.

Most cameras have a depth-of-field scale engraved on the lens barrel. This scale is a set of lens-opening numbers which appear on each side of the focusing mark. By looking at the f-stop number you have selected on both

sides of the scale, you can see the range of distance which will be in focus.

For example, say the man's face is seven feet away. By using a lens opening of f/16, you'll be able to focus on everything from five feet to about 12 feet, including the needle which may be at 5.5 feet.

On an f/16 setting, the depth of field guide tells you that everything between the two 16s (5 to 11 feet) will be in focus, so both the needle and the man's face are focused.

Your next picture may be of just the needle without emphasizing the man's face. To take this picture you use an f/4 or f/2.8 aperture. At this setting the depth of field is much smaller. If you focus on the needle at 5.5 feet, the face at seven feet will be outside this depth of field and out of focus.

With an f/4 lens opening, only the area very close to your point of focus will appear in focus. This means the man's face will be out of focus if you focus on the tip of the needle.

But as you look through your camera, you may not be able to see this depth of field, even after you've set the smallest lens opening. This is because your camera lens remains all the way open until the split second you take the picture.

Cameras with a depth-of-field preview button allow you to close the lens down to the preselected setting and permit you to check the focus on the man's face and the needle. Closing down (or stopping) the lens can make the viewing screen quite dark, so you do it only while you check the depth of field. Then, before taking the picture, open the lens to allow careful viewing of the scene.

Exposure

With an automatic camera it's easy to take exposure determination for granted and leave all the control up to the camera. Automation works fine for average subjects, but it can lead to poor pictures if the subject is extremely dark or light, or if the lighting is contrasty.

An exposure meter, whether built into the camera or handheld, is an instrument that interprets everything it's pointed at as a middle shade of gray. If you're photographing a green field with the sun overhead, following the meter reading will give the correct exposure because that scene approximately matches the middle shade of gray reflectance. But if you try to photograph a snow-covered landscape, following the meter will produce

an underexposed picture. The meter will still interpret the scene as the middle shade of gray, even though the snow scene reflects about two stops more light.

With light or dark subjects or contrasty lighting, try to base your meter reading on the area in which you want to record significant detail, rather than on the entire scene. You may have to make a close-up reading or a substitute reading off the palm of your hand to get the correct result. This is especially useful in extremely bright situations, such as a snow scene.

To make a substitute reading, just hold your hand with the palm facing your camera in approximately the same lighting conditions as your subject. Set your exposure for the light reflected from your palm, but then open your lens one f-stop more than that indicated by the meter because your palm is approximately one stop lighter than the middle shade of gray. (Since your thumb is pointing up, you can remember to always open up the lens one stop.)

For example, if your off-the-palm reading suggests using f/8, you should open the lens to f/5.6 before taking your picture. This technique takes longer to explain than it does to use in practice, but it's a very helpful technique for difficult exposure conditions.

Bracketing your exposure is another technique that professional photographers use when faced with unusual lighting conditions. Bracketing means shooting a series of pictures

at different exposures rather than making just a single exposure of your subject. Begin by making your first exposure at the setting recommended by your meter or best guess. Take a second picture, increasing the exposure by one stop, and a third, decreasing your exposure by one stop less than your first. This process gives you three chances of getting a correctly exposed picture instead of just one. For critical work with color transparency film, bracket in one-half f-stop increments rather than whole stops. This process requires you to use more film, but it's the best guarantee of getting a good photograph.

Automatic exposure control

There are two automatic systems — shutter priority and aperture priority. Shutter priority means the shutter speed is not important, so that is the control you set. The meter adjusts the lens opening for proper exposure at the shutter speed you've selected.

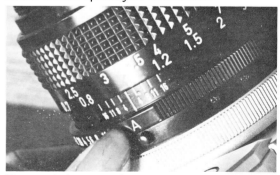

Shutter priority systems have the "A" symbol on the f-stop ring. You set the shutter speed, and the camera selects the f-stop needed to produce an average exposure.

The advantage of this system is that you can select the shutter speed you need to freeze or blur the action. The disadvantage is that the camera may select an f-stop that gives you either too much or too little depth of field for the composition you desire.

The aperture priority system works just the opposite. You select the f-stop or lens opening for the desired depth of field and the camera selects the shutter speed to give you the right exposure.

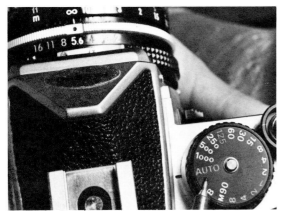

Aperture priority systems have the "Auto" on the shutter speed dial. You set the f-stop, and the camera selects the shutter speed.

The disadvantage is that the camera may drop your shutter speed below the speed at which you can successfully handhold the camera. It's difficult to hold the camera still below 1/60 of a second, with a short or normal lens.

Either the shutter priority system or the aperture priority system will give you properly exposed photographs. But you should be

aware of the settings the camera has selected. If you aren't, your automatic camera could give you properly exposed "blurs," or pictures with a distracting depth of field.

Some expensive automatic cameras select both the shutter speed and the lens opening. But even these cameras can't read your mind and don't know when you want to use an unusual setting to create a certain effect.

Estimating exposure. If you don't have a built-in light meter or a separate handheld exposure meter, use settings suggested on the film's instruction sheet. Tape them on your camera as a guide.

You can also try the "Sunshine Rule of 16." This rule of thumb works with any kind of film for outdoor shots. The rule is: When shooting under bright sunshine, simply set your f-stop or lens opening on f/16. Then adjust your shutter speed to the speed closest to the ISO of your film.

This means that with ISO 400 film, you would set your lens opening on f/16 and use a 500 (1/500 of a second, that is) shutter speed. With Ektachrome 64 film, again use an f/16 lens opening with a shutter speed of 60.

Creating pictures with impact

A photograph can be an exciting, dynamic visual statement or simply a dull record of what was happening when the shutter was released. The difference is usually not because of luck or the quality of the camera, but rather

within the creativity and motivation of the photographer. To make photographs that communicate effectively, the photographer must know how the picture is to be used and what is to be communicated. An attention-getting photograph for an exhibit, for example, may have very different requirements than a photograph accompanying a news story, yet both pictures could probably be made at the same location.

News photos. To illustrate a news article, keep the picture simple and get as close as possible to your subject. Avoid handshakes and shots of people holding trophies. If the photo is to report on someone receiving an award, take a picture of the recipient doing whatever he or she did to earn the award rather than a picture of the award ceremony.

The photographer taking this picture improved its impact by placing the student in front of the donor, in sharp focus.

Arrange news photos to include as few people as possible and select a camera angle that shows faces.

One solution is to move in close to catch the reflection of the winner's face in the plaque. You can read the plaque and see who won it at the same time.

Check with managing editors in advance about deadlines and the type of film they prefer. Some papers will use instant prints and others may agree to develop your film for you.

Displays and exhibits

Photographs are a good device for calling attention to exhibits and displays. The story should be evident at a glance, so select pictures that are simple and have dramatic compositions. Unusual camera angles, dramatic action, and extreme close-ups are sure eye-catchers. The larger the pictures, the better. Use nothing smaller than 8" x 10", and 11" x 14" or 16" x 20" is ideal. Both color and black-and-white prints can be effective, but black-and-white prints will usually show up better from a distance. Prints should have a matte finish so they are not shiny and reflective.

The extreme close-up, coupled with the out-of-focus viewer, conveys a complete story. The selective focus keeps the face from distracting from the grasshopper. The fingers holding the grasshopper help draw the viewer's eye to the picture.

Reports and records

Photographs often illustrate various points in a report better than words do. If the report isn't to be printed, use dry mounting tissue or other photo mounting adhesive to attach the print to the page. Avoid using photo-mount corners; they usually fall off with handling. Also avoid water-base glue which will cause the print to buckle.

Composition

When you pick up a camera and click the shutter, you will record an image on the film. Whether that image communicates or not depends on how you organize the subject through the viewfinder. We call this *organization composition*. While there are no hard and fast composition rules, these guidelines will usually improve your pictures.

Center of interest. When you look at a photograph, your eyes should immediately recognize one thing as the most important element of the picture. That element is called the center of interest. Remember that your eye will always gravitate toward the lightest area in the photograph. Try to compose your picture with the center of interest in a well-lighted area. Keep the picture simple; leave out all unnecessary details.

Faces almost always make strong centers of interest. You can strengthen the impact of a photograph in some cases by including enough surrounding area to allow for an off-center placement of your subject.

9 Photography

Rule of thirds. The best place for the center of interest is usually not exactly in the center of your picture. Try dividing the viewfinder into thirds using vertical and horizontal lines. Compose your pictures so the center of interest falls where two of these lines cross, and it will usually be more interesting to look at than if it were centered. Try to keep the horizon line in the upper or lower third of your picture and not through the center. Try to arrange your subject matter for balance. but not necessarily symmetry.

Mentally divide your viewfinder into thirds, both horizontally and vertically. Compose your picture so the center of interest lies where these lines intersect, rather than dead center. This will usually give your pictures a more dynamic and exciting look.

Depth. You can create a feeling of depth by composing a picture with an object closer to the camera than the center of interest. For instance, framing through tree branches or placing another object in the foreground adds depth to a landscape picture.

Foreground which surrounds the subject can have a framing effect.

Action. Keep people busy and they will appear more relaxed and natural. Avoid having your subject staring directly into the camera unless it's a formal portrait. A few interesting props give the subject something to work with and help create a natural feeling.

Keep people busy, but be sure you can see most of their faces.

Camera angle. An unusual camera angle or viewpoint can add a great deal of interest to an ordinary subject. A low camera angle suggests strength and drama. A high camera angle will make your subject look more submissive and gentle.

Foreground helps put the subject into context. By crouching in the wheat field, the photographer was able to get a low, strong angle of both the wheat and the farmer.

Background. Unless it definitely tells part of the story, keep the background plain. Avoid extremely light or dark backgrounds.

Timing. While timing is one of the most important techniques used by professionals, it is often overlooked by amateur photographers. Try to get your picture at the most dramatic moment, the one that symbolizes the event you're photographing. This is just as important when taking a picture of someone working as it is when photographing a sporting event. Train your instincts to respond to the most significant moment when you are taking pictures of someone. It often requires shooting several pictures rather than just one or two.

Leading lines. Lines draw the viewer's eye directly toward your center of interest and increase impact. Without them, pictures tend to be dull.

The impact of this scene is increased when the photographer adds creative leading lines.

Selective focus. Selective focus can make a big difference in the message your picture conveys. Changing the focus can change the message of the photograph by deliberately emphasizing one element and de-emphasizing another. Use of a soft focus for the background removes distracting elements, thus strengthening the composition.

A 3.5 lens opening knocks the house out of focus and emphasizes the pump.

Formal portraits. These pictures are often produced in a studio. If you have flash equipment, a simple setup involves a diffused electronic flash held above and left of the subject. The 100mm lens is ideal for this work. Also consider taking portraits outdoors on an overcast day. The clouds diffuse the light, creating shadowless illumination. Don't overlook the possibility of taking the subject in a natural setting. Natural light, such as light normally present in a room through a window or by a lamp, conveys a feeling of atmosphere that can personalize the subject.

If you have flash equipment, you can make a simple studio setup, with a diffused electronic flash held above and left of the subject.

Lighting the scene

The world is full of light sources for your photographs. You can use a campfire, a light bulb, the moon, a candle, reflect light from a white wall — the list is almost endless. Of course, the sun is about the most common source, and its quality changes almost hourly

— from the soft luminescence of pre-dawn to the hard brilliance of noon and the orange glow of sunset. The same scene shot at various times during the day can take on a completely different look.

High speed films make it possible to take indoor shots without using a flash. For the most natural look, try to arrange for side lighting, possibly from a nearby window or open door.

This low-light shot was taken with only the room and lamp light.

If you use daylight color film under artificial lights, you will get poor color rendition. This can sometimes be improved with the mixture of sunlight or light from a flash.

Camera setting for flash

When using an electronic flash, you no longer need fast shutter speeds to stop action. In fact, the duration of the flash is

shorter than the fastest shutter speed, which means the flash itself will stop almost any action regardless of the shutter speed set on the camera.

Most cameras indicate which shutter speed you should use by making the number (usually 1/60 or 1/125) a different color or marking with a symbol.

Most cameras indicate the proper shutter speed to use with a flash by the correct speed on the dial.

Many cameras have a hot shoe attachment in the top so you don't need to use a flash cord. Some cameras even automatically synchronize the camera when the flash is attached. Since the shutter speed remains constant, you must change the lens opening to adjust the exposure. Subjects near the flash receive plenty of light, so you can use a small lens opening. Subjects farther away from the flash receive less light. Therefore, the lens must be opened wider to take in enough light for a proper exposure.

To determine the correct lens opening, use the scale on the back of your flash unit. For

manual flash units, simply set the ISO on the flash and use the suggested lens opening.

Use the scale on the flash to determine the best f-stop. Set the ASA on the dial and use the f-stop across from the distance.

Many flash units have automatic exposure features which eliminate the need for continuous exposure adjustments. When the flash unit is set on automatic, its light-sensitive eye will measure the light reflected from the subject and control the duration of the flash.

A computerized automatic flash is great for taking fast-action pictures. The key is to set the flash and camera for the maximum distance you expect during the shooting session. From that point on, you need only to focus and shoot. The unit's electric eye will adjust the exposure according to the light reflected from the subject.

Another advantage of an automatic flash is that it allows you to choose from a range of f-stops to control depth of field. It also saves your battery because only the correct amount of light is used for the exposure, and no more.

Using flash outdoors

In bright sunlight a flash can reduce deep shadows and lighten the subject.

To figure the correct exposure, remember that you must use the shutter speed which synchronizes with the flash. Check the light meter reading for the lens opening at that shutter speed. Then adjust your distance from the subject until the lens opening agrees with the opening suggested by the scale on your flash.

Flash accessories

The most common placement of the electronic flash is on the camera's hot shoe which can carry the electric impulse directly to the flash without the use of a cord. While this placement is very convenient, it produces a picture that looks flat and un-natural.

In nature, subjects are rarely lit from the front but almost always from the top or the side. To make your subject look natural, try to light it from a side angle. Side lighting will also be more comfortable for your subject and will eliminate red eyes on your subjects.

You can purchase a bracket to hold your flash to the side and slightly above the camera. This requires a connecting cord from flash to camera but helps provide better lighting effects. You can also solve the problem of

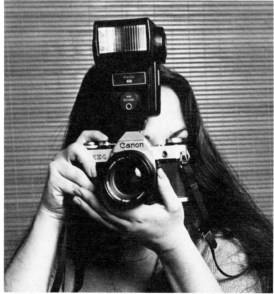

The hot shoe attachment is the most convenient place for the flash, but the picture often loses the soft gray tones needed.

harsh, unnatural shadows by using a diffuser, or by bouncing the light off a reflective surface.

A plastic diffuser fits over the flash's reflector to soften the light. Diffusers are available with various grid patterns for use with a normal, wide-angle, or telephoto lens.

You can make your own inexpensive diffuser by taping several layers of white tissue or matte acetate over the flash unit. A rule of thumb to figure your exposure for a manual flash unit is to open one-half f-stop per layer of tissue.

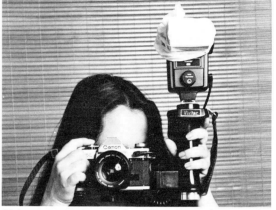

Make your own inexpensive diffuser by taping several layers of white tissue over the flash. Open the lens one-half f-stop per layer of tissue.

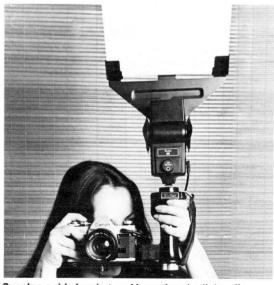

By using a side bracket and bouncing the light off a white card, you can keep the gray tones, making the picture more normal.

Another way to diffuse light is to bounce the flash off a nearby white or almost-white wall or ceiling. While there are formulas to figure the exact lens opening when you "bounce" the flash, in general, open your lens two f-stops to compensate for the decreased illumination.

Of course, the bouncing technique is much simpler if you have a computerized automatic flash unit.

Camera accessories

Protecting your camera

The first camera accessories you need are those which will protect your investment. These include protective filters, cleaning supplies, and protective bags.

Protective filters. Filters protect lenses from scratches, bumps and dents. Since lens paper can often scratch the lens, buy a filter with each lens so you rarely have to clean the lens. Instead, you will clean your protective filter when needed.

Protective filters can be purchased under various names, including haze, ultraviolet (UV), or skylight. These filters will also cut haze or ultraviolet light reflections.

Cleaning supplies. To get the most benefit from your camera system, you must always keep it clean. Carry a supply of lens tissue and fluid. Don't confuse this with eyeglass tissue which will scratch the lens. The silicone

material contained in eyeglass tissue will also ruin the anti-reflection coating on your lens. Carry a soft brush to wipe away dust and an ear syringe or a can of compressed air to blow dust from the internal parts of the camera.

The only paper you should ever use to clean your lens is the type designed for photographic lenses.

Protective bags. Inexpensive gadget bags will protect and organize your equipment. These spacious bags often have compartments for lenses, film, and accessories.

A photographer who travels extensively or who works in extremely dusty situations needs a good case, preferably foam-lined. While these cases are heavier and don't carry much equipment for their size, they are a valuable protective device.

Many photographers who plan to always carry a gadget bag or carrying case find they don't need to buy the tight-fitting leather camera cases.

Inexpensive gadget bags will protect your equipment and help you keep it organized.

Filters

Filters can be important when you are using black-and-white film. Even though colors such as red and green look quite different to your eye, they may appear as the same shade of gray in a black-and-white print.

To make the black-and-white print more natural looking, you can use filters to darken some colors and lighten others. Colored filters lighten colors similar to their own and darken colors that are complementary.

In black-and-white photography, a yellow filter will make yellow and orange appear lighter, while blue will appear darker. As a rule, the most useful filter for black-and-white photography is a yellowish-green filter which darkens a blue sky so that white clouds stand out.

A polarizing filter will help reduce unwanted glare and haze, darken blue skies to make the clouds stand out, reduce reflections in glass, and make the colors appear richer. This filter is valuable for both black-and-white and color photography.

When you are using color film, three filters will interest you.

■ No. 80B makes it possible to use daylight color film with photolamps 3400° Kelvin.

■ No. 80A gives correct color rendition when you are using daylight film with regular incandescent lights or tungsten lights.

When you are using tungsten-balanced film indoors with a flash or outdoors without a flash, use an 85B filter.

There are six common types of fluorescent light, and each requires different filter combinations for optimum results. For less critical work you can use an FLD filter and daylight film. If

you add an FLD filter, open your lens one stop. You may also use color compensating (CC) filters to correct color balance under fluorescent lighting. There are several kinds of fluorescent lighting, but cool white seems to be the most popular. When using daylight film under fluorescent lighting, a CC30 magenta gelatin filter will improve the color balance. This filter requires 2/3 stop more exposure.

There are various special effect filters you may wish to try. A starburst filter will create four-pointed stars on any bright point of light. A neutral density filter allows you to use high speed film in bright light. Also try a repeating or multiple-image filter-type lens.

FILTERS for BLACK-and-WHITE Photography

SUBJECT COLOR	FILTER TO LIGHTEN THIS COLOR	FILTER TO DARKEN THIS COLOR
Blue	Blue	Red, yellow, orange
Green	Yellow, green, orange	Red, blue
Yellow	Yellow, green, orange, red	Blue
Orange	Yellow, orange, red	Green, blue
Red	Red	Blue
Purple	Blue	Green

Common filter names based on Kodak Wratten designations: light yellow, 3 (K1); medium yellow, 8 (K2); light green, 11 (X1); dark green, 13 (X2); dark yellow or orange, 15 (G); red, 25 (A); blue, 47 (C5).

Lenses

Lenses are generally classified as normal, wide-angle, and telephoto. A normal lens has a focal length approximately equal to the diagonal of the negative. A 50mm lens for a 35mm negative is considered normal and for a 2¼" x 2¼" camera, 85mm is considered

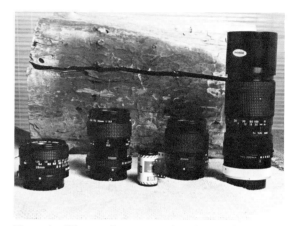

The main difference between various lenses of the same brand is the focal length — the effective distance between the lens and the film when the lens is focused. For most 35mm cameras, a 50mm lens is standard. Any lens with a focal length longer than this is called a telephoto lens and will bring the subject closer, while any shorter than 50mm is considered a wide-angle lens and will take in more of the scene.

normal. A normal lens has an angle of view of about 50 degrees, which is similar to the angle that the human eye sees sharply.

Lenses with a focal length shorter than the negative diagonal are considered wide-angle while the longer ones are usually called telephoto. The longer focal length lenses cover a smaller area and compress the apparent distance between the foreground and background. The shorter focal length lenses cover a wider area and tend to distort subjects near the camera. Wide-angle lenses distort less when held level. Low-angle and high-angle photography with wide-angle lenses can cause severe distortion.

As a general rule, the slowest shutter speed you can safely handhold equals the lens length. This means that for a 100mm lens, you should use a shutter no slower than 1/125 when handholding.

Zoom lenses are lenses with variable focal length, and they often appear to be the perfect compromise. But while these lenses may be fun to use, they are often too heavy and bulky to carry permanently on a camera.

Before you buy extra lenses, exploit your standard lens fully. Soon you'll know what type of pictures interest you most and you can buy a high quality lens for this purpose.

Lens selection. When selecting lenses, try to limit your choice to as few as possible. This will save money, extra weight, and indecision over which lens to use. Most experienced photographers settle on one or two favorite focal lengths for the majority of their work and reserve other focal lengths for special purposes. For photojournalism, a moderate wide-angle and a short telephoto lens are most useful. In a 35mm format, this would be a wide-angle of 35mm focal length and a telephoto of 100mm focal length.

The wide-angle lens is ideal for pictures of two or three people engaged in a common activity, and for pictures of scenery where you need extra depth of field. The telephoto lens is useful for portraits and close-up shots because it produces a more pleasing perspective than the normal lens. The shallower depth of field inherent in the telephoto lens makes it

possible to throw backgrounds out of focus, concentrating your viewers' attention on the main subject.

Once you have these lenses, you'll find that you use the normal lens so seldom that it hardly pays to own one. In fact, if you're purchasing a new camera, you would probably save money buying just the camera body with the moderate wide-angle and the telephoto and not buying the normal lens at all.

Tip: Use a lens shade on any lens that is not deeply recessed in the lens barrel. The shade prevents glare and protects the lens from bumps.

A superwide-angle (16mm or fisheye) takes in a very wide view of this brochemical lab, yet tends to distort everything near the edge of the picture and near the lens.

A midrange wide-angle (35mm) in a meat lab works well in tight quarters with little distortion.

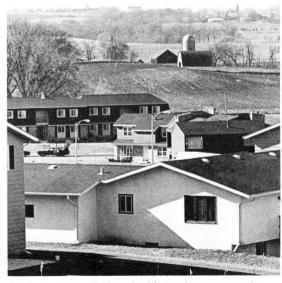

A telephoto lens (135mm in this case) compresses the scene, accentuating the closeness of the houses to the farmland.

Other Accessories

Extra batteries. Batteries in any camera are important, but they become critical when you're using a fully automatic camera. Many of these cameras depend on the battery to operate not only the exposure meter but also the lens opening and the shutter. A dead battery means no pictures.

Lights. You need these for copy work and indoor shooting. Clamp-on lights with reflectors are inexpensive and flexible. Copy stands offer even more versatility. Select lamps of the color temperature Kelvin that matches the film you will be using. (See section on close-ups.)

Tripods. These steadying devices permit the use of slow shutter speeds and small lens openings for greater depth of field. Tripods are also sometimes used for copy jobs. Select a sturdy tripod that's easy to set up and adjust. It should have a center post for quickly changing camera height and an easy-to-operate, positive-locking pan-tilt head. Metal tripods are generally more rigid and durable than those with plastic parts. Stability is the crucial feature here. You will often need a cable release to keep from moving the camera when you release the shutter. A monopod, or one-legged telescoping support, may also be used to steady a camera.

Autowinders and motor drives. These accessories are popular among sports and portrait photographers. They release the shutter, advance the film, and cock the camera.

Autowinders advance the film at the rate of one or two frames per second. Motor drives advance up to five frames per second and are heavier than autowinders.

Film holders and protectors. If you'll be using several rolls of film in one outing, film canisters on your camera strap will help you keep your hands and pockets free. They also protect against misplaced or damaged film.

A lead-shielded film bag is a good idea for photographers who frequently pass through airport X-ray checks.

Close-up photography

Nearly everyone who uses a camera can think of occasions when it would be important to take close-up photographs. Close-ups add greatly to the impact of a slide show and can be a valuable teaching tool as well. Close-up photography isn't difficult, but does require some additional equipment and practice.

Close-up devices

There are two techniques for adapting a single lens reflex camera (SLR) for close-up work. One is to add a supplementary (close-up) lens to the camera's existing lens. The other is to increase the distance between the lens and the film plane by using extension tubes or bellows.

Supplementary lenses. Supplementary lenses are the least expensive and most convenient solution. They attach directly to the front of the camera lens like a filter, converting its entire focusing range to shorter distances.

Supplementary lenses are really low-power magnifiers and are available in diopter strengths from +½ to +10. The higher the number, the closer you can focus. A +2 and a +4 supplementary lens are a very useful combination for a 35mm camera equipped with a 50mm normal lens. Supplementary lenses stronger than +5 are quite difficult to use and may reduce the sharpness of your picture. The areas you can photograph using various close-up lenses on a 50mm lens are shown as follows:

Supplementary (close-up lens)	Camera focusing scale set at infinity
+2	9" x 13½"
+3	6" x 9"
+4	4½" x 7"

Supplementary (close-up lens)	Camera focusing scale set at 24 inches
+2	4½" x 6½"
+3	3¼" x 5"
+4	2¾" x 4¼"

The advantages of supplementary lenses are:

■ They are small, light, and easy to carry in the field.

■ They require no exposure compensation.

- They can be combined to get even closer to the subject.
- They don't interfere with the automatic diaphragm function of SLR lenses.

Extension tubes and bellows. Extension devices can be used only on cameras having interchangeable lenses. They are inserted between the lens and camera to increase the lens-to-film distance. The greater the extension, the closer the camera will focus.

Extension tubes are rigid metal rings that can be used separately or in combination to achieve varying amounts of extension. When used with a 50mm lens, tubes are best suited to photographing subjects one-inch high or larger.

The advantages of extension tubes are:

- They are less expensive than bellows.

- They are fairly compact and rugged, making their use in the field feasible.

- The more expensive units retain the automatic diaphragm operation of the lens.

Extension bellows consist of an accordion-pleated cloth tube mounted on a geared track. With a 50mm lens, bellows work best for subjects one-inch high or smaller. They are larger and heavier than other devices but allow more flexibility for small objects.

Advantages of extension bellows:

- They are faster to adjust than extension tubes.

- The amount of adjustment is infinitely variable.

- Bellows permit greater image magnification than extension tubes or supplementary lenses.

Because extension devices increase the lens-to-film distance, the light intensity reaching the film decreases. To compensate, you must increase the exposure in proportion to the amount of extension used. Directions for calculating this exposure factor are supplied with the instructions for these devices. If your camera is equipped with a through-the-lens light meter, the meter will automatically compensate for the exposure factor.

Close-up techniques

Camera steadiness becomes more important in close-up work as any camera movement is magnified as much as the image is. A good sturdy tripod is recommended when it can be used. Unfortunately, most tripods can't be set low enough for many natural subjects. A bean bag, boat cushion, or rolled-up jacket can be a low-angle camera support. A cable release is also recommended.

Lighting is often a problem in the field as many subjects are in the shade or in partial sunlight. A small electronic flash unit is a very handy accessory to supplement natural light. A few tests in close-up situations will help you determine the correct close-up exposure with flash. The short duration light output of the flash will also serve to freeze rapidly moving objects as well.

A reflector made of white posterboard or aluminum foil is very useful for lightening shadows. Place the reflector as close as possible to the shaded side of the subject without getting it into the picture area. A reflector can also be used with a flash to lighten the harsh shadows created by direct flash.

Backgrounds can be a problem when the subject blends into the background so well that it becomes indistinct or when out-of-focus light areas distract from the subject. Artificial backgrounds can be made from cardboard or cloth. Natural colors, such as brown and green, tend to complement most natural subjects. Bright colors will give the photograph a studio appearance and may conflict with the colors in the subject. Keep the background distant enough to become slightly out of focus and free of shadows. Make sure the background is large enough to cover the entire picture area.

Document copying

Effective lecture slides can often be produced by photographing existing illustrations and graphics from textbooks, magazines, or other existing sources. However, beware of copyright violations.

A 35mm camera equipped with a close focusing device is ideal for this purpose. Document copying is easiest if you mount the camera on a copystand. This is simply a vertical pole with a mounting plate for the camera. The height is adjustable, and the camera always stays parallel to the base. A photoflood light mounted on each side approximately 45 degrees above the base will provide glare-free illumination.

Because good copystands are expensive, you may decide to build one. Plans to build a wooden model that works very well can be obtained from Eastman Kodak Company. Write to Eastman Kodak Company, Motion Picture and Audiovisual Markets Division, Rochester, New York 14650, and ask for Pamphlet No. T-43, "A Simple Wooden Copying Stand for Making Title Slides and Filmstrips."

You can also use a tripod for copying, but tripods are awkward to use with the camera pointed straight down, and the legs often cast shadows on the material being photographed.

A sheet of ¼" plate glass is helpful to flatten documents that may be wrinkled or to hold magazine pages flat. Just place the glass over the document and shoot through it. To keep your camera from reflecting in the glass, mask the camera with a piece of black cardboard. Cut a hole in it for the camera lens and hold directly beneath the camera when you're making the exposure.

When copying material that's very light in tone, such as printed data on a white background, your camera's meter will read the white background as gray, and your slides will be underexposed.

Make substitute readings off the palm of your hand or off a gray card rather than directly off the document.

WARNING: Most printed material is copyrighted and therefore illegal to reproduce.

■ The slide tape medium defined

Slide and slide-tape presentations will always have a place in education, public information work, and technical communication. "Playback" hardware is reliable and easy to use. It's also widely available. Production tools and services are fairly cheap. Almost anyone can get the resources to create a slide show.

At their best, slide shows combine words and images to get your message across to your audience quickly and effectively. They offer image size and clarity (resolution) unmatched by any presentation medium, bar none. At their worst, slide shows are boring, amateurish, uninformative, and insulting to the intelligence of the audience.

This chapter can help you take advantage of the strengths of the slide show medium and avoid the pitfalls. The skills and resources you will need are minimal. If you can write an effective business letter you can probably learn to write a serviceable script. If you can focus a camera and set the proper exposure, your picture-taking ability is adequate. You'll certainly need a 35mm camera and a typewriter or word processor. You'll need access to a cassette recorder-playback unit with a "sync" pulse capability. Nice-to-have items include a light table, access to a sound recording studio and desktop computer graphics software.

Slide show production is not a step-by-step, "cookbook" project. It's a process. Decisions you make at each step along the way, particu-larly in planning, affect what you need to do at every other step. An obvious example is that a change in the narrative will probably imply a change in visualization. You'll get the best presentation possible if you keep the whole project in mind as you work. At the same time, you can only proceed by breaking the process apart into discrete "do-able" units.

You can see that technical or "creative" work is just part of the process. As much as half the work on a slide show is non-technical. Don't be misled by the implied time order in the outline. You're likely to finish the tasks in roughly the order shown, but you'll actually work on many of them at the same time.

Production does come last, however. You can waste a lot of time and money by shooting slides and ordering artwork before you finish planning and writing. As the old and very wise saying goes, "You may never have time to do things right, but you always find time to do things over." Finally, notice that most of this outline could be part of the planning process in just about any communication or education project. Media selection is a decision you make, not the place you start.

By now you've probably decided that this approach to slide-tape production makes it more complicated and more difficult. Think of each step in the process as an opportunity to

Steps in the "process approach" to slide-tape production

A. Initial planning
 1. Identify the communication "opportunity"
 2. Audience analysis
 3. Statement of objectives

B. Media selection

C. Content development
 1. Message strategy or *treatment*
 2. Assembly of information
 3. Organization of information
 4. Script development and visualization
 5. Review and revision

D. Production
 1. Deadlines
 2. Budgets
 3. Photography
 4. Graphic design
 5. Assembly of slides
 6. Narration and sound-mixing
 7. Pulsing of the finished product

make your production better. You can capitalize on those opportunities or you can squander them. Clearly, this is a balancing act. The amount of time and effort you invest in planning should match the scope of your project. You need not make a life's work out of a simple slide show. You will improve your results if you use the process approach.

The slide-tape medium defined

Let's take a minute to agree on the definition of the term "slide-tape presentation." A standard slide-tape show is an eight-to-12-minute production with a "sync pulsed" soundtrack and 80 slides. Of course, some narrow topics, or audiences with shorter attention spans, require fewer slides.

Why 12 minutes as a maximum length? Primarily because a longer show will drag if you only have 80 slides. Why 80 slides? Because that's how many fit in a carousel tray.

Since slide-tape is a visual medium, you want to include as many images as possible. Carousel slide trays do come in a 140-slide version, but they aren't good for synchronized presentations. The slots that hold the slides are very narrow. This can cause the slides to stick. Thus, 80 is the magic number of slides.

In a 12-minute show there are 641 seconds of "screen time." (The screen is black for one second at each slide advance. With 80 slides you have 79 changes and 79 seconds of

darkness in your show.) That gives you an average viewing time per slide of just over eight seconds. If your script and visualization work well together, that will be about the right amount of time. If you can't squeeze the information you need to cover into 12 minutes or less, you have one of two problems. Slide tape isn't an appropriate medium for your message or you need to produce more than one presentation.

Most shows have 55 to 70 photographic images and 10 to 25 graphics. Graphics have three important uses. They organize the content. They add emphasis to key points. And, they help explain difficult concepts. If you're using almost all graphics, you probably need a publication rather than a slide show, particularly if most of the graphics are "word slides." This means that your topic isn't visual or you don't have the resources to get the images you really need. Either way, you and your audience will be better off with a simple fact sheet. If you have few or no graphics, you're leaving out a powerful technique that can strengthen your presentation.

All the slides will be horizontal. That is, the long axis will be parallel to the floor and ceiling. If your show has a mixture of horizontal and vertical slides, it can distract or confuse your audience. No "amateur mistake" does more to detract from a presentation.

Here's why. Most screens have a horizontal format fairly close to the 3-unit-by-2-unit

"aspect ratio" of 35mm slides. Even with a square screen, you normally set up your projector so that horizontal images are as high and large as possible. That gives folks in the back of the room a chance to see what your show is all about. As a result, portions of the vertical images bleed across the ceiling and miss the bottom of the screen. You actually lose up to one-third of your image. If you have graphics in the "missing" part of the slide, the audience doesn't get all the information you want them to have.

An obvious solution to the problem would be to set up the projector so that vertical images fall completely on the screen. Unfortunately, as you will see on the next page, that can result in more than a 50 percent loss in image size.

Say you're projecting horizontal slides on a horizontal screen that's six feet wide and four feet high. The image area is 24 square feet. Now suppose you change your projector so that vertical images just fit the top and bottom of your screen. The long axis of your image is only four feet and the short axis drops to 2.67 feet. Image area is only 10.67 square feet. That's exactly 44 percent of what you had with all horizontal slides. It's as though you more than doubled the distance from your audience to the screen.

Finally, the show will have a well-narrated soundtrack that drives the slides with "sync" pulses. If you don't have a sound-track, you're developing a speaker support package.

Initial planning

If your goal is just to have a slide show, you shouldn't read this section. You can throw together a few slides from your files and record a "hip shot" narration on your cassette recorder. You'll be done in a few hours. Of course, your audience is likely to give the persentation the same kind of attention you did. But you will have achieved your goal.

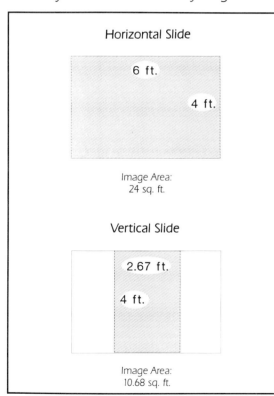

Horizontal Slide

6 ft.

4 ft.

Image Area:
24 sq. ft.

Vertical Slide

2.67 ft.

4 ft.

Image Area:
10.68 sq. ft.

Comparison of projected image size with horizontal and vertical slides.

The information here is for the person whose goal is to make and deliver a message that addresses a real communication problem. That takes good planning and a clear, unambiguous statement of what you're doing and why. If you're serious about your slide show project, you'll have hundreds of decisions to make as you work. Without a useful plan, you will have little to guide you in those decisions.

Identify the communication "opportunity"

The world is full of problems. But a problem isn't a communication opportunity unless delivery of some kind of message will help solve it. And, it isn't a communication opportunity for you unless you can create and deliver that message.

The fact that some crops traditionally grown by American farmers are no longer profitable is a problem. Assuming that farmers know what the prices are, it may not be a communication opportunity. However, the fact that some farmers continue to lose money producing these crops probably is. Information about enterprise management would enable them to make better business decisions.

Keep in mind, though, that lack of information isn't the cause of every problem people have. Most smokers have plenty of facts about the health effects of their habit. Information isn't the basis for their behavior. If you are strictly an information provider, this problem may not be a communication opportunity for you.

Audience analysis

You can already see how one step in the "process" approach loops back, or ahead, to another. You couldn't have identified a communication opportunity without having some idea of who the audience would be. And, more detailed audience analysis will probably change some of your ideas about the communication opportunity.

Boiled down, audience analysis simply means to gather the information you need to answer three questions:

- Who are they?
- Why do they care about what you have to say?
- What's the best way to deliver your message?

In fact, the "Who Cares?" and "So What?" tests will help you throughout the planning and production process. They will guide your efforts better than a production "cookbook" ever could.

You don't need to conduct a year's research on your audience before you start your project. (Although if you were planning a communication campaign with a budget in the millions you might do just that.) You should assemble readily available information about your audience and look for clues on how to proceed in a sensible manner. You need to be able to look at what you're doing from your audience's point of view. You can't do that unless you understand who they are.

Statement of objectives

Most people would agree that a clear statement of objectives is necessary when several people work together on a communication project. A typical project group often includes a writer-producer, photographer, graphic designer, sound technician, and one or more subject-matter experts. Coordinating all their activities is difficult at best. Without common understanding of the objectives of the project, it would be impossible.

If you're developing a slide show on your own, however, it's tempting to skip over this step in the process. After all, you "know" what your purpose is or you wouldn't be doing the work. Why should you bother writing your objectives down? Here are three good reasons.

First, you can't succeed in anything unless you define success before you start. You need some description of the outcome you hope for from your project and a basis for measuring that outcome. You'll seldom do a follow-up evaluation on a simple slide show. But, you'll produce a better presentation if you think about how you *would* evaluate it if you had the chance.

Second, if you *can't* write a clear, concise statement of objectives, you probably aren't ready to begin your project. You don't have any basis for deciding what information to cover and how to present it. You need to do more thinking before you start working.

Third, a good statement of objectives will help keep you on target as you work. When script writers get bogged down, it's often because they have drifted away from their stated objectives. Material that doesn't relate to the purpose of a script is naturally more difficult to work in.

The statement of objectives doesn't have to be complicated and it shouldn't be long. Two or three sentences should do. Avoid a lot of jargon or technical terminology. Just prepare a clear statement of what you hope your audience will do with the information you present to them through your slide show. Notice that you do not describe the *effect* the slide show will have on the audience.

Media selection

As mentioned earlier, media selection is a decision you make in the communication planning process, not the place you start. Several factors that are usually considered are listed on the following page.

Perhaps you're surprised that the list doesn't include anything like "media effectiveness" or "communication effectiveness." That's because no medium is inherently superior overall. The impact associated with "high production value" media such as film and television is usually the result of superior planning and project design, not a quality of the media themselves. That's good news for you because you don't need a large budget to plan your work.

Aspects of audience analysis

Demographics: Age, sex, socio-economic status, education, ethnic and religious categories, family status.

Attitude "clusters": Some attitudes and beliefs seem to go together. Would you describe your audience as "health food save the whales anti-nuke?" Maybe they're "gun owner death penalty pro-military."

Relevant behaviors: To the extent that your objective is to shape or initiate behavior, what do members of your audience do now and why?

Communication Issues: Where do members of your audience usually go for information on your topic? Do they seek, information on the topic at all? Are they more likely to avoid information on the topic?

Topic knowledge: What do they already know, or think they know? Are you providing new information or correcting misinformation?

Topic attitude: Will your audience have a positive attitude to what you have to say? Will they be negative? Will they be indifferent?

Motivations: What motivation does your audience have to be exposed to your message? What motivation do they have to remember and use the information you provide?

Setting: Where will your audience be and what will they be doing when they receive your information?

Since this chapter's topic is planning and production of slide-tape shows, it doesn't go into a lot of detail on general media selection. It will discuss some strengths and weaknesses of the slide-tape medium you should keep in mind. It also mentions some communication problems or objectives that might lead you to choose another medium.

Slide-tape has some real advantages. Shows are cheap to produce, revise, and duplicate. Equipment is relatively cheap, widely available, easy to use, and reliable. Slide-tape is a good way to have the same information presented the same way to numerous audiences at different places or times. There's nothing better than slides for getting visual information across to a large audience.

Slide-tape's biggest limitation is that it's a linear medium. Words and images are presented one-by-one in a fixed sequence. You have to put the material together in a way

Media selection criteria

1. Content and objectives
2. Audience and setting
3. Technical and administrative factors
 a. cost
 b. production and delivery support
 c. portability
4. Your preferences

that's logical for your audience or they can't use it. There's usually no way to go back over a specific point your audience misses or doesn't understand. All you can do is show the whole thing again.

Slide-tape also puts your audience in a passive receiving mode. They sit in the dark to watch and listen. This is not a good learning situation, particularly for adults. Adults like to ask questions when they come to mind. They want clarification of key points before going on to new topics. They like to give their own opinions. They like to see how their peers respond to new information as they make their own evaluation. Slide-tape is weak on all these points.

Another drawback with a slide show is the limited amount of information you can present. A good rate of speech for a narration is about 150 words per minute. For a 12-minute slide show, you're limited to 1800 words. You get about 250 words on a standard, double-spaced typed page. So, a slide show can present the equivalent of about seven pages of written information. If your topic is very visual, that should be enough. The pictures will carry a good part of the message. As was stated earlier, if your topic isn't visual, slide-tape isn't the medium for you.

Some communication objectives make slide-tape a poor choice. For many communicators, the objective is simply to put a body of information in mediated form so other people can access it. They can't answer

all the audience analysis questions posed earlier. They don't know whether the audience needs all the information or only a part of it. The chapter you're reading right now is a good example of this situation. And the print medium is better for this than a slide-tape show.

Finally, slide-tape would be second choice when "real time" presentation of action sequences or processes is required. In this situation, video or film would be preferable if you can afford them.

Content development

The initial planning steps discussed in previous sections help you decide *what* you want to accomplish with your slide show. In the content development phase of the project you'll decide exactly *how* to go about it. This section will deal with message strategy, assembly and organization of information, and script writing.

Message strategy or "treatment"

You probably don't want to hear that there's still another planning statement to write before you actually "get to work" on your slide show. If you've done the other planning steps, you already have an implicit notion of how you'll proceed and why. Write it down before you go on. This will give you a chance to see if your ideas are as logical on paper as they seem in your head.

The treatment describes the approach you'll take in getting your message across to your audience. It should address the type of mood you want to set, the basic audience interests to which the show will appeal, and the use of any special audio or visual effects. If your audience doesn't care much about your topic one way or the other, you might need a fairly slick, entertaining show to hold their interest. If the audience is highly motivated to get the information you offer, a competent, businesslike presentation will probably do the job. The treatment will also give a tentative idea of how much time and how many slides you'll devote to major sections of the show.

As you think about message strategy, you'll consider four important factors:

■ The nature of the information or message you want to present.

■ The objective for your presentation.

■ Specific considerations of what your audience already knows and believes about your topic.

■ General ideas about how people learn from media.

There are three types of new information you might present to an audience. These are *something more, something else,* and *something different.* Each category has its own implications for communication strategy.

The first category refers to information that simply builds on knowledge your audience already has. An example of this might be an avid fisherman reading a magazine article about how to use a certain type of lure. In this situation, we assume that readers understand what the information is for and that they are motivated to use it. The presentation can be very straightforward.

By the way, you should take care to interpret viewer motivation carefully. Many communicators regard television or video as a powerful information delivery medium because audiences spend so much time watching. They forget that most people enjoy TV viewing as an activity, not necessarily to obtain information. In the case just mentioned, the reader may be avidly interested in fishing, but he may enjoy it vicariously with little opportunity or intention of actually getting in a boat. If the goal is selling magazines, that fine. If it's selling lures, you have a problem.

The second category, *something else,* refers to topics about which an audience has little prior information. It's unlikely that the audience would have strong opinions about the topic one way or another. It's also unlikely that the audience would have much interest. A slide show describing the Extension Service to urban community leaders might fall into this category. In this case, the strategy would be to describe extension programs in terms of issues the audience *does* care about. Examples might be water conservation, in-home horticul-

Sample treatment

Knowledge at Work for Florida's Future
Celebrating the 75th Anniversary of Extension

Opening says that extension has been helping people help themselves for 75 years. First visuals show programs most people would know...traditional agriculture, 4-H, and home economics work.

Use historical black-and-white photos to show how extension contributed to Florida's development over the decades. However, keep to a minimum (only 4 or 5 shots) and have them bring audience forward in time to present. Recognize that people will care more about what we offer now and for the future than about what we did in the past.

Bulk of presentation will feature specific extension programs related to the eight national extension initiatives. Don't talk

about this work in the abstract. Show how real people are benefiting from real extension activity focused on real problems.

Be sure to show full range of programs and to include examples from all parts of the state.

Close with visual contrasts between past and present. Narrative will draw parallels between social and economic challenges of the future and our achievements of the past. Leave audience with the impressions that extension will offer as much in the future as it has in the past.

■ **Content development**

ture or 4-H activities that prevent school drop-out.

The last category, *something different,* is the biggest challenge for a communicator. The new information may contradict knowledge or beliefs the audience already holds. Even worse, it may imply that members of the audience should change their behavior in some way. Research on persuasion and attitudes suggests that people have strong "ego defensive" motivation to avoid this kind of information. Without being aware of it, they selectively ignore, forget, or distort messages that are inconsistent with what they already know or believe.

Fortunately, from a communicator's point of view, very few people achieve complete internal consistency. Eating habits, for example, don't always match attitudes on diet and health. So, ads for low-cholesterol foods stress health benefits while ads for fast-food hamburgers stress taste and convenience. The idea is to "position" your message in terms of audience interests and attitudes.

Finally, if your goal is to induce some type of actual behavior by your audience, think about using "models." For example, don't simply tell people to use chemicals carefully. Instead, show someone the audience can identify with in a situation they're likely to encounter themselves. In addition to communicating the objective information about safe chemical use, you can allow the audience to see for themselves that the proper methods are easy and effective.

Assembly of information

At this point, the steps in the process loop back and forth. In fact, if you're making your own slide show you may see assembly and organization of information as part of the same task, not two different steps. A professional script writer dealing with a topic on which he or she has little personal knowledge will obviously have to do some research. However, it is assumed that if you're producing your own show you already have some information you want to get across to an audience.

Even in this situation, though, there are two good reasons to think specifically about information assembly before you go on. First, there may be information "gaps" between what your audience knows and what you want to tell them. Suppose you're doing a presentation for home gardeners on understanding fertilizer labels. Does your audience already know what nutrients their landscape plants need? If they don't, it would be helpful for you to tell them before you get to the main content of your show.

Second, you probably have more information on the topic than your audience needs, or can digest, in a slide show. Your statement of objectives and audience analysis will guide you in deciding what information to include. As already mentioned, if your objective is to tell the audience everything you know, some form of print media would probably do a better job.

Organization of information

With a linear medium you have to work harder to organize your information logically. With a bulletin or pamphlet, the audience can skip over the parts they aren't interested in and re-read the confusing parts. A slide presentation is a different story. If your show is poorly organized, it's a waste of everyone's time.

For most people, though, the standard outline style is fine to show the structure of information that's *already organized* but almost useless as a tool for *organizing it in the first place.* Fortunately, there is a better way. A technique called the "bubble outline" makes organizing the information for your slide show as easy and painless as possible.

Let's see how it works with material from a hands-on slide-tape workshop. The assignment is for workshop participants to write and produce a slide show for 4-H youngsters on how to carve a jack-o'-lantern. This topic was chosen because it's visual and easy. Dealing with content doesn't get in the way of learning production techniques. The information organization phase began with some leading questions that help participants identify two or three vital main ideas. A typical response might be these: To make a jack-o'-lantern you have to get the pumpkin, carve the face, and display the finished product.

Other ideas are then written down. Don't worry about major headings, minor headings, presentation order, or any of the things that make conventional outlining so difficult. It doesn't even matter if related items are close together on the page. Just try to get all the important ideas down on paper.

Finally, connect the bubbles. First connect sub-topics to main topics. Then devise a linear flow of main topics from beginning to end.

Now you have a working outline for your show. You can begin script writing. This outlining technique is recommended because

it makes a complicated problem easy. You may prefer some other approach. Regardless of how you go about it, you'll get the best possible script if you begin with a logical organization of the information you want to present.

Step 1

Step 2

Step 3

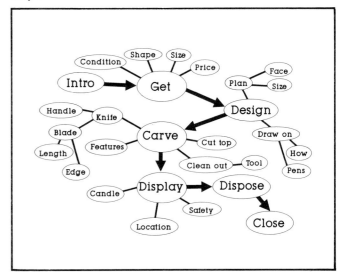

Organization of information needed for carving a jack-o'-lantern using the "bubble outline" method.

Script development and visualization

Now to confront one of the enduring "chicken or egg" questions. Which comes first, the words or the images? As the heading for this section suggests, you have to work on both at the same time.

If your subject is something like visible symptoms of plant disease or classical Greek architecture, there are probably some things you'll need to *show* the audience. If your subject is financial planning for small farms and businesses, there are some things you'll have to *tell* them. Keep in mind, though, that the script is only the written "blueprint" for an audio-visual experience you will bring to your audience. They will hear words and see images simultaneously. Therefore, you have to consider what the audience is seeing *and* hearing throughout script development.

You may be familiar with pre-printed "storyboard" pads like the one on this page. These are intended to help with slide show scripting. The idea is to sketch or describe the image you want in the visual "field" and then write the corresponding copy in the box below. You can do the same thing with simple note cards. Once you have all the words and images linked together, you can shift the cards or boxes around to get them in a logical sequence. This method leads the writer to deal with small units of the script in isolation from each other and then try to combine them all.

The script format shown on the following page is often recommended. This format helps you think visually and verbally at the same time. And, since the narrative portion of the script is continuous, you're less likely to lose context as you write. Suppose you write a half page of copy with no change in visuals. Either you're going into more detail than is good in a slide show or you need

more slides to go with the copy. What if you have several slide changes and only a line or so of copy? If the images can carry the story alone you're in good shape. If not, you need more narrative to help out.

As you plan the visualization for your slide show, think in terms of three different functions images perform.

Pre-printed "storyboard" pad.

Covering visuals are used when there really isn't much of a visual aspect to what the narrative says. You might have a photograph "looking down" a busy highway as the copy talks about progress and forward movement. A tiny seedling might symbolize new beginnings. Naturally, since this is a visual medium, you want a minimum of non-visual narrative in your script.

Illustrative visuals complement the narrative by showing a visual example of the subject. If you're talking about the importance of fresh water you show a lake or river. It doesn't have to be any particular body of water. The primary information is still carried by the script.

Literal visuals are graphics or photographic slides that show specifically what the narrative is talking about. These visuals actually convey critical information. Most often, literal visuals show steps in a physical process. Suppose your presentation is on pruning tomato plants. You want a script that describes the steps and slides that show *exactly* what to do. The same is true for diagrammatic art or word slides that support the narrative. Words and pictures should relate specifically.

The term "see-hear compatibility" describes the extent to which narrative and images "fit together." If your presentation has literal visuals that don't coincide properly with corresponding text, the audience has two problems. First, they must try to make sense of a basically nonsensical situation. Then, when they realize that words and picture do not relate, they must decide where to focus attention. At best, this is distracting. At worst, it's confusing.

As you write, plan visualization that serves the function of the script at each point. Don't leave literal visuals on the screen after the narrative moves on to another topic. If you have to compromise and use illustrative or covering visuals where you would prefer literal visuals, write the script to help the audience understand what they're seeing.

This script format helps you think visually and verbally at the same time.

Content development

The following are some general guidelines for planning visuals that will support your narrative effectively:

- Cover only one main idea per visual. If you need to make numerous points about something, use numerous pictures of it.
- Plan visualization to move from the general to the specific, from the overall view to the close-up. A close-up can be disorienting without a wider shot to establish frame of reference. The audience will be impatient with a wide shot if the narrative goes on to address a particular aspect of the overall scene.
- As a rule, prefer actual photographic slides of people rather than artwork, particularly cartoons. People are interested in other people and what they do. People use others they identify with as models for decisions and behavior. Some cartoons come across as condescending or frivolous to adults.
- On the other hand, to illustrate complex physical processes or operating principles of machines, prefer simplified artwork to actual photographs. This will enable you to leave out distracting detail and help the audience grasp the real point of your presentation.
- With diagrams of any complexity and "bullet list" word slides, plan progressive disclosures or "builds." This will give the impression that the visual is changing even if it really isn't. It will also help focus audience attention on a particular portion of a graphic.
- Use, but don't overdo, "specialty" slides. The best way to show contrast or comparison is with a split-image slide showing both "conditions" on screen at the same time. A good way to convey variety or range of examples is with three-or four-way composite slides. An effective technique for emphasizing specific points is the use of "key word" text superimposed over photographic images. Cost for specialty slide production is significant but within reach for some do-it-yourself productions. Local, professional-quality photo labs will be fastest, but most are expensive. Mail order photo services will be less expensive and take a little longer.

And remember, just because visual ideas have been discussed first, doesn't mean that visualization comes before writing the narrative. Think about images and words at the same time. Now, on to writing.

A script is different from any other document you'll ever write. That's because, with the exception of a few people who review and critique your work, *no one will ever read your script.* Your audience will sit in the dark and have your words read to them one by one. That's why successful scripts are marked by two essential characteristics. Their *structure* helps the audience follow the presentation without getting distracted or confused. And, their *wording* is geared to the way we make sense out of what we hear, rather than what we read.

The structure of the script includes the introduction, the body, and a closing. The introduction may be a literal description of what is to follow. It can also be an establishing passage that paves the way for the body of the presentation more subtly. In any case, the introduction tries to get the audience in the right frame of mind for the rest of the show. It lets them decide, consciously or unconsciously, whether to pay attention or not. It also gives them a basis for "processing" the information in terms of their own interests. This is an important aid to recall.

The body of the script has two elements: information and transitions. Obviously, the purpose of the script is to present information according to the outline you developed earlier. Transitions between major sub-headings can be just as important as the information itself. They let the audience know that the presentation is leaving one topic and moving on to another. This helps audience members organize the information in their minds. This is another aid to recall.

The script concludes with a closing tailored to the purpose of the presentation. If the show is primarily informational, the closing would include a summary "review" to remind the audience of the key points. If the show is primarily persuasive, the closing would call for

specific action or restate and support the attitude or position being advocated.

Learning theory suggests that the brain "remembers" all the information that's ever processed through the body's sensory systems. Whether people can recall and use what their brains have stored is another matter. Some messages are more effective than others because they capitalize on an "information processing" model of learning.

The learning model predicts that this message structure will increase audience members' ability to recall and use information when they need it. That's why it's used in so many forms of communication. English teachers preach that every composition needs a beginning, a middle, and an ending. An army sergeant years ago explained military instruction to this author as, "Tell 'em what you're gonna tell 'em. Tell 'em. And tell 'em what you told 'em." Even civilian lesson plans call for summary introductions and conclusions. In a class on advertising writing, the professor always demanded that students, "Put a benefit in the headline." Every good sales presentation ends with a "closer." The salesman tells the prospect exactly what he or she should do next to buy the product. The point is that you probably already know the principles of message structure. Just apply them to your slide show and you'll be successful.

Most general writing guidelines, such as those offered in this handbook, can also help you improve your script writing. However, a script is a specialized document and some aspects of word choice and sentence structure are different. A "trick of the trade" you might find useful is to read the copy aloud as you write. That will give you a feeling for how the script will "sound" as opposed to how it would "read."

As you would expect, there also some general rules that script writers follow. Here are a few "*dos*" and "*don'ts*" illustrated with examples from the pumpkin carving exercise mentioned earlier:

Write "talk." Obviously, you have to go with technical accuracy over simplicity. Your narration will be easier to understand, though, if it sounds more like talking than writing.

NO: Regardless of the size or shape one is seeking, one should be certain to select a specimen that is in satisfactory condition.

YES: Regardless of the size or shape you're looking for, be sure to pick a pumpkin that's in good condition.

Avoid jargon or technical terms. To the extent you have technical information to communicate, you'll have to use technical terms. Keep them to a minimum and, if possible, define them when you first use them.

NO: Pumpkins are botanically classified as cucurbits.

YES: Pumpkins belong to a plant family known as cucurbits.

Use personal pronouns. Pronouns give your writing a friendlier, "one-to-one" feeling that gets the audience involved. Using pronouns also helps keep you focused on that fact the you're "talking" to another human being as you write.

NO: Once a satisfactory pumpkin is found, the next step is designing the jack-o'-lantern face.

YES: Once you've found the pumpkin you're looking for, you're ready to design the jack-o'-lantern face.

Vary sentence length. Using long sentences will make your narration hard to understand. Too many short sentences will make it choppy and irritating. Mix up sentence length just like you do when you talk.

NO: Make the long, straight cuts first, save any small details for last, and remember that it's easier to cut the design out in sections than to go around a large feature in one continuous cut, a point that' particularly important if your design includes a toothy grin.

YES: Make the long, straight cuts first and save any small details for last. It's easier to cut the design out in sections than to go around a large feature in one continuous cut. This is particularly important if your design includes a toothy grin.

Use power verbs and nouns rather than modifiers. Too many adjectives and adverbs will make your writing weak. Nouns and verbs that tell the whole story add power and interest to the script.

NO: And, if you plan ahead and follow a few simple guidedlines, your project will be more enjoyable and more economical at the same time.

YES: And, if you plan ahead and follow a few simple guidelines, you'll have more fun and save a few dollars at the same time.

Prefer active voice over passive voice. Academic and technical writing sometimes deliberately adopt a detached or "objective" third-person passive style. Active writing is inherently more interesting.

NO: Remember, room should be left for a good-sized opening at the top of the pumpkin.

YES: Remember to leave room for a good-sized opening at the top of the pumpkin.

Avoid long series. If you have too many items in a series, the audience may forget the point before you get to the end. The problem is even worse if you do not tell them the point until you get to the end.

NO: Keeping your knife sharp . . . keeping the knife handle clean . . . wiping your hands frequently . . . planning carefully . . . and working slowly and deliberately will help you avoid cutting yourself as you carve.

YES: So you don't cut yourself as you carve, keep the knife sharp and the knife handle clean. You'll also reduce the chance of injury if you plan carefully and work slowly and deliberately.

Whole books have been written on script writing, so consider this brief section as little more than an introduction. Remember that all writing is more art than science. Rules are only guides to get you started in the right direction. Ultimately, there's only one important measure of good writing: how the audience responds to it.

Review and revision

If you get defensive about your writing, you may find the next step the hardest in the entire process. Go back through the script expecting to find problems. Also, ask for a script review by colleagues or people who are similar to your audience. There are two reasons for review and revision.

First, very few writers can generate finished copy in a first or second draft. The first writing is a tremendous mental effort. If you do it right, that is. You have to create the entire structure for your presentation and fit all your information into that structure. Inevitably, there will be weak areas, inconsistencies and other problems you just can't see as you write. Once it's all down on paper, though, you can go back for a more objective look. If you can make yourself look critically at your own work you can make big improvements in your script.

Second, your opinion of the script really isn't what matters in the end. You know what you *meant* to write. You'll probably find the script clear and easy to understand. The question is whether clarity and comprehensibility is on paper, or only in your head. Ask one or more colleagues who understand the topic and your objectives to review the work. Get some representatives of your audience to do the same. What do they think the script says? Do they understand what you've written? If you find yourself explaining and elaborating as they raise questions, you probably have some revisions to make. Remember, your audience won't get to ask questions until the presentation is over. That may be too late. Revise and revise until you get it right.

Production

This section discusses the production skills you will need to produce your own slide show. Other chapters in this handbook give

more comprehensive treatment to each topic. You're encouraged to read them if you want to develop fundamental skills in those areas. The information here deals specifically with the work and problems you will encounter in producing your own slide show.

Typical materials and service costs for a one-projector slide-tape presentation		
Film and processing	4 rolls x $12.00	$48.00
Graphics	15 frames x $12	180.00
Audio tape	2 reels x $8	16.00
Cassette tapes	2 x $1	2.00
Carousel tray	$6	6.00
	Subtotal: $252.00	
Duplication costs		
Slide duplication and assembly	$.58 x 80	46.40
Cassette duplication	$2.05	2.05
Carousel tray	$6.00	6.00
	Subtotal: $54.45	
	Total:	$306.45

Deadlines

Asking how long it takes to produce a slide show is like asking, "How long is a rope?" You need more information before you can answer. A well-produced slide show with predominately new photography and graphics will take somewhere between 80 and 120 hours of time. An important variable is the effort needed in photography. Also, if you're the source of all your own information you might be able to save 30 hours or so. Still, if you're planning your own production, you're making a large time commitment.

As you'll see later, a number of specialized activities is involved. Whether you do the work or someone else does, it all needs to be scheduled. Since much of this work has the ability to expand and fill all available time, you'll work most efficiently if you set firm deadlines.

The most obvious deadline is the first show date for your presentation. Then, using information only you have, decide how long it will take to accomplish various tasks and "work backward" from that critical date to establish deadlines you can live with. Without some amount of control and coordination you're likely to wind up doing everything at the last minute.

Budget

Costs for a first-rate slide show produced by an advertising agency or production company in a larger city could easily run between $1000 and $2000 per finished *minute* of presentation. A reasonable estimate for a 12-minute show, then, would be $12,000 to $24,000. You could spend many thousands more with an original music track, big-name photographers, well-known narrators and so on.

Your production budget, however, is more likely to run in the hundreds of dollars than the thousands. The chart on this page gives reasonable production costs for the type of show you would be likely to create on your own.

Some assumptions used in developing these estimates are as follows:

■ This is a one-projector show as defined earlier in the chapter.
■ You'll narrate yourself or have narration done by a support facility available to you.
■ Of the 80 slides:

15 will be graphics you produce on a computer graphics system and have converted to slide form by a commercial service bureau,

25 will be available from file sources.

You will do original photography to get the remaining 40 slides.

■ **Production**

■ Your shooting efficiency will be 3:1. That is, you'll shoot about 120 frames of film to get the 40 slides you need

■ You'll have the finished product duplicated so you can keep the show intact and still use your original slides for other purposes.

This budget is only an estimate, of course. It doesn't include any travel you may have to do for photography. Also, it doesn't include the most valuable resource of all — your time.

Photography

You may not be planning to do any photography. Many "self help" or "do-it-yourself" slide show producers use existing slides they borrow or pull from their files. Certainly it's good to save time and money if the existing slides are really what you need. However, there are three problems with relying exclusively, or nearly so, on file material.

First, and most serious, is the tendency to write the script around the slides you have or can get easily. That's a backwards approach. The idea is to write a script that specifies the slides you *need* to get your message across. If those slides are available from file sources, fine. If they aren't you need to get them, not change your script to accommodate what you have.

Second, it's possible that using file slides is false economy. You may spend hours and look at dozens or hundreds of file slides to find a single image. With good planning you might be able to shoot a new slide in minutes. And, it would be exactly what you want.

Third, file slides tend to look exactly what they are. Some are good, some are bad. Some are old, so the color is starting to fade. Hair and clothing styles may be dated. Graphics are an inconsistent hodgepodge. File slides can make your show look like it was thrown together. New photography and graphics give your show a unified, custom look that tells your audience you think they're important and you're serious about communicating with them. As a general rule, then, shoot new photography whenever you have the chance. It will pay off in the long run.

After script review and revision it's a good idea to prepare a shot list. This is just a list of the images you'll need to take, create, or acquire to complete your show. However, rather than listing them in presentation order,

Sample shot list

Show #	Image type	Description	Source	Status
1.	Document	Cover page of news magazine featuring biotech at main topic	Library, shoot on copystand	Done
2.	Document	Montage of biotech articles from journals and magazines	Library, shoot on copystand	Done
15.	Document	Magazine ad on PCs from the mid-'70s	Library, shoot on copystand	Assigned to RT, 9-22
5.	Graphic	Main title: "Florida's Biotechnology Initiative"	Generate on computer	File done still to print
28.	Graphic	Comparison of biotech firms: Fla. v US	Generate on computer	Done and in show
17.	Slide photo	C-U of microchip	Chip on and shoot on copystand	Scheduled for 9-27
20.	Slide photo	M-S person a desk reading patent document	Shoot at biotech center	Scheduled for 9-28
18.	Slide photo	C-U of DNA model	Slide morgue	RT to select

as the script does, the shot list is organized by image type, source, or other categories that apply to your project. The chart on the previous page shows part of the shot list from a recent production. Graphics are listed together, new photography is listed by location, existing slides are listed separately. A shot list helps you plan your work better. It's essential if you have photographers or illustrators who will help with your show.

The primary equipment you need at this point consists of a 35mm camera with lens. You want a "single lens reflex" model. That means the camera view finder looks through the actual lens. As you frame your shot, you see what the camera sees. Good cameras cost anywhere from a couple of hundred dollars to a thousand dollars or more. You can get everything you need for about $500.

Don't buy features you don't need. Once you become reasonably competent, computerized focusing and automatic exposure control will just get in your way. In any case, be certain your camera allows you to set exposure manually. There will be times when a camera's automatic setting won't give you the picture you want. The type of lens is actually more important than the brand of camera. The best choice for slide photography is a "zoom" lens with a range of something like 35mm to 80mm. It should also have the "macro" feature. The standard lens most camera dealers include with 35mm cameras is a "fixed focal length" 50 or 55mm lens. That isn't what you want.

Mounting zoom lens to camera body. Note 35-80mm" designation on upper right portion of lens. "Macro" designation is at lower right.

A detailed text on photography can explain what all these millimeters mean, if you're interested. Here's the practical point you need to understand: A 30 or 35mm lens gives you a slight "wide angle" effect. An 80mm lens gives you a slight "telephoto" effect. A fixed focal length 50mm lens gives an undistorted picture similar to what you see as you look at a scene. But that's all it gives you. For a wider view that includes more of the scene in your picture, you have to move back. To get a closer view, you have to move forward. And that's a problem.

Sometimes you just can't get where you need to be for the picture you want. Even when you can, moving around to get the right composition is hard work. The zoom lens lets you move your apparent point of view by several feet with a simple turn of the lens

barrel. All three shots shown on this page were taken from the same spot using the zoom settings shown. To get the same three shots with a fixed focal length 50mm lens you would have to move about 15 feet.

The macro feature is important because it lets you get fairly tight close-ups. The lens used for the shots on right can focus on objects as close as four inches away.

For slide photography, film selection boils down to two questions. First, do you want Kodak Ektachrome, Fujichrome, or Kodachrome? Second, what *film speed* do you want? The first question involves a trade-off between processing convenience and color quality. The second involves a trade-off between light requirements and image sharpness.

Many experienced photographers believe Kodachrome gives richer, more faithful color rendition. Kodachrome also seems to have better "archival" quality, so that the images don't fade as much over the years. However, few photo shops process Kodachrome on site. It's usually sent off to regional labs, and that can take several days. The photographers who prefer Kodachrome usually say that Ektachrome is "colder." They see less brilliance in reds and yellows along with more blue and green overtone in the slides. However, Ektachrome is developed by "E-6 processing"

Top left shows wide view, shot from 18 feet with lens set at 35mm.

Middle left, shot from 18 feet with lens set at 50mm.

Bottom left, shot from 18 feet with lens set at 80mm.

Above shows normal photo and photo shot with macro lens.

10 Slide-tape production

which is available in most cities and many smaller towns. Some photo shops will give one- or two-hour turn-around on E-6 slides. Fujichrome is also an E-6 process film. Film "speed" is indicated by a number on the label. With Ektachrome film you normally choose among 100, 200, and 400. Fujichrome is also available with a "speed" of 50. Kodachrome comes in 25 and 64. These are *ISO* numbers, which used to be *ASA* numbers. Again, consult a photography text if you're interested in the absolute meaning of the film speed numbers. There are two practical points that could be important to you. For a full discussion of film type, see Chapter 9, "Photography."

The higher the number the "faster" the film. In general, if you had lighting conditions that required shooting at 1/30th of a second with a 100 film, you could shoot at 1/60th with 200 film and 1/125 with 400 film. Similarly, if you had an aperture setting of 8 with 100 film, faster 200 film would let you close the aperture one "stop" to 11, and 400 film would let you set the aperture at 16. All of this means that faster film will help you get a well-focused picture when you have less light than you'd like.

On the other hand, faster film is "grainier." Even the best slides taken with 400 film can have a fuzzy look to them if they're projected on a large screen. In comparison, 100 film gives a sharp, crisp image if you have your camera focused properly. So, if you're shooting outdoors on a sunny day, use 100 film.

Most new cameras come with a simple instruction booklet that tells you everything you need to know to begin taking usable pictures. More detailed texts and photography courses are available, of course. The key to proficiency is understanding the connection between your camera settings and manipulations and the results you see when the slides come back from the lab. Once you do, you'll be able to choose aperture settings and shutter speeds as easily as you shift gears in your car.

Shot composition simply means showing the audience what they need to see to get the point of the presentation. You don't need to know anything about balance or visual dynamics to take good slides. Simply start with your own idea of what the picture is supposed to say. Then, make yourself look at the scene you see in your viewfinder *as a picture*. If the picture is good, snap the shutter. If you see distracting foreground or background elements, move before you shoot. If the main point isn't prominent in the picture, rearrange things or move. Of course, if you don't have an idea of what the picture is supposed to say, you probably shouldn't take it.

In composing your shots forget about arty camera angles. Whenever possible, shoot from the point of view your audience would have if they were looking at the scene directly. Your slides should give a better look, not a different look. When you need to use close-ups, it's helpful to show the audience a

progression from wide shot to medium shot to close-up. This keeps the viewer oriented and reduces confusion. When close-ups are called for, it's almost impossible to get too close. Let the audience really see what your show is talking about.

Remember that people are interested in other people and what they do. Almost any picture is more interesting if it has a person in it. Avoid artificial poses, though. Have your models actually doing something that makes sense in the context of the picture. If there really isn't anything to do, have the person naturally looking at whatever the picture is intended to show.

You also want to keep in mind the one thing professional photographers do that amateurs don't. Take lots of shots. When the scene has contrasting areas of light and shadow you need shots at several exposure settings. This is called *bracketing*. Take an exposure reading with the camera pointed at the high light area. Next, point the camera at the shadow area and set the exposure as indicated. Then take at least three pictures; one with the "shadow" setting, one at the "high light" setting and one in between. Bracketing helps you be sure of getting at least one shot that has correct exposure for the main point of a scene with heavy lighting contrasts. When a scene has action, taking a number of shots is also a good idea.

Graphics

Developing graphic slides for your presentation has two aspects. First, you have to plan the content of each slide. Second, you have to create the slides or get someone to create them for you.

Do-it-yourself slide show producers make a few common mistakes with graphics that detract from the quality of their presentations. For the most part, these mistakes are easily avoidable. One problem is including too much information on a slide. This usually happens when complex slides developed for use in lectures or publications are incorporated into slide shows. These slides have to stay on screen too long to be understood. And, much of the information is too small for the audience to see well. Another problem is the use of crude or childish cartoon art that's inappropriate for the audience. It's also common to see an inconsistent mix of graphics styles.

Effective graphics should deliver information without attracting attention to themselves and distracting your audience from the message. As you do with photography, make yourself look objectively at each graphic frame you plan. If you do that, balance and composition will probably take care of themselves. These simple guidelines will help you develop effective graphics:

■ Try to convey one, and only one, main idea with each graphic slide. You can still use graphics to relate several different concepts. Put them on screen one at a time. Make separate slides for each one or use a "build" approach that adds new material to what the audience has already seen. Once the audience understands all the components of the overall idea, bring on a slide that shows the relationship among them.

■ Keep each graphic as brief and simple as possible without sacrificing meaning or accuracy.

■ Don't go wild with color. Having a different color for each word in a sentence may work with grade-school children, but not with adults. If you're using a number of word slides, follow the same color scheme throughout the presentation. Choose one neutral color for the background. Choose another that contrasts without clashing for most of the text. Be consistent in use of one or two additional colors for major headings and emphasis. Stick with this combination.

■ Limit copy on word slides to six or eight lines of text at most. With more material the lettering gets too small to read. Also, the slide has to stay on screen too long.

If you have a microcomputer, you'll find that creating graphics for your slide show has never been easier. Powerful desktop graphics packages cost only a few hundred dollars. New businesses called "service bureaus" will turn graphics files into finished slides for as little as $10 to $15 each.

With an EGA or VGA computer monitor, you can shoot adequate slides right off the screen. The result isn't fancy but it will still deliver information to your audience. To reduce screen glare, turn out room lights and close blinds or curtains. Full darkness isn't necessary. For best results, use a tripod so you can shoot at ½ to 1 second exposures. This is important to get even color all the way across the slide. Set the camera up so that the lens is centered on the monitor screen with its axis perpendicular to the plane of the screen.

Shooting photo from monitor (top), and result.

If you have a zoom lens like the 35-80mm zoom recommended earlier, adjust it to the 80mm setting. This minimizes the image curvature at the edges of the monitor screen. Use ISO 100 E-6 slide film. The aperture setting will depend on the brightness of the monitor. It's best to shoot a test sequence with settings at each f-stop from 32 (or whatever is the "highest" on your lens) through 11 or 8. Shoot one sequence at a shutter speed of ½ second, another at 1 second. Pick the shutter and aperture setting combination that gives the best looking slide.

Finally, don't assume that you need an artist or computer graphics system to produce all the graphics you need. Graphics that will fit into your show are sometimes where you find them. A little imagination is all you need.

Use a little imagination for title slides: Don't assume you need an artist for all the graphics.

Slide assembly

As you near the end of a slide show project you have 80 slides in various stages of production. Some are photographic slides you have shot or plan to shoot. Some are photographic slides you will try to borrow from existing files. There are graphics that you've completed and graphics you're still working on. There are slides you will use if you can't find anything better. There are full-image slides that will be used in split-screen slides. If you're lucky there may even be a few that you've assigned to someone else to shoot or create. What you need at this point is a simple, efficient system for managing all these "mini-projects." Otherwise, you have to remember every aspect of every slide all the time.

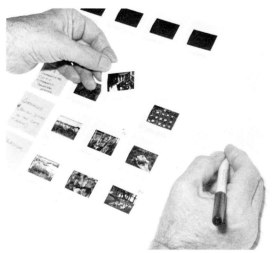

Write the name of the show and number on each slide. Place slides in corresponding numbered pocket.

A good way to handle this problem is with ordinary clear plastic slide pages. If you keep your file slides in notebooks or folders, you probably already have some of these. Each page has pockets for 20 slides. They cost 25 or 30 cents. You'll need 16 of them.

Use an indelible "A-V" marker to write the name of the show in the area provided between the binder holes on the left edge of each sheet. Then, as shown below, number the left-hand pockets in each row from 1 to 80. As you finish with each slide, put it in the numbered pocket corresponding to its position in the show. Write any special production details on 2" x 2" cards. These notes will pertain to specialty slide production, slide source, reminder of the photography assignment for a given slide, and so on.

Store the card for each slide in the numbered pocket corresponding to that slide. As you assemble slides that will be used in composites, put them in the remaining pockets in the appropriate numbered row. This is particularly useful when you need to use the same shot in more than one position. A given image might serve as a background for a title in one position and appear somewhere else as a full-screen image. If you're considering two or three different slides for a particular position in the show, store them in the appropriate row until you make your choice.

This system will enable you to keep track of the slides and working information about the slides. It will also allow you to organize and store the "work in progress." This will keep it from crowding limited office space and reduce the chances that pieces of the project will get lost.

Narration

It would be unusual to spend more than five to 10 percent of the time that goes into a slide show on the soundtrack. However, what the audience hears is at least 50 percent of what they get from your presentation. The quality of the soundtrack can have a disproportionately large impact on the overall quality of your show. So, it makes sense to do everything you can to ensure that the soundtrack is at least as good as the rest of the work. Unless you have a special need for sound effects the soundtrack will have two elements: the narration and the music.

As your own producer, your first soundtrack decision will be whether to narrate yourself or get someone else. If you're comfortable narrating and have a pleasant voice, there's no reason you shouldn't do it. If it's important that you be identified as the authoritative source of the information, you should probably narrate unless you're so uncomfortable that you interfere with the message. As a rule, get someone with training and experience to do your narration. Competent narration is reasona-

ble for a 12-minute script. Commercial studios in larger cities, of course, might charge several hundred dollars.

Regardless of who reads your script, remember that a slide show narration should be a vehicle for information delivery. It should not attract attention to itself. In choosing a narrator, think about regional speech characteristics, age, gender, obvious ethnicity, and other factors that might register with the audience. The narrator should try to read naturally and avoid artificial speech mannerisms. At the same time, the narrator must use variations in stress and speed to put in "punctuation" so the audience can follow the material. The narrator must also look at the script visualization to be sure there is enough time for all the slides.

It is possible to narrate directly into a cassette recorder. However, mistakes are inevitable for most narrators and sound editing is difficult with cassette production. It's necessary to stop recording, rewind past the mistake, play back until just before the mistake, stop the machine, put it back in record mode, and continue narrating. All of this interferes with natural timing in the narration. It can also result in audible snaps and pops on the finished soundtrack. You're better off recording on a reel-to-reel machine and correcting mistakes by splice editing. Then you can transfer the soundtrack to cassette when you're done. You can do all this with "home stereo" equipment, if necessary.

Be careful in using music on the soundtrack. With popular tunes there's always the danger that the audience would rather hear the music than the narration. There's also an obvious copyright problem. Keep the music volume low so it doesn't drown out the narration. Consider the match between the mood of your show and the mood of the music. For most informational slide shows a short piece of music at the beginning and end is all you need.

All that remains is to add synchronizing pulses that will drive your slides as a properly equipped cassette unit plays the soundtrack. For this you need a cassette machine that generates and records standard 1000 Hz pulses. Numerous cassette units are manufactured with this capability.

To "pulse" your tape you simply play the soundtrack with the machine in "pulse record" mode and push the "slide advance" button each time you want a slide change. This is easier if you mark your script to show exactly where the changes come. Remember that the screen will be blank for 1 second between slides. If you want a new picture to coincide exactly with a specific word in the soundtrack, plan accordingly. Again, mistakes are inevitable. Most machines allow you to rewind past a mistake, reset the slides, and begin pulsing again.

10 Slide-tape production

If you plan to send your show to other people for use, you should let them know whether to start on slide position "one" or "zero." To start on zero you place a plastic "blank" slide in the projector gate and then place the carousel tray in position. At the first pulse, the projector lifts the blank slide into the closed slot opposite the zero indicator on the tray and shows the first slide. This enables you to bring up the first slide after the show begins, usually over music. The other approach is to bring the first slide up on the screen before starting the tape.

After pulsing the tape, play the show back to make sure it runs the way you want it to. If there are no mistakes, you're done with your slide show project. Congratulations!

Conclusion

S lide show production is more art than science. No rule or guideline given here is immutable. You can do anything you like as long as you have a purpose and what you're doing works. In the end, all that's important is whether the audience you're trying to reach gets the message you want them to have.

Because the equipment involved is cheap and widely available, just about anyone can produce a slide show. You don't need a technical-professional bureaucracy of shooters, editors, producers, writers, graphics specialists, and so on. You can make every decision your way and you can get the resources to implement those decisions.

Do remember, though, that professionals "make a big production" out of their productions for a reason. They know that identification of objectives, analysis of audience, development of treatment, and sound script writing with good visualization are all essential to a successful presentation. Actual production work, no matter how competent and creative, is only one phase of a larger, more involved process.

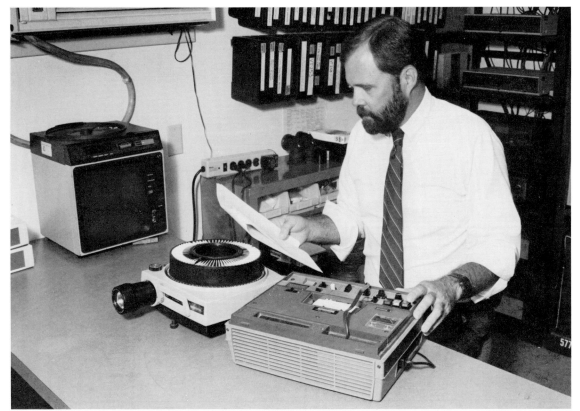

To pulse your tape play the soundtrack with the machine in "pulse record" mode and push the "slide advance" button each time you want a slide change.

Radio is the medium of the mind. With visual stimulation supplied by your mind's eye, you can unlock a world larger than life, brighter than brilliant, and more intense than anything our physical world can deliver.

Radio is effective. Even more, it's efficient. Compared to other methods of direct mass communication, it can be one of the most cost-effective. With a modest investment in a cassette recorder and some concentrated effort on your part, you can make contact with a part of your audience that is increasingly mobile and distracted by other messages.

The challenge in radio is to understand what it can do for you. Then use innovation and creativity to make it work for you.

This chapter will cover eight basic areas of using radio as a communication tool:

Reasons for using radio.

Methods of using radio.

The three basics of radio.

Writing for radio.

Reading for radio.

Interviewing for radio.

Working tools of radio.

Promoting yourself and radio.

Reasons for using radio

Radio works

But, why? Dr. Elizabeth Loftus, University of Washington psychologist, says in an article in the March 14, 1983 issue of *Advertising Age* that a person will react faster to a sound than a picture. According to Loftus, people respond to light in 180 milliseconds (ms), but respond to sound in an average of 140ms.

You may be satisfied if your program is within the allotted minutes and seconds provided, let alone milliseconds. But those 40ms may be more important than you think. According to the article's authors Al Ries and Jack Trout, psychologists speculate the brain translates visual information into sound-like information the mind can comprehend to account for the 40ms delay in comprehending pictures.

Not only do we hear faster than we see, but this same study showed that our hearing lasts longer than our seeing. A visual image fades in one second unless our minds do something to file the idea away. A heard idea lasts four or five times as long.

That's why some of us easily lose our train of thought when we read printed words. We end up backtracking to review the message. But because sound lasts longer in our minds, spoken words, songs, and jingles are easier to follow and remember.

Based on this, Ries and Trout spend a lot of time convincing their clients that a picture is not worth a thousand words, as Confucius supposedly said 2,500 years ago. The agency owners point out how ironic it is that Confucius is remembered not for what he looked like, but for what he said.

Radio as a communication tool

Social scientists believe people go through a multi-step process when making up their minds about something. These steps include: awareness, interest, evaluation, trial, and adoption.

Radio and other mass media are most effective during the first two steps: the awareness stage when people first learn of an idea, and the interest stage when they get more information about it.

At the evaluation, trial, and adoption stages the most important influences are friends, neighbors and personal experiences. But the process is highly interactive. People are often influenced by previous mass media exposure. Radio interviews, news stories, public service announcements and personal testimonies of success will affect this process beyond just the awareness and interest stages.

Radio is local

Local stations thrive on local names, local events, and local situations — the exact information you have to supply. Listeners find out what local and regional events are taking place, and they like information about the people in their community.

Radio is popular. Arbitron, a radio rating service, says 96 percent of all people 12 and older listen to a radio station at least once a week. And two out of three listeners tune into FM stations, according to an article in *American Demographics* (February 1986) magazine.

Radio can't do everything

Radio, however, can not be everything to everybody. Because a listener can't fold up a radio program and file it away for future reference, radio works best when notifying, reminding, or telling uncomplicated stories that are easily remembered. Radio is most effective when messages are simple and to the point. Today in radio there is a growing emphasis on shorter, fragmented information programs and more music and entertainment programs. That has been become a major challenge for those people using radio to disseminate information.

Methods of using radio

Marketing

The fact that virtually everyone has a radio makes it a powerful marketing tool. But the key to your success is also marketing. How well can you sell the idea that what you have to say is important enough to increase the audience's willingness to listen to the station? Successful marketing requires an understanding of the priorities of radio station operation.

Station staff

The process of getting your information to your audience is one that includes many potential barriers or gates. Although you are always aiming to satisfy the information needs of your audience, you must pay attention as well to the people who control the gates your information will confront. In radio, it's those gatekeepers who decide whether your information deserves to be broadcast. Your goal should be to package your basic information in a style and format acceptable to the gatekeepers.

To begin to understand radio station operation, let's first look at the management structure. Although staff organizations will be slightly different from station to station, there are some basics.

Station manager. This person is in charge of all operations. At smaller stations, the station manager is often also the owner, the program director, and the chief engineer all wrapped into one. At larger stations, the station manager may be higher in the organization than you need to start. It could be that the manager of the larger station may not be closely enough involved in the everyday programming of the station to be able to help you.

Remember, station managers have multiple interests. They are responsible for everything at the station, not the least of which is sales. Make sure your discussion takes into account how you feel the information you are offering will affect the audience's overall perception of the station.

Program director. This person could be your initial contact at a station. Program directors are responsible for the combination of music, news and information you hear on the station. With the program director, too, you must concentrate on what your information will do to enhance the listener's image of the station.

News director. This person may be your most frequent contact at a station. After having sold the idea that you generate useful information on a regular basis, you will end up providing much of it to the news director in the

form of news stories, news tips, and calendar information. Job turnover can be relatively high for news directors, especially at small stations. You may need to build new relationships regularly.

Identifying your audiences

Remember "Rule Number One." Know *who* you want to talk to and why.

Think about natural groupings of your clients: groupings by age, political interests, geographic location, family income, gender, life style, and many other segregating factors. Think of each group and combination of groups as a target. How can you reach the target?

Take older adults as an example to get you thinking about grouping and targets. Many older people tend to be home a lot. Radio brings the outside world to them and literally keeps them company. To reach them with information about an upcoming workshop on housing alternatives, you could send a public service announcement to an all-talk station.

Think carefully about who will best use the information you have to offer. Then, compare that group or groups with the various listener groups that are attracted to individual stations in your area. Be specific. Target your audience carefully. This is the same targeting process an advertiser uses to deliver a sales message to a

specific audience. Take the time to really listen to the radio, especially the commercials. Take a cue from the way advertisers get their message across. Notice how they get *your* attention. Then apply that knowlege to the programs or spots you produce.

After you have identified your target audience, go to the radio station and talk with the program director or station manager. Do they agree on your mutual target audiences? If so you can be of mutual benefit to each other.

Radio's strength is in its ability to reach target audiences. Take advantage of this by learning the listening habits of your clients and working directly with the stations that reach them.

There are three basic formats available for your use — news, public service announcements, and radio programs. Each is effective with various target audiences. Each will allow varying levels of involvement on your part. Yet each is a unique vehicle for your information.

News

News is the easiest way to start using radio, because it's fueled by our basic product — information.

Radio news stories are becoming shorter and more to the point. A typical story is less than 60 seconds long and tells one piece of information clearly. Stories work best when someone involved tells how they feel about what is happening.

What is news?

News can be defined as any piece of information that will affect your head, heart, or pocketbook. In other words, news is information that will stimulate someone's curiosity or intellectual interest; information that will create an emotional response; or information that is of economic importance to individuals or groups.

Another important dimension of news is time. The information must be timely. Did it just happen? Will it still be interesting tomorrow? Will it continue to be an interesting topic? Or in the case of long-term work, such as scientific research, will the information be released soon at a national scientific meeting? That is, is it timely?

Review your information and make a list

As you think about the information available in your office each day, list the types of information and their sources. Head, heart, or pocketbook. Then sort that list according to timeliness and interest. Soon this type of sorting will become second nature.

Review the stations and make a list

Remember the part about knowing your audience? It's very important here. Your first audience includes station gatekeepers, your second is the target group of listeners.

11 Radio

Listen to the stations in your area. Decide which ones emphasize news directed to your target. How many hours or minutes of news do they present? How many voices do you hear? Do they do newscasts on the hour and half-hour? Do they only supply network news with no local news? Do they spread their local news through certain parts of the day? Start making a written list of the traits you identify with each station. Soon a pattern will emerge and you'll be able to tell one from another.

Why not just go to the station and ask them what their news department needs? In this age, information is power, and time is a salable commodity. If you want to be effective with a radio news department, assume that everybody will be in a hurry whether they look like it or not. Don't use some of your precious time allotment for an explanation of already available information. Do your home-work before you talk. You'll be able to ac-complish more.

What goes into a story

Your local radio station is primarily interested in local news. These are news sources that easily lend themselves to localization:

■ Major events.

■ The week's activities.

■ Timely problems and solutions.

■ Experiences of local people.

■ Weather information.

■ Market information.

■ Local information about national news stories.

■ Timely information from your area of expertise.

Delivering the news

At mid-size to smaller markets, you may arrange to deliver radio news quotes known as *actualities* to each station. This will allow each station to either run or edit them to fit their style.

Although most stories will end up running 60 seconds, it's best to supply slightly more information to allow stations some editing leeway. Begin with a lead for the station announcer to read. Then, write a brief but specific introduction to the story. Use one or two recorded actualities from the main source of information. Each actuality should run approximately 10 to 30 seconds. Close with a conclusive remark and a generic sign-off.

Some stations will run a story just as it is. Others will take your script and actualities and have an announcer read it. Still others will take only a single actuality and shorten the story to fit their needs.

An educator carefully times his report as he consults with a station.

Major market news

In large media markets, it's becoming more and more difficult to place radio news. Because competition is strong, many stations stylize their newscasts to stand out on the crowded dial. They simply refuse to run anything their competition might have also received. In most large markets, it's best simply to become a news source. Provide information in a regular and timely fashion. Develop a relationship with the station news staff that allows them to trust and call on you when they identify a story. In return, this allows you to call them when you feel you have newsworthy information.

Sample radio news script/story 01:29 refried beans

Announcer: Oregon State University foods and nutrition researcher Margy Woodburn and graduate student, Susan Nester, have found that flu-like food borne illness can sometimes be traced to improper handling of Mexican refried beans in restaurants.
Woodburn explains:

Actuality: "Many people without any formal training in being restaurant managers feel that if you heat a food it then becomes safe to eat — no matter what its problems were before. This is not true. Staph enterotoxins are very stable, they remain active after the food is well reheated and they cause illness when you eat the food."

(:24)

Announcer: Woodburn and Nester interviewed several Oregon Mexican food restaurant managers.

Actuality: "Our findings were first of all that the restaurant managers had a sincere desire to serve safe food. The problem wasn't their interest and emphasis on it, it was their lack of knowledge of when food might become unsafe."

(:15)

Announcer: Woodburn indicates how to properly handle Mexican refried beans.

Actuality: "Our research shows that 2 to 3 hours is a maximum total time that they should have been at this in-between temperature between 45 and 140 degrees. If the conditions under which they were held let the bacteria grow, then no amount of heating after this will make the beans safe to eat."

(:19)

Announcer: At Oregon State University, this is Dave King reporting.

Total running time 1:29

NOTE: "*Actuality* is a radio production term referring to the actual words stated by the subject of the report.

Sample radio news script/story 01:30 user fees on the Columbia

Announcer: User fees are fees charged to those who use something, but Oregon State University agricultural economist Mike Martin says his research on the lower Columbia River port system, including the Port of Portland, shows all user fees are not the same.

Actuality: "The lower Columbia requires quite a bit of public expense to make that an international shipping lane and the strategy now is — the philosophy of this administration is — the users of a particular publicly financed facility pay the bill."

(:12)

Announcer: With proposals ranging from a tonnage tax to a flat fee, Martin says he's looking for one with the least negative impact.

Actuality: "I guess our attitude is that, being Pacific Northwest oriented, that we would like to have Congress, if they're going to accept a user fee...I don't know if we want to concede that to them. But if Congress is going to impose a user fee, let it be one that will have the least impact on changing the current equilibrium flow between ports."

Announcer: Martin says his research indicated a flat fee would be best.

Actuality: "What is clear, for instance, is that fuel prices have a fairly high impact on a port's specific rates and therefore a user fee through fuel charges at a particular site may be relatively harmful. One implication is that international shippers spread fixed costs to all traffic so that a flat fee may be better than some sort of variable cost fee that has to do with mileage or time or tonnage or fuel."

(:28)

Announcer: At Oregon State University, this is Dave King reporting.

Total running time 1:30

11 Radio

Wild sound

Sound is what makes radio effective and unique no matter what the market size. For you to be effective, think of sounds the station can use to sound unique.

The Associated Press advises its news reporters to pay close attention to background sound. Also known as *wild sound,* background sound can enrich and enliven your report. Sound carries the atmosphere and mood of the story. Artfully used, it will help bring your listener into the story.

Wild sound, however, should never dominate your story. You should write the story so that it can stand alone without wild sound. Then, be able to add it appropriately so it will enhance your effort to communicate.

Again, pay close attention to the style a particular station uses. If you are supplying information to a station that uses a lot of wild sound, deliver additional taped wild sounds and ambiance from the scene for them to use. If nothing else, your story will more likely be used because the station knows it will be able to create a story a little different from its competition down the street.

Public service announcements

Public service announcements, known as PSAs, are short spot announcements, usually between 10 and 60 seconds long, that provide important information to the listener.

Primarily, these spots contain what is known as *mobilizing information* — information that will help the listener do something. For example, a PSA can be about an upcoming meeting with the site, time, and topic. Or it could be gardening information that helps people choose seeds or provides tips on planting. Or it could cover the subject matter of one of your publications with a final line on how and where to get a copy.

At one time, radio stations were required to run PSAs free as a public service. But those regulations were abandoned in the early 1980s. Now the radio station marketplace is the controlling factor. Many people felt this would mean the end of PSAs. But, to the contrary, PSAs are alive and well.

Most stations realize that information is part of the reason people listen to the radio. And if the station can provide the kind of information that helps people do things they want to do, the stations will build and maintain a loyal audience. This provides outside information sources such as your organization a key to understanding what information should be provided to a station in PSA form.

Oregon's agricultural progress radio PSA
00:30 drought

Rain — or the lack of it — has been on most people's minds throughout this year. For statewide agricultural research, the drought has answered a few questions, but posed many many more...what did we learn and what happens now? Check the latest edition of Oregon's *Agricultural Progress,* the magazine that lets you know how science is helping Oregon grow.

Get a free copy at your county Extension office, or write:

Editor
Agricultural Experiment Station
OSU
Corvallis (30 sec.)

"Your money matters"
radio spot: 30
kill: *(last date to use)*

When you're spending more than you're bringing in, when your credit card owns you instead of the other way around, when a "savings account" is just a fantasy — sounds like you could use some money management skills. If you're a single parent or married, eighteen to thirty-four, you can learn more about budgeting, about spending, and about saving. And you can do it without cost. Call your local office of the Oregon State University Extension Service. Ask about the new home study series, "Your Money Matters."

(30 sec.)

Returning again to the concept of knowing your audience, spend some time and effort deciding who a station's audience is. Then, help the station help you by providing information that audience can use.

The best use of PSAs

Because of their length, PSAs are difficult to use as teaching tools. They are best used to attract attention and then explain where listeners can get additional in-depth information. The 30-second PSAs shown in this chapter are typical. The first two-thirds of the copy attracts attention. The last section hooks the listener with the mobilizing information. What, where, and how to get it.

PSAs are excellent tools for reminding people about your organization and its services. Even when people do not write for the information, they are still pleased to know that you are offering this service. PSAs are important to public institutions, because they help satisfy the public's right to know about where their tax dollars are being spent. PSAs are an excellent method of telling people what you are doing as you help meet their needs.

Ask radio stations how they prefer their PSA information. Some stations have 3 x 5 card boxes next to the on-air announcer so she or he may read announcements when needed.

If this is the case at your station, try providing a brightly colored 3x5 card that will slip easily into the station operation.

Radio programs

A third way to use radio to distribute your information is to write and possibly record your own two- to 30-minute radio program.

Longer-format radio programs have been a typical use of radio for many educational and informational organizations in the past. As radio stations compete for a significant slice of the audience pie, it can become more difficult to justify the greater amount of time needed. But, it is not impossible. Careful attention must be paid to the type and style of program proposed. It must truly satisfy the needs of the audience. If it does, anything is possible.

Situations that may work for longer format radio programs include how-to programs, call-in programs that answer questions directly, market information programs on a daily basis, and consumer-oriented programs that supply timely information about saving money, conserving resources, and making informed decisions.

Remember, radio is the immediate medium. It can reach people with timely information well before newspapers and television can. Use that to your advantage by being the first source of that useful piece of information.

Radio program construction

Let's start at the beginning and look at some of the parts of an effective longer-format radio program. An opening to a radio program serves as bait to grab listener attention. Billboarding — telling what topics you'll cover — is a good technique to catch and hold attention.

You can use the same technique at the end of the show to promote the next program. For example, if you have a program coming up the next day, you might say, "Tomorrow we'll talk about a new method of garden tilling...a simple and easy way to fertilize shade trees...and how 4-H member Kathy Jones turned her hobby into a real business enterprise. Join us again on 'Extension Reports' at noon tomorrow."

Local events offer a double-barreled opportunity. Promote them before they take place, and then provide follow-up coverage. Interviews or reports recorded at the events give your broadcast that needed change of pace. Localize out-of-town events by telling how they affect listeners in your local area.

Timely information related to local issues makes good radio listening. And no story beats the successful experiences of local people.

Good ideas for radio programs

Your week's activities provide a never-ending source of ideas for radio talks. Who wrote to you? Who stopped by the office? What were their problems? Whom did you visit? What observations did you make?

A question-and-answer program is a good example of a radio program that will fit into the style of radio today. It satisfies your need to deliver information to a broad spectrum of people and to keep a record of the broad-based and interesting questions that come into your office during the week. Once a week, answer them on your radio program. The format is universal and well-tried. Audience interest is high because the questions are generated by the members of the audience themselves. As a bonus, your office reinforces its reputation as a credible source for solving problems.

From the radio station's point of view, this is a true radio-style program, not just an educational program crammed into a radio format. A professional question-and-answer program such as this makes the station look good by providing a valid public service.

...or try this one:

Sample radio script.

Hi, I'm _____, with the _____ County office of the Oregon State University Extension Service. Today I'm going to tell you how to dig and store your potatoes for the best possible quality.

To enjoy the great taste of new potatoes, dig them right out of the garden, wash them off and pop them in the oven. There's nothing like it! Remember though, new potatoes will keep for only a few days, so don't harvest more than you can eat.

Now if you want to store most of your crop to enjoy later in the year, don't dig any potatoes until the vines have been dead for two weeks. You can wait for them to die on their own, or you can cut them off when the potatoes reach ideal size. Let the potatoes lie in the ground the full two weeks to toughen the skins, so they'll be more resistent to cuts and bruises.

When the time has come and the soil is dry, dig up your potatoes and put them directly in bins or ventilated containers. Don't wash them first and don't put them into plastic bags. Store in a room that stays pretty consistently at 45 degrees. That will keep them from sprouting, shriveling or rotting.

Tomorrow I'll tell you when to harvest garlic.

I'm _____ from the _____ _____ County office of the Oregon State University Extension Service.

Take a look at the organization of the radio script shown. It has a simple structure you can use for any radio program:

■ Open/intro.
■ Teaser/headline.
■ Body/substance/advice.
■ Billboard.
■ Close/identification.

Start by identifying yourself. It tells your target audience who you are and what qualifies you to be handing out advice. Then open with a sentence that both grabs interest and sets up the topic. Continue with your advice, arranged simply and logically, with each step in the correct order.

Remember this is radio — you get one chance to be understood.

You may wish to end the body or advice portion by indicating other sources of information, promoting a publication or an upcoming workshop. Then, promote your next program and close with appropriate identification for you and your organization.

A few final don'ts

Getting and staying on the air means pleasing the gatekeepers. But...

■ **Don't** beg, plead, or threaten to maintain free air time. A good program will stand on its own merits. If you are having trouble, find out why and fix it.

■ **Don't** use free air time to promote a project or an idea for which you would buy newspaper space. If your project has an advertising budget, allot some to radio. Legally, broadcast media that use the physically limited public airwaves are considered different from newspapers where, in theory, space is limited only by economics. But do not abuse the difference. Remember, radio stations are no longer required to provide free time.

■ **Don't** promote anything related to games of chance.

■ **Don't** promote commercial products if you are a non-profit organization. Always be even-handed and use generic product names if possible.

Writing for radio

V isual imagery is the key to writing for radio. Make your listeners "see" what you are saying. Help them visualize themselves taking action in a situation you are describing.

Researchers have found that audience recognition and recall are much higher when you use imagery-eliciting words and phrases in your copy.

Writing PSAs is an example of radio writing at its toughest. They are short and to the point. On the other hand, their shortness may allow them to be lost in the cacophony of the radio

station's combination of music, news and information. When writing for radio, imagine yourself riding in a car with the window rolled down and the car noise and traffic distracting you. How will you be able to grab and maintain the listener's attention?

Be careful. Commercial producers sometimes use cheap tricks to grab people's attention. A little of that goes a long way in this business. Instead, think of word pictures and alliterations that will subtly attract attention.

Visual radio writing

H ere's an example of imagery from a study reported in a recent issue of the *Journal of Broadcasting*.

Straight announcement copy:

"Acme Puncture-Proof won't leave you stranded on a dark and deserted highway..."

Imagery-eliciting copy:

"There you sit on a dark and deserted highway. It's midnight and every second brings a strange sound. You have a flat tire. You wouldn't be in this situation if you had purchased Acme Puncture-Proof..."

Notice the first style does have some visual words in it. But the second style actually puts you into the situation described.

When writing copy or scripts or just putting an outline together for a radio show, always remember what radio does best. Help your listener imagine the scene you're depicting.

Know why you're using radio

B efore you write one line of copy or say a word on the air, decide exactly what you want your listeners to know, feel, and do. How do you want them to behave, react, or change? List specific message objectives. Decide on one basic, timely idea for each program. It may be part of a larger idea. Collect and organize logically all related information, facts, data, and substantiating evidence which will make your message believable and acceptable to those who hear it.

Get your listener's attention

U se a visual fact, an interesting idea, a thought-provoking question, or a challenging statement. Arouse interest, curiosity. Your lead must catch the attention of even the most casual listener. The first two sentences of your story or spot are the most important. If you don't get the listener's interest in the first 10 seconds or so, chances are you won't get it at all.

Try reading this:

> "Feeding immediately following the flowering period of many shrubs is becoming a common and recommended practice."

Pretty confusing! But use the same content for this kind of attention-getting lead:

> "Do your flowers and shrubs look hungry right now? Well, that's only natural. Flowers and shrubs need a little snack, especially right after blooming. For many, that's now."

This line has visual and timely appeal. Your mind's eye sees the hungry plants needing food right this minute.

Use mass audience appeal

Never exclude anyone who may be a listener. Present your information in such a way that it will be of interest to many listeners. Which of these two versions has the broader audience?

> "Poultry producers — egg production is highest and profits are greatest when layers receive 14 hours of light per day."

Or:

> "Hens don't lay eggs in the dark! They need 14 hours of light each day for top production. This pays off in two ways: higher profits for the poultry producers...and lower egg prices for us all."

The nature of your information may dictate that you tailor your message to a selected audience. Always remember, whatever your subject, there are people who will hear you who do not know what you are talking about. This advice applies to any subject, whether it's agriculture, building construction, or economics.

Always figure your audience has a generous portion of the "general public" in it. Instead of talking "to" your audience, talk "about" them. Tell what they do and why, and how this is important to those who aren't familiar with your subject. Any one professional should be considered a member of the general public when you are talking about specifics of another subject, outside their realm.

Identify your sources

Give the source of your information logically, naturally. Listeners are more likely to believe what you say if it is credited to an authoritative source. If the source is you, then try to indicate the basis of your information. Other sources should be identified, but not belabored. Handle attribution as if you were "telling" the information to a friend. In radio, attribution generally precedes the statement, whereas newspaper style usually has the source following the statement.

For instance, say:

> "Science may have caught the bug. Fred Stormshak, Oregon State University animal scientist, says he thinks he's found the bacterium causing the recent outbreak of intestinal dairy disorder."

Instead of:

> "The bacterium causing the recent outbreak of dairy intestinal disorder has been tentatively identified by Oregon State University animal scientist Fred Stormshak."

Easy listening

Steering wheels

Make your program or story easy for your listeners to follow. Remember, radio is the "hearing" medium. Each word, each idea, must logically fall into place so your listeners can get your message easily and accurately. Your script must have a liquid or flowing quality. Words like *however, but, on the other hand, or, and, furthermore, therefore, so, well, then,* and *likewise* act as steering wheels to guide your listeners' thinking. Use them to start sentences.

If you are writing a radio program or spot script, try to bring some conversational quality to it. Write for the ear. That means using phrases and words you'd hear in casual

conversation. Use as few technical words or terms as possible. Find the simplest word that will carry your meaning.

In each of the following instances, the second word is better than the first:

utilize—use	contribute—give
purchase—buy	facilitate—help
procure—get	option—choice
accomplish—do	however—but
eradicate—wipe out	

If you use a new or unfamiliar word, explain briefly what it means.

Write for reading

To make script reading easier, break hard-to-pronounce or often-mispronounced names and words into syllables. For example: "dacron" (DAY-KRON), "debris" (DAY-BREE).

Write short. Use short, easily read, easily understood sentences. Keep a period at your fingertips. If you use a long sentence, follow it with a short one. This will permit you to catch your breath. Strive for a comfortable rhythm. Remember, your listeners have to understand instantly.

Write words and symbols so they are easy to read and understand. For instance, use pounds rather than "lbs." and percent rather than "%."

Numbers in radio present a special problem. According to most broadcast style manuals, it's hard for people to understand numbers read quickly. To avoid this problem:

■ Try not to use long lists of numbers.

■ Avoid starting a sentence with an exact number.

■ Round off large and detailed numbers.

Repeat. Don't hesitate to repeat or re-emphasize any part of your message that your listeners might have easily missed. This can be done as a summary or as mobilizing information that may include addresses, amounts, dates, titles of publications, sources of additional information or key points that need stressing again.

Read aloud. Test your writing by reading it aloud. This is the best way to catch poor phrasing and tongue twisters. If you can read your copy easily and smoothly, chances are others can, too. Check for readability and listenability while you are writing and after completing the story.

Paint word pictures

Use simple, direct visual language. Use examples and comparisons with which the listener is familiar. Paint word pictures, such as "icing so smooth you hate to put a knife into it," or "mold that looks like a light coat of flour on the leaves."

Use action verbs and a minimum of adjectives. Don't judge the information for your listeners. Present the facts. Descriptive detail allows your listeners to decide for themselves whether the information is useful. Let your audience decide for themselves if an event is "big" or "exciting." How big is "big"? What is "exciting"? Good word pictures speak for themselves.

Use contractions

Your copy will read more easily and sound better if you use contractions. For example, use don't instead of do not. But beware of contractions such as could've and would've. They sound like could of and would of, which are improper grammar. At times, for emphasis, you won't want to use the contracted form, such as "For safety's sake, *do not* leave chemicals within the reach of children."

Punctuation

Some style experts feel punctuation must be unlearned when writing for radio. It is clear that when writing for radio, the fewer

extraneous marks the better. The most useful punctuation marks are a comma and a period. A hyphen or a dash can be used to indicate a pause slightly longer than one called for by a comma.

Never use quotation marks. Instead, indicate direct quotes by the context of the sentence. "He said that..." is the same as using quotation marks around what was actually said and it is much easier to read aloud. You also can insert an indication that the remarks have ended by closing with a phrase like "...and that concluded his remarks."

Many people who read radio copy for a living suggest you eliminate the word "that" as often as possible from your copy. We don't use it much when we talk conversationally to friends, and some consider it a harsh word to hear. You should probably use it only for clarity.

Timing

A timely radio presentation means more than just timely subject matter.

Radio time literally equals money. Time is sold or time is given away. You should recognize the importance of having your spots and programs exactly the correct length.

Practice writing to exact times. As a rule of thumb, figure 60 words equal approximately 30 seconds of time. Practice writing for yourself, as if you are the person delivering the information you have compiled. Or, if you are

writing for someone else, check your script with the person who will read it. Then begin to write for the speed that person reads.

If you are doing a structured but unwritten program, always have useful information available to fill time. Outline your presentation in short enough segments so that if you run long you can cut the last segment or two without appearing to have left something out.

Mechanical helps

Type your copy clearly in the usual manner (not in all capitals), and double or triple space so it's easy to read. Avoid splitting sentences at the end of pages and words at the end of the lines. Write words out — don't abbreviate.

Use 8½" x 11" mimeograph or other soft fiber paper. Never use onion skin or bond paper; it rattles. Use a separate sheet for each story.

Number all pages. Underline words you wish to emphasize. Mark places where you wish to pause. Note pronunciation trouble spots. Leave pages loose; don't clip or staple them together.

For answers to specific questions about details of writing for radio or television, refer to style manuals such as the *Associated Press Broadcast Style Manual*.

Reading for radio

The first myth of radio is that you must have an exceptional voice to be believed.

Especially for radio news, you need not have an exceptional voice. Authority and credibility come from rehearsing your copy, being familiar with all the words, and pacing to avoid breathlessness. Associated Press management advises reporters to convince their audience they are the ultimate authority on the story covered — without sounding pompous.

For better delivery

Radio is an intimate medium. It's just you and your listener in a kind of one-sided conversation. And conversation is the key word.

Think of a recent discussion with a close friend or a loved one. Spontaneously, you explain, you soothe, you convey how you feel. Now, read aloud from a book. Unless you have practiced, your voice will probably sound stiff, cold, and distant. The difference comes from conversational writing and conversational delivery.

Your attitude or psychological state greatly affects your radio delivery. A national survey indicates that the biggest faults in educational or informational programs are lack of enthusiasm coupled with poor voice characteristics.

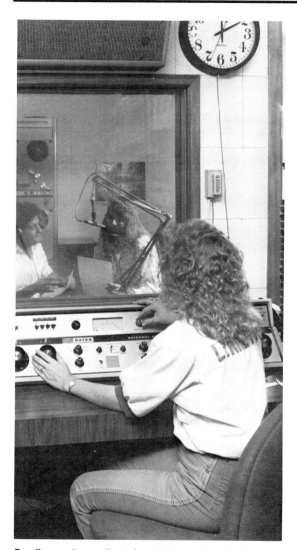

Reading and recording often occur in closed studios with the engineer separate from the program participants.

Enunciation and pronunciation

Do you enunciate each part of a word clearly? Or do you slur certain syllables? Problem words include:

temp-a-ture for temp-er-a-ture

prob-ly for prob-ab-ly

git for get

jest for just

Don't drop the final "g" in sewing, cooking, and other words ending in "ing." And often is pronounced "of'n." The "t" is not sounded. It takes practice and conscious effort to perfect the art of radio speaking.

Four rules of radio delivery

Think the thought. Regardless of the topic or idea, think about it, see it, feel it. Project your personality. Sell your listeners on the points you're making. Be persuasive. Enthusiasm and sincerity will help convince them you believe what you're saying. Visualize the insect pest you are describing. Taste that suggested low-calorie dessert. Be impressed by that new research finding.

Think the thought through to the end. Read or speak by phrases. Know how the sentence will come out before you start it. Keep half an eye on the end of the sentence while you are reading the first part. This will

Gesturing and smiling, even to an empty studio, adds personality and vitality to your broadcasts.

add smoothness to delivery and will help you interpret the meaning of the phrases as part of the whole idea.

Talk at a natural speed, but change occasionally to avoid monotony. Vary the pitch and volume of your voice to get variety, emphasis, and attention. Control your breathing to take breaths between units of thought; otherwise, you'll sound choppy. Avoid dropping your voice when it sounds unnatural to do so.

Use your body. A relaxed body helps produce a relaxed-sounding voice. Do a few exercises just before going on the air. A little physical activity reduces tension (just don't be out of breath). Sitting up straight as you read helps your breathing, too. Also, try some voice exercises. An easy one is to whisper the

11 Radio

alphabet as loud as possible. It sounds a little strange but it does wonders to loosen vocal cords and throat muscles.

Talk to an individual, not a crowd or a microphone. Speak clearly in your normal, conversational, friendly tone. Your aim should be to *talk* to your listeners, not to read to them. Talk to the individual you've pictured in your mind as if they've never before heard what you're saying and they may never hear it again. You must get your meaning across the first time.

Your voice reflects your state of mind and body. During humorous lines, smile — your audience will "hear" the smile in your voice. To emphasize a point, use your hands. Frown, shake your head in disbelief, count off on your fingers — all these mannerisms help you "feel" the material and help your audience get the message.

Practice. Never give up practicing speech and delivery techniques. This is an area that needs constant attention. Try reading the newspaper aloud once or twice a week. It's a good way to remind yourself to practice.

Always listen to the final product, whether it's a recording of you on the air or someone else reading what you have written. Listen to how it sounds to the audience. Listen to what you did as if you were an individual in the target audience. Did it work the way you thought it would? If not, why not?

Three Bs of delivery

- Be yourself.
- Be at ease.
- Be enthusiastic.

Interviewing for radio

According to Ken Metzler, author of *Creative Interviewing—The Writer's Guide to Gathering Information by Asking Questions,* many people are inherently uncomfortable in an interview situation. Although they are quite capable of carrying on a pleasant conversation, when it comes to doing a formal interview they become tense and unnatural. This is a problem all of us face even when interviewing someone we've known for a long time.

It doesn't have to be that way if we take some time to create the needed quiet conversation conditions and relax ourselves. Things like prepared notes and thinking too much about the next question all contribute to an uptight interview. Relax and the person you are interviewing will relax. Don't pretend you are Phil Donahue or Ted Koppel. Just be you, talking to an interesting person.

Some tips

Meztler and others offer some general interviewing tips.

Let your guests know why you are interviewing them. This will help you get the answers you want and will help put them at ease because they know what you want.

Always prepare well in advance. Many trial lawyers suggest never asking a question that you don't already know the answer to. That's a little extreme for most situations you'll be in, but hardly bad advice. Know what to expect. Know what you want. Be flexible enough to respond to specific information you didn't already know. But have a good idea what you want to accomplish. This will save time for both you and your guest.

Ask "Why?" and "What do you mean?" to gather more and clearer detail.

Never allow your guest to give you vague answers. Remember you may know what she or he means, but the radio station's listening audience does not.

Avoid asking convoluted questions. This often happens when you are well prepared but not so well rehearsed. Ask simple straight-forward questions without much qualification. Then carefully listen to the answer. And don't ask two questions at the same time.

Don't talk too much yourself. A good nod of the head or an under-the-breath uttered "uh-huh" will give your guest the cue that you're listening without butting in. Remember you want this to appear to be a conversation

with two people although the guest will do all the talking. Say only as much as is needed to accomplish that feat.

Know your focus. Before the interview, as you meet and first start talking with your guest, discuss your subject's information in general, but also focus on a specific area, emphasizing two or three main points. List the points in their natural sequence. Suggest how long each section should take.

Prepare your guest. As you visit with your guest, list "lead" questions that you can ask if necessary to move the interview along smoothly and on schedule. If you have time, make brief notes of the information your subject will give in answering the lead questions. These will help you if she or he should forget some of the important points when you actually turn on the microphone.

Encourage your guest to talk freely. Use questions or comments to draw the person out, or to clarify a point.

Open the interview with a direct question. Make sure it is one that requires your guest to take the lead in the discussion. Begin your questions with who, what, when, where, why, or how — relying heavily on how, what, and why. The purpose is to frame a question in such a way that your guest can't answer it with a yes or a no. If you begin a question with "Do...?," "Did...?," "Are you...?," "Is it...?," "Were you...?," or "Have

you...?," you automatically invite a yes or no reply. This forces you to do most of the talking. Another and even more troublesome way of getting into the yes or no reply is to give the information yourself, and then ask, "Isn't that true?" After a few statement-questions you'll be interviewing yourself.

Stress the pronouns "you" and "your" in your questions. Ask your guest to talk in terms of I, my, and mine. Make a special effort to show that you're genuinely interested in what your guest has to say. Maintain eye contact and a warm, close feeling; nod, smile, and give positive, supportive feedback. This will demonstrate your interest and boost your guest's confidence. In addition, your audience can "hear" your interest in the discussion.

Be interested in your guest as a person. Be knowledgeable and enthusiastic about the message. Your audience and the gatekeepers will surely know if you aren't.

Working tools of radio

When you want to provide a radio station with information requiring little or no editing, your basic tools are a good quality cassette recorder and a good quality microphone. When you actually assemble, edit, and produce your own story or spot announcement, you will need a more sophisticated set

up, including reel-to-reel tape recorders and tape editing capabilities.

Tape and tape recorders

There are two tape formats currently available. They are cassette tape and ¼" reel-to-reel tape. The increasing quality of cassette tape and cassette recorders, along with the diminishing size of the recorders, has made cassette tape the preferred medium for gathering information for use on radio. After you have gathered the information, the possibility of using reel-to-reel tape comes into play.

Cassette tape

Audio tape consists of a very thin layer of iron oxide emulsion cemented to an acetate or mylar base. The recorder generates magnetic signals that arrange the iron particles on the recording tape into "sound patterns."

A radio producer at Oregon State University once said buying cassette tape was like buying tires. The temptation is to go for the medium value at the lowest price. But, if you're after quality, whether for a weekly radio show or for delivering raw news and information to radio stations, you should buy a reliable product that suits your needs.

The first rule is to stay away from generic or non-brand-name, three-for-a-dollar tapes. They are not worth the money and could

waste your recording effort. Choose recognized brand-name tapes. When you record speech, choose a Type I tape. The package will tell you it's a ferric oxide (Fe_2O_3) normal bias (or normal position) tape. Most recorders are designed for this type of tape. These will work perfectly for your radio show and your news story. If your cassette recorder and microphone are high enough quality and you are going to record the higher dynamic range of music, you should buy the highest quality Type I tape you can find.

Some newer portable cassette recorders and most home cassette decks allow you the option of using Type II "chrome" (CrO_2) high bias tape. This is good for music recording or spot production where you will be using a music background.

Cassette tape recorders

Knowing which cassette recorder to choose for your office will depend on how much money you feel you can spend and what you plan to do with the equipment you buy. However, there are several general points to keep in mind.

Make sure it has a tape counter. As simple as this sounds, some recorders are made without them. You need a counter when you are recording an interview so you can note a point on the tape at which something important has been said and find that point later.

Choose your options. You'll be offered the choice of a stereo or monoaural recorder. Although stereo might seem more sophisticated and therefore more desirable, for the purpose of information gathering and distribution, stereo is of little help. And in a portable recorder, you are probably better off spending your money on something else essential to your task.

That could be having the option of manual or automatic recording level control. Many modern cassette recorders have some kind of automatic level control. However, you'll find it helpful to be able to switch from one to the other as needed.

Generally, recordings are of higher quality if you watch the recording levels and adjust them manually and subtly. The word "subtle" is important. An automatic level control is designed to search for available sound and almost instantly bring it to a constant level. This is not subtle. A person standing ten feet away from you *should* sound different than the person standing six inches away. With the choice between automatic and manual level control, you have the option of allowing them to sound different.

Consider weight and size of the recorder. Don't skimp on size and lose quality, but don't get something so large and cumber-

some that you tend not to take it with you at a moment's notice, either. Some of the best recordings you'll make will be the ones you get just because you grabbed your recorder and microphone as you were going out the door. Recorders come in all shapes and sizes. Find one that gives you adequate quality but still is small enough to fit your working style.

Choose a plug-in recorder. Be sure your recorder will let you plug in a microphone so you're not forced to use an inferior built-in microphone. While checking for a place to plug in a microphone, known as an input, check for auxiliary inputs for another recorder or the telephone.

Get good headphones. Finally, consider a good set of headphones instead of the typically supplied earplug. This will help you hear the true quality of your recording and help you work unobtrusively in a busy office.

Reel-to-reel recorders

Cassette tapes are fast becoming the accepted standard for delivering information to radio stations. But, if asked for a preference, many stations still prefer ¼" reels of tape recorded on full-track recorders (meaning the entire tape going only one direction is used to record the sound). Most stations can use both cassette and reel tapes. However, if you have access to a reel-to-reel recorder you may find it useful,

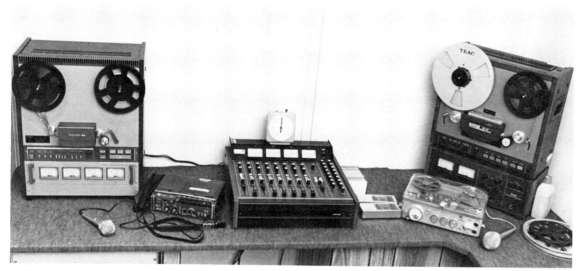

Professional quality is available in multi-channel decks and in battery-powered cassette and reel recorders.

especially for editing. Just remember to record full track, going one direction only and use high quality tape of 1.5 mil thickness.

Microphones

The microphone is the frontline of your radio efforts. It takes the most abuse and is arguably the most important link in the chain.

Microphones are devices that change acoustical energy into electrical pulses. Although the microphone principle of sound reproduction hasn't changed in years, new developments and refinements have been incorporated in microphone construction.

Each microphone has its own pick-up pattern, output impedance (high or low), frequency response, and output level. These characteristics determine the type of microphone best suited to your recorder and need. Be sure to buy your recorder and your microphone as a set or take your recorder with you when you buy your microphone.

Basic types of microphones include:

- Condenser — excellent frequency response, low distortion, expensive, crisper-sounding, more sensitive to faint signals.
- Dynamic — sturdy, unaffected by atmosphere, good frequency response, medium-

priced, will handle loud sounds with minimum distortion, requires no batteries, your "best bet."

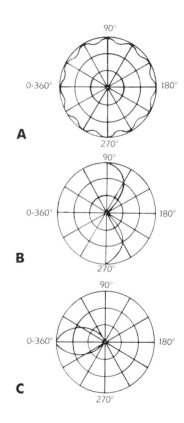

A microphone's response pattern (sound pickup designation) should correspond with the mike's application. The most common response patterns, illustrated by thick lines are (A) omnidirectional, (B) cardioid, and (C) unidirectional.

Another important aspect of microphones is the pick-up pattern. Some are *unidirectional,* meaning they will pick up sound primarily from one direction. Others are *omnidirectional,* meaning they will pick up sound from all directions. Some are *cardioid,* meaning they will pick up sound in a heart-shaped pattern favoring one side. And there are *hypercardioid* or *shotgun* microphones designed to pick up sounds from a limited area over long distances.

Most often, an omnidirectional microphone will be the most useful to you. However in some cases you may have a special need for a unidirectional or even a shotgun microphone.

Common sense is important with microphones. Get one that works well with your recorder, and take care of it as the fragile tool it is.

Some experts say too much emphasis is placed on the kinds of microphones available. In fact, the most critical factor in whether the microphone works for you is how well you use it. Skill and technique come from practice. Learn to use the tools you have to their full capability.

Tape editing

The magnetic sound patterns on recording tape are similar to the printed word. Just as words, sentences, and paragraphs on a printed page can be edited, deleted, or rearranged, so can words, sentences, and paragraphs on tape. With practice you can become quite adept at building the tape content to fit your particular needs.

The irrelevant, the unwanted, the distracting have no place in any radio presentation. Remove them by editing. Often it is necessary to shorten a program or a quote. Do this by editing out the weaker parts, keeping only the portion which makes the point you want. Experienced tape editors have perfected their art to the point that they can make singular words out of plurals by eliminating the "s" sound.

There are two editing methods: Recording from one recorder to another, called *electronic editing* (also known as dubbing), and cutting and splicing the original tape. This method is usually used only on reel-to-reel tape.

Electronic editing

This requires two cassette recorders connected by audio cables from the auxiliary output of one to the auxiliary input of the other. Electronic editing is particularly useful for inserting interviews and other previously recorded material into a program or spot that you're assembling. Use one recorder to play your selected actuality and the other to record it. It's important that your recorders are equipped with pause switches. Using the pause or edit switches, cue or position both tapes to the proper location, and then start them simultaneously. It's that simple.

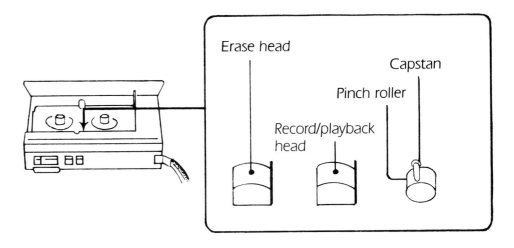

The position of the recorder's components can be easily seen in this diagram.

It usually helps to locate and identify the closing phrase so the tape can be stopped before reaching unwanted audio. After the last sound of the phrase passes the playback head, push the pause switch on the record machine or quickly turn down the record volume. Practice a little, and you'll have no trouble.

Cutting and splicing

The combination of cutting and splicing is by far the most accurate method of editing. And, it's the reason you use a reel-to-reel recorder.

The first step is to remove the head cover on your machine and locate the playback head. Identify where the recording takes place in the middle of the head. Next, listen to the tape carefully, perhaps two or three times, before you do any cutting.

Decide what you want to take out and how you want the finished tape to sound. Use a grease pencil on the shiny back side of the tape to mark the starting and ending points of the part to be cut out. Place the marks in the short, silent spaces between words you want to keep and words you want to take out.

With a single-edge razor blade or scissors, cut to the inside of the marks on the portion you wish to remove, known as the *outtake.* Lay the outtake aside; don't discard it until the finished product is to your satisfaction.

Your editing job is made much easier and faster if you use a grooved splicing block. The block allows you to make precise cuts with a razor blade.

The splicing tape is used to rejoin the two cut segments of the tape. It is a little narrower than the recording tape and is placed over the cut so it doesn't extend beyond the edges of the recording tape. If used carefully, no trimming is needed.

Better recording techniques

Proper recording and microphone techniques become especially important with the low-cost, non-professional equipment in wide use today. Noisy recording areas and poor acoustics, commonplace in most offices, increase your chances of making poor-quality recordings.

Here are some tips to help you cope with or overcome any environmental problems you may encounter.

Always start with a clean tape. This means using a new tape, or one that has been erased. Bulk tape erasers, also called *degaussers,* are available at most electronic equipment stores. A poorer-quality alternative is to run the tape through with your recorder in the record mode with the record volume turned all the way down.

Tape erasers (demagnetizers) remove previously recorded signals and should be used prior to recording.

Cleaning your recorder

If the sounds from your recorder are muddy or muffled, the problem may be caused by dirt. Avoid this quality loss by regularly cleaning the recorder heads, the capstan, which is the shaft that actually drives the tape, and the

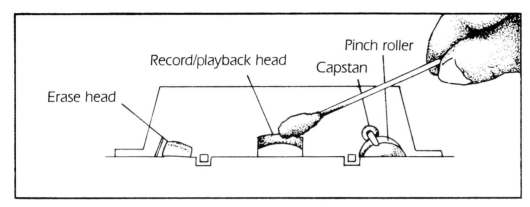

Erase head

Record/playback head

Capstan

Pinch roller

A cotton swab can be used to gently clean main functioning parts of a recorder.

rubber pressure roller. Use a cotton swab dipped in denatured alcohol and gently clean these main functioning parts.

Begin with the heads — both playback and record. Then move to the capstan, the vertical metal spindle that spins. And then clean the pinch roller, the rubber wheel that pushes the tape against the capstan when the recorder is playing.

You are actually cleaning away metal oxide that rubs off the tape. If you use high quality tapes, you'll have fewer problems than if you use bargain tape.

If you are working with a reel-to-reel recorder or one of the larger cassette recorders, like a Wollensak-style, the heads and other parts will be easy to get to. Smaller portable cassette recorders with doors that hold or enclose the

tape make cleaning more difficult. Try pushing the PLAY button to move the heads out in the open.

Caution: Many Wollensak-type recorders have rubber pinch rollers that are softened by the alcohol. Cleaning these rollers in this fashion could cause your tapes to play at irregular speeds.

Additional recording hints

Always turn the monitor speaker off when you are recording with a microphone. That's a primary cause of squealing feedback.

Record at the highest volume at which no distortion occurs. The higher volume on the recorded track helps cover up any noise that might be inherent in the tape or the recorder.

If your recorder has a VU meter, adjust the volume upward to the point where the needle just touches the red on the loudest parts. The sound should be clear, strong, and undistorted when played back on your machine. Do a few test runs.

Always observe the recorder manufacturer's recommended operation and maintenance procedures by reading and following the manual's instructions. Remember, your recorder is a sophisticated electronic instrument; it takes a lot of practice to operate it correctly. The more you use it, the better your final product will be. And don't bang it around. Underneath that rugged shell are delicate operating parts. Do not haul your recorder in the trunk of your car, either. If possible, place it on the seat, on a cushion, or on a piece of foam rubber.

Always allow your recorder to warm up before you use it. Run the tape for a couple of minutes before starting to record. This is especially critical in the winter when the recorder has been in a cold car for several hours. If possible, bring it into a warm building several hours before recording time.

Proper microphone technique

Hold the microphone six to 10 inches from your mouth and at a 45° angle to the direct line of speech. This will help prevent "blasting" and distortion of plosive letters "P" and "B" and the sibilant letter "S." Also this

Proper microphone technique showing proper distance and angle.

will diminish the effects of poor room acoustics. The optimum distance and position will vary with different microphones. Experiment! In all cases, sit or stand in a comfortable position. When holding a microphone, remove rings or other jewelry to avoid striking it.

Place the microphone as far from the recorder as possible. A sensitive microphone will pick up the recorder's motor and tape transport noise. If you use a microphone stand, try to avoid placing the recorder on the same table as the microphone.

In the beginning

When you start recording, be prepared to keep at it. Stopping and starting usually results in distracting noises and varied recording level and voice quality. You can edit out silent pauses later.

Don't speak for 10 seconds, at the beginning or end of your recording. This gives the tape a clean, silent leader and close.

When you do begin, it helps if you use a standard reference opening that includes the date, the place, your subject's name, and your name. Later you will find this valuable information as you sort through a dozen tapes looking for a specific piece of information.

You may also want to count down, "five, four, three, two, one..." This allows your voice an opportunity to stabilize as you start.

When you begin, speak in your normal conversational tone and volume. Don't whisper and don't shout. When talking, always maintain the same distance from the microphone.

If you clear your throat or cough, be sure to turn away from the microphone.

Remove all paper clips and staples from your copy before starting the broadcast or recording. It's too much of a temptation for everyone to start fiddling with them when nervous. Keep your notes still.

Avoid tapping your pencil or clicking your ballpoint pen. Also be careful that the person you are interviewing isn't doing so.

Tape storage

Store reels of tape in boxes or cans. The original box protects a tape from dust and physical damage to its edges. For periods of

long storage, metal cans sealed with adhesive tape are best. If the tape came in a sealed plastic envelope, leave it there until you're ready to use it. Wind reels of tape loosely. Store upright on edge, not flat. Avoid stacking. The weight may warp the plastic reels or damage the edges of the tape. Also, because of the possibility of the magnetic signal transferring from one layer of tape to the next, it's best to store all your tapes' tails out, meaning the end of the recording should be at the outside of the reel.

Store away from radiators, heating vents, hot water pipes, and windows. Do not leave tapes on a car seat or on the ledge behind the back seat, exposed to the sun's damaging rays. Store away from even slight magnetic fields, such as those created by electric motors, magnetic tools, TV sets, or computers.

Store at an ideal temperature (72°F) with an ideal humidity (50%), if possible.

If the tape is exposed to extreme temperatures, such as in mailing, allow several hours for it to return to room temperature before using.

Promoting your efforts

Word of mouth

This is one way to spread the message that radio stations in your area are helping distribute your information. You and your

public. There is nothing wrong with plugging your broadcasts at meetings, during office visits, on farm and home visits, in telephone conversations, and elsewhere.

Posters

Simple posters you make yourself can be very effective. For wider distribution, you might want to use more refined printed posters. Display them at meetings, in store windows, at grain elevators or anywhere members of your target group will see them.

Brochures

If you have a regular radio or television program or time slot, brochures might be helpful. In some states, producers make extensive use of brochures to promote radio and television series and spots. Brochures are particularly useful in providing your audience with dates, air times, topics, and talent listings.

Newsletters

These are ready-made for promoting your broadcasts. People on mailing lists are familiar with what you do and will make up the nucleus of any audience for your information.

Displays and exhibits

Fairs, field days, shows, store windows, bulletin boards, conferences, meetings, conventions, and festivals all offer opportunities for displays or exhibits. These are great places to promote your radio and television programs.

Awards

Using awards judiciously can be a method of maintaining existing radio station cooperation and support. Give a plaque or certificate of appreciation to a station staff member who has been especially helpful that year. This also helps keep you in mind in a positive fashion. Get as much news coverage out of the award presentation as possible. This shouldn't be difficult. Most stations are awards-minded.

Invitations

As a good will gesture, invite station personnel to your organization's functions as guests. Remember they are part of the public you are trying to reach. Be especially watchful for things that could benefit them as individuals as well as media professionals. Once you have a station representative coming to your functions because he or she wants to, you have a friend who will be much easier to work with in the future.

Conclusion

Radio can be a useful, cost-effective, and creative outlet for your information. To make radio work for you, remember these basic ideas:

Know your audience. The more you know, the better you will be able to prepare information that actually reaches the target and has a positive effect.

Use your creativity. Explore the many interesting ways to use radio to distribute your information.

Know what news is and practice finding it. Sound news judgements can accentuate the power of radio.

Regularly review your radio work. Self-criticism can be tough, but it is one of the best ways to improve your presentation.

Work at the level of production you are most comfortable. Once you overcome the technical aspects of radio, you can judge your potential and increase your proficiency as needed.

Be yourself. Practice until you are comfortable. Then you'll be able to concentrate on getting the information correct rather than worrying about how or what to do.

Video and television 12

It takes but a glance at statistics on television viewing to be convinced that television messages can be a powerful, educational tool. Unfortunately, although television is a dominant force in entertainment, news, elections, and the development of a national culture, it is still sorely under-utilized for educational purposes.

In the emerging information age, when the trend is to move "from institutional help to self-help," television and videotapes can be our forum to speak with millions of people where they live, study, work, and play. The equipment is in place. The channels are open. The medium is available and waiting for our message.

The potential of video

Forecasters have predicted for years that television and videotapes would be a dominant force in education outside the classroom. With the falling cost of video equipment and the increased ease of operation, the dream of producing a customized, effective videotape is within the grasp of any educator who will work to understand, not only the mechanics, but the creative process of video productions.

The last decade has brought revolutionary developments in television which have opened new opportunities for the educator. Today videocassette recorders are in more than a third of America's households. Market analysts predict that figure could jump to as high as 85 percent before the turn of the century.

While entertainment videos are currently the most popular, the public's clamor for educational videos has created a multi-million dollar industry and a tremendous opportunity for educators. Market experts say that non-movie cassettes now account for 35 percent of cassette retail sales and sales are expected to climb even higher. Jane Fonda's aerobics tapes earned over $17 million in one year, and numerous how-to tapes on everything from golf to gardening net millions in annual sales.

If ever there was a golden opportunity for tremendous returns from a small investment, video is it. Today the power of video is within reach of educators hundreds of miles away from a television studio or production house.

This chapter is written for educators without television production degrees or access to professional production equipment. Do-it-yourself videotapes do not have to look like home movies. They can be attractive and effective by following some basic principles.

Design and planning

Television is said to be the child of not two but three parents — film, radio, and theater. Yet television is a medium unlike its parents in many ways. It operates with its own rules and delivers its message in a way no other medium can match.

In spite of these differences in the mature form, the genesis of every video or television program applies the same principles of planning and design. A successful producer must recognize the quality of video production, the audience's demands, and the message's impact. Success begins by answering the questions common to all communication efforts.

What is the message? Perhaps the most overlooked step in video production is deciding exactly what message is to be conveyed. Without a clearly stated, one sentence message that you want conveyed to the viewer, your video could be little more than a modernized home movie.

First define a clear message. For instance:

"Extension is worth the taxpayer's investment."

"Tomato diseases can be identified and treated."

"Communication skills will improve 4-H meetings." or

"Home computers can solve four common household problems."

Once your message is clearly defined, every decision related to your production should constantly be checked against this message.

"Which activity best shows a return on the taxpayer's investment?"

"Can the problems of this plant disease best be explained with a live plant or with a diagram?"

"Would role-playing be better than a lecture to teach effective communication skills?"

"Should the video program design allow the viewer to actually use a computer in conjunction with the video program?"

It is important that you keep the objectives of your program to a minimum. Too often video-taped programs try to achieve too much at once and, as a result, accomplish nothing. It is far better to make several short, single concept programs than one long, involved program.

Who is the audience? Before the first cable is connected to the video camera, every producer should ask, "Who will want to watch this tape?" "Why should they care?" "What difference will this tape really make?"

An important part of planning and writing a video script is identifying how much your audience already knows about the subject and how much importance they place on it. If the audience feels the subject matter is extremely important, move directly to the point and begin giving factual information as quickly as possible. Long introductions can give the audience the impression that no new information will be presented.

On the other hand, if the information seems fairly new to the audience, be sure to establish the background and context. Without this

foundation, the videotape could appear complex and confusing.

Is videotape the best medium? Video is not the best tool for every situation. Production is expensive and time consuming. It should only be used when the message is truly visual and action oriented. If the presentation is simply a lecture (a talking head), is it really important that the audience see the speaker? Would an easy, inexpensive audiotape be just as effective? Would a printed publication be less expensive and more effective in conveying technical information? Would a slide series be easier to modify for a wide variety of audiences?

The type of video shot you need is determined by the interests of the intended audience. In this scientific video, for example, the crew uses a large number of close-ups because of the audience's interest in scientific details.

What post-production help is available? If the raw video will be viewed exactly the way it is shot, you have to plan ahead and be creative as you go. Titles, introductions and narration will need to be shot in sequential order. Camera starts and stops will need to be carefully coordinated with the talent or subject-matter specialist.

Before beginning. If you are like most new video enthusiasts, you will probably record your first programs without much planning. This is a natural way to become accustomed to your equipment.

However, your audience will subconsciously compare your production against programs seen every night on network television. Locally produced educational programs never look the same as high budget, unionized productions, but you can offset many of the differences with a carefully planned and well-targeted videotape.

Pre-production

Now you are ready for the actual program planning or what video professionals call pre-production. Pre-production can save time and money because it helps ensure that the final product will meet the needs of your audience. This is the time to touch base with everyone related to the project. This includes subject-matter specialists, anyone providing financial support, and administrators.

Decide whether your program will be a studio shoot (a talking head, panel discussion,

or interview), a field demonstration (a specialist showing a technique), a documentary or event presentation (a review of an event or a crop year), or a dramatization (a parliamentary procedure demonstration or an example of family communication).

Get an overview of the equipment, talent, crew, time, and production budget available. While you cannot duplicate a well-financed,

fully staffed network program, you can study the competition and learn from it.

Analyze your favorite television program and commercials. Start by turning off the sound. You will be surprised at the number of times the camera angles change and shift. To use this fast pace, you need to plan production time for several different camera angles, especially if you are using one camera.

During the preproduction meeting with the specialist, discuss the message and needs of the audience as well as the location, talent and production time line.

While analyzing network programs with the sound off, take time to study the lighting, the framing, and the way the talent reacts to the camera. Watch the camera movements, the focusing, and the use of titles and credits.

As you begin to plan your own program, remember that time is one of the most valuable commodities in the hectic video world. This means that the video program is usually less than 20 minutes long. The viewer should clearly understand the program's goals in the first 30 seconds, if possible, and should be receiving basic information within the first 100 seconds.

You may want to plan periodic breaks within your program to allow the viewer to rewind and replay or simply assimilate the new information. Because the television screen is so small, it requires little eye movement, and no hand or body movement. Viewers can become almost hypnotized without some break in the program. Plan for changes in the pace and transitions to give the viewers time to assimilate the information.

Script writing

The important thing to remember about scripting video is to write not only for the ear but also for the eye. Don't get too wordy. Use an informal conversational style that is correct, yet pleasant to hear. Unlike formal scientific writing, it's perfectly acceptable to use the words "you" and "we" when writing a script for a videotape. Unlike a script for

radio, scripts for videotapes can include some lengthy pauses, as long as you have enough interesting video material or music/sound effects.

As you write, remember to keep the transitions smooth and logical. Once you are finished with your script, read it aloud. If it sounds too formal and stuffy, change it. Then listen to the narrator read it. Correct any areas which feel too formal. Although the videotape may eventually be viewed by thousands of people, you are really talking to only one person at a time. (For more ideas about writing, see the section on writing in Chapter 11, "Radio" and Chapter 1, "The art of good writing.")

Usually, it's a good idea to write and record the script for a narrated program before the video is edited. Editing the video first and then trying to write and record an audio script to match will rarely meet your goals.

Story board run-down sheet.

The video should be used to enhance and emphasize the educational message. Be alert for places where the video can provide the entire message without words. The script is the road map; do not look for short cuts. Look for more interesting side roads to the same destination.

The narration, or mixture of narration and taped dialog, should always be written in the active instead of the passive voice. Sentences should be direct and uncomplicated while helping to paint a visual picture.

With video scripts, it is best to lay out all of the visual information on one side of the page and all of the audio on the other side of the page. More complex programs may require story boarding to help everyone involved visualize the end product.

As you complete the script, review the program's purpose and message. If appropriate, review these points for the audience to give the program continuity, reinforcement and harmony.

Never script interviews or programs which are normally extemporaneous. Word-for-word scripting does not allow for the spontaneous enthusiasm needed to carry off an interview.

Narration

When producing a narrated program, try to involve the narrator as early as possible in the production. Allow the narrator to review the outline and make suggestions. As the narrator rehearses the script, watch for any long, difficult or unfamiliar words or names. Allow the narrator the freedom to change words or phrases if it does not affect the meaning. Details of the actual audio recording are covered in Chapter 11, "Radio." Take time to study the information about equipment and recording techniques.

Planning the visuals

Once the scripting and possible story boarding are complete, organize a location or shot list. Determine the order in which each item will be recorded. Next, make a list of the equipment and talent needed at each location site.

This is the time to decide if you will edit the program or show the tape exactly as it is recorded. If you will not edit, practice with your equipment to understand how much it backspaces for a pause or what happens when you hit *stop* instead of *pause*. Many machines offer a "record lock" feature to allow you to disconnect power and move the machine without causing a *glitch* (a visible video interruption) in the tape. Read every page of the equipment manual.

On the other hand, if you know you will edit later, it is important that you allow the tape to roll 10 seconds before the talent starts each sequence and another 10 seconds at the end. Closeups need to be shot much longer than will actually be used. If you plan to edit the tape later, spend time with the editing equipment before your shoot to understand what kind of raw footage you really need. Nothing will improve your field video quite as much as your first editing session.

Site survey

Now you are ready to conduct a site survey or to check each location. You should already know whether you will be taping in a studio or on location. In most cases, a studio will meet your basic requirements for electrical outlets, lighting, and support facilities. Videotaping outside a studio can present many problems, but most can usually be solved by taking the time to conduct a simple site survey.

Use the following checklist:

■ **Power.** Is electricity available? Will you need long extension cords? Will you need three-prong adapters? Will you need a fused power strip? Will you need to tape the extension cord to the floor to prevent people from tripping? How many batteries will you need? Do you know the location of the fuse box? What is the amperage of the circuits?

■ **Sound.** Sit in each location several minutes with your eyes closed, just listening to the sound. Is there traffic noise? Do airplanes, trains or bells interrupt regularly? Is there a hum from central air-conditioning or heating? Is there equipment nearby which will create an electric hum?

■ **Lighting.** What type of lighting is available? Is it a mixture of several types of light? Is there a background window that will interfere with the shot? Do you need to bring extra lights, reflector curtains, or light-correcting window film?

■ **Space.** Is there enough room for you to use the video equipment? Can people pass through the area without interrupting a shot? Can the camera be placed the correct distance from the talent?

■ **Site logistics.** Can you drive a vehicle near the location to unload equipment? Have you made arrangements with the owners, managers, and users of the space? Are bathroom and refreshment facilities available? Is there a cart available for easy transporting of the equipment? Are there security problems related to the video equipment?

■ **Talent.** Have you made arrangements to include necessary "extras" from the location, such as farm workers or audience members?

12 Video and television

After the site survey, develop a complete list of props, equipment, and arrangements needed. Organize people to help, finalize the scripts, and prepare to work with the talent.

Talent selection and preparation

When selecting the person who will appear on camera, remember that the message is all-important. This means the talent must be able to communicate technical information in a clear and direct way.

Many educational and industrial programs call for the use of subject-matter specialists who have little or no video experience. Any preparation you can give these speakers will go a long way toward making your final production more effective.

Tape a three-to-five-minute demonstration or interview with the talent you are considering before you make a long-term commitment. Many subject-matter specialists can improve their television appearance through practice. On the other hand, some highly knowledgeable specialists have many irritating and distracting mannerisms. It is best to discover these problems early.

If you decide to work with non-professional actors, start the taping session by explaining that they may need to repeat some sections many times. This does not necessarily mean they have made mistakes. Explain that the use of different camera angles, changes in audio setup, and backup shots are important in video production. If you do not explain this

ahead of time, the talent will begin to feel they are doing something wrong and will appear impatient, nervous, uptight, and uncomfortable.

As a general rule, do not have a television monitor in the talent's view during the recording session. An inexperienced actor cannot keep from looking at a monitor during the performance.

Use only a professional teleprompter with non-professionals. Do not use script cards. Untrained actors will clearly appear to be reading and the overall performance is stilted and insincere. Instead, if the talent needs notes, allow them to be held in plain view. In many cases, the talent may actually be more comfortable holding something or "ad libbing" segment by segment.

Sets and locations

For many educational programs, the background involves real locations — kitchens, classrooms, barns, homes, and gardens. While this is less expensive and sometimes more convenient than a studio, it also can have its own built-in problems.

No location is perfect for video. You will need to work with the owner to make slight adjustments. Furniture may need to be moved and pictures rehung. You may have to bring in extra electricity and add lights. You can determine many of the changes you will need to make during your site location. Make a

simple sketch of the area. Show the location of the talent, camera, lights, and microphone. If you need closeups or wide shots, mark the locations of these camera movements or positions.

Set up the camera and analyze the scene carefully in the viewfinder of the monitor. A shiny object in the camera's view will burn a spot into your picture, so move it or cover the spot with non-reflective tape. If it is a location you see often, ask an outside observer. Things you accept as a normal part of the scene could be distracting to viewers. Pay special attention to posters and signs with words which will distract your audience.

Work with equipment in your office to become familiar with it BEFORE you go into the field. An hour of testing in your office can save days of work in the field.

Equipment planning

A complete discussion of equipment is covered separately at the end of this section. However, decisions about the number of cameras and lights will be covered here.

If you have access to editing equipment or a video recorder that performs video inserts, you can use two comparable video cameras and two recorders to ensure that you get all the overall shots and close-ups you need.

Use one camera locked on a tripod for the general or cover shot. This camera will rarely change camera angles or zoom in for a close-up. The second camera, also mounted on a tripod, shoots from a slightly different angle and always remains zoomed in for close-ups. Two video recorders are used to simultaneously record the event. They are stopped only at predetermined spots to change locations, talent, or props.

During the editing session, close-ups from the second recorder are inserted at the appropriate time on the tape containing the cover shot. This technique (called ISO for isolated camera) saves time and ensures continuity of the close-ups with the overall program.

Lighting the production

M any manufacturers claim their equipment delivers excellent video pictures in low light situations. Yet lighting still remains one of the most important factors in the overall quality of your production.

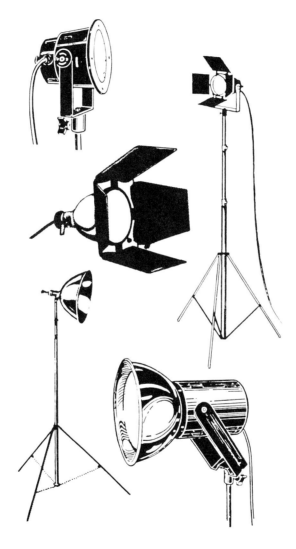

Use different types of lights to brighten faces, erase shadows and separate the subject from the background.

Because the picture you see on the television screen is only two-dimensional, you have to add fullness and depth to your picture by the use of light. Probably the best lighting conditions for outdoor shooting is a bright but hazy or overcast day. In this kind of a situation, there are few shadows, colors will be brighter and more vivid than with full sun, and your talent will not squint. But since you can't always count on an overcast day, plan to use reflectors and overhead canopies.

You can make a reflector out of a wide variety of materials, but foam core is probably the best. This material, available from art supply stores, is lightweight foam with white paper covering on both sides. You can also use commercial parabolic reflectors with pebbled surfaces to soften the reflected light.

Use an assistant or a reflector stand to position the reflector in front of the talent, usually low enough to reflect light into the face. An extremely bright day gives harsh shadows. You will need to use more than one reflector to overcome the problems. Do not be surprised if your talent squints and complains about the light in the eyes. This is another situation when inexperienced talent needs your help in understanding the reasons for the various pieces of equipment.

Another technique for softening the bright sun is an overhead canopy, called a silk. This is a white piece of fabric stretched overhead to

12 Video and television

The key light, located on one side, casts the most light. The fill, located on the other side, softens harsh shadows. The back light points at the back of the head and separates the subject from the background.

block out some of the light. In a way, you could say you are creating your own overcast day. This outdoor lighting technique is more expensive and complicated than simply using a reflector, but if you intend to shoot in one location for several days, it could be a real timesaver. In addition to creating more even light, it will keep the heat of the sun away from your talent and probably lower the frustration level. Just remember, a large fabric canopy can become a sail in a small breeze.

Indoor lighting

Indoors, basic lighting usually consists of at least three lights, arranged to give good, basic illumination. The *key light* is the brightest light and is located to one side of the camera, facing the subject. The *fill light* cuts the shadows created by the first light and evens out the illumination on the face.

While these two lights provide good lighting to the subject's face, the picture will look rather flat without a *back light* to separate the subject from the background. This third light also softens the shadows created by the first two lights.

Again, one of the real advantages of video is that you can look at the results of your lighting during setup and make changes until it is right. Lighting for groups requires extra time and care.

You do not have to invest a bundle of money to have good lighting equipment. In fact, you can use a photoflood bulb in a simple ceramic or metal socket. Do not use plastic sockets because photofloods can get very hot.

Remember that lighting always involves both light and shadows. As you light your production, look at the shadows, especially on faces. Remember that shadows work like a seesaw — raising the light source moves the shadow

Good lighting usually requires more than one light to erase harsh shadows.

downward and moving the light to one side causes the shadow to move in the opposite direction.

As a general guideline, the shadow at the side of the nose should not touch the cheekbone and shadows around the eyes should never obscure the eyes. Shadows under the chin should not fall on the collar. If there is a shadow of the body on the background, the body and the shadow should always overlap.

Production day

One of the advantages of a small video operation is that you can do many jobs yourself and be sure that they are done exactly the way you want them done. This means that as you go through the production you can continuously ask yourself, "Is this technique, viewpoint, or camera angle the best I can use to communicate with my audience?"

You can see the picture yourself in the viewfinder to be sure that there is nothing to distract the viewer's eye. Last-minute changes will not upset the production crew because *you* are the crew.

You should arrive at the location in plenty of time to set up your equipment and run some test video to be sure that everything is working properly. Remember, one advantage of videotape is you do not have to wait for film processing to see the results. Therefore, always run a test shot and review it before you start with your talent.

If you have a long setup in extremely bright sun or other uncomfortable conditions, keep your talent in the shade and use a stand-in for setup. Only when everything is ready to roll should you bring the talent onto the set.

First run through the scene with the talent. Be sure that all props are in place and that the talent clearly understands what you expect. Remind the talent you will probably shoot the scene at least three times and that retakes do not necessarily mean the talent has made a mistake.

If you are conducting a one-camera production, this is the time for a final review of each stop you will make in the production to go in for a close-up.

Before you start the recorder, make one final check. Is the microphone operating properly? Is the picture carefully composed? Are the lights adjusted correctly? Do you know when you will stop the tape recorder?

When you are ready, start the recorder. Do not cue or signal the talent to begin unless the tape you are recording will be the final tape the audience sees. If you plan to edit onto another tape, be sure to allow plenty of lead time before you cue the talent.

Once you cue the talent, do not move away from the tripod area. Although you may be tempted to move in order to adjust equipment, talk to someone, or flip through your notes for the next shot, don't do it. Any movement in the area, especially if you have an untrained

actor, will be a distraction. This usually means no spectators in the area.

Stand immediately beside or behind the tripod and make direct eye contact with the talent. Nod and give an encouraging smile to brighten the talent's delivery. It is difficult to talk into an empty lens, so the camera operator needs to help humanize the camera.

When you reach a predetermined stopping point or when a mistake occurs that cannot be corrected in editing, allow the tape to run a few seconds past the stopping point. It is especially important that you remain calm if the stop was made because the talent made a mistake. The more tense you become each time the talent makes a mistake, the greater the likelihood that the mistakes will proliferate. If the talent seems to stumble at the same point, stop the production and work to change the trouble spot. Sometimes offering a drink of water helps.

The talent will be understandably curious about the results. However, unless viewing the tape will help correct the problem, do not show the talent a replay of the video tape until the scene is correct. Show the talent segments that look smooth and professional, and the chances are good that the rest of the production will also look smooth and professional.

Camera techniques

Because the camera is the viewer's window into the action, the camera operator must know what the viewer will want to see and present it in an interesting way. The camera operator's moves should be smooth and steady to avoid any distracting elements.

Good video production techniques will also provide a variety of scenes. These help the viewer understand the general setting where the action is taking place. One of the beauties of television is that each viewer can have a front row seat, so make regular use of close-ups.

Unless there are reasons in the script to do otherwise, most videotapes begin with a *master* or *cover scene* to establish the setting for the production. You can also open with a medium shot of the speaker or talent who may verbally set the stage and introduce the production. A few hints on composition and camera operation should help ensure a successful production.

Composition

Visuals are the heart of video. There is little that will have a greater impact on the final appearance of your tape than the composition or arrangement of the subjects within the screen. The basics of composition used in still photography apply to television as well. Refer to the composition section of Chapter 9, "Photography" in this handbook for an in-depth discussion of composition.

Classic rules of photography composition encourage the use of the "rule of thirds" which divides the screen into thirds both horizontally and vertically. The main subject is then placed on one of the intersections of these lines. This is simply a rough beginning point for composition and not an absolute rule. Leave space above people's heads in normal close-ups, medium, and long shots. Don't have the subject's head touching or cut off by the top of the screen.

Remember also that the viewer's eye naturally moves toward the brightest object on the screen. Therefore, remember that *subjects dressed in white* or *brightly lit objects* will be the center of focus for your viewers.

Video images usually move. It is important to place the dynamic subject in the screen to give room for action or movement. This means that people should always be looking into the picture. Movement should go toward the center instead of away from the center. As the subject moves, the camera usually anticipates the action and gives the subject plenty of room to move into the screen. The viewer wants to know where the subject is going, not where it has been. Also remember to consider the direction of movement when you are moving the camera around a static subject.

Because the television screen is so small, good video composition can often show only parts of a person's face or an object. The important key to remember is to avoid cutting the face

The distant shot (called the cover shot) sets the scene.

The medium shot shows most of the action.

The close-up shot gives the audience all the details.

on a natural cut-off line such as the eyes, mouth, chin, waist, hemline, or knees. Instead, try to cut the close-up of your subject either inside or outside of this imaginary natural cut-off line.

Look for unusual camera angles to tell your story. Extremely low or extremely high camera angles can produce an unusual and striking scene. Experiment with wide shots of the entire room, medium shots that include two people, close-ups which usually take in only the head and shoulders, and extreme close-ups that show only part of the face for dramatic impact.

While the zoom can provide additional motion, do not overuse the technique. Zooms to an extreme close-up should never be attempted with a hand-held camera. In general, a tripod will always improve the shot. If you hand-hold, try to keep the camera lens zoomed all the way out (using the wide angle part of the lens).

Depth of the scene

Because television is a two-dimensional medium, it is important to work to create the illusion of depth by using foreground, background, or a variety in the scene. Include tree branches, fences, or furniture in front of the subject to give the scene depth.

Brightly lit subjects in strong colors seem closer to the viewer than dimly lit, less saturated colors. Also remember that zooming in, or using the narrow angle portion of the lens,

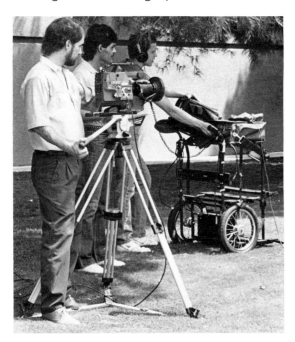

A good field set up includes a tripod for stability and a field monitor, preferably color, for instant playback. Batteries increase mobility.

reduces the illusion of a three-dimensional scene. Zooming out, using a wide-angle portion of the lens seems to exaggerate depth.

Continuity

If you break to change the camera angle, especially for a close-up, review the last camera shot before you begin recording. You want to be sure that the edit will be smooth from the long shot to the close-up. This factor is called *continuity.*

If the homemaker was holding a knife in her right hand on the long shot, be sure she is holding the knife the same way on the close-up. If you do not make a conscious effort to check continuity, you will discover too late that the knife in her hand in the close-up scene was in the rack on the long shot and that the two onions that were in the long shot magically disappeared in the close-up.

Check to see that people are standing in the same place, wearing the same clothes, looking the same way and holding the same items before you begin running the recorder.

You can also have continuity problems simply by changing the location of your camera too much during a scene. For example, if two people are facing each other while talking, the amateur cameraperson may think it will improve the scene by shifting the camera to the opposite side to add a variety of shots to the production. The cameraperson may not notice until it's too late that this camera

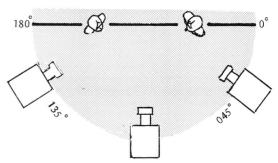

Run an imaginary line between your subjects. While the camera can move in or out, it should never cross this imaginary line.

movement made the talent appear to have switched chairs or places in the scene. This problem is called *crossing the line.*

Run an imaginary line between your two subjects. No matter how close or far away the camera moves, it should never cross beyond this imaginary line.

Reaction shots

Once you have shot the overall scene and the close-ups, you may want to get some additional interesting shots to add variety to the production. These shots are called *cutaways* or *reaction shots.* They include the reactions of people in the audience laughing, nodding in agreement or listening intensely. They could also include plaques and mementos in an office, decorations and conversation pieces in a home, animals playing, or plants growing on a farm. These shots could be extremely valuable in the editing session.

For example, if you are editing a program of a father talking about what it is like to be a single parent, you probably will not stop an emotional section to adjust a camera angle. However, when you begin putting the program together, you may find that the middle five minutes is unrelated to the theme of your program and you want to cut it out.

If you simply remove that section, you will have an obvious edit called a *jump cut.* This is distracting to the viewers and clearly signals that you have edited the program and something has been left out. If you have taken cutaways in the room, perhaps of toys, pictures or the child playing, you will be able to edit the tape so the audio flows. Then you can cover the edit point with a cutaway. When taping a presentation, it is especially important to get a series of "reaction shots," showing people reacting to what is said or done.

The talking head

Talking head programs are just exactly what the name implies — a shot of a person talking with little or no extra video to illustrate, demonstrate, or animate the message. These programs are common for interview and lecture programs.

While some subjects and speakers may be interesting enough to hold a viewer's attention simply by opening their mouth and speaking, most speakers communicate better if you add other visuals. If talking is truly all that is needed, why not use only an audio tape?

Sometimes there is no choice but to do a talking head program. Maybe time is truly short, and you must record and distribute emergency information. Maybe you are dealing with an administrator or busy talent who only has time for one take. To make the best of your situation, start with an attractive set.

If possible, place the speaker in an environment related to the topic. If appropriate, move the talent outdoors. An agricultural economist can stand near an empty corral as he talks about low beef prices and hard times. Get on top of a building overlooking a busy street with the community development specialist as she talks about community growth. Adjust your camera so you can see the busy city in the background and perhaps go to some cutaways of the community in post-production.

If you must use an indoor studio, select the chairs carefully. A narrow, firm armchair will keep the talent from fidgeting or wiggling. A high stool which allows the talent to put one foot on a rung of the stool and the other on the floor can be especially attractive for a speaker who is short or overweight. Using a stool often makes the talent seem more alert, vibrant, and interesting.

In either case, turn the chair or stool slightly to the side so the speaker must turn to face the camera. This angle will be unnoticeable to the audience, but it helps the talent look slimmer and more alert.

The talent should never be placed in a chair that swivels or rolls. In spite of all warnings, the talent will soon begin to turn in the chair and roll on the wheels. Not only is this distracting to the viewer, it also makes it almost impossible to keep the speaker properly composed and in focus.

If possible, place the chair in front of an unpatterned drape with proper back lighting. Use simple but attractive set additions, such as green plants, an attractive lamp, or a few books. Be careful of set distractions. Spray shiny chrome with dulling spray or hair spray.

Whenever possible, try to add a visually interesting, three-dimensional prop to your educational program. Use the real thing or a working model for interesting close-ups. Again, simplicity is the secret.

Props make the production scene more interesting, but too many props will cause it to appear cluttered. Because video allows you to review and analyze the scene immediately, always record a sample shot to check for distracting glares.

Stress to the talent the importance of looking directly into the camera during the entire production. If the talent must look away, looking down as if to notes is probably best. With most talking heads, you will pull into a fairly tight close-up. If the talent continuously looks to the side away from the camera, he will appear shifty and untrustworthy in the close-up shot.

Video and television 12

Interviews

In many cases, especially with a guest who has absolutely no experience with video, an interview situation is the best. Hopefully the interviewer has had experience with the video camera and can help guide the inexperienced guest.

One advantage of the interview situation is that it gives you several options in post-production. If the answers were complete without hearing the question, the presentation can often be edited to exclude the questions. If you do this, however, it is vital to have plenty of interesting cutaway shots of things in the room, graphics, or the reaction of the audi-

ence. These shots will assist with smooth transitions between edits. Read Chapter 11, "Radio" for more suggestions on interviewing techniques.

Once you are ready to shoot a "talk show," especially if it is a one-person presentation, it is best to allow the talent to present and record the entire speech from beginning to end with no cuts. Record mistakes, bobbles and hesitations. Sometimes the first presentation is the most spontaneous, and you may be able to correct any problems in editing. In addition, once the talent knows the entire presentation is safely recorded onto video tape, retakes may be much more relaxed and smoother.

Hints to the talent

Clothing. In general, the talent should wear comfortable clothing. Television has a tendency to add a few extra pounds to the talent, so aim for slim-fitting clothes instead of a heavy, horizontally striped suit. Avoid clothing with sharp contrasts such as a dark suit with a bright background. Lighten a dark suit with a pastel shirt. Stay away from bright plaids, busy flower patterns, or herringbone fabrics.

At all times, your clothing should look appropriate for the subject you are discussing or demonstrating. You will look very uncomfortable and unbelievable if you try to plant a garden or spray cattle in a suit.

Because video can be replayed immediately after it is shot, always take time to review the footage before the specialists, actors or props leave the area. Check the script to be sure you have all close-ups, reaction shots and good continuity.

12 Video and television

In general, it is best not to wear solid white, black, or navy, which sometimes appears as black on the screen. Instead, wear medium blue, charcoal gray, and greens. Reds can stand out too much and be badly distorted. On the other hand, pinks, oranges, yellows and other warm tones have a more calming effect and are good for video work.

For a formal presentation, men may select a blue or gray suit with a conservative pattern in the tie. In general, avoid vests because they make you look too formal. Wear calf-length socks.

Women who dress conservatively should be careful not to appear stuffy. Wear pearls, a simple necklace, or gold chain. Avoid long, dangling earrings which could distract. Excessive jewelry reflects the light into the camera. This includes shiny wristwatches, earrings, tie clasps, or bright buttons. While dulling spray can tone down flashy jewelry, the talent may object.

Make-up. Although better cameras and lighting conditions have done away with much of the need for makeup on the television set, it can still be helpful to men and women alike. Simple face powder can eliminate distracting shiny spots on a face or balding head.

Men should shave immediately before a television appearance. A blade instead of an electric shaver is preferable. The television camera has the tendency to accentuate any hint of a five o'clock shadow and gives the

Men may need a touch of face powder to eliminate shiny spots on the face or head. Make-up can also help cover the "5 o'clock shadow" which often looks bluish on TV.

beard a bluish tint. Men with heavy beards may want to use a very light powder or make-up base to overcome this bluish cast.

A woman's normal make-up will probably be acceptable on television. However, dark reds or maroons have a tendency to turn blue-red and look harsh in a television camera. If you are light complected or have blonde eyebrows, you may wish to use a slightly darker make-up and darken the eyebrows.

Well-groomed hands are especially important for television work because the camera will often focus extremely close on the hands. Be

sure your nails are clipped to a medium length and there are no chips in the polish. If needed, use make-up on your hands as well to give them a smooth appearance.

Posture. Research has shown that 60 percent of the audience's perception of the talent comes from non-verbal body language. Because television is such a close-up media, any non-verbal cues will be greatly exaggerated. Casually reclining in a chair, for example, could be interpreted as laziness and disinterest in the subject. Therefore, always lean slightly forward in your chair to show involvement and interest.

Make a conscious effort to keep eye-to-eye contact with the interviewer. If you are speaking directly to the television audience, look directly into the camera and avoid shifting your eyes from side to side. Your eyes give the real cue to the audience as to whether you are trustworthy, enthusiastic, and self-assured. More than any other body gesture, the eyes send the strongest message to the viewer.

In an interview situation, always be aware that the camera could come on you at any time, so always look involved and interested. Keep your eyes from roaming. Especially beware of glancing at sideview cameras or monitors out of the corner of your eye.

Video and television 12

Television performance mindset

Initially performing on television may be one of the most difficult and, at times, discouraging of all public presentations. The smallest distracting mannerism is accentuated, and since there is no immediate feedback from the audience, it is difficult to be enthusiastic.

Research has shown that the talent's attitude toward the opportunity to communicate by television will make the major difference in the way they are perceived by the audience. Confident, flexible, and apparently relaxed speakers communicate much more effectively on television than self-conscious, timid, and rigid talent.

The best way to improve television appearances is for the talent to critically analyze a videotape of each program for body language, eye contact, sound of the voice, and gestures.

Post-production

Before the talent leaves

Once you have shot the presentation to your technical satisfaction, ask the talent to review the tape, especially if the talent is also the subject matter specialist. Make a checklist of every spot that needs editing. This will not only be valuable to you later, but it will also give the talent confidence that you will not allow the errors to appear on the final videotape.

This is also a good time to talk about cutaways. As you review the raw footage, ask the subject-matter specialist which visuals could be added at each point. Make arrangements to get maps, charts, and other props to add to the tape. If you have access to a character generator, make note of all titles, words and phrases which should be superimposed over the speakers or cutaways.

This is also the time to check little details, which, if left unchecked, can grow into massive problems. Are all the names in the program spelled correctly? Is each followed by a correct title? Is every mistake in the *dialog* clearly noted, followed by a plan for correcting the problem? Have arrangements been made to collect data slides or data information?

Wild sound

When possible, always record audio related to the picture even if you do not plan to use this audio as the primary sound of the tape. The sound can be used with the volume turned down during editing as an introduction to the subject to become a background for the narration. Because *wild sound* can be such an important part of videotape, it deserves the same attention to good fidelity, volume, and freedom from distortion.

Graphics and props

Television should be prepared for both the ear and the eye. This means that graphics play a major role in giving your production a professional look. The graphics do not need to be complicated or expensive.

As you are preparing your outline and script, make notes in the margins for any graphics, words, titles, props, or charts that add to the message. Start early to prepare and gather these visual items. Graphics and props are especially important when you are dealing with a program which will be mostly talking heads.

Aspect ratio

Because the television screen is one fixed size, the shape of any graphic or art work becomes critically important. The relationship of the height to the width of the screen is called the *aspect ratio*. In television this ratio is four to three. This means that visuals should be prepared specifically for television use.

When designing a graphic for television, it is usually best to prepare all graphics on posterboard cut to 14" x 16" inches. Use light blue or tan posterboard instead of white. Outline a 12" x 9" inch rectangle in the center of the board. This will be the correct size and ratio for television use.

12 Video and television

Graphic production techniques

If you work with a professional editing facility after shooting your production, you may be able to add many of the titles, words, and graphics in the studio. These words can be electronically generated and added during the editing process. In addition, many personal computers can now produce graphics acceptable for video use if the electronic timing between the computer and the video equipment can be synchronized.

If you do not have access to synchronizing equipment, you may find that press-on letters offer the easiest solution to a titling problem. In general, these commercially prepared letters appear far more acceptable than hand-drawn work. The letters are available in a wide variety of sizes and character styles. For more information on the selection of a typeface, refer to Chapter 6, "Graphic design."

In order to use press-on letters, simply center the letter sheet over the correct position on the card and rub. The wax coating on the back of the letter sheet adheres to the poster. The letter will remain behind when the letter sheet is lifted.

Once the graphics are prepared, the talent can choose to refer to them on camera or they can be added later using insert editing, described below. When producing these charts, try never to have more than five lines of lettering per card. In most cases, there should be 15 letters or less per line.

The teleprompter allows the talent to read while looking directly at the camera. Homemade cards will NOT substitute. Actors reading cards look unnatural and untrustworthy.

Slides

Slides can be transferred to video, but only the sharpest, clearest slides should be used. Video only has a contrast range of 20:1 while film has a range of 100:1. This means that you lose a great deal of detail in each slide shot to video.

In addition, many educators are surprised to learn that the aspect ratio of 35mm slides is drastically different from the aspect ratio of television. Only about two-thirds of a 35mm slide can be seen on television. This means that slides with important information around the edge of the picture are unacceptable. It should go without saying that vertical slides are totally unacceptable unless used with a film chain which allows the close-up camera to zoom into a small area of the slide.

Editing

If you have done much videotaping, you have no doubt wished that you could edit out or remove a distracting blunder. Hours of acceptable tape can be almost unusable if there are even minor problems throughout the tape.

Video editing is accomplished by copying portions of the videotape from one machine to another, while avoiding those sections you do not wish to keep. The simplest form of editing involves two videotape machines and some connecting cables. More professional editing requires a control unit to program, preview, and perform each edit.

Editing involves almost as much time and planning as the production. Start by reviewing all the tape you have shot. Make notes that refer to the counter number on the playback machine. Highlight segments that best fit the script and purpose of the program. If you are using a machine that allows audio and video insert edits, you can often plan to use the sound from one scene and the picture from another.

When selecting tape sections you wish to copy, remember to look not only at the message and performance of the tape but also at the production quality itself, such as the lighting, sound, and camera work.

"Home style" editing equipment

To edit in your office, away from a professional studio, you will need a machine with audio insert and video insert features as your "record" machine is in an editing operation. The "play" machine can be a relatively inexpensive model. However, a player offering forward and reverse search makes the editing operation easier.

The general setup for editing simply involves connecting the *audio* and *video out* of the play machine to the *audio* and *video in* of the record machine. If you only have one monitor or television, connect it to the record machine.

Load your master or original tape in the play machine and load the blank tape in the recorder. To test your setup, play the original tape and press "record" and "play" on the record machine. Record a minute of the picture and sound and then stop both machines. Check the recording of this test program to be sure that everything is correct. If it is not, recheck your connections.

If you are using the insert mode, this is a good time to check the technique. Because insert editing requires a signal to *already be* recorded on the tape, you can start the test by recording a black signal from your camera. Leave the lens cap on the camera and plug it into the record machine. Press "record" and "play" and let the recorder run for 10 minutes. Now test the video and audio insert editing technique.

Basic editing techniques

The editing techniques you choose for editing will depend on the type of program you produce. This chapter will discuss the two most common techniques — *assemble editing* of recorded material, such as a demonstration, and *insert editing*, such as music on a narrated program.

Assemble editing records not only picture and sound, but also a synchronizing beat called a *control track*. The control track is vital to the picture quality and insert editing. Insert editing lays down only the picture, leaving the sound and control track alone, or only the sound, leaving the picture and the control track alone.

In general, the equipment hookup and the program opening are set up in the same way for all editing. All tapes should open with at least a minute of black and silence. To achieve this, attach the camera to the recorder and put the cap on the lens. Do not attach a microphone. Use the record and play button and allow the tape to run from the beginning for about a minute.

If you shoot your titles from title cards, pause the camera after the minute of black. Remove the lens cap and frame the first title. Take the camera off pause for the desired length of time and pause again to change the credit poster. Allow the last poster to run 15 seconds beyond the length of time you need in the final production. If your machine has audio insert, it is best to add the music later.

The next step depends on the editing technique you use. In the assembly edit technique, you simply begin with your first picture and sound selection. Programs with a narration usually start with the sound before the pictures are added.

Assemble editing

Assemble editing is the simplest method of editing and uses the simplest kind of video equipment. As explained above, equipment with forward and reverse search make the editing job easier. After setting up the equipment, you may follow these steps:

■ This process will require a record machine that allows you to quickly take the record machine off of "pause/record" to "regular record." Test this now with a blank tape or one that is not valuable. Start by playing the tape, then put the machine in "pause." Next tap the "record" button so the machine is in "record/pause."

The secret is to change the machine quickly from "record/pause" to "record/play." This is usually accomplished by either hitting the "pause" button a second time, or hitting the "play" or "record/play" buttons simultaneously. You need to test the technique needed for your machine several times until you can quickly activate the "record" status from the "pause/record" status.

Editing is smoother with edit control equipment designed for the job.

■ Now you are ready to edit. Look at the original, raw field video in your play machine. Locate the starting point on the "play" (original) tape of the first scene you want copied onto the edited version. Rewind this "play" tape slightly and stop the play machine.

■ Find the starting point on the "record" tape where you want the new material from your original footage transferred. Hit the "pause" button when the record tape gets to the exact point you want the new material to start.

■ With the record machine in "pause" at the exact point you want the new material to start, tap the "record" button on the record machine. The controls on your recorder should now indicate the machine is in "record/pause."

■ Now that the record machine is in "record/ pause" and you are ready to quickly activate the "record" status, play the original field footage in your playback machine.

■ When the play machine reaches the point on the original footage you want transferred to the record tape, quickly take the record machine out of the pause mode. Record all the material from the original footage you want transferred to the edited tape.

■ Don't get in a hurry to stop the recording process. Allow the two machines to run 10 to 15 seconds after the tape passes the end of the footage you want transferred onto your new edited tape. (You will cover up this unusable material with your next edit.) Stop both machines.

■ Now you are ready for the next edit. Return to your play machine with the original field video. Play this original tape until you find the beginning of the next scene you want to transfer to the edited master. Stop the machine and rewind the tape slightly. Stop the play machine.

■ Rewind the record machine and play your edited master tape until you reach the exact point where you want the new material to start. Hit the "pause" button now.

■ Touch the record button on the recorder as discussed previously. The record machine should now be in "record/pause." Again prepare to take the machine quickly out of

record/pause into the straight record mode, as practiced above.

■ Now play the videotape on the play machine.

■ When the playback machine reaches the starting point of the new material you want to transfer to the edited master, quickly take the record machine out of "pause" and into "record." This will record the new material, as discussed above.

■ Again allow both the player and recorder to run 10 to 15 seconds after the end of the section you want transferred to the edited tape, as above.

■ Rewind the record machine and look at your edit point. If it is not correct, this is the best time to redo the edit. Learn from your mistakes.

■ Continue editing the tape using this start/stop assemble editing technique from beginning to end.

■ At the end of the program, use the camera to record the credits.

■ At the end of the credits, replace the cap on the camera and record at least a minute of black onto your tape.

■ If you want to add music, a small section of narration, or a small piece of video without sound, use the techniques described in the following insert editing procedure.

To do this, leave the lens cap on the camera and attach the camera to the record machine. If the narration is completed either on audio tape or on another videotape, feed the audio output into the record machine through the audio input. Activate the record and play button. Start the audio portion of the tape. This records a black video signal and the control track at the same time you lay down the audio track.

After the audio narration ends, pause the record machine. If you want to record closing credits, do it now while the camera is set up. When this is completed, replace the lens cap and record a minute or two of black before stopping the machine.

Now that the narration is completed, you can rewind and begin inserting the video material. Follow the instructions for your record machine and use the experience you gained in the test you ran before starting editing.

The secret to smooth editing when working from beginning to end is to allow the record machine to record *beyond* the point you wish the edit to stop and then rewind the tape to overlap the unwanted material with the next edit. Insert edits between two portions you want to keep are the most exacting. Test it on another tape first.

You will use a similar technique for inserting background sound or music after the video portion of the program is completed. Again, the entire tape needs to have been recorded

using the record-play controls. In order to add a sound track, use the audio insert controls and follow the instructions for your particular record machine.

Insert editing

Insert editing records only the picture or sound portion of the tape. It does not record the synchronizing beat called the *control track*. After the opening is on the master tape as described above, the entire tape must be recorded using the "record" and "play" buttons before using the insert edit controls.

Editing summary

Because there is a wide variety of video-cassette machines, exact instructions are impossible to give here. Follow the instruction book for your recorder to test the insert editing mode. Recheck your tape and keep experimenting until you understand how these controls work.

Using this editing technique, you can prepare an acceptable videotape for your educational program. While practice will make your edits better, they will never be as smooth as those prepared with an editing control unit. If you have access to professional editing equipment, use it. If you cannot be present during the editing session, you may want to use the techniques described above to make a "rough cut" to serve as a guide to the editor in the professional studio.

In summary, editing takes time and patience. The simple fact that you are making a copy of the original material means that you will lose some of the video quality. This is generally offset by the removal of distracting material during the editing process and the ability to insert graphics, narration, and music.

Nuts and bolts (and buttons and cables)

Formats. The war that raged a few years ago between the BETA and VHS formats has calmed with VHS claiming the victory for the home market. Today, buyers may be lured toward the mini-VHS, 8mm or even the ¼" formats which promise a high degree of portability. However, before you buy into a system drastically different from the standard two-hour VHS format, consider a VHS camera-recorder combination. You could also develop an inexpensive system by using a 25-foot camera cable with an inexpensive, nonportable recorder.

Recorders. If the sole purpose of your recorder will be to record television shows and play back prerecorded tapes, a basic, inexpensive recorder should fit your needs. Before you buy an extra $150 worth of special features, ask yourself how often you will really want to record an hour every day for a week. Even on the slower speed, a tape will not hold more than six hours of programming. Many of the extra features are never used by the average consumer.

On the other hand, if you intend to edit with your machine and use it extensively for portable shooting, you need to invest about twice as much money for a portable machine with edit features.

Editing requires two machines. The playback machine can be an inexpensive model with few features. However, the record machine needs to have video insert, audio insert, and shuttle search.

Don't forget service—you will need it some-day. While mail order equipment may look attractive, a typical $100 repair bill could offset your savings. Most video stores offer extended warranties which are probably a good investment. In addition, a local vendor can be a valuable source of free education.

Cameras. No single camera is right for every situation, but there are a few features you will probably want. Consider cameras with an automatic iris, zoom lens, one-button or automatic white balance, and a macro lens.

Tubeless cameras also have many advantages and are competitively priced. They do not leave a trail of light when crossing bright spots, such as chrome or jewelry. In addition, they are not ruined if they are aimed at the sun.

On the other hand, some features may not be as attractive as they first appear. For example, extremely small, hand-sized cameras create a problem with camera movement.

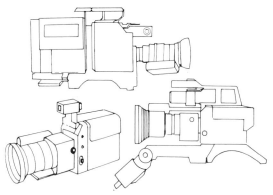

Different camera features meet various needs. Tubeless cameras and macro focus lenses are helpful while autofocus can cause problems.

Experience has proven that the lighter the camera, the more likely it is to produce "earthquake" video. Hand-held cameras which don't rest on the shoulder are the worst offenders. Since any serious camera person always uses a tripod, ultra light cameras offer little benefit.

Automatic focus can be another trap. While it may sound like a logical choice at first, it often produces distracting video. Because it usually focuses on the closest object, anything passing in front of the camera will trigger the focus control. If you buy this feature, be sure you can override it.

Viewfinders offering color instead of black and white may also seem like a good idea, but they are harder to focus. Most professional cameras have black-and-white viewfinders for that reason.

Tape. Videotape is more similar to audiotape than to film. It is magnetically sensitive material that records both sound and picture. Videotape takes a real pounding because the sharp video heads contact the tape 30 times per second. The wear and tear on the tape is greatly compounded when the machine is set in the long-play modes or used for rapid scanning or extended still frame playing.

Videotape is probably one of the least expensive components of the entire videotaping operation. Therefore, it is false economy to record anything of value at a slow speed or on an old tape. Recordings made at slower speeds are much lower in quality. They can not be edited on professional editing equipment. In general, *never record on the slower speeds.*

In addition, beware of the extended play tapes promising eight hours per tape. These tapes are much thinner and will not stand up to demanding use.

Labels and record guards. It is surprising how many people will spend hours recording a program and then get too busy to label the tape. More than one tape has been lost or rerecorded because it was not marked. Get in the habit of labeling your tapes before you start the recording session.

When you are finished recording, break the record tab out of the back of the tape case.

■ Nuts and bolts (and buttons and cables)

Batteries. There are three kinds of batteries: lead-acid, Ni-Cd, and lithium. You have to know which kind you have, because they require almost totally different care.

Lead-acid gel batteries should be recharged immediately after each use and should never be allowed to completely run down. Ni-Cd batteries, on the other hand, should not be stored full and should always be drained completely before they are recharged.

Ni-Cd batteries can quickly build up a memory of the last use. This means that if you recharge it after only 10 minutes of use for a time or two, for example, do not be surprised if, just when you need a 30-minute battery, you get only 10 minutes. To correct the problem, drain repeatedly and recharge.

Lithium batteries are relatively new, but are expensive and non-rechargable. They are not affected by heat or cold and have a longer shelf life than other batteries.

Microphones. Sound is, unfortunately, usually considered only as an afterthought in video productions. After the cameraperson has spent so much time with the video equipment, it is sad how often tapes are virtually unusable because of poor sound.

There are two kinds of microphones, each with its own uses. The *omnidirectional microphone* picks up sounds from all directions at all times. It is usually the type built into video recorders and used in lavalier mics. While it is great for group discussions, it can

Omnidirectional mics are great for groups while unidirectional mics work best for one per person.

also pick up a lot of undesirable, distracting noise from traffic, motors, and unrelated conversations.

The *unidirectional microphone*, on the other hand, picks up only within a very narrow range and must be pointed directly at the speaker. However, it can eliminate most unwanted noises from a tape. Most hand held mics are usually directional mics which work well for individual speakers who can stand close to the microphone.

Always make a test run with your microphone, especially if it requires batteries. If the last user left the microphone switch on, you will probably need new batteries. If the microphone sounds weak or cracks, you may

have a broken wire, damaged microphone, or a microphone with the wrong impedance. Do not start the shooting session until you correct the problem.

Accessories. Some accessories should be considered vital to a video production unit. They include a clip-on microphone with a windscreen, earphones, a camera tripod, color balanced lights for indoor shots, and a transport case. Highly desirable accessories include extra batteries, a cigarette lighter power attachment, a 25-foot camera cable, a portable color monitor, electrical extension cords, and a power strip.

Mind over machine

Before you plunge headlong into the control center of video cables and buttons, remember that one of the most important components of the video production is a calm, confident attitude. One of the real advantages of videotape over film is the instant playback—you can know immediately if you are doing something wrong and can correct it before you invest lots of time.

Therefore, be sure to plan enough setup time to allow for plenty of test runs and playbacks. Be confident that you can correct any problems that arise. If you become extremely tense and frantic, it is almost certain that you will have "equipment problems."

If something does not work, start at the beginning and check your set-up. A cookbook-

style list of steps can be valuable to even experienced operators. Above all, don't force anything. Video equipment is designed to operate smoothly; brute strength almost always does more harm than good.

While there are few ways you can permanently damage a video recorder, short of using brute force, you can burn your camera's tube without knowing it. (Cameras with chips instead of tubes rarely have this problem.) Any extremely bright light — the sun, reflections from chrome car bumpers or water, or bright theater lights can burn spots into a camera

tube in seconds. Even when the power is turned off, direct sunlight in the lens can burn the tube, so always keep a lens cap on the camera when it is not in use.

Extreme heat, humidity, or cold can also hamper video operation. If you are taping outdoors in direct sun, shade your equipment. Do not leave your tapes in a hot car. On the other hand, if you bring the recorder into a warm room from a cold car, moisture can condense inside the recorder, so do not use it for several hours.

Static electricity, whether from a storm cloud passing overhead or from a nearby coiled electrical cord, can also temporarily cause the equipment to malfunction.

Aside from these few problems, video equipment is really quite forgiving. Since videotape can be used again and again, practice is practically free. Set up the equipment at home when you have plenty of time to test it without people watching. Make a checklist that works for you and follow it.

Fine tuning

There are so many minor variations in set-up procedures, it is best to refer to your own instruction book. At first, the instructions can be confusing, but keep trying. After you have used your camera for a few months, it is a good idea to reread your instruction book. It is amazing how many things make more sense after you have a little experience.

The basic setup connects the camera to the recorder and the recorder to a monitor. The audio can connect to either the recorder or the camera. The sound should always be turned off on the TV monitor when you record or you will get feedback, a high-pitched whistle. If possible, monitor the sound and pictures from the recorder, not the camera. Remember, one big advantage of videotape over film is that you can check your work immediately and correct any problems. Be sure that you always rewind and view your tape periodically to be sure everything is still working correctly.

Work with the local TV station production staff to help them quickly find and tape news stories. Be available during the shoot, but don't interfere with their need for speed.

Color control. The human eye usually does not notice subtle changes in colors when viewed in various lighting conditions, but they happen. The video camera does not have a brain to automatically compensate for these changes, so you will have to think for it. This usually involved two controls — *color temperature and white balance*.

The *color temperature* control is usually a simple knob with pictures of a light bulb, fluorescent light and the sun. Once you tell the camera basically what kind of light it is seeing, it is ready for a fine control. To do this, zoom in on a piece of white paper or anything white. Activate the white balance control, which is usually a button you push for two seconds. Once the camera knows what white looks like under a lighting condition, it knows how to adjust for all the other colors. Remember that the camera must be readjusted every time you change from one lighting situation to another, such as from outdoors to indoors.

Focus. Many camera operators have difficulty focusing the camera. Too often the picture will look sharp and clear until you zoom into a fuzzy closeup. This is because you did not focus on the close-up before you started.

In order to focus properly, always zoom in as far as you can, regardless of how far you plan to zoom out for your final shot. Focus on this close-up shot, and then zoom out to compose the picture. Remember, if your subject moves closer to the camera after the tape has started to roll, the close-up will no longer be in focus, and you will need to refocus the close-up.

Zoom. A sure sign of an amateur is lots of camera zooms. Do not zoom unless you have a very good reason. Simply think of the zoom control as a smooth way to set up your initial shot. If you need a close-up, try to plan a pause in the tape and set up while the tape is not recording, then take the camera off pause and cue your talent to resume the demonstration. Never attempt a closeup without a tripod. Remove the zoom stick or handle, if the camera has one. It will only catch on your hand and move the camera on the tripod.

Equipment care

Tender loving care. Ordinary dust, brute strength, and simple neglect are probably the three worse enemies of the video camera, recorder, and tapes. Video equipment is designed to operate smoothly and reliably when cared for in a reasonable way.

To protect the equipment from dust, simply cover it when it is not in use. The video camera should be sealed, preferably in a case with a foam lining. Keep all video equipment away from excessive heat or cold during transportation, operation, and storage. Never let the equipment get wet. If you do, have it checked by a repairman before attempting to use it again.

Camera. Hopefully, you will keep a protective filter on the front of your video camera. This can be a haze or a UV filter. A filter protects the camera from dust and allows for easy cleaning which will not endanger the lens. When the filter or lens is dirty, begin the cleaning process by blowing away all dust and dirt. Wipe the glass with a clean, soft lintless cloth. Never use facial tissue or paper designed to clean eyeglasses; both can scratch the lens.

Recorder. Even the smallest particle of dust or dirt can cause big problems inside a videotape recorder. The small particles in cigarette smoke can cause the recording head to scratch the videotape. Keep the air as clean as possible, and clean the machines often. Your instruction book should contain simple instructions for cleaning and maintaining the recorder. Follow these instructions on a regular basis to ensure high quality recordings. Head cleaning tapes work by means of a mildly abrasive material. Therefore, it is unadvisable to use a cleaning tape in day-to-day machine use.

Tape. The videocassette itself is probably one of the most neglected and abused elements of the video taping process. The videotape should always be clearly and correctly labeled. Some studios have the rule that an unmarked tape is available for use. If you care about the tape, label it.

Store the videocassettes standing on end with the rewound section down. Storing the tapes on their side can damage the edge of the tapes.

Avoid humid or excessively cold storage areas. The plastic cassette will warp at 130° F, and tape becomes unstable at 160° F. Unfortunately, these temperatures are not uncommon inside a parked car on a hot, summer day. Cold temperatures cause the tape to contract at different rates on the hub. In addition, extremely cold tapes can pick up moisture when brought into a warm room and sweat much like a glass of iced tea. When a tape has been in a questionable storage area, allow it to return to room temperature before using it in any machine. Also, be sure to store tapes away from any strong magnetic field, including large audio speakers.

When you have played a tape and are ready to rewind, let the tape fast forward to the end and then rewind it. This repacks the tape and should help ensure that the tape is not crimped during the next use.

Public presentations of videotapes

Sources of programs

While most of this chapter has talked about video production techniques, you should remember that it is almost always cheaper to buy an educational tape from another source than to make your own. You should undertake making your own videotape only after you are convinced that there are no tapes available to meet your specialized needs. Collect catalogs of educational videotapes from universities as well as educational tape corporations.

Public outlets and distribution

Many educators are realizing that in order to reach new audiences with educational material, they must turn to new outlets for distributing videotapes. Many public libraries now offer a section of educational videotapes and are eager to help distribute the kind of information offered by agencies such as the Cooperative Extension Service. In addition, many states have tested distribution systems through retail stores and specialty shops with success.

Cost of videotape reproduction is the major drawback to massive distribution through nonprofit agencies. In addition, it is important that the local agency staff be involved in planning and carrying out videotape distribution through public outlets. All tapes should contain the local agency's name, address, and phone number for follow-up information. This builds identity and support for the agency's program with new audiences.

The United States Department of Agriculture (USDA) is one organization that has developed a nationwide system of videotape critique and sales. Videotapes on topics of national interest are listed in a catalog, along with content and source for purchase. Before beginning videotape production on your own, be sure to check this and other important sources of programs produced in other states.

Room setup and presentation

Videotapes are of no value if your audience is not able to see and hear the presentation. This requires careful attention to the room setup and equipment operation.

Television should never be viewed in total darkness. Normal to dim lighting is not only more comfortable to the eye, it also gives the viewer enough light to refer to educational handouts or take some notes.

Be sure that the televison is not in front of a window or situated so that harsh light strikes the screen and causes a glare. Walk around the room to check the visibility from all locations in the room.

While this simple splitter will operate two TVs, a power splitter should be used for three or more TVs.

For public display, you should provide one television set for every 20 to 30 viewers. This may mean that you need to combine television sets with a coupling device. Supplies for splitting and amplifying the signal are available at most consumer electronic stores. If the signal is carried to more than two television sets, it is important to boost the signal as it is split. A power distribution box should cost only $10 and is well worth the investment.

When presenting a videotape to a large audience, such as a conference or large workshop, remember to tape all cords to the floor. Once the televisions are in place, adjust the color to provide the best match possible. If the color adjustment varies widely between various television sets, the audience will be distracted and miss part of the educational message.

In general, no one should sit closer than seven feet, or further away than 20 feet, from a 19-inch television. No one should sit more than 45 degrees from the center of the screen nor have to look up more than 30 degrees.

Once the televisions are in place, adjust the volume. It should be loud but not blow over the viewers closest to the television sets. As you adjust the volume in an empty room before the viewers arrive, remember that a room full of people can absorb a great deal of sound.

Copyright

Videotape duplication is so simple that many educators duplicate tapes without considering the possibility that they may be violating the copyright law. While the new copyright act does provide for "fair use," this is not a blanket license to duplicate copyrighted works. In addition, you cannot assume that simply because you are using the tape for nonprofit educational use that you are free from copyright restrictions.

While the law does allow for duplicating a portion of work for critique and educational purposes, there are specific disclaimers for films and AV materials. When in doubt, always return to the original source of the videotape and negotiate duplication rights. In addition to staying within the law, the quality of the duplicates made from the master is always better than a pirated copy.

Working with the television station

Contact with television stations

Televisions are in almost every home in the United States. The medium is a powerful, potential outlet for the Extension educator. But first, you must work with the media gatekeepers, the television station personnel. Details of working with electronic media, both radio and television, are covered extensively in Chapter 11, "Radio" in this handbook.

There are three basic outlets for your educational information — newscasts, public affairs programs, and public service announcements. The key to getting time on any of these outlets is to clearly understand the needs of the station and the audience and meet those needs.

Air time is a precious commodity. Before you approach a television station, carefully review the station's format, audience, and needs. Be able to explain how your educational program will enhance the station's attraction to potential viewers. Chapter 11 on radio production offers an excellent approach to contacting personnel of the electronic media. Take time right now to review the sections on contacting stations. Most of the criteria for contacting radio stations apply to television stations as well.

The major difference is that it is almost impossible for most organizations to produce broadcast quality video. This means that you will need to work with the television station's production staff. Field production time is costly and usually tightly scheduled, so have a carefully developed plan before the production crew arrives. Rehearse all demonstrations to ensure that the presentation is smooth and professional. Work with the station personnel ahead of time to prepare graphics and props.

Watch the newscasts of the station you want to contact for several weeks. What kinds of stories do they use? Look for new and interesting angles to your stories. When you

contact the station's news department, be able to quickly explain why your story is important to the station's viewing audience. Provide all the factual information concerning the time, date, and place of the event. Establish yourself as a credible source of information for the news department.

An effective 20-second public service announcement in prime time can be far more effective than a half hour of talking heads in the off-hours.

Cameras and video recorders are continually becoming lighter, more portable, and easier to use.

In today's high tech society, it is important that the viewing audience perceives your educational program as being effective, relevant, and modern. The time you invest in a high quality production will be well worth the effort. Refer to the earlier sections on make-up, props, and television appearances to prepare for your production.

The law no longer requires television stations to provide a minimum amount of public affairs and public service programs. This means that only top quality programs meeting a real need of the audience will be aired. Again, take the time to study the needs of the station and develop a proposal to meet these needs. Work with the public affairs director to develop top quality programs and announcements.

Conclusion

Any predictions about the future of television and video education are destined to be shortsighted and filled with inaccuracies because of the speed of new developments in the field and the economic considerations in the practical implementation of the technology. However, a few trends will doubtless continue to have a big impact on the use of this powerful teaching tool.

Cameras and video recorders will continue to be lighter, more portable, and user friendly. The introduction of the chip camera has already made a big impact on the consumer market and will continue the trend toward one-piece camera/recorder units.

Stereo VCRs are more common, and stereo broadcast television is a reality in some markets. Dolby Noise Reduction and even digital audio options will be offered in more and more video units. With the proliferation of home computers, video graphics, and character generation for titles and captions is possible for even the simplest video production.

Video projectors and big screen TVs are gaining acceptance in the educational world. Discussions of high definition TV for the American market will continue, as will experiments with video photography cameras.

New video information delivery systems are continuing to be tested in many markets. Video text systems, video marketing, alternative networking, and cable television are having a big impact on even the networks' audiences. Teleconferencing is firmly entrenched in the business world and is having an impact in the educational market as well.

These are just a few of the options which may soon be available to the educator using video production in an educational program. Regardless of the exact implementation of these new developments, one fact is certain — video technology plays an increasingly important role in the economical delivery of information.

Few communications professionals have not, at some point, felt overwhelmed by the virtual tidal wave of educational materials overflowing their "Read" box. To compound problems, the public is demanding that the most up-to-date answers be made available faster, more efficiently, and at times and in locations convenient to the user.

In reality, the information needed to meet these demands is probably available somewhere in the preponderance of educational books, publications, videotapes, audio tapes, computer programs, and visuals. While the technical revolution has allowed mass production and distribution of these materials, it is only now giving the user a tool to adequately control this abundance of information.

For years, a fantasy of educational professionals has been to have a world of customized information at their fingertips. Interactive technology is beginning to open the door to this fantasy.

It is important to remember that these new resources are not intended to replace standard communication tools, such as publications and videotapes. However, they will probably make the material developed for these media more accessible to the public.

While interactive communication includes a wide variety of emerging resources, such as audio and videotext, this chapter will focus on CD-ROM, related CD developments, and interactive video systems for training, educational presentations, demonstrations, and

public information delivery. For further information on other related technology, refer to the sections on electronic media (Chapters 11-12) and electronic hybrids (Chapters 14-18).

CD-ROM

A new level of Information storage and retrieval

Few experts would disagree that optical disc technology (videodisc, CD-audio, CD-ROM) is a major solution in the immediate future for storage, rapid access, and retrieval of massive amounts of material. While no one innovation will be the solution for all problems, each will certainly play an important role in the educational communications office of the future.

What Is CD-ROM?

CD-ROM stands for Compact Disc Read-Only Memory. The compact disc is read by a laser beam of light and is connected to a computer. CD-ROMs look similar to the popular mirrored CD audio discs and are indeed the same medium. (CD audio players are one of the fastest growing consumer electronic products ever introduced.) While the data storing CD-ROM won't play on a home audio CD player, it is just as durable, economical, and relatively trouble free as the common audio CD.

With the CD-ROM, there is never a problem with a missing file, a borrowed manual, or a torn-out page. The disc is coated with the same polycarbonate used to make bullet-proof windows and has an expected lifetime of more than 50 years.

Storage capability

Probably the most attractive feature of the CD-ROM is its convenience in storage and retrieval. One CD-ROM can store over 400,000 pages of double spaced, typed pages. In book form, that much information would fill 250 large reference books, or 10 sets of encyclopedia. If you could read one page per minute for 12 hours a day, it would take you nine months to read all the information that can be placed on one CD-ROM.

The CD-ROM can hold words, Illustrations, music, software programs, and even video Images.

13 Interactive communication technology

Two optical storage tools, the videodisc (the large silver disc) and the CD-ROM, are the emerging solution to storage, rapid access and retrieval of massive amounts of information.

It is staggering to realize that once the digital information is mastered, a single CD-ROM can be reproduced for around $2 and mailed for less than 75 cents.

More than words

CD-ROM will store much more than words. In fact, anything that can be digitized can be stored on CD-ROM. This means the same disc can hold illustrations, music, software programs, and even video images. Because of this versatility, the CD-ROM is beginning to be used to aid fields of study in which the "designer" pulls parts together to create the whole. One example of this is a prototype disc which aids interior designers in their work. Many more of these types of applications are expected to be developed in the future.

Retrieval

The benefit of the CD-ROM is best realized when its massive storage is coupled with an effective retrieval package. With a properly designed disc, a user can find the information in only a few keystrokes or clicks of a mouse. The system can search the mass of information normally contained in shelves of books or over 1500 floppy discs, and relatively quickly give the user a menu of articles or publications containing the type of information requested. Then the material can be quickly scanned and only the most relevant printed or copied to a floppy disc and edited with a standard word processing package.

There is a wide variety of retrieval packages available, depending on the needs of the user. If you know exactly the type of information you want, a key word search will probably be faster. However, if you want to quickly browse to find related facts quickly, a retrieval package which links ideas, commonly called a hypertext program, can be the most effective. (See Chapter 16, "Computers in communication," for a more detailed discussion of hypertext.)

Search times. As with any other type of computer or information technology, the final product can never exceed the quality of the material and organization used to produce the disc. Discs produced with outdated, poorly organized information and retrieved with older systems can be a major frustration for users.

Even at best, the retrieval time from a CD-ROM is considered somewhat slow in the computer world. Some seemingly standard searches may take up to one second (lengthy in computer terms) and a complex search can take even up to a minute. Fortunately, if the information is truly valuable, the users will tolerate the 60-second wait.

And, it is encouraging to see that both the hardware and the software are improving in their ability to search and retrieve faster. Each new product promotion boasts faster retrieval times and more effective searching.

What about new information? Critics will also point out that a CD-ROM can not be rewritten. This means that if new information is developed, it can never be physically written onto the silver disc. Of course, it will probably never be printed on the bottom of old publications in agents' shelves either. In the real world, older paper publications would simply be replaced with newly printed ones.

In much the same way, information agencies of the future will probably repress CD-ROM publication discs on a regular basis, maybe once a year. Because the majority of the

information will already be in master digital form, only the modifications will need to be added. The cost of a master (about $2,000) is hardly a factor, considering the fact that the disc can hold about a quarter of a million pages of information.

Information for which updates are critical can be added to the hard disc in the computer that manages the CD-ROM. The new files will be automatically retrieved instead of the older file on the CD-ROM. The user will probably never know, or care, where the information is stored. The important point is that the latest information is quickly and easily available.

Can't more paper publications do the job? Even if a central information office could gather, edit, typeset, print, bind, and distribute all the latest information at an astounding speed, the education professional still has to deal with information overload. In reality, even if the new publication is available, there is no guarantee that it will be referenced immediately. Typically, when people are pressed for time and must find an answer quickly, they will reach for the sources they know the best, which are probably the oldest. The problem is that when something better comes along, people aren't familiar enough with it to use it comfortably and don't have the time to learn.

With the assistance of a CD-ROM and retrieval package, a user can quickly find, review, and retrieve the newest information just as easily as older information. Thus, electronic storage of material will increase the

likelihood that the information used will be the most up-to-date possible.

What equipment is needed? A CD-ROM requires the use of a CD-ROM player. Players are connected to computers and perform like a giant external hard drive. The players come in a wide price range because of the variability of features. Some are equipped to play music as well as retrieve text, and some simply cost more because of their speed in retrieval.

What about the cost? In 1990, a CD cost $2,000 to press. Each copy cost under $2. You can probably expect costs to drop even more as use of the technology increases. However, the real cost must also include preparing the information in digital form and organizing it with a retrieval package before mastering. In the same way, any comparison to the cost of publications printed on paper must include the cost of typesetters, printers, and operators, as well as binding, storage, and distribution of the tons of paper needed to distribute the same amount of information on one CD-ROM.

Writing for the CD-ROM. Because the computer retrieves information in chunks, ideally in sizes of 10 pages or less, and displays information only one screen at a time, writers will need to modify the way they conceive and present information.

This means that a writer probably should not say "as you read in Chapter 3" or "as you see below." Instead, information should be thought of more in modular terms with the possibility to connect and link pieces together.

One of the challenging problems is tables. Because computer screens are sometimes more difficult to scan horizontally than paper, many wide tables must be redesigned to work effectively.

For the first time, the computer format of publications on the CD-ROM makes it possible for the writer to add annotation, extra explanations, examples, and leader notes to the publication. In fact, the computer can deliver a slightly different version of the publication depending on the interest level of the reader. While the information stored on the CD-ROM can never be changed, by copying a file to a standard drive and using a word processor, the user can also modify, update, combine, or simplify the material to suit the exact educational needs of the situation.

Finally, it is important to realize that some collections are not appropriate for CD-ROM. Some information, such as daily weather, markets, and mail are more appropriate for an on-line search of a mainframe computer. However, when information has at least a one-year shelf life or is reference material, the CD-ROM is an ideal delivery system.

Outlook

In addition to the CD-ROM, two additional laser compact disc innovations are on the horizon. They are the Compact Disc Interactive (CDI) and the Digital Video Interactive (DVI).

CD-I was introduced in 1986 and promises to integrate motion, audio, visual, and text/data information on the standard CD-ROM. It should be able to store 7,000 natural pictures and 256 colors. It will probably be used both in the educational and home entertainment markets.

DVI was introduced in 1987, but is still in the development stages. It is hoped that it will combine sophisticated data decompression capabilities with standard CD-ROM configuration in a delivery system that will be used much as traditional interactive video systems are used today, but at a fraction of the cost.

Interactive video

A new tool to reach an ever-changing clientele

Today's consumers of information are demanding customized answers, delivered quickly, in a convenient and entertaining way. And they often want this information at night and on weekends. They want information at their fingertips while visiting malls, stores, and libraries. Interactive video can respond to some of these demands. It is one of the many emerging resources which could soon change the face of all information delivery in the United States. It has tremendous potential to customize information at a cost rivaling many mass other media innovations.

Interactive video is not the solution for all communication problems. It will not replace publications, news stories, or traditional video-

tapes. It is simply an emerging tool which must not be ignored by any educational organization striving to reach an ever-changing clientele.

Definition

In brief, interactive video is a video presentation in which the sequence of viewing video segments is determined by the user. This means that instead of viewing all information in a linear way, as is the case when viewing a traditional videotape, the user sees material based on selected responses to menus or questions, or selections from a printed manual.

When interactive video is mentioned, images of highly complicated, expensive projects sometimes come to mind. The concept may be rejected without adequate consideration of the medium. It is important to remember that there are various levels of interactive video requiring variable amounts of equipment.

The simplest design, called Level I, consists of a video player, a remote control, and a television set. With this system, the user operates a remote control to start, stop, and back up to review material. The amount of interactivity is limited by the functions of the remote control.

Visually, a Level II system may appear much the same to the viewer. However, the equipment involved in this level includes a video player which has an internal microprocessor programmed to perform certain playback sequences and to respond to viewer choices

Information kiosks can be found in many public places and are ideal for answering frequently asked questions.

during the program. The program control is encoded on a disc. A correct answer allows the program to move forward while an incorrect answer triggers a repeat of the information.

Level III involves a computer which responds to the user's input and answers. The computer controls all other devices, such as the video player and audio devices. This level of interactivity provides all the benefits of computer-aided instruction — branching, user controlled pace, lesson management, record keeping, and feedback. This level of involvement can also involve special accessories such as touch screens, light pens, bar code readers, and special devices allowing simulated equipment adjustment.

The intriguing attraction of interactive video is that it combines two of the most powerful

educational tools available today — computers and video technology — and makes them easily accessible to a user who has never operated either type of hardware. Within a few seconds, a user is usually able to receive customized information in a pleasant and entertaining package.

Unlike conventional linear video programs which allow the viewer to remain passive, interactive programs not only allow the viewer to become involved, but they demand it. The user is rewarded for each interaction with the machine and is often motivated to learn more because the machine is responding to the user's immediate needs.

An example of Level I interactive video technology could be a viewer using a videotape on roping techniques or dancing. Using simply a videotape player with pause, slow motion, and rewind, the viewer can study in detail any portion of the educational program again and again. A similar tape could be used for mechanical subjects such as adjusting a sewing machine or a piece of farm equipment. The step in question could be quickly located and viewed.

Interactive video can use either videotape or a video disc. For maximum effectiveness, however, the video disc has no rival. The replica laser disc can hold 54,000 frames per side. One video disc alone could hold a total of 40,000 pages of text, 5,000 photographs, 12 minutes of motion video, eight hours of film strips presented at two frames per minute, and 1,000 microcomputer programs.

Application of interactive video

Interactive video can play a major role in information delivery, educational delivery, and problem solving. It can have its most significant effect in out-of-the-classroom, informal education; in "how-to" training for individuals or small groups; and point-of-delivery education for large groups of people on a one-on-one basis in shopping malls, entertainment centers, and libraries.

Obviously, "how-to" training can range from the very simple, with prepared video segments selected from a menu, to extremely complex artificial intelligence for problem solving.

The problem with the relatively slow acceptance and limited use of interactive video is economic balance. Interactive video is expensive to produce and deliver if you measure the expense in the short run. With interactive video, as with other newer innovations, the cost analysis should be conducted over several years, taking into account the total number of people reached. With this type of evaluation, interactive video can actually prove itself to be more cost efficient than the more "traditional" information delivery methods. This is due to the dramatic reduction in staff time required after the development and initial delivery by the interactive video system. Used correctly, interactive video can be more cost efficient and less demanding on staff time than one-to-one training.

Production quality plays a large part in the effectiveness of an interactive video program. No longer will people stay tuned just because the picture moves. They are bombarded daily by hundreds of visually sophisticated images and they have many choices from which to draw visual information.

If the visual message doesn't meet a minimum level of professional competence, the viewer will likely tune out. Even in small group training sessions, viewers are distracted when they are faced with a technical problem. Poor production quality of both video and audio can also damage a program's content credibility.

Touch screen menus allow the user of an interactive video system to quickly find the needed information.

13 Interactive communication technology

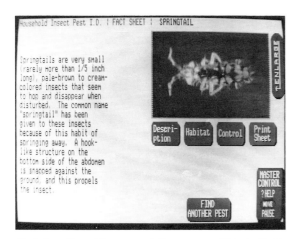

An interactive video presentation can combine a visual, still or motion, from the laser disc with text and graphics from the computer to give the user full control at all times.

Hardware overview

The marketplace is overflowing with a wide variety of interactive video hardware, software, and accessories. Unfortunately, materials developed for one type of hardware and software will often be incompatible with another unit. Therefore, it is critical before any purchases are made that you conduct a complete survey of the hardware and software most prevalent in your field of interest.

Cost versus benefit

The cost of an interactive video production should be considered in light of several factors, such as: Who will be the primary audience? What is the subject? Will it make heavy use of slides or motion?

It is important to realize that although the master disc costs only $2,000, with $20 for each additional copy, there can be extensive production costs in tape production prior to disc mastering. Video production alone for customized instruction packages may range between $45,000 and $260,000. This does not include the cost of educational designers or the computer programmers.

On the other hand, simple menu-driven interactive video programs, involving high quality educational video programs, developed for other uses, can cut costs considerably —

A Level III interactive video program involves a complex computer program, coupled with a video player, to provide branching, user-controlled pace, record keeping, and feedback. Yet the user only has to touch the screen to receive the information.

especially when combined with a pre-existing programming shell.

Because interactive video technology appears to have promise in a large number of areas, there are many outside grants available to agencies and universities. In fact, many agencies controlling grant funds are looking for innovative, dynamic information delivery and dissemination programs to advance their special educational needs.

Non-profit organizations and agencies can justify some of the cost of interactive video development by reducing costs for staff training, leader training, and travel. Interactive video does not ask for a raise, charge overtime, or mind teaching the same lesson hundreds of times.

While retraining for use of interactive technology may be an additional cost consideration, it can usually be conducted on a gradual or pilot basis. Such training will no doubt be an important part of a nationwide trend toward retooling educational professionals in the use of all emerging resources, such as satellite education, teleconferencing, use of data bases, and computer-based instruction. A well-designed interactive video program should require a minimum amount of training in the field.

Today, the use of computers stretches beyond the familiar word processing functions to the production of visual aids and other graphics. Just as the word processing functions have helped with writing and editing copy, the graphics functions can ease the manipulation and production of graphs, charts, publications, line drawings, and other graphics or illustrations.

In response to the demand for software and hardware that do not require large investments, manufacturers are developing a number of products to aid in the electronic "cutting and pasting" of copy and graphics. The benefits of such graphics production systems are almost limitless, and the cost of* obtaining them can be minimized, if you so desire.

Advantages of computer graphics

The desktop computer can assist a person with limited graphic or artistic skills to create useful illustrations and other graphic materials. Common program devices aid in drawing straight lines, rectangles, circles, ellipses, and other shapes. A wide variety of textures or colors are easily placed within selected areas. Images may be quickly enlarged or reduced in size, duplicated, flipped horizontally or vertically, inverted, stretched, or rotated. Photos or hand-drawn illustrations may be scanned (digitized) and entered into the computer for further manipulation. Also,

electronic clip art is available that can be altered or combined with other words or images to suit a particular purpose.

Computer graphics equipment and programs

Devices for graphics input

Keyboard: Used to generate copy as well as provide commands. Used in combination with other input devices and program tools.

An electronic pen is applied to a special tablet (pad) to perform a variety of graphic functions.

Mouse: An electronic device that uses a rolling ball underneath a hand-operated controller to move a pointer, or cursor, on the screen. (Current technology offers a similar device without a ball.) This two-dimensional rolling action, along with convenient mouse buttons, allows you to quickly execute program commands and utilize the "tools" to create graphics productions.

Electronic pen and tablet: An electronic pen is applied to a special tablet (pad) to perform a variety of graphics functions for generating illustrations.

Trackball: Has the ball exposed on top for the hand to move the pointer or cursor on the screen to accomplish functions similar to that of the mouse.

Touch screen: A system in which the user can interact with the program by touching the screen (cathode ray tube).

Digitizer/scanner: A hardware/software package that converts (scans) hard copy or video signals into digital information that may be manipulated on the computer with painting or drawing programs. The resolution of digitizers varies from 72 to 300 or more dots-per-inch. Inexpensive digitizers are available that snap into the ribbon cartridge holder of a dot matrix printer. Another type is hand held and drawn or swept across the page. Others require the original document to be placed into a desktop unit (flatbed scanner) that scans the document in a stationary position or slowly feeds the original document

through the unit during the scan. Some scanners input through a video camera and the image (picture) is subsequently digitized for computer usage. More expensive scanners with certain software can read typed pages. These reading devices, known as "optical character recognition" systems, can input text for further editing or formatting.

Programs useful for creating graphics

Word processing programs let you input and edit text. You can select typestyles, type sizes and column widths, check your spelling, and refer to a convenient electronic thesaurus. Recent versions allow you to perform most of the functions found in the publishing/layout programs. These include importing graphics into a document (in order to "paste up" or compose pages), wrapping text around graphics, customizing menus, and generating footnotes, an index, and a table of contents.

Publishing/layout programs allow you to "paste up" pages electronically, similar to conventional methods. They present you with a blank page upon which you can import and organize text and illustrations into page layouts for publication. They provide formatting commands, on-screen rulers for aligning text and graphics, tools for drawing rules, bars and boxes, and modest text editing for additions or corrections. Some can automatically create footnotes, headers, tables of contents, and indexes. New releases wrap text around various shapes of graphics. The strength of publishing/layout programs is the assistance

Research to determine the software programs that best fit your production requirements can save you valuable time later.

they provide in integrating and positioning text and illustrations for readable layout and practical design.

Painting programs allow you to create artistic illustrations on the computer. This is in a "bit" (bit-mapped) or pixel-by-pixel format that prints as a pattern of dots with 72 dots-per-inch resolution. Circular and angular lines appear somewhat ragged or stairstepped, but certain illustrations may require this pixel-by-pixel precision.

Drawing programs are more useful for drafting or in creating other technical illustrations. This utilizes a "PostScript" (object-oriented) language that, when printed on a

laser printer, produces smooth, sharp lines with 300 dots-per-inch resolution.

Painting/drawing programs combine the best features of both painting and drawing programs through a two-layered screen. Once an illustration is completed, you may convert the pixel-by-pixel paint image to the PostScript language of the drawing portion of the program.

Graphing programs assist in creating line graphs, bar charts, pie charts, and other graphic displays of numerical information. Some allow easy selection of various chart styles, type size, texture, and three dimensional effects.

Presentation programs aid in creating graphics, organizing and presenting, or projecting computer aided presentations.

Animation programs allow you to generate moving images on the screen.

Printers

Printing quality varies with the quality or precision of the printer and its ribbon. Photocopying an original that has been printed on a dot-matrix printer can "flare" the individual dots, often resulting in an improved, darker final print quality. PostScript documents printed on the laser printer will have smooth circular letters or objects and not be stairstepped as with dot-matrix printed materials. Plotters may be useful for certain graphics projects. They are often used in producing overhead transparencies or posters in color. Generally, daisywheel printers are limited to printing text and are not suitable for the production of graphics.

Computer graphics projects

Desktop publishing commonly involves electronic page make-up. The typestyle may be chosen and pages formatted, organized, and "pasted up" electronically. The printout can then serve as the original from which the printing plate is made. Extension field staff, school teachers, and others are using desktop publishing to generate newsletters, programs, fact sheets, publications, and a wide variety of printed material. Most productions are created

using word processing programs combined with painting or drawing programs, as they increasingly contain the necessary features. The publishing/layout programs require much more study and experience to use them efficiently and effectively.

Overhead transparencies may be produced quickly on the computer. Word processing programs are commonly used to generate the text, but painting and drawing programs can increase their effectiveness through the addition of illustrations and other graphics.

Overhead transparencies with illustrations and other graphs can be produced quickly on the computer.

Certain graphing programs quickly convert numerical information into effective forms such as line charts, pie charts, bar graphs, and other graphing formats. Some programs let you quickly select type size, texture, color, and three dimensional effects. Dot matrix printers can then print directly on an overhead transparency acetate or on paper, from which an overhead transparency can be made on a photocopier. Photocopying is also a convenient method to enlarge text and graphics to a readable size. Laser printers can provide sharper letters and other images, particularly if the program uses the PostScript language. Transparencies with good resolution and clarity can also be produced directly on a plotter, with readily available colors.

35mm slides may also be produced from computer-generated text and graphics. The clearest and sharpest method of making a slide from the computer involves an expensive film recorder, but other methods are also effective. A photograph may be taken directly from the screen, and a colored lens filter may be used to add color if the computer program and monitor do not have color. The visual may be printed on colored paper to increase interest. Or it may be printed on white paper with color added by use of a colored lens filter on the camera or by overlaying a sheet of colored acetate during shooting. Another method uses lithographic film instead of common slide film for the addition of color. Some programs and colors are available that use a multi-colored ribbon on a dot-matrix printer.

Direct projection of computer presentation materials is becoming more common with the development of computer projection devices. Early computer image and video projectors were cumbersome and didn't project a very sharp image. A more recently developed device overlays the stage of anoverhead projector, whereby a reasonably large and visible image is projected from the computer onto a screen. For those who convert computer signals to regular video signals, a sharp, new lightweight projector is now available.

Posters, flipcharts, and exhibit materials may be produced with word processing, painting, or drawing programs. The photocopier may be used to enlarge the production to an appropriate size. This may require several sheets of paper assembled for a larger visual effect. Certain computer programs are also available to aid with enlarging text and graphics. Another method of creating large computer graphics is to generate page-sized graphic material, convert it to a transparency, and project it onto a larger area for easy tracing. A digitizer may be helpful in converting existing graphics for these purposes.

Video support graphics are increasingly being produced due to technological advances in camera/recorders that have made good quality video production affordable. And more and more educational video productions are being generated by educators in the field. Computer graphics are often used to supplement video creations and may include titles, other textual information, illustrations, charts or graphs, or animated graphics.

Computer-generated graphics may be recorded in these ways:

■ Graphics may be recorded directly from the computer screen, but nonsynchronous gray lines will appear to move across the screen.
■ A printed copy may be recorded directly. Printing directly or photocopying onto colored paper will add zip to these productions.

The desktop computer can assist educators to plan, design, produce, and present useful visuals and other graphics.

■ Graphics may be recorded directly through a direct connection between the computer and a video recorder. Recording digital computer signals onto videotape requires a specialized computer program.

Video studios use character generators (dedicated computers used to create electronic text) to create titles, other text, and graphics for video productions. Some move the text on or off the screen or mix it with other images. Certain camera/recorders now possess modest built-in character generators. A gen-lock is a device that can synchronize and mix two video signals, such as a computer graphics signal and a realistic video scene. Desktop computer programs are also available that perform a similar function.

Summary

Visual planning forces communicators to more clearly think through the message, establish objectives, and improve the organization of the individual points to be made. Many studies have shown that visual aids and other graphics increase learning and retention of knowledge. Other studies substantiate that visuals improve the audience's perception of a presenter, such as appearing more professional, persuasive, credible, and trustworthy.

The desktop computer can assist educators to plan, design, produce, and present useful visuals and other graphics. These tools can improve the quality of communication and enhance educational programs, as well as careers.

The basics of 15
desktop publishing 15

Computers were originally designed primarily to handle numeric data; however, more words than numbers are now being processed by computers. The development of the microcomputer or "personal computer" and word processing software has brought computers into offices of all sizes. The advent of laser printers that use proportional fonts has made it possible to print out pages of near-typeset quality, using different type styles and sizes. Pagination programs can electronically integrate graphics and text into a fully formatted page layout, eliminating the need to paste pieces of paper together on a layout board. Because these systems can be contained on a desktop, the term "desktop publishing" (DTP) has come into popular use to describe the process.

Is desktop publishing for you?

Although DTP systems can be used to produce impressive letters, reports, proposals, and similar materials where a few copies are printed on the laser printer, the main advantage of DTP systems comes in preparing master pages that will be duplicated by photocopying or offset printing. Materials such as newsletters, classroom materials, fliers, and handouts for meetings, workshops, and field days take on a professional look when the master pages are electronically formatted. The elements are perfectly aligned and cleanly assembled with none of the rough edges that can show in a "cut and paste" assembly. Another advantage of a DTP system is the ability to try out different formats and type

styles. Just as a spreadsheet lets you plug in different numbers and see the results in a series of calculations, so a DTP program lets you quickly see the results of different layouts and type styles in presenting a document.

Desktop publishing is something nearly everybody in a communications job wants, but not everybody is happy with once they have it. One of the big advantages of desktop publishing — the ability to try out different formats and to make last minute changes — can become a handicap if people want to keep making changes instead of approving a printout. Some offices make the mistake of buying equipment without allowing time and budget for training persons to do the work.

"Training may be expensive, but stumbling along because you are untrained is even more expensive," writes Dr. C. J. Wallia in a technical communications journal. Citing an estimate from Dataquest, a leading high-technology market research company in Silicon Valley, Wallia gives this alternative to not supporting training: "For every dollar spent on software, ten dollars will be spent on learning."

Also, it is important to realize that unlike word processing, which the average office worker can learn fairly easily, page design requires both specialized training and aesthetic judgment. Not everyone takes naturally to the task. If one person is expected to serve in multiple roles — as writer, editor, and page designer — that person needs some skills in all these areas. On the other hand, if a small

work group will be using the system, you can expect the introduction of a DTP system to cause some changes in the work flow and functions of individuals in the group.

The personal computer and the laser printer can transform communicators into potential editors, layout artists, and publishers.

Desktop publishing takes many forms, with many products claiming to incorporate DTP features. Overall, the features available in DTP programs keep improving. A reviewer in *PC Magazine* notes that sometime, somewhere, when no one was looking, somebody upped the ante in the desktop publishing game. Programs that run on PCs are increasingly measured against professional publishing

standards. These products are expected to do what the big boys do: provide sophisticated typographic control, high-resolution graphics, and quality output [via PostScript]. . . . Our new higher expectations include true WYSIWYG (what-you-see-is-what-you-get) displays and network functionality.

These features are found in the high-end DTP programs such as Ventura Publisher and Aldus PageMaker. However, a less powerful program may meet your particular needs satisfactorily. If you decide to get into the DTP game, it's up to you to decide what level of features you want.

Computer disks now come in two sizes.

First, you need to determine what kinds of publications you intend to do, and what parts of the job you want to do electronically. Then, look at the available software to see what packages of programs will do the job you want. Here you will be considering word processing programs, graphics programs, and full-scale DTP programs. Next, see what hardware will drive the software. Computers have differing capabilities, and it is important to select hardware that can run the software you want to use. Experts in the field often advise buying a level of power one step higher than what you currently need, just to keep up with advances in software. For desktop publishing, you have to give close attention not only to the computer, but also to its peripherals such as monitor, input devices, and printers.

Selecting hardware and software is like buying a car in that there are a lot of options, and there is no single best choice for all uses. The next section of this publication presents points to consider in selecting hardware and software for desktop publishing, based on the types of publications your office will be producing. The final section offers guidelines to help you design a quality publication.

Selecting hardware and software

Because technology in this field is changing rapidly, choosing components for a system is a challenge. On the one hand, you want to plan a system that can be expanded, and that will assure compatibility between elements. On the other hand, items become obsolete with disconcerting rapidity, and today's hardware may not run the software you will want a few years from now. If you are considering a large expenditure to build up a publishing system and are not well versed in computer systems, it may be wise to have a consultant draw up a blueprint. To make informed decisions, you can also get current information from computer magazines and desktop publishing magazines. (See "Suggested Readings" at the end of the book for names and addresses of some of these periodicals.) A good overview of equipment is provided by some of the buyer's guides, such as the magazine-style *Desktop Publishing and Office Automation Buyer's Guide and Handbook*.

Macintosh vs. PC-compatible

There are two major computer systems in the U.S. desktop publishing market — the Macintosh and the PC-compatible computer. The PC-compatible system offers more choices, as it includes both computers made by the IBM corporation and "IBM-compatibles," "clones," or "look-alikes" made by other companies. This group of computers is sometimes referred to as MS-DOS computers, because of the disk operating system they use. The Macintosh, an Apple product, uses a different disk operating system, so disks are not interchangable with MS-DOS computers. However, software and cable packages are available to provide a bridge between the rival

■ Selecting hardware and software

systems. Also, the two systems are coming closer together; with each new generation, as Apple computers adopt more features of the MS-DOS system, and vice versa.

A traditional difference between the Macintosh and the PC-compatibles has been explained in terms of right brain and left brain orientation. The Macintosh is oriented toward spatial relationships, visual perception, and intuitive connections (right brain functions). Not only does this computer handle graphics well, it tends to make use of icons — symbolic images on the screen — to prompt a choice from the user, whereas MS-DOS programs (reflecting left brain, linear thinking) often require a typed command. MS-DOS programs generally rely more on information in the user's head as opposed to information on screen. This means that the Macintosh tends to be easier for a novice computer user, but the MS-DOS approach offers more shortcuts for the experienced user.

Apple options

A pple introduced the concept of "desktop publishing" with the Macintosh computer, which was designed for integrated handling of text and graphics. Apple offers hardware and software designed to work together, so that choosing compatible components for desktop publishing is fairly simple. The programs are designed for use by non-technical people, and are relatively easy to learn. It is also easy to establish local area

networking for a small work group to use the system. A disadvantage of Apple systems is that they tend to be higher priced than comparable MS-DOS systems.

A mid-range Macintosh system might consist of a Macintosh SE, a LaserWriter, a word processing program such as Microsoft Word or WordPerfect, ReadySetGo pagemaking software, and a graphics program such as MacDraw. A high-power system would be a Macintosh II computer, Aldus PageMaker as the pagination program, and Adobe Illustrator to create graphics.

IBM options

I BM-compatible systems are the predominant standard for business offices, and a variety of software applications are available for these machines, making an MS-DOS system a versatile choice. The main disadvantage of building an MS-DOS desktop publishing system is that a bewildering number of options are available in the MS-DOS world, and compatibility is an issue. In fact, one reviewer has called the task of choosing hardware and software for desktop publishing in the MS-DOS world "the toughest challenge you as a computer user may ever face."

When you decide to try desktop publishing, your first decision will probably be whether to choose Apple or MS-DOS-based hardware.

15 The basics of desktop publishing

A typical MS-DOS system might consist of a 286 or 386 computer, a Hewlett Packard Series II LaserJet printer, WordPerfect 5.0, Ventura Publisher, and Publisher's Paintbrush and Corel Draw! to provide graphics. However, there are numerous options. The following discussion is directed toward choosing components for an MS-DOS system. Keep in mind that the field is changing rapidly. It is advisable to make sure you have current information before making a selection.

Selecting software

The primary software needed for desktop publishing is a state-of-the-art word processing program. This and a graphics program may be all that you need for desktop publishing. If you find that you want more page make-up power than your word processing program provides, you can get a full-featured DTP program.

Each choice you make to some extent narrows subsequent choices. Once you select your primary software — a DTP program and/or a word processing program — there are a limited number of other programs (such as graphics programs) that will work with it. To begin with, all software you choose must be compatible with the disk operating system.

Disk operating system

The disk operating system is the foundation for any computer use. There are different systems such as MS-DOS, UNIX, and OS/2.

The standard for IBM-compatible computers has been Microsoft's MS-DOS or the proprietary versions such as IBM's PC-DOS. The current version is MS-DOS 4.01. An alternative operating system is available in Microsoft's OS/2, which is designed to run on the 286 microprocessor chip used in AT class computers and will also run on the newer 386 chip.

Frequent upgrades of DOS are released. Whether or not you need to adopt an upgrade depends on how much you need the features of the new system in your applications. For example, MS-DOS 4.01 allows more flexibility in managing a hard disk than does DOS 3.3. With DOS 4.01 you can make partitions of any size, and you can format a large disk as one drive. Also, although DOS is generally limited to using 640 kilobytes of RAM (random access memory), Version 4.01 includes a file (himem.sys) that provides access to an additional 60 kilobytes.

OS/2 is a different operating system that was written specifically for the 286 computer. Not only does OS/2 break through the 640 kilobyte limit for RAM, it also allows multi-tasking operations. The multi-tasking capability means you can tell the computer to execute one task in the background — recalculate a spreadsheet or print a document, for instance — while you work on another task in the foreground. Major software is just becoming available for use with OS/2 at this writing. WordPerfect 5.0 and several databases for OS/2 have been released.

Word processing programs

A word processing program is a basic part of a DTP system, unless you are using a comprehensive program like Interleaf Publisher which includes its own word processor. Most DTP programs allow for text editing, but are not as easy to use for writing and editing as are word processing programs. With DPT programs like Ventura Publisher and Aldus PageMaker, it is more efficient to compose and edit a document in a word processing program, then import it into the DPT program.

Communicators have access to a wide variety of software for many different applications.

■ **Selecting software**

The line between DTP programs and word processing programs is blurring, as word processing programs now incorporate features formerly found only in DTP programs. For example, WordPerfect 5.0 will drive a laser printer directly, allowing use of multiple fonts and sizes, providing proper letter spacing and justification with proportional fonts, automatically snaking text through a multicolumn format, and flowing text around graphics. It provides sophisticated features in handling of proportional fonts, such as automatic hyphenation and justification, kerning (finetuning the spacing between letters within words) and control over leading (the vertical space between lines). It will allow you to import graphics into your text from graphics files of a number of supported formats, and will allow resizing and rotation of these graphics.

Other word processing programs which rate highly for DTP applications are Microsoft Word, Nota Bene, and XyWrite III Plus. Multi-Mate Advantage II and WordStar 2000 Plus also have some DTP features. Certain other word processing programs may offer advantages for specific applications. For example, T$_E$X-based products and FinalWord II are tailored to the needs of scientific publishing.

A state-of-the art word processing program may be all you need for desktop publishing. In any case, it would be advisable to gain experience with a high-end word processing program such as WordPerfect 5.0 before buying more complex programs. Your experience will then help you decide which addi-

tional programs can be put to good use. For example, if you are doing a newsletter in which several stories start on page one, and all continue to other pages, you want a feature that lets you assign frames for each story, so that each story flows into its proper space on the jump pages.

For more information on the capability of high-end word processing programs compared to full-featured desktop publishing packages, look in current computer magazines. You will find articles such as these: "Publish It on a Desktop," "WordPerfect on the Move," and "Desktop Publishing: Can You Justify It?" For step-by-step instructions on how to get special effects with WordPerfect 5.0, such as dropped initial capitals, refer to WordPerfect 5: Desktop Publishing in Style. For full citations of these articles, refer to the "Suggested Readings" section at the end of the book.

Desktop publishing programs

You can spend $70 to $2500 on a desktop publishing program. The more expensive programs are, of course, much more comprehensive than the low-end programs. The trade-off for their power is that the complex programs require time and effort to learn. The more complex programs are also more demanding as to what equipment they require. People who are serious enough about desktop publishing to use Ventura Publisher or Aldus PageMaker will want the hardware to support an intensive publishing effort. This

means a mouse, a scanner, a high-resolution monitor, and a laser printer in addition to a relatively fast computer with a large hard disk and extra RAM. The total cost of hardware and software will run between $5000 and $10,000. Interleaf Publisher is the most demanding of the high-end programs, requiring a Macintosh II with 5 MB of RAM or a 386 IBM-compatible with 6 MB of RAM. The total cost will be about $25,000.

Low-end programs are easy to learn and can be useful for simple documents such as fliers and short newsletters. They provide clip art packages and generate their own fonts. However, the low-end programs are designed primarily to work on dot matrix printers. With most low-end programs, even if you print on a laser printer with a capacity of 300 dots per inch, you get only 75 dots to an inch in the output. You can print line drawings and "fancy font" typefaces, but they have jagged edges. In general, low-end DTP programs do not offer sophisticated handling of fonts. You do not get automatic hyphenation and kerning, for example. Among low-end DTP programs, PFS: First Publisher is a best-seller. Version 2.0 can access both soft fonts and cartridge fonts with a laser printer, as well as generating its own dot-matrix style fonts.

Mid-range DTP programs offer more sophisticated features in handling type, such as automatic kerning of proportional fonts. Mid-range programs such as Byline and GEM Desktop Publisher provide style sheets to help you design documents.

15 The basics of desktop publishing

Ventura Publisher and Aldus PageMaker are the established rivals in the high-end DTP market. Each has its own area of specialty that it handles best. Ventura excels at handling long technical documents. The operator can set up style sheets to handle a series of documents the same way. Ventura is also a good choice for a magazine-style page layout. The program maintains each text file and graphics file separately, and the operator feeds these files into designated· frames to make up the pages. An article can therefore jump across pages and still maintain its integrity as a file. The Professional Extension package offers additional features useful for technical documents, such as handling of tables. PageMaker is a good choice for handling short documents, especially those with an irregular format. It excels in handling intricately designed pages, and is often the preferred program for Macintosh users.

The high end of the DTP market has been redefined by the introduction of personal computer versions of IBM's Interleaf Publisher. A powerful publishing tool, Interleaf was previously available only for mainframe computers. Versions are now available for the Macintosh II and for IBM-compatible 386 computers. Interleaf is designed for use by work groups in which writers, artists, and editors collaborate on document production. PC Magazine describes Interleaf Publisher for the 386 as "the most ambitious desktop publishing program ever written for a personal computer, combining graphics-based word processing, page formatting, charting, and graphics" [12, "Fact File," p. 142]. Still, the program lacks some of the aesthetic options found in PageMaker and Ventura Publisher. As of this writing, you can't wrap text around a picture, there is no automatic kerning, and manual kerning can be done only by converting text to a graphics element. Offices that do only occasional desktop publishing, or have limited implementations, need to consider whether they want to make the investment in equipment and training to run a high-end program. As Jayne Sutton points out in her review of Ventura Publisher, "the *best* desktop system is the *right* system, not necessarily the one with the most features." Her review includes this caution:

> Ventura is the most powerful DTP system around — some people say it's also the most *unused,* because no one in the office has time to learn it. Some would advise prospective Ventura users to count on a year and a half to learn the program, particularly if it is to be used to produce a wide variety of document types and formats. And unless the volume of work is sufficient to support a specialized Ventura operator, it appears that other options, desktop or otherwise, may be preferred.

Graphics software

A wide variety of graphics packages is available, designed to meet various needs. You can get programs that provide fancy headline fonts and libraries of clip art for production of fliers and posters. Freehand drawing programs are available for people with enough artistic talent to draw with a mouse. Computer-assisted design (CAD) programs help architects, engineers, and other design specialists in production of technical illustrations. Business graphics programs convert tabular data to pie charts and bar graphs for publications, slides, and on-screen presentations. Statistical graphics programs are designed to plot regression analyses and other complex mathematical functions.

Computer-assisted design and graphics packages enlarge the creative pallet of the DTP user.

Graphics are handled in two basic ways in a computer: raster graphics and vector graphics. Paint programs generally use raster graphics, in which the image is bit-mapped (composed of dots). Bit-mapped images can be edited electronically a dot (or "pixel") at a time. When you enlarge an image in a raster graphics program, it loses resolution, and looks worse in the printed version than it does on screen. Some paint programs use 600 x 400 dots for the total screen. When you print at 300 x 300 dots per square inch, you can't get a picture bigger than about 1 x 2 inches without losing quality. Draw programs are limited to line drawings (unlike paint programs, which can produce shaded images), but they have the advantage of using vector graphics, which recalculate the image so that you can enlarge an image without losing resolution.

Some graphics programs are object oriented. They identify a given image as a discrete object, so that you can enlarge, reduce, or reposition any of the objects on the screen independently of other objects.

There are two ways of bringing graphics into a text file: saving the graphics file and importing it into the text document, or using a windows environment (e.g., Microsoft Windows, Windows/286, or Windows/386). WordPerfect imports graphics; Microsoft Word operates under Windows. Publisher's Paintbrush is a popular paint program that does not operate under Windows, and can be used with WordPerfect. Corel Draw! is a versatile drawing program that operates under Windows and can be used with Microsoft Word and Ventura Publisher.

As with low-end DTP programs, some graphics programs do not take advantage of the capabilities of laser printers. They may print on a laser printer, but at 75 dots per inch.

Choosing a computer

As newer versions of software are released, they tend to become larger, requiring both more storage space and more RAM (random access memory). As a result of being larger, programs also tend to become slower. Storage space, RAM capacity, and operating speed are therefore main considerations in selecting a computer. Different generations of computers offer different options.

Generations of computers

Generations of computers are often classified by the microprocessor chip they use: for example, the 8088 chip, the 286 chip, or the 386 chip. Each generation is more powerful than the preceding generation. For desktop publishing, a 286 or 386 computer is recommended.

IBM's PC/XT computer and its clones use an 8088 microprocessor chip. This is an "8-bit" chip, meaning that it can process 8 bits at a time. Machines that use the 8088 chip are limited in RAM capacity and in operating speed, and will not run OS/2. Prices are dropping for the 8088 computer; however, this class of computer is not recommended for a new purchase if sophisticated desktop publishing is desired. If you have an 8088 computer that you want to upgrade, look into the possibility of adding an accelerator board and an expanded memory board.

The AT class computer — also known as a 286 computer — is faster than an XT. It uses Intel's 16-bit 80286 (or "286") microprocessor chip which will run OS/2 as well as DOS. This class of computer generally sells in the mid-range. The newer 386 machines, named for the 32-bit 80386 microprocessor chip which they use, sell for $2000 and up at this writing.

Disk storage

Computers store information on disks in the form of bits (off/on signals) and bytes (a series of bits). One byte will store one alphanumeric character. The capacity of hard disks is measured in millions of bytes, or megabytes (MB). By contrast, a double-sided double-density 5.25 inch floppy disk will hold 368,640 bytes of data. This disk is known as a 360 K (kilobyte) disk. Floppy disks also are available in high-density versions with capacities of 1.2 MB and 1.4 MB, in 5.25 and 3.5 inch sizes, respectively. One 360 K floppy disk will hold 150 to 180 typed pages saved in a word processing format. However, once you use a DTP program that converts your text to bit-mapped graphics, storage needs expand dramatically. A floppy disk might hold only a few pages of bit-mapped text and graphics.

15 The basics of desktop publishing

A hard disk assembly with at least 40 MB storage capacity is suggested for DTP applications. Just how much storage space you need depends on what programs you intend to run, and what kinds of files you intend to store. Graphics files, for example, require a large amount of storage; it could take a full megabyte of memory to store a page-sized, scanned graphic image. Pagination programs that convert the text file to bit-mapped graphics require a high level of storage space for their output. If you plan to use Ventura Publisher with graphics and a variety of font sizes, a 100 MB disk would be appropriate.

One precaution with hard disks: sooner or later all hard disks fail. To avoid disaster, back up your files. This means both data files and any customized program files such as WordPerfect printer definitions or Ventura Publisher style sheets. For backup, you may want a high-density floppy disk drive installed in your computer. Or you can use a removable drive, such as those made by Konica, Kodak, and IoMega.

Adding RAM

R andom access memory (RAM) is the memory used by the computer to carry out the functions you order. Each program you want to run uses a certain amount of RAM. If available RAM is too low, your programs will not load. In some instances, if you run programs with marginal RAM, the program may develop corrupted files.

Large databases and spreadsheets often require more than 1 MB of RAM. Desktop publishing programs also are increasing in their RAM requirements. WordPerfect 5.0 requires 512 K of RAM. Ventura Publisher requires almost 640 K of RAM for itself, leaving little RAM available for any other use. If you will be using many graphics, you may need 2 to 5 MB of RAM. Interleaf Publisher requires 5 MB of RAM on the Mac II, 6 MB of RAM on a 386.

After the first 640 K of RAM (conventional RAM), the memory is configured either as extended memory or expanded memory. Expanded memory is the only kind of additional memory that computers with the 8088 chip can use. AT-class computers and 386 computers can use either expanded or extended memory. However, software applications are designed to use a specific type of RAM. Ventura Publisher, for example, uses expanded memory.

Expanded memory is added to a computer by plugging an EMS (Expanded Memory Specification) board into a slot on the computer's bus, and using software that manages the expanded memory. The software may be called an LIM 4.0 driver (referring to the Lotus/Intel/Microsoft Expanded Memory Specification) or an expanded memory manager (EMM). The EMM works like this: The EMM divides the added RAM into areas called pages. It then reserves what's called a page frame within the normal 640 KB address space. By swapping data or sections of

programs between the expanded memory and the page frame, the EMM creates the effect of having up to 32 MB of memory. This technique is called bank switching, and anyone who has floated a check on a banking account understands the principle at work here (Jerome, p. 283).

If you need expanded memory for one program and extended memory for another program, you can get a board that can provide memory in either form, switching the form as needed. Or if you have extended memory installed in your computer, and you need expanded memory for your applications, you can supplement DOS with a program to convert the extended memory into expanded memory.

How fast will it go?

C omputers operate at various "clock speeds," rated in megahertz (MHz). You will need an operating speed of at least 10 MHz for reasonably fast processing. AT class computers are available at speeds of 8 MHz, MHz, 10 MHz, 12 MHz, 16 MHz, and faster. The newer 386 computers operate at speeds of 16 MHz, 20 MHz, 25 MHz, and faster. Another factor in operating speed is whether the computer uses a wait state. Computers with zero wait state run faster than those with one wait state. Disk access speed as well as clock speed affects the operating speed of your computer. For complex desktop publishing applications, a hard disk speed of no slower than 40 milliseconds (ms) is recommended.

Upgradability

Do you plan to add on to your system later? Some computers have more space for expansion than others. A computer with "open architecture" may offer wider latitude for upgrading, in that it is able to accept the installation of boards from various manufacturers. Another consideration in upgrading is that components may drop behind state-of-the-art and need to be replaced. Some computers are designed to allow replacement of a large number of components.

Monitors and graphics boards

A high quality monitor will be expensive. However, higher priced monitors may be more cost effective in the long run. Looking at blurred letters and smeared colors for hours makes for unhappy and unproductive computer users who suffer from eye fatigue, nausea, and headaches.

Some monitors have features that are designed to serve a particular application, such as desktop publishing. Other monitors are designed for all-purpose use. It is wise to "test drive" different monitors to see what features best meet your needs. Try out the actual programs you will be using to see how they look on the monitor. Factors such as monochrome vs. color display, screen size, resolution, scan rate, and flicker all affect your subjective evaluation of the monitor.

Whatever monitor you choose, make sure it is of high quality and its features fit your specific needs.

One specialized monitor for DTP use is the large screen monitor. People who produce a high volume of page layouts often insist on a 19-inch or 24-inch (diagonal measure) display. On 12-inch and 15-inch monitors, you see only a portion of the page at a time, or a reduced sketch of the page. Large screen monitors show the full page, or even two pages side by side. Oversize screens not only make it easier to see page layouts, they can also be seen from more viewing angles, which can be more comfortable for the operator.

Oversize monitors give you more characters on the screen, not larger characters. If you have trouble discriminating between a period and a comma when viewing a display in Ventura Publisher, you may be in the market for a high-resolution monitor, some of which are also large screen models.

A specialized type of high-resolution monitor is the paper-white monitor, which displays black characters on a white screen. Many DTP users prefer this display to the more common display of light characters on a dark screen.

15 The basics of desktop publishing

However, a paper-white display screen needs a high-resolution monitor with a continuous coating of phosphor on the tube and no apparent flicker in the display, and the price of these monitors runs high.

Monitors are driven by graphics boards (also called graphics cards, or more formally, video display adapters). Monitors and their supporting boards are produced to certain standards, each standard having its own scan rate, color selections, and on-screen resolution. At this writing, the emerging standard is IBM's VGA (Video Graphics Array). VGA hardware has downward compatibility with EGA (Enhanced Graphics Adapter) and CGA (Color/Graphics Adapter) standards, although certain programs designed for lower-resolution modes may not work with the VGA board.

The different adapters produce a different number of total dots on the screen. They also provide different sizes of text cells, the text cell being the number of dots provided to form a character. The more pixels to a character, the sharper the display. VGA adapters typically support two main display modes: a screen display of 640 x 480 pixels in 16 colors, and a display of 320 x 200 pixels in 256 colors. The high resolution mode is better for text and graphs; the low-resolution mode gives more realistic images when reproducing color photographs and similar artwork.

If graphical user interfaces supplant character cell interfaces, as some experts predict, a high-resolution monitor — at least VGA

resolution — will be a necessity. Some manufacturers offer monitors and graphics boards that provide higher resolutions than the standard VGA display. This display mode is called VGA plus, super VGA, or extended VGA. Various manufacturers offer multiple frequency monitors that can be upgraded from standard VGA to super VGA with the addition of the enhanced VGA card.

Input devices

The most common input device is the keyboard. The 83-key keyboard has 10 function keys on the left and combines cursor control keys with a number pad. It is often favored by people who are doing word processing. The 101-key "expanded" keyboard has 12 function keys, placed in a row across the top. The space saved is given to a separate cursor control pad, allowing the number pad to stay in numeric mode. This keyboard is generally favored by people who are doing spreadsheets and other number-intensive operations. Another option, offered by Northgate, is a 101-key model with the function keys on the left.

Keyboards from different manufacturers have a different feel (and a different sound) when you press the keys, and you may want to try several brands to find the type that suits you. However, the keyboard must be compatible with the central processing unit (CPU) of the computer; not all keyboards work with all CPUs.

In addition to the keyboard, desktop publishing often uses other input devices. Pagination programs and graphics programs generally require a mouse as an input device. The mouse is moved across a desktop or a special pad to "point and shoot" — that is, to point to a position on the screen, and to choose an option by pushing a button on the mouse. Another hand-held device is a stylus used with a bit-pad, which lets you input line art by tracing. Optical character scanners can read a variety of typefaces and are used to input text from a printed page, while a graphics scanner can digitize graphics from a printed copy.

Desktop publishing systems generally require a mouse to input information.

Desktop printers

Desktop printers come in three categories: dot-matrix printers, laserjet printers, and inkjet printers.

The dot-matrix printer is an impact printer. That is, it uses the strike-on principle, similar to a typewriter, except that the letters are formed of dots rather than a solid line. Nine-pin printers are best used to print working drafts and proofs. The more expensive 24-pin printers produce a higher quality image that may be used with DTP applications.

Laser printers operate by electrostatically bonding ink to a page. They produce images in a dot pattern, typically at 300 dots per inch. (This measure applies to an area in the center of the page. Type at the periphery may not meet this standard.) Some laser printers print 600 dots per inch. Laser printers are quiet and fast, and they can handle proportional type, which gives them the ability to produce text that looks like it has been typeset.

Laser printers do not match commercial typesetting in quality, either in the sharpness of the letters or in the proportional spacing. Commercial typesetting offers 1200 to 2500 dots per inch. However, the better resolution of commercial typesetting is not necessary for all printing needs. If you are going to do quick-copy reproduction by xerography or by offset printing on uncoated stock, the laser characters are generally acceptable for the camera-ready master pages.

High quality printers, scanners, and graphics programs have transformed the design and reproducibility of images.

The inkjet printer is a new introduction to the desktop printer family. It offers resolution comparable to the laserjet at a lower price. Inkjet printers can print in more than one color of ink. The page output is slower than with a laser printer.

PostScript: pros and cons

When buying a laser printer, a major decision is whether to choose a PostScript printer or a non-PostScript printer. PostScript is a page description language that tells the printer how to generate fonts. PostScript printers cost more but they offer more font sizes than are possible with soft fonts. PostScript printers also last longer. An ACT/PS printer has a life expectancy of about 600,000 pages, compared to about 100,000 pages for a printer using the Canon engine (Hewlett-Packard, QTS, Panasonic).

The common alternative to buying PostScript fonts is to buy soft fonts or a font cartridge. Soft fonts are font patterns that come on floppy disks. Bitmapped fonts come with a specific set of font sizes provided. Outline fonts have a vector graphics pattern from which you can generate bit-mapped fonts in desired sizes. Outline fonts offer more flexibility in font sizes, but require time to generate the font. In smaller sizes, the letter shapes from

outline fonts are not as crisp as with bitmapped fonts; however, outline fonts give good quality headline type. Whether bitmapped or outline styles, soft fonts are installed on the hard disk, then downloaded to the printer for use. Depending on how many soft fonts you want to use at a time, you may need to add a memory board to your printer to store the fonts. A font cartridge has the advantage of making fonts immediately available when the computer is turned on, without having to load the fonts into the printer. Font cartridges, however, do not offer the flexibility and wide range of choice that soft fonts offer.

You can get an add-on PostScript controller to allow you to print PostScript fonts on a non-PostScript laserjet. A less expensive alternative is provided by programs such as Freedom of the Press, which uses the computer's memory to interpret PostScript files. Another alternative to using PostScript is provided by the CAPCard, a graphics co-processor that provides scaled fonts, as does PostScript, but is faster in operation. The CAPCard board is installed in the computer rather than in the printer.

Electronic printing services

You can do part of your printing preparation in-house and hire part of it out. For example, you can use your word processing and/or pagination programs to prepare your text and graphics to your specifications, then take the disk to a service bureau that will output your electronic files on a laser printer. This could be a good solution if you prepare occasional

fliers or newsletters, but not often enough to justify the purchase of a laser printer. You can use an inexpensive dot matrix printer to get proofs of your pages, and have someone else's equipment produce the master pages.

For better quality type, some desktop printing service bureaus and commercial printers offer typesetting of your electronic files on high-resolution equipment such as Linotronic or Compugraphic. Depending on what software you are using, you may need to locate a typographer whose equipment supports PostScript. If you are using Ventura Publisher, you need the PostScript interface. If you have a modem, you can send the digitized copy by phone to the typographer. Otherwise, you may be able to send your file on a disk. If your file is too long to place on a floppy disk, you can break the file into segments, or you can use a high-capacity portable disk drive.

Producing a quality publication

Quality must begin at the conception of a document. It is not something that is added on at the end with fine tuning of a document's appearance. Regardless of the technology you use, you still need to follow the steps for good writing: know your audience's needs and interests, organize and write your material to meet your communication objective, and rewrite for accuracy and clarity. Once you have done this, however, desktop publishing technology gives you additional

options for better quality control of the printed materials. You can quickly try out different formats and type styles, to select the page design that looks best to you, before you produce the final pages. Because you have control over the document right up to printing, you can change content as well as format, making last-minute changes if necessary.

Establishing a format

Not many DTP users are trained as page designers. Some DTP programs offer help by providing predefined formats for different types of publications. You can select a different format for each kind of publication you produce: newspaper articles, reports, newsletters, etc. The templates or style sheets provided can be useful guides. However, the default settings provided by a program are not always the best. WordPerfect 5.0, for example, provides too wide a center space in the two-column mode; for a better looking page, change the distance between columns from the default of 0.5 inch to 0.3 inch.

Part of a page designer's job is to achieve a sense of unity for all the pages in a publication, or in a series, without falling into a mechanical sameness. To do this, a designer will establish a grid, a basic underlying structure for a page design. The grid determines margins for text areas and for graphics, space for headlines, and so forth. With commercial magazines, the grid can be quite complex. For less complex jobs, it is still a good idea to establish a simple grid that will

■ **Producing a quality publication**

assure consistency of margins, headers, footers, and columns. Pay attention not only to outside margins, but to the small details that make for a sense of unity. Establish consistent spacing between columns, between illustrations and text, and between illustrations and accompanying captions.

The number of columns to a page is an important choice in formatting a document. The one-column format, with text running across the width of the page, is best used for

page sizes smaller than 8.5 by 11 inches. For example, if you use a 5.5 by 8.5-inch page, obtained by folding an 8.5 by 11 sheet, you may want to use the one-column format.

If you use an 8.5 by 11-inch page, a single column of text produces a line that is too long for the eye to comfortably follow it. In 10 point type, 3.5 inches is the maximum line length for ease of reading. A two-column format provides better legibility on an 8.5 by 11 page and allows more flexibility in layout.

Columns may run in "professional newsletter" style, in which columns are filled in sequence, or "newspaper" style, in which stories may be spread across to columns, regardless of the length of the story.

A three-column format allows still more versatility. All three columns may be used for type, with an option of having illustrations run across one, two, or three columns. Selected type areas can be treated as graphics, and can run as a two-column or three-column block.

A variant of the three-column layout uses the left column on each page for headings; the text is placed in the other two-thirds of the page. This style is often used for resumes and can also be used for newsletters. It is especially useful to give graphic interest to a newsletter that has no illustrations. Headlines, breakout copy, and art go on the left; text on the right. This example also shows that the number of columns in the underlying grid is not necessarily the same as the number of columns that show on the page. You may have two columns on the page, but because the page is divided into thirds, it has an underlying structure of three columns.

There are also page formats with more than three columns, but typesetting and design become more demanding with these styles, and they are generally less suitable for DTP applications.

Make sure the format you choose reflects the style of the material and enhances readability.

15 The basics of desktop publishing

Making design work for you

Good page design not only gives a sense of unity, it also clarifies the material presented. To help your information communicate more effectively, consider these tips from professional designers.

Remember that people don't like to read. They will leaf through a brochure, look at pictures, do a lot of things rather than start reading. Understanding must be intuitive, with access routes made clear. Make your page like a map, with easy routes made clear, and some landmarks so readers know where they are.

Use visual structuring techniques to make the communication more functional. A well-organized page will subconsciously reassure the reader. For example, use some of the following techniques.

- Break text into manageable chunks, using white space, rules, screens, or other graphic devices to separate the chunks.

- Layer the information for easy skimming.

- Use enough heads to identify topic changes.

- Use more space before a head and less space after, to clearly associate the head with its following text.

- Break out information into lists, bulleted if sequence is not important, or numbered to indicate priority or chronological order.

■ Apply the squint test. That is, squint your eyes and look at the page. What pops out first? This focal point should be a main point of information.

Leave enough white space to give the eye a break, and to give the reader a sense of ease with the page. It isn't necessary to fill every bit of space with text or a graphic. However, white space should be judiciously placed. Avoid what designers call trapped white space — that is, white space that does not run into a margin or a divider space of some kind. This principle applies to text as well as illustrations. For example, if a flush-left head takes two lines, make the second line longer than the first line to avoid trapped white space.

Choosing type

You can get a variety of type faces to use on your laster printer, and you can select a typeface to suit the purpose and mood of each particular document. When it comes to choosing from among the available typefaces, consider the purpose of your document. An advertising flier may appropriately use a typeface that calls attention to itself, whereas a grant proposal needs a conservative look. The masthead of a newsletter can use a more attention-getting type than can the body of the same newsletter.

The abundance of different type faces available with laser printers creates a temptation to use a number of them at one time. The advice from graphic designers is "Don't." Adding too

This is Helvetica, a sans-serif typeface.

This is Century, a serif typeface.

Times Roman is highly legible

this is too tight this spacing is too wide

WORDS IN ALL CAPITAL LETTERS LOSE THEIR SHAPE.

Italics can be hard to read and should be used sparingly.

Don't mix *too* many **different** type styles

Type styles speak for themselves.

■ **Conclusion**

many different type styles causes the page to look like a group of competing signs, without consistency and focus. (This is also known as the ransom note school of design.) The appearance of the page should support the message, not call attention to itself. For most uses, two different type faces are enough for a document. Instead of using more type families, change type size and weight within the same family. Also use placement of heads as the cue to level of importance. Centered heads are a higher level than flush left heads.

Two major families of type are "serif" and "sans-serif" styles. Serifs are the horizontal lines at the top and bottom of letters in traditional type styles. Sans-serif styles, which do not have serifs, have a more contemporary look. You can mix the two styles by using a sans-serif type such as Helvetica for headlines, figure captions, and other lines that you want to stand out in a document. Helvetica is not as good for text, as it is harder for American audiences to read than a type with serifs.

If you have much text to present, it is important to consider legibility of typefaces. Highly legible types include Times Roman and Century Schoolbook. Times Roman is a classic face that has been transferred to laser printers. There is not an extreme difference in line weight between vertical and horizontal strokes. It is easy to read, and easy to photocopy without losing part of the strokes. Century is another highly legible typeface with heavy weight serifs, and is a highly legible typeface, designed for textbook

applications. Type faces with extreme contrast between the horizontal and vertical strokes do not give as stable a visual image. The page seems to flicker, making it hard to read. Also, you may lose the serifs when you photocopy the page.

Use of all capitals or italics calls attention to a word, but makes the word harder to read. Capitals and italics should therefore be used sparingly. Readers recognize words in part by their overall shape. Words in all capitals tend to lose their distinctive shape, making them harder to recognize. Text in italic type is lighter in weight and less familiar in shape, making it harder to read than upright type.

Legibility depends not only on letter form, but also on letter spacing, word spacing, and line spacing. Some word processing programs give you a range of options in letter spacing. If your only choice is wide or tight, use tight. Spaces between words should be no more than one character wide. (The character "m" is used as a printing standard for spacing.) If your word spacing is wide, and you can't tighten it up, then use more space between lines to balance the appearance of the copy.

Right justification is not essential. In fact, many graphic designers prefer ragged right. Justified lines are harder to read than ragged right when there are noticeable gaps between words.

Conclusion

Desktop publishing is a process that can enhance your printed materials and help you get your job done more effectively. Remember, however, that everyone is overloaded with printed information. For your information to have a competitive edge in an over burdened environment, it has to be well structured, logically and visually.

Remember, too, that it will take time for staff to learn a new system. Training and support need to be provided. The vendors have created numerous hardware and software options. It is up to you to select and use these tools wisely to produce effective informational materials.

The advantages of telecomputing are numerous, whether it be with other microcomputers, RBBSs, mainframe computers, or all three. The additional cost for hardware and software needed to get your microcomputer connected to the telephone may well be worth the investment.

This chapter contains the basic concepts of microcomputer communication. A general idea of how computers communicate is recommended before the purchase of related hardware and software. Please don't let these concepts and terminology turn you away from telecomputing. Users of home computers who are not programmers or technicians can still have many enjoyable and profitable hours telecomputing. It's just a phone call away.

Choosing the right modem, software, and information service may take a bit of research and patience, but the results are worthwhile. Obtaining marketing information or running the large or constantly updated programs may result in greater economic efficiency. The free software, information exchange, and entertainment can also be quite valuable.

Once you've studied and made selections you're ready to go online. Enjoy your introduction to the world of telecommunications.

Telecomputing applications

Numerous applications exist when you have the capability to go online with your microcomputer. Telecomputing applica-

tions may be found on remote bulletin board systems, direct micro-to-micro communication, and by accessing large mainframe computers.

Perhaps the most common type of telecomputing is through the use of remote bulletin board systems (RBBSs). There are literally hundreds of RBBSs located throughout the country. Most are available 24 hours a day. They are operated by computer clubs, computer hobbyists, businesses, and universities. An RBBS is basically a microcomputer connected to a modem which can automatically answer the telephone. Once the proper connection is made, you operate the RBBS microcomputer from your keyboard.

RBBSs may allow you to leave a message for someone, read interesting articles, list items for sale, do some shopping, get assistance with your computer problem, trace your family tree, or play games. The biggest use of RBBSs is to download software. Users can save hundreds of dollars by downloading freely distributable business, educational, or entertainment software.

Downloading is the process of transferring programs or information from one computer to another. An example may be a farmer who learns of a computer program to estimate the cost of production for soybeans. This program happens to be on a bulletin board hundreds of miles away. The farmer accesses the bulletin board's microcomputer via the telephone by using his microcomputer and modem. By using the RBBS's commands, the program is sent to the farmer's microcomputer and saved on his floppy disk for future use.

An RBBS which specializes in having software available is generally machine specific. An IBM-PC RBBS, for example, will generally only have programs which will run on the IBM- PC or compatibles. RBBS's specializing in information delivery are generally accessible by any brand of microcomputer.

Most RBBSs do not charge for use; the only cost may be a long distance phone call. RBBSs generally can only handle one caller at a time. The programs you download and save on your floppy disk can be quite valuable. You may even pay for the extra hardware and software needed for telecomputing in just one phone call to an RBBS. One warning though, if a program is free it may be worth exactly

16 Computers in communication

that amount! Make sure the program is accurate before you base a financial decision on the results of that program.

Direct micro-to-micro communication is gaining in popularity. To explain this type of telecomputing, let's use an example. Suppose a friend or neighbor has a computer program or marketing report you would like to have. It is possible to connect your microcomputers via the telephone and send programs or information back and forth. Sending a copy of the diskette will not work if you don't have the same brand of microcomputer or disk operating system (DOS). By sending it via telecomputing, your machine's DOS will record it per your machine's standards on the floppy disk.

The software referred to in this section and in the RBBS section is public domain and FreeWare or ShareWare software. Public domain software is developed by individuals or universities, is not copyrighted, and thus may be legally distributed without paying for it. Commercially developed and marketed software is copyrighted and not in the public domain for free distribution. It is against federal copyright laws to reproduce copyrighted software without permission. This includes sending that software over the telephone line.

Large mainframe computers often have excess capacity and are sometimes able to serve large geographic areas. Several different users can access the same computer for different purposes all at the same time. This is called timesharing. An example could be a large computer located at the corporate headquarters. Branch offices could access the main computer through regular or leased phone lines.

Timesharing on mainframe computers is generally offered by large businesses and universities. Timesharing, unlike RBBS, generally involves a fee for its use. You generally need identification numbers and passwords to get on these systems.

Mainframe computers may cost hundreds of thousands of dollars and can be characterized by having tremendous power, vast memory and storage capacity, and the capability of allowing several users to be operating it at the same time. Although a mainframe computer is more than what most of us need, and certainly out of our price range, we can still utilize that huge power and mass storage by timesharing. Telecomputing with mainframes allows us to run programs or retrieve information by giving commands from our microcomputer's keyboard.

Mainframe timesharing computers generally offer one or more of the following types of programs:

■ **Communication** — leaving a message for someone or reading a message from someone, sending a letter to several users, asking your county agent a question or ordering a publication.

■ **Information delivery** — getting today's commodity futures price closings, last week's livestock inventories, USDA reports, a flight plan and weather reports, insecticide recommendations, marketing advice — the list has no end.

■ **Problem solving/analysis** — should you participate in the farm program, your diet analysis, tax planning, loan analysis, a least cost feedmix, crop budgeting, car cost analysis — again, the list is extensive.

Overview of telecomputing

The following overview assumes we just want to talk to another computer with our microcomputer. The other computer, which we are calling, will be called the *host computer*. Here's how it works.

Your microcomputer and modem is turned on and you have your communication software program "booted up." You dial the host computer's phone number. The modem connected to the host computer automatically

answers the phone and you hear a high pitched carrier signal. Your hardware and software accepts this signal and completes the connection. You are now online.

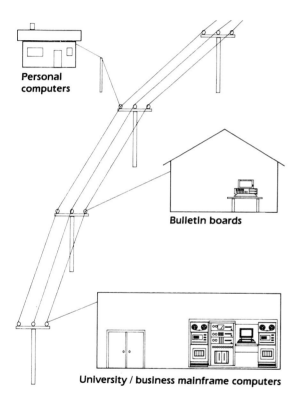

Personal computers

Bulletin boards

University / business mainframe computers

As you type on your keyboard the information goes into the internal memory, where the communications program is loaded, then on to the serial card. The serial card and RS- 232 port changes the form of this information and sends it to the modem. The modem converts

the information from electrical impulses to analog sound compatible signals and sends it down the phone line.

The host computer system completes the same tasks in reverse order. Your information reaches the host computer's memory, the host computer then responds to your request. This process is repeated every time you touch your keyboard.

The actual process is a little more complicated. Going through each step in a little more detail should help you make a wiser purchase and result in fewer problems when connecting and operating your microcomputer telecommunications system.

How data are stored and handled

When data are stored on a floppy disk, or when being processed by the central processing unit, each character such as the letter A, or number 6, is stored as a unique number in base two, also called binary, that is eight digits long. Each binary digit is called a bit, so we say each character is stored as an eight bit number. Fortunately, most computers use the same coding method for recording these eight bits. The American Standard Code for Information Interchange (ASCII), often pronounced askie or askie-two, is used to code the bits. Although ASCII is the most

common, some systems use the Extended Binary Coded Decimal Interchange Code (EBCDIC), often pronounced eb-se-dick.

Each letter, number, etc., is represented by one byte of information. There are eight bits for each byte. The eight bits in memory which represent the character are actually electric impulses or switches. These switches are either on or off. We can think of these switches or impulses as being a 1 or a 0. The sequence of these 1s and 0s will determine what the character will be.

Don't worry, you're not going to have to memorize all of these 1s and 0s for every character, that's done automatically for you. An ASCII chart can be found in almost every computer or printer manual. There are two ASCII character sets. The standard set includes 127 characters. If you look at this set you'll notice these are the characters we use most often. The extended ASCII character set includes a total of 255 characters.

The ASCII representation of the letter S is 01010011, a combination of eight bits which are 0s or 1s. If you are using the standard set of ASCII characters you only need to send the seven "low order" bits. Thus, when sending the letter S using seven data bits instead of eight it would look like this: 1010011. Notice the 0 on the left has been dropped.

The host computer system will request that you send a 7-bit or an 8-bit word length. Many of the timesharing and informational systems use a 7-bit word. The downloading

of microcomputer programs, however, often requires the use of the extended ASCII character set and thus requires the use of all eight bits.

Your microcomputer uses all eight bits for internal processing and storage. The data bits travel about in a parallel fashion. Information is sent to a parallel dot matrix printer in this fashion, eight bits at a time. A parallel printer is usually faster than a serial printer. One reason is simply due to the mechanical differences of the two printers. Another reason is due to the way in which information is sent to it. Serial transmission sends bits one at a time.

Parallel transmission - sending an "SOS" message

0 ——▶	0 ——▶	0
1 ——▶	1 ——▶	1
0 ——▶	0 ——▶	0
1 ——▶	0 ——▶	1
0 ——▶	1 ——▶	0
0 ——▶	1 ——▶	0
1 ——▶	1 ——▶	1
1 ——▶	1 ——▶	1
(S)	(O)	(S)

Serial transmission - sending an "SOS" message

01010011 ——▶ 01001111 ——▶ 01010011
(S) (O) (S)

Parallel transmission can be thought of as an eight lane highway with one car in each lane travelling side by side, all in the same direction.

Serial transmission is accomplished on a single lane road with eight cars bumper to bumper all traveling in the same direction. Also, the "speed traveled" in parallel transmission (eight lane highway) is usually much greater than in serial transmission (single lane road). It is thus obvious why parallel transmission is faster than serial.

Serial cards and the RS-232 port

Data in transit to another computer travel from your microcomputer's memory to its serial card. The serial card is a printed circuit board containing several integrated circuits and a connector (or port) for attaching the modem cable. The serial card contains a universal *asynchronous* receiver/transmitter (UART). The serial card and the RS-232 port are generally sold as one unit.

Your microcomputer may or may not have the serial card as standard equipment. You may hear this equipment referred to as the serial card, serial port, communications adapter, or RS-232 interface. These terms are often used to identify the equipment needed to connect your modem to the microcomputer. The serial card may cost between $50 and $300 and can generally be installed by the owner. Multifunction cards are readily available which contain a serial port, parallel port, and other options as a clock/calendar.

The serial card can add a parity bit if you are using a 7-bit word. A parity bit can be used by the receiving computer for error checking.

Serial card and RS232 interface.

Typically, parity is set at even, odd, or none. Under even parity, which is most common, there must be an even number of bits in the byte, including the parity bits. If the 7-bit ASCII code for a letter contains four 1-bits, the parity bit will be a 0, if it contains three 1-bits the parity bit will be a 1 to bring the total number of 1-bits up to an even number. Odd parity works the opposite of even while a setting of no parity will ignore the parity bit all together so that no parity bit is sent.

The receiving computer counts the 1-bits. If the total number of 1-bits doesn't agree with the parity setting an error in transmission will be detected. Error messages may differ, they may interrupt further transmission. Regardless of the method used to warn you, what you see on your screen is not what was originally sent to you if you are on the receiving end.

The parity bit is added on the high order side (left side) of the byte. As a review, our letter S has gone through these stages so far:

01010011 (original 8-bit ASCII)

1010011 (7 bits used for transfer)

01010011 (an even parity bit added or 11010011 for an odd parity bit)

■ **The modem**

Synchronizing the flow of data

Controlling the flow of data can be accomplished by *synchronous* or *asynchronous* transmission. Asynchronous is the most common transmission method used with small computers. Synchronous transmission sends characters one after another at specifically defined time intervals. Modems must be synchronized with each other before transmission can occur. Remember that most synchronous and asynchronous modems are not interchangeable.

The most common method of data transmission, asynchronous, sends data characters down the transmission line at random intervals. It can do this by telling the receiving computer when a byte is starting and when it's done or stopped. It does this by sending a start bit and a stop bit. The start bit (here comes a character) is always a 0 and is added to the low order side (right side). The stop bit (I'm here, go ahead and process me) is always a 1 and is added to the high order side (left side). Let's take another look at our letter S before we send it to the RS-232 port:

01010011 original 8-bit ASCII

1010011 7-bit data transfer

01010011 parity bit added

1010100110 stop (left) and start (right) bits added

It's necessary to have all these rules and regulations if you expect your ten-page report

to be on your supervisor's desk (many miles away) in less than seven minutes!

The original 8-bit letter S went down to seven bits and is now back up to 10 bits before we can send it on its way down the telephone line. How fast will it get there? It depends on your *baud rate*. Baud refers to speed of transmission. 300-baud means 300 bits per second. We have 10 bits per character so we can transmit 30 characters in one second. 1200-baud transmission would send 120 characters down the phone line every second. This includes the 7-bit character plus the parity, start and stop bits.

Sending data to the modem

The serial card and the RS-232 port are responsible for changing the bits stored in memory as ons and offs or 0s and 1s to different voltage levels. RS-232 is a standard developed by the Electrical Industries Association (EIA). You may see this EIA term used in reference to serial cards, etc. EIA means it conforms to the "industry standard" like USDA choice.

The RS-232 port sends these characters in terms of various voltages, to the modem via a 25-pin plug and cable. Not all 25 pins or wires are used and some are not wired straight across. It is best to buy the cable when you buy the modem, and specify what you're going to use it on and how you're going to use. If you need to rewire, consult

your microcomputer, serial card, modem technical manual, or the dealer you purchased them from.

The modem

Although modem is now accepted as a word, it started its life as an acronym for MOdulator/DEModulator. A modulator converts the RS-232 voltages to voice grade (analog) sounds or tones for the phone line. Demodulators convert those tones back to voltages for the RS-232 interface. Remember to check system requirements before you purchase a modem. Do you need synchronous or asynchronous, and do you need 300, 1200, 2400, or 9600 baud?

Modems can be evaluated like any piece of equipment. Like cars, modems have different features, capabilities, speeds, designs, and prices. Modems can range in price from as little as $50 to several hundred dollars. Most modems fall into the $75 to $300 price range. Although you may be able to get by with the $50 modem, a more expensive model may pay for itself in the long run. Let's examine some of the choices.

Acoustic coupler modem.

16 Computers in communication

The acoustic coupler type modem is a piece of hardware equipment, which is external to your microcomputer. A cable runs from the microcomputer's RS-232 port to the acoustic modem. It has its own power supply. The acoustic coupler has a physical coupler or two rubber cups. These rubber cups are designed to hold the standard round handset of the telephone.

The acoustic coupler modem has two main advantages. It is generally less expensive than the other types of modems and is your best traveling companion. The other types of modems require you to connect the modem between the wall connection and the telephone by using the small wire with the plastic clip at the end called an RJ-11 connector. Most residential units have this type of phone connection. Some office buildings, hotel rooms, and most phone booths do not allow this type of connection. An acoustic coupler type modem can be more versatile if you often move your computer.

The main disadvantage of an acoustic modem is the speed and quality at which they operate. Acoustic modems are manufactured to run at speeds of 300-baud or less. These modems can let room noise filter in around the rubber cups and cause "garbage" to be transmitted or may even interrupt transmission. The quality of transmission is also dependent on the condition of the mouthpiece and receiver. Acoustic coupler modems were once considered the modem of choice, but are no seldom used.

Direct connect external modem.

Direct-connect is perhaps the most popular type of modem used today. These modems offer higher quality and faster transmission. Many direct-connect modems offer the selection of either 300, 1200, or 2400 baud-transmission speeds. Most direct-connect modems also offer the capability of automatic dialing and answering of the telephone.

Direct-connect modems are external to the computer and are often placed under the desktop telephone. Like the acoustic types they have their own power supply, have the cable to the RS-232 port, and are connected between the telephone and the phone company's jack by using the RJ-11 connectors. External modems have control panel lights which indicate when you are sending or receiving data.

Internal modem.

Internal modems are much like the direct connect types except they are without the outer case. They are simply a circuit board which plugs into the main circuit board inside

the computer. The obvious advantages are that you'll have one less piece of equipment to plug in, fewer cords and less equipment sitting on your desk. The telephone cord's plastic RJ-11 connector plugs into the back of the computer where the internal modem circuit board is. An internal modem may decrease your total hardware costs because the circuit board usually contains the serial card with the UART, etc. Thus the internal modem takes the place of both the serial card and the external modem.

A disadvantage of using an internal modem is not having control panel lights to tell when you are transmitting and receiving data. Most software programs will indicate on the screen when you are connected and when you have disconnected, but give no indications as to actual data flow.

Modems on a chip.

The fourth type of modem is one which is all on a computer chip. The computer chip could be plugged into the main circuit board of the microcomputer and serve as the serial card and modem. Many predict that the modem will become a standard piece of equipment on all microcomputers sold.

Technical duties of the modem

The modem's technical duties are to receive the electrical voltages from the RS-232 port, convert them into sound analog tones and send the data down the phone line. The data, parity, start, and stop bits are still there but are now in the form of audible signals versus transmitter logic or electrical voltages.

The computer receiving this data has a modem which performs the same functions only in reverse order. The receiving modem converts the analog signals back into various voltages. The RS-232 port and the serial card again convert the voltages back into ons and offs. The serial card strips out the start and stop bits, checks the parity, and then strips that bit out too. We end up with the same 7-bit letter S, converted back to the full 8-bit ASCII character, which we sent just a fraction of a second ago. This procedure is repeated every time you press a key on your keyboard while telecomputing.

You may see the term "Bell Compatible" used to describe modems. Bell 103 (for 300-baud) and Bell 212A (for 1200-baud) compatible means it conforms to industry standards. A majority of the information sources use the Bell standards, and most modems on the market conform to the Bell compatibility standards.

Communication software and parameters

In addition to the hardware, or serial card and modem, you will need a computer program that instructs your microcomputer to access the modem and act like a data terminal. Communication software is sometimes sold with the modem and may be specifically written for that particular brand. Most communication programs, sometimes referred to as comm packages for communications programs made to operate with your computer, can be used with almost any modem. RBBSs often have free communications programs available and Shareware communication programs are available for about $45. Communication software can range in price from free to a few hundred dollars.

Communication software is your set of directions on how to interact with the host computer by using your microcomputer. The software should provide the ability and directions on how to:

■ Set your communication parameters.
■ Turn your printer on and off.
■ Save incoming data to disk file.
■ Send data from a disk file.
■ Store and dial telephone numbers, redial if busy.

■ Store and use pre-programmed function keys.
■ View or delete a file previously saved on disk.
■ Strip and convert characters.

The options in these programs will vary; you should have a good manual which explains them. An RBBS may have a free program which you can download and save, but may not be of any use if it doesn't have any documentation with it.

Setting communication parameters

Now that we understand how bits and parity are handled we can get down to the business of properly setting our communication parameters or "protocol."

Most communication parameters can be set using the communication program. Some of these parameters will be controlled by setting a switch or pushing a button on the modem. Some parameters, depending on the modem, may require software and hardware settings.

The communication program should offer a menu of items which you can change to match the host computer's protocol. Some of these parameters, or questions the communication program may ask, are:

1. **How many data bits? (7 or 8)**

 Your response will depend on what you are doing. If you are on a timesharing system and only using the 7-bit ASCII

standard set of codes (1-127) you can answer 7. If the host system requires 8 bits, like most downloading programs do, you will need to enter an 8.

2. How many stop bits? (1, 1½, 2)

You will never be asked about start bits, that's always a 1. You have the option of using any of the three. Most systems use just one, regardless if you're using a 7- or 8-bit character.

3. Parity? (Even, None, Odd, Mark, or Space)

(Even and None parity settings are the most common.)

Even - the parity bit will be assigned a 1 or a 0 to ensure the total number of 1 bits is an even number.

None - meaning no parity bit, used when sending 8-bit binary characters or when you have to use the full 8-bit extended ASCII character set.

Odd - the parity bit will be assigned a 1 or a 0 to ensure the total number of 1 bits is an odd number.

Mark - the parity bit will always be a binary 1, a 1 will always be sent but will not allow for error checking.

Space - the parity bit is always a binary 0, and like Mark parity does no error checking.

4. Duplex? (Half or Full)

Half duplex is like a CB radio, one way transmission at any one time. Characters are sent to the screen at the same time

you transmit them. Full duplex is like a telephone, two parties can be sending at the same time. Under full duplex, the character is sent to the receiving computer, which sends it back to you. Your communications program then displays it on your screen.

Warning: You may also see "Simplex" data transfer. Simplex data transfer is one way only all the time. An example may be a stock market ticker tape, certainly not an option for telecomputing.

5. Echo? (On or Off)

The echo setting works in conjunction with the duplex setting and is sometimes referred to as local copy. It has to do with getting the information to your screen. If you see double characters or no characters at all, your duplex or echo setting is wrong. If you see double characters (bb instead of b) switch to echo off or use full duplex. If what you type doesn't appear at all on the screen, switch to echo on or use half duplex.

6. Speed? (300, 1200, or 2400)

Speeds up to 9600 baud are possible. Remember, both the hardware (modem) and software (communication program) must be capable of transmitting at the same speed. Some host systems are capable of determining your speed setting and adjust their speed accordingly. This is called "autobaud" and makes things a little easier on your end.

Sample menu of software communications parameters

Set new defaults

Present program defaults:

Baud rate	1200
Parity	E
Data bits	7
Stop bits	1
Echo	N
Messages	N
Strip #1	17
Replace #1	0
Strip #2	19
Replace #2	0
Strip #3	127
Replace #3	0
Pacing p=	2
Logged drive	B:
Margin width	70
Screendump file	B:SCRNDUMP.PCT
Radial delay	20
Connect prompt	CONNECT
Line 25 help	Y
Foreground	7
Background	0
High inten.	15
Print port	LPT1:
Print init.	
Print width	80
Comm. port	COM1:
Comm. init.	,CS,DS
Modem init.	
C/R subst.]

(PC-Talk III, communications program for the IBM Personal Computer by Freeware - user supported software, Tiburon, CA)

Computers in communication 16

Evaluating telecomputing application sources (online services)

The computing tasks available by telecomputing may come from many different sources. The applications previously mentioned suggest the use of several different host computers. An RBBS may offer free software, your neighbor's computer may have some programs or information you want, while a mainframe computer has some marketing or weather information critical to your business and has a program you want to run which is too big for your microcomputer to handle. How you evaluate these sources is no easy task. The following are some points to consider when making that evaluation:

Usefulness. Before you subscribe to or call up that computer, does it have what you are looking for? Request information from the company which will list programs or information available. Many timesharing systems have a free hour or two of use so that you may check them out before you sign up.

Cost. A long distance phone call may be the only cost of using some of these systems. Other systems may have subscription fees, monthly minimums, additional charges for information retrieved, connect, processing, data storage - and training charges. The combination of subscription, telephone - and computer charges could range from as little as $10 to as much as $120 per hour or more.

Reliability and dependability. Host computers may have "down-times" due to hardware or software problems. If a system is down, usually at night for repairs - quite often it's not too reliable. Most systems are available 24 hours a day with reduced fees for non-primetime use. Software or information received should be evaluated for accuracy. Does the program make the calculations correctly? Did it take into account all of the variables? What was the source of that information? In general, can you depend on that information or analysis?

Turnaround. The speed of data analysis or information retrieval varies among host systems. If you are paying $20 per hour you want the information to be displayed within a few seconds of your request. Time is money. Systems which are menu driven are easy to use but may take a long time getting from one application to another, especially at lower transmission speeds.

Ease of use. Systems which are "user friendly" provide additional help when needed. Good host computer systems designed for noncomputer people provide additional help messages for each question asked by the system. Data input is checked and the user is informed when an inappropriate response has been entered. Immediate online help, plus an easy-to-understand manual, makes telecomputing much more enjoyable.

Recommendations

The first step in preparing to go online is to try to determine what applications you need. Your needs will help you determine what type of hardware and software you will need. Users who are interested in retrieving large amounts of text should seriously consider buying a high speed (1200/2400 baud) modem. The more you plan to use your microcomputer telecommunication system, the more sophisticated equipment you should consider. Auto dialing, pre-programmed function keys, and transmitting at high speeds will justify the more expensive modems in a short period of time.

Once you have determined what types of applications you need, evaluate which services are applicable to your needs. Most modems and communications software will allow you to communicate with almost any system. The system requirements or protocol will provide you with a list of options your equipment and software should provide. The quality of your telephone system should also be considered. Some rural phone lines contain too much static and interference to work properly with your telecommunication equipment. Static on the phone line will cause garbled transmission and may even disconnect you from the host computer. Line static will garble more information if you are transmitting at higher speeds. Some computer dealers will recommend the 300-baud modem for that reason.

The following are some specific recommendations:

■ Information services should be menu-driven.

■ Communication software should be capable of saving information to and transmitting from disk (or your type of data storage).

■ The hardware and software should be capable of setting the baud rate, duplex, word length, stop bits, echo, and parity.

■ Communication software should be capable of sending to the printer at any time during the online session.

■ Communication software should have good documentation.

■ Modems should be provided with a good users manual and operating instructions.

■ Local support should be available for modem and information service questions, with at least a phone number included.

■ Information services should provide good online and printed documentation.

Artificial intelligence

The topic of artificial intelligence (AI) can spark a lively debate. Is it really possible for machines to act intelligently? Will a computer replace me? Although AI research is a long way from developing intelligent machines, it has made important contributions to the use of computers which can influence the role and scope of professional communicators.

What is AI?

The goal of AI research is to develop computers which can think, reason, and solve problems in a manner which would be considered intelligent if performed by a human. AI research adds expert systems, robotics, and natural language to the technological achievements of the past decade.

Expert systems

The expert system is the first result of AI research which has received widespread use. An expert system is a computer program which incorporates the knowledge of an expert with a computer program that can reach a conclusion, in response to a user request.

A human expert makes decisions based on facts, experience, and knowledge of the subject. Developers of expert systems try to mimic the decision making process of an expert by summarizing the experience and knowledge (about a certain subject) of an expert into a set of rules. This set of rules is called a knowledge base. The process of assembling expert knowledge into a form which can be appropriately used is referred to as knowledge engineering.

Several computer programs are commercially available which can use a knowledge base and information supplied by users to reason through a problem to reach a conclusion. This type of program is called an inference engine, because it makes inferences based on inputs from a user. An inference engine is commonly packaged with other expert system development tools and sold as an expert system shell.

Expert system development normally consists of domain experts and knowledge engineers. The knowledge engineer works with the experts to extract knowledge for the expert system. Expert system applications are often diagnositc or classification problems.

As a professional communicator, you may be involved in expert system development as an expert or a knowledge engineer. Communicators in larger organizations, for example, may serve as an expert in developing an expert system to generate the first draft of a news release. The expert system would guide a client or fellow employee through the process of providing appropriate details and then organize the information into a news release. Communicators with a computer background may choose to study methods of knowledge acquisition to become knowledge engineers. A communicator's skills in summarizing and organizing information are important assets for a knowledge engineer.

Robotics

The term robot conjures up visions of remarkable devices such as R2D2 or C3P0. These are science fiction devices, however, with capabilities far beyond those of today's robots. Robots are mainly used in factories to perform specific, repetitive operations such as welds on equipment. If robots are to someday assume even mundane tasks, then they must be able to see. Machine vision is a related field of research which uses video cameras and image processing software to enable a machines to "see."

A robot's actions are controlled by software. The challenge for researchers is to develop an expert system which relates sensory inputs to a knowledge base to enable a robot to move about an office in performing tasks. The magnitude of this challenge should keep robots from having a direct effect upon your life for several years.

Natural languages

One of the problems many of us face in using a computer is learning the computer's language, or set of valid commands. The concept behind natural language research is that computers should learn our language. Instead of typing a cryptic command to run a word processing program, you should be able to type or speak an instruction like "start my favorite word processor" or since we com-

monly use acronyms you might say "run wp." The computer would receive the statement, determine what you wanted, and perform the necessary action.

The pressing need for natural language is in the area of information retrieval from large databases which may consist of publications, pictures, and computer programs. An information retrieval program using menus might require 10 to 20 menu choices to reach the desired information on the past president of an organization, for example. With a natural language interface, the request could be phrased in English (Spanish, German, etc.).

The challenge for natural language researchers is to interpret the proper meaning of a word given the context of a request. Communicators can plan an important role in the evaluation of natural language systems.

Hypermedia and multimedia

Hypermedia and multimedia are terms which communicators will be hearing more often. The basic purpose of hypermedia, or hypertext, is to display textual information on a computer. Since most computers only display a few lines of text on a screen at one time, hypertext allows users to select certain words or phrases to be expanded.

The approach to hypertext is similar to writing a newspaper article, in that the main points are covered in the first paragraphs and the following paragraphs expand upon the first. With hypertext, the first paragraph would be displayed with all key phrases highlighted. If users wanted more information on a phrase, they would select it with the keyboard or mouse. Once a phrase is selected, a paragraph of more detailed information is displayed. Hypertext allows users to see as few or as many details as they desire.

Multimedia refers to the multiple media which a computer can control for information delivery: programs, text, digitized images, motion video, and audio. With multimedia, the hypertext notion described above can be expanded. Instead of a phrase expanding into more text, it could just as easily expand into a motion video sequence, a digitized image, or digitized speech. This feature greatly enhances the capability for a computer program to communicate with a user.

Professional communicators must be involved in implementing, evaluating, and improving applications of hypermedia and multimedia. A communicator familiar with this technology, can be an integral part of multi-disciplinary teams who are developing computerized information sources.

Teleconferencing provides opportunities for a meeting without the inconvenience, time loss, and expense of face-to-face interaction. Teleconferencing is an available, alternative communication medium that is effective when well used.

Teleconferencing doesn't replace the need for all face-to-face meetings, but it is a good communication supplement. It can improve the quality of conventional meetings by taking care of "housekeeping" chores beforehand.

Teleconferencing can be a combination of telephone, radio, video or other visual transmission, and computer technologies. It can be used with problem solving, staff development, report writing, proposal development, information sharing, job candidate selection, project planning, informal training, credit courses, and other tasks as well.

There are many teleconferencing options. These range from a simple, three-person conversation using a push button telephone to satellite-delivered, full-motion, full-color, live television conferences with hundreds of locations and thousands of conferees. Some of the many options are covered in this chapter. A glossary at the end of the chapter explains unfamiliar terms.

Audio teleconferencing

As its name implies, audio teleconferencing is based on voice only. It is used by professionals in business, government, univer-

sities, and public service agencies to help meet increasing demands for easy, cost-effective communications or educational needs.

Teleconferencing is a very interactive medium. The skills required are not difficult for the motivated learner to master. All it takes is a little training, background reading, a pilot test, and perhaps, the observation of an experienced teleconferee.

As with most things, practice helps, too. Frequent teleconferencing will encourage variations of style and technique that will improve the teleconferences — and help participants.

Personalizing the audio teleconference

Teleconferencing sometimes is approached as a glitzy concept, and it's easy to get caught up in the glitter of the technology and

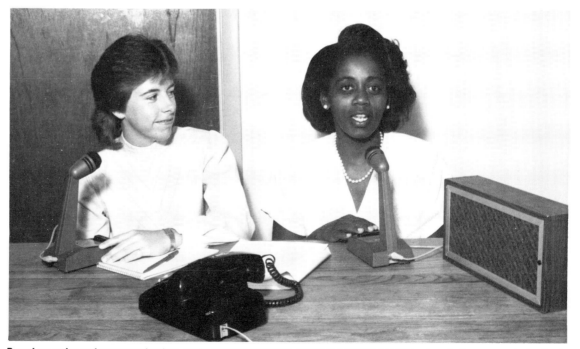

Based on voice-only communication, audio teleconferencing makes it possible for many people to communicate simultaneously without traveling long distances to meet in person.

lose sight of the goal — to communicate. Keep in mind, however, that meeting the needs of participants should be your goal — not showing off the bells and whistles.

An awareness of the weaknesses and strengths of the teleconferencing medium being used can help you keep your attention where it belongs. All the answers are not in yet, but experience and research provides some guidelines for conducting a successful teleconference that meets participant needs.

Plan with participants. Remember that people who are involved in the planning process of a project develop a vested interest in its successful outcome. Developing such an interest in participants pays dividends in positive results and feelings about the technique and the medium.

Provide background. Make sure teleconferencing participants have the right background information, including appropriate print materials. Background materials should include conference goals that you have worked out in advance with conferees; an agenda; names and locations of conferees; and a little about the conference leader.

Work at becoming a group. Become a group ready to accomplish a series of tasks *before* the conference ever starts. A pre-conference session helps participants understand the direction you intend and gives them preparation time. Well-prepared participants use their conference time to better meet agreed-upon goals.

Get acquainted. Most audio teleconferences are for small groups, but successful 50-state national conferences are possible and can be effective. Whatever the size of your meeting, its goals are more easily met if the conferees know each other.

Of course, this is not always possible. One way of getting acquainted through long distance is for the leader to develop background biographical materials on participants. A registration form is an easy way to collect biographical information.

Use names. During the conference, use individual names and speak directly with participants. When you ask a question, you can encourage involvement by calling on participants by name. Addressing questions to the total conference with words like "everybody" or "anybody" often yields no response. Direct questions are more apt to yield a response that others can react to and build on.

Identifying key views is one of the leader's roles. An alert leader will try to balance interaction and include all viewpoints. Speaker identification helps keep this balance.

Conferees should start comments with their name and, perhaps location, until voices become familiar. This adds clarity to discussions because it identifies the source of viewpoints expressed.

Build on backgrounds. Build your conference on a knowledge of the backgrounds and experiences of participants. In many teleconference situations, the leader will know useful facts about conferees. That information, plus any facts gathered from registration, can be used to personalize conference interaction. This improves the discussion flow and enhances effectiveness.

Talk to someone. Speak as though you're talking to one person rather than to a group or a microphone. Use the full range of gestures just as in a face-to-face situation. Your voice will reflect those actions and be more personable and convincing, resulting in a more energetic delivery. Read information only as a last resort, and do it sparingly.

Conducting an audio teleconference

In the early stages of a teleconference, call upon each location if feasible. Ask questions such as, "Who is at your location?" or, "What additions do you suggest to our agenda?"

This allows participants to be introduced by name and location, provides an opportunity to check the equipment, and quickly involves conferees. An informal start will often help reduce hesitancy to participate.

Positive leader attitude. Those responsible for a teleconference have many names, including leader, presenter, programmer, or moderator.

Leaders should show enthusiasm for the task. They need an ability to draw participants into the conference.

An inexperienced teleconference leader should observe, team-teach, or interact with experienced teleconferees to learn how to more effectively use the medium.

Alert participants to concerns. Before the teleconference, some leaders wish to call some participants and go over questions or concerns. This gets them involved and will contribute to success.

Use interactive techniques. Interactive techniques strengthen teleconferencing.

Interactive formats include:

■ Well-handled, open discussion.

■ Roll calls for questions or input at appropriate times.

■ Short case studies followed by discussion.

■ Brief interviews followed by discussion.

■ Simple role playing situations followed by discussion.

■ A reactor panel.

■ Lecture discussion.

■ Time-limited group work at remote locations.

■ Team teaching.

The key is involvement of conferees.

The leader's responsibility. You can promote interaction by delegating specific teleconference tasks.

Encouraging two or more presenters to work together can provide variety necessary for a successful teleconference. If this interactive teaching is well planned and well done, the learning experience can be richer and have more depth than a single teacher.

Design opportunities for participants to interact frequently. If participation is slow, direct questions to specific individuals, groups, or sites rather than to the conference at large.

Constant talk by one or two individuals or requests for instant response from participants are not effective techniques.

Be prepared to wait 5-15 seconds for participants to prepare answers to any substantive questions. They may have to move to a microphone.

Who prepares the site? A designated coordinator at each of the teleconference sites can ensure conference success. This liaison helps group interaction there. The site facilitator should:

■ Set up telephone and teleconference equipment and be sure it works. Arrange for any audiovisual needs.

■ Handle technical details of the conference such as calling the teleconference "bridge," a device that links phone lines together. Make sure you have a good connection.

■ Distribute print materials to site participants.

■ Help site participants with details related to attending the conference.

■ Keep teleconference leaders informed of progress of the program at that site.

■ Manage any planned on-site interaction.

■ If appropriate, be involved with evaluation.

■ Serve as the eyes and ears of the leader at the site. This is especially necessary in workshops or other teaching/learning situations.

■ Collect appropriate registration, evaluation, or feedback materials and forward them to the teleconference leader after the conference.

The conferee's responsibility. Ideally, a conferee should be an active participant. A conferee should:

■ Be prepared to participate and know expectations.

■ Be on time.

■ Listen and participate where appropriate, but avoid dominating conference time.

■ Identify himself/herself when speaking.

■ Complete evaluation surveys and provide feedback on the teleconference.

Bridging service. A device that electronically connects three or more parties for a phone conference is called a bridge. Bridge types vary. They can be owned or leased.

Professional bridging services are also available. There are also government, university, and commercial sources for either call-in or

call-out. Many commercial and government bridge services offer operator monitoring as a standard feature.

Monitoring can be a valuable feature for any teleconference, but especially for conferees who are inexperienced. Operators stand by; attend to possible equipment failure or line deterioration; call out for an additional person, if needed; or record the conference.

By contrast, a "conference call" operator simply puts participants on the line and leaves the conference. This means you are on your own. You pay for the calls out.

Audio teleconferencing and videotape.
Videotape can enhance your audio teleconference. A short tape (5 to 10 minutes long), shown before an audio conference, can visually present a resource person or information on the conference subject. A tape copy can be sent to each site before the conference.

By planning ahead and keeping them simple, videotapes can be used for more than the teleconference itself. Slides or overhead transparencies are other options.

Costs of audio teleconferencing. The cost of microphones and speakers for your telephone vary widely. Select equipment that fulfills the conferencing need without breaking the budget. When choosing equipment, allow time to talk with experienced teleconference users and professionals for their opinion.

Professional teleconferencing equipment can be rented at reasonable cost from commercial sources. This may be the best answer for occasional or trial use, or when "portable" teleconference equipment is used to bring the speakers to face-to-face meetings.

Audio teleconference evaluation. Evaluation is a very important element in teleconferencing. Develop an evaluation form if you offer a teleconference service or simply have a teleconference.

The first step is to determine how and by whom the evaluation results will be used. Needs differ. Administrators want decision making information. Teleconference presenters want feedback on effectiveness. Evaluation results should be used to shape the next conference.

In conference evaluations, consider the following:

■ Main presenter and/or moderator:

How well were the messages formulated and delivered?

How well was the conference conducted?

■ Materials:

How appropriate were the materials provided for the topic under discussion?

If combinations of media were used, how effective were they?

■ Interaction:

How much involvement was there?

Did the conference do a good job of integrating a variety of participants?

Did the interaction contribute to the learning process?

Did interaction significantly help reach conference goals?

■ The site facilitator:

Did the facilitator have effective guidelines?

Did the facilitator do the assigned task?

■ Site:

How conducive was the site to achieving conference goals?

■ Equipment:

How appropriate was the equipment for meeting conference goals?

How did the teleconference equipment function?

Did the audio/visual equipment work?

■ Effects:

What was the impact on participants?

Did participants feel the conference was time well spent?

Videoconferencing

The electronic age has brought together video, telephone, and computer technologies to produce intriguing possibilities for communicators. Live, full-motion, broadcast-quality, one-way video, with two-way audio is one of the most effective videoconferencing formats available. In this type of conference, live video and audio signals are usually distributed by satellite. Two-way audio is usually accomplished through telephone lines.

There are other forms of videoconferencing that also deserve attention here.

Audio graphics teleconferencing. Options such as freeze-frame or slow-scan video teleconferencing are available to deliver sequenced, still photos of the actions or graphic materials of a presentation, usually through phone lines.

They are primarily used in room-to-room exchanges or in the new desktop video systems for executives' desks. Obviously, there is limited production quality to the transmission.

Other enhanced delivery systems include telewriting graphics devices linked to computers. Engineers and others who must see each other — or data and documents as they are developed — may find these approaches useful.

Compressed video

Compressed video is a way to change a video phone image into digital form for transmission or storage. By digitizing and compressing video images, two-way video conferences can be done through dedicated telephone lines. Large government and corporate networks that deliver this type of conference are in place throughout the country.

Special equipment is needed at all sites to compress, send, and receive these video signals. A graphics camera is usually available. Again, this is for small, room-to-room situations or video phones. In this type of teleconference, quick movements may result in a blurring sensation on the screen depending on the system's capability.

Planning a broadcast, satellite video conference

Development of a videoconference of any type is a team effort. Early in the process, consult with an experienced videoconference

The electronic age has brought together video, telephone, and computer technologies to produce intriguing possibilities for communicators.

production staff to see if the project is suitable for the medium. Some characteristics of subjects that make for effective videoconferencing include a topic that:

Is timely and newsworthy.

Requires interaction.

Cannot wait to be resolved in other ways.

Needs to be presented live to a large target audience at the same time.

Is visually or action oriented.

Has important consequences for the participants.

Once you have determined that a videoconference is appropriate, you need to determine:

The participants for the conferences and their geographic locations.

The specific participant-centered goals of the conference.

Preproduction tasks.

Tasks needed during the production period.

How downlinking or delivering the production will be achieved.

The division of costs and a cost analysis for the entire project.

A plan with deadlines and fixed responsibilities outlining each step toward the production goals.

The format/interaction of the actual production.

How the conference will be evaluated.

How conference results will be shared with participants.

Costs of satellite videoconferencing

Studio production, uplink, and satellite costs for an hour long low-production, one-way video with two-way audio program can be several thousand dollars. If well designed and executed, the interactive impact of videoconferencing is impressive and cost-effective — especially if sites such as universities or other locations agree to downlink the production, at their cost, because it also meets their needs.

Also, there are ways to do "executive" satellite video conferencing with limited equipment and personnel in a non-studio setting. This is more of a conference room or office approach. It can be useful and economical for staff briefings.

By contrast, face-to-face workshops are often much more expensive. A recent national conference required 400 field staff from throughout the country to attend three two-day workshops, delivered back-to-back, in Ft. Worth, Texas. The cost reached into hundreds of thousands of dollars.

A major advantage of the videoconference alternative is the "real time" delivery to all field staff nationwide. Clearly, the world of video-conferencing, although perceived as expensive, can be cost-effective.

Computer conferencing

The use of computers for conferencing has become more attractive and practical. Personal computers are in wide use. Their costs have come down, and their capabilities have grown.

Computer conferencing takes three basic forms. Two of these are *asynchronous,* and one is *synchronous.* One type of asynchronous computer conference involves only telephone lines and computers. Conferees can enter the conference at any time.

Another asynchronous form adds a data bank capable of storing visual materials with a transmission and retrieval system that stores such materials, either with or without the capability to manipulate those visuals.

In contrast, synchronous computer conferencing requires all conferees to be present at the same time. The advantage of such conferences using the computer is that visual materials, or text materials, can be exchanged in "real time" during the conference.

However, synchronous conferences generally are not as productive, well received or satisfying as the other types. They are more demanding because they require significant typing skills, immediate responses to the message being delivered, and the presence of all conferees. This type of conference also does not allow conferees to enter as they need to, nor does it give them "thinking room" before they must respond.

Asynchronous computer conferences make sense when people have something to discuss or decide when there is no other way for participants to get together. As mentioned, the major strengths of such conferences are that an individual can:

- Participate in the conference when it is convenient.

- Participate in several conferences during the same time period.

- Give thoughtful consideration to the comments of others and respond after study or research.

A moderator is needed to keep the conference moving. Group members should be provided with conference objectives, ground rules, an agenda, and a schedule. Early on, participants should agree on when to start and end the project. They should also agree on goals, a timetable, response guidelines, and their expectations.

Computer conferences are still in relative infancy, but there are already some well-established procedures that will increase the probability of success:

A strong desire for communication.

A clear sense of structure and purpose.

A moderator open to ideas from everyone.

Between 8-15 people who commit to two or three sessions a week.

Conveniently located computers.

Training and assistance in using computer conferencing software programs.

Communication needs compatible with the technology.

Teleconference glossary

Acoustic feedback, audio. Unpleasant howl from loudspeaker caused when the loudspeaker sound is accidentally fed into the microphone and then overamplified. To fix, turn loudspeakers away from microphones.

Ad hoc teleconferencing. Popular term for teleconferences using an informal, one-time only or occasional network or site; usually a single event teleconference.

Add-on conference. A telephone or Private Telephone Switchboard (PBX) feature that allows a user to add a third party to a two-party conversation. Also referred to as three-way calling or three-way conferencing.

Amplified telephone. The general term for a "hands free" telephone using a sound amplifier and microphone rather than the usual handset. Term used instead of speaker phone.

Audio teleconferencing. Teleconferencing which allows individuals or groups to communicate through voice transmission. Two-way systems that allow participants remote from each other to hear and be heard.

Audiographic teleconferencing. Voice and graphics communication between two or more groups, or three or more individuals, who are in separate locations linked by a telecommunications medium. Permits transmission of graphic and alphanumeric information (diagrams, charts, text, free-hand drawings, etc.) as an adjunct to audio teleconferencing.

Uplinks are an integral part of teleconferencing.

Bridge. An electronic device which mixes telephone calls from three or more locations, in a single conference. People call in to participate, or the operator calls out.

Bridging services. Service that provides bridge time and related services to customers who want to link multiple locations for teleconferencing purposes.

Conference calls. Telephone conversations tying three or more individuals together through the assistance of telephone company or PBX operators. Conference operator calls to add individuals and groups to the teleconference.

Dedicated system. A full network which is either leased or owned for the specific purpose of teleconferencing. It can also be used for other communications purposed by an organization.

Dial-in. An audio teleconferencing system or bridge which requires participants to dial through normal telephone circuits to participate in the teleconference. Also referred to as "meet-me".

Earth station; Earth terminal. The ground equipment, including a dish and its associated electronics, used to transmit and/or receive satellite communications signals.

Local area network (LAN). A private telecommunications network carrying voice, video, data and other communications among desks, work stations, or conference rooms in a discrete area.

Origination site. Location from which a videoconference is transmitted or linked to the satellite.

Point-to-multipoint. A teleconference configuration which allows information to be communicated from one point to many.

Port. Position on a teleconferencing bridge that accepts a telephone line.

Receive site. Location of satellite downlinks; participants will be at a receive site during videoconferences.

Satellite. A celestial body orbiting another of larger size. Commonly used to describe communications satellites which are geostationary in orbit.

Teleconferencing. Conducting a meeting through interactive electronic communications. Interactive group communication through an electronic medium. The use of telecommunica-

A teleconference is broadcast live. It will reach many people in remote locations who may not have had the money or time to travel to a conventional conference.

tion systems by groups of three or more people, at two or more locations, for the purpose of conferring with one another. Two-way communication between two or more individuals, remote from each other using a telecommunications medium.

Tele-training. An integrated system for the planning, delivery and management of training or instructional programs using teleconferencing; a way for organizations to connect students at one or more remote sites with their instructor at a central classroom. Also called tele-teaching, tele-education or distance education.

Transponder. The equipment on a satellite that accepts the signal sent from earth and, after amplifying and changing the frequency, sends it back to earth for reception. May be referred to as a repeater.

Transportable earth station. An earth station that is mounted on a trailer and can be moved from site to site.

Uplink. A satellite earth station capable of transmitting up to a satellite.

Video teleconferencing. Communication between two or more groups or individuals who are remote from one another, using telecommunications channels for fully interactive video and audio or one-way video and two-way audio; includes full-motion video, and, in some definitions, freeze-frame or compressed video images.

Classrooms can serve as remote locations where participants may view a teleconference and take part in question and answer sessions conducted by telephone.

■ **Electronic
information delivery**

The age of delivering current information by computer is here. Called electronic mail or E-mail, it's a good way to deliver your information to the public immediately. After loading your press release, entire publication, or other prepared text into the computer, you can release items of 100 words to 100 pages long. Length depends only on the program you've contracted to use. The public may then enter the system by computer to take only the information it wants.

Today, almost all professional writing in this country is stored on computer disks. Once you have recorded your press release or publication on a disk, you have completed the most difficult task in distributing it by computer. All you need to do now is "load" the information into a computer so others can access it. People don't even have to mechanically dial up a computer system to get the information. VSAT (Very Small Aperture Technology) allows a system to send only the reports people want — automatically — to be printed out as they are released, much as a teletype machine does.

Electronic information delivery

Although many people think of it as a new technology, electronically delivered information has actually been around for some time. The U.S. Department of Agriculture, for example, has published press releases and other reports since 1981 on a computerized information delivery system called "USDA Online." In 1985 the USDA established a second service, still

in operation, called the "EDI (Electronic Dissemination of Information) Service."

If your organization is in business to distribute information, as the USDA is, you have to be serious about how you do it. It's pointless to

struggle over a news release or publication if you don't distribute it effectively.

The age of delivering current information by computer is here. Called electronic mail, or E-mail, it's a good way to deliver your information to the public immediately.

18 Electronic news

Analyze your information

Determine what you want your service to be. Will it be used primarily to disseminate news? Who are the proposed users? Or, will you want the system to also include the ability to transfer information for and about your staff throughout the organization? Obviously, the size and scope of your needs will help you determine the type of service you require. Explore these aspects of your own operation.

■ Your clientele.

■ The information you would like to distribute.

■ Sources of your information.

■ How to build in security and information clearances.

■ Payment for the information.

■ Commitment of your boss — and the staff — to the project.

Your first step is to analyze your information. Is it news? If so, do you now have a way to get it to your clientele while it's still news? Or is it information used for reference or background that your clientele may use to plot trends or match up with technical work being done elsewhere? Is it information that people don't need as quickly as you can generate it, or does your organization provide statistics and/or information that people apply as soon as they receive it?

If yours is like most communicators' offices, you have some of each: hard news as well as "softer" news. You probably have more information than you think, though, that could use quick delivery. If the information is useful, then the sooner it's in the hands of the user, the better. After all, you may not know all the purposes for which your clients apply your information. Needs vary. What you consider not so important may be information one of your clients has been waiting for.

Postal mail doesn't work for hard news. In this age of the wire services, FAX, and computer modem technologies, computerized delivery does work. If you want to get information out to the public at once, then E-mail is an excellent technique. Everyone has the same crack at it. It's fair. It's fast.

The best aspect is that you're not dumping "news" into the postal service to be delivered two, four, 10 or more days later. A real-life example tells the story. A professional in USDA's Office of Information conducted an interesting mail study. She put three empty envelopes in the same USDA mail pickup at the same time of day, one on a Friday, a Monday, then again the following Friday. She sent them to the same address — her home about 24 blocks away in Washington, D.C. The envelopes all arrived in the same mail delivery, the Monday following the final mailing. The postage the mailroom applied to the empty envelopes moving through its system varied: 22 cents, 56 cents, and $1.58, respectively.

Had the professional used E-mail, she would have delivered the information to its delivery point quickly, at a considerably lower cost.

Benefits of electronic mail

■ Delivers your information to the public immediately.

■ Saves money on postage and other mail costs.

■ Helps you compete as an information supplier.

■ Can give your information national distribution and visibility.

■ Upgrades your information program.

Save money

You're ahead if you can beat the budget-cutters at saving money in your own shop. With a well-run computerized service, you can point to your savings on delivery costs when they attempt to trim your budget.

Here's an example. The USDA's Office of Information, using its computerized EDI Service, transmitted 168 national and regional one-, two-, and three-page press releases and other documents at an average of $2.28 each. Thousands of people then had access to the documents.

That same month in 1989, it cost USDA about $516 to send one press release via the postal service to about 2,100 addresses throughout

the country. That cost included postage, envelopes, adhesive address labels, and other supplies. Neither the EDI Service nor the postal mail costs included labor.

Of course, costs change as time goes on. But since postal rates are always going up, this example will apply for a long time to come. To get an idea of the money involved, multiply 168 releases x $516 = $86,688. That's about the entire operating budget for the USDA's EDI Service for that same fiscal year. The system loaded thousands of documents from 10 different agencies over the 12 months and received documents as well. And that cost included all six additional USDA agencies retrieving data from the service, plus some agencies outside USDA.

While your operation may not give you the same volume of savings, it can save on postage and the related costs of distributing information. Where should you — the communicator — spend your information delivery dollar? Paying $86,688 to distribute one month's press releases by mail? Or sending those releases plus thousands of other documents of 10, 50, or more pages for the entire year to thousands more people for the same cost? Put it in terms of your own operation.

Also, costs for electronic mail delivery go down through volume and technological efficiencies, while postage and other conventional mail costs go up. On a postage system, each time you add a new name to your

mailing lists, you pay for it. Not so with computerized delivery.

Postage costs went up twice since the USDA started the EDI Service, from 20 to 25 cents — a 20 percent increase. And the Postmaster General recently announced they'll be going up again! On $100,000 worth of postage, that's an extra $20,000 spent. In your organization, that increase *alone* could be more than the entire cost of operating a computerized delivery service. Again, remember that while the specifics of these costs may vary over time, the cost-cutting lessons don't.

Compete better

Elsewhere in this handbook communicators describe how to compete successfully for print and broadcast time. Once you've established your service, you'll reach a new plane, a new information dimension in your ability to compete. With the couple of minutes it takes you to sign onto your system, load your release, check to make sure it's in the system, and sign off, you'll likely be ahead of your opposition.

You can release your information before your competition reproduces theirs for distribution. Yours can be in the newspapers while theirs is still in the mail. Distribution costs will be so low, relatively, that you can distribute more. Opportunities will open to you. You'll start finding information you never felt useful to release to the public — perhaps because it was outdated before it reached them.

National distribution and visibility

Don't think because your organization works in only one state your information isn't necessarily useful in others. Many of America's major cities are informatin crossroads for parts of two or more states. If you contract with a firm that already has a national computerized information delivery service, your information and your organization can get national visibility.

You'll also get better regional use of your information with electronic delivery. And it costs you no more to release your information nationally than it does within your state. Since users pay for the information, it costs the same to load a document, whether one or 1,000 people access it.

Getting your organization in position

Computer technologies are transforming almost every aspect of a communicator's job. Consider, for example, the possibility — and indeed, the reality — of storing the entire information output of your organization for each year on a single compact computer disk and being able to sell that disk for a few dollars to whoever wants it!

By starting a computerized information service, you'll take a valuable step. You'll start training yourself — and your staff — on what is fast becoming a basic information tool as familiar to many comunicators as the telephone.

Setting up your service

Find a reliable contractor. Some people use their own computers to create and maintain the database. Others contract with a firm to use its computer. The latter is usually recommended because you use a firm's technical support staff and its software program to keep the system running. Your contractor is more likely to make sure the system keeps working than people in your organization who you may not manage.

As you establish a database, remember that you need a contractor who will give you the system that fits your needs. The contractor needs to be a competent firm you can trust, one that has the equipment and is staffed to keep your operation running. Above all, to be successful, your service needs to be dependable.

The U.S. Department of Agriculture has published press releases and other reports since 1981 on a computerized information delivery system called "USDA Online."

You don't have to worry about billing. The contractor handles that. There are many reputable contractors.

Shop around

Operating costs of a service vary a great deal with a specific situation and are impossible to fully explain here. It pays to look into the options. Costs generally depend on:

■ Your contractor's prices.

■ How much information you load.

■ How much you and others in your organization retrieve from the service.

■ How good your equipment is.

■ How well you use the system.

Choose equipment for speed and error checking

Contract for the system. Don't create it in-house. Aim your efforts at getting information on your service, not on the technical and time-consuming task of keeping the system running. Leave it to technical people. Your service will grow as your contractor grows.

Use proper equipment for the job. Don't skimp on quality. Your service must be dependable. You need equipment that will load your information at high speed. You'll load numerous materials over time, often pages long. High-speed equipment should pay for itself,

by maximizing online time and minimizing down time.

When looking at systems, keep in mind that loading speed doesn't always control the receiving speed. The system you're using determines baud rate, or bits of information transmitted per second. If you can, get equipment that lets you load at 4800 or 9600 baud. Be aware that 2400 baud is not twice as fast as 1200. But every little "bit" helps.

Faster loading makes your release available to your customers faster — important when you have several to load. If you load them together in a string, none are available until the last is loaded.

Use equipment that checks each line for errors as you transmit it. Your information must load exactly as written. Subscribers won't use information they can't trust.

Use equipment that will let you administer the system, if that's required. And remember to plan for growth. The loading standard is creeping up from 1200 to 4800 baud.

Staff your system

Your staff should be as large as needed. Its size depends on:

■ How many documents you release.

■ Backups for vacations, travel, training, illness.

■ How much of the material is on disk.

- **Inform and educate
 your clientele**

- Whether you'll have to edit and rewrite documents.

Some retyping is okay, but remember that retyping is inefficient. When typing for release, type it on a disk. And yes, a service can be built on a shoestring. But you're far better off getting your director or boss to give you the resources you need. Management must back you totally after the decision is made that E-mail is a step the organization must take. Management must commit the necessary staff to operate it.

When you undertake E-mail, you should realize that you are creating a new unit, in much the same way your organization may have a television unit, graphics, radio, press release, or a photography unit. You need to supervise the staff, hire and fire, reward and punish.

Needed: dedication, training, time

Everyone will need training to load and receive data, and they must also know what to do when something goes wrong. System operators should know who to call, so keep names and telephone numbers handy. They should also know enough about the system so they can intelligently convey symptoms to a repair person.

Get training from the firm you contract with. While these systems are hardly more difficult to learn than a new piece of home stereo equipment, computers themselves can be difficult.

Think of your delivery service as a "news" service. It must contain news, or at least useful information. The information must be there when people expect it. For that, you need to be staffed for peak workload. You can't fall behind with news or current information and be dependable. When people go into a database time and again only to find useless information — or no new information at all — they will stop using it.

You must be dedicated to running a dependable service. The staff needs a news and information background. They must know the needs of newspeople. You can't operate a dependable service by imposing it on a staff already working on another assignment. They may not become committed. This is a full-time operation.

Inform and educate your clientele

Make sure the people you already send information to know they can get your information by computer. Print on every release, publication, everything you distribute — in a prominent place — that the information is available by computer.

A good tip: In your contract, include a requirement for the contractor to advertise your service. Give your name and a telephone number to call for more information. Or have them call your contractor to sign up. Clear it with the contractor first, however. The company will likely get many calls.

Everyone will not want everything you distribute. But everyone might want some of it. They'll pick and choose. The people who wanted it before should want it now, too. If in doubt, load it.

What to distibute

Distribute any information your organization produces for the public by electronic mail. Put the name and number of a contact on each document. Electronic mail is a news service — and more. Here are just some of the possibilities.

- Keeping in touch with your management team on the road.

- Communicating individually with news media, field offices, clients, and others.

- Sending reports, already written, back to your office from the field.

- Distributing press releases.

- Displaying appointment, calendars, and travel schedules.

- Publishing research results, grants, papers, briefs.

- Transmitting farm and business information.

- Disseminating consumer information of all kinds.

- Distributing speeches.

- Publishing transcripts of conferences and news briefings.

- Transmitting story ideas for news media.

- Advertising new publications, computer software, etc.

Some releases may not be suitable because of length. Perhaps you'd load just the "executive summary." You can't load graphics, at least at present, but tables work fine.

Break long releases into sections. Use section headings. That way, your customers won't have to search through entire reports to access a section they want.

Everyone has different reasons for wanting releases broken up. Some want the back or middle parts first, while others may need only the summary. Other clients often want the parts that wire services don't give them. Some of your clients may want to receive information section by section so they can edit each for further distribution while receiving the next section. With other people, seconds count.

Unless you request otherwise, the standard format for computerized delivery services is "last in, first out." The release you loaded most recently will be at the top of the list to be delivered in the system. That keeps the most current information up front. When you load reports that you've broken up, however, they'll be in reverse order to the order in which you loaded them. To avoid the problem, simply load long reports or books backward.

Who pays?

W ho pays? is one of many questions surrounding delivery of information by computer. Having users pay for it is one way to operate such services.

Your clientele generally won't like the idea of paying for your information. It may be public information they've paid for once already.

One good way to establish your service is to provide it free to selected clientele for a certain length of time. You can simply assign your news media user identification numbers and pay their bill when they download your information. Experience shows that after the initial curiosity is gone, most people don't waste their time fooling around in a database. Those who want it, stay on and will pay for the service.

Apply the savings you'll make on postage and other mailing costs to delivering your information by computer. Then you should have enough money to pay for the service. If you like, for example, you could make it available free to news media and a few libraries in your state and pay for that from the mail savings.

To acquaint your audiences with your services, it's important to advertise. Start by announcing your service in a press release. Send that release to the people who reach your audiences. Tell them what information you'll make available by computer. Include a name, telephone number, and address to contact, and include the price. Get news and trade

media within your coverage area to do stories about it.

Notify your audiences about your new service on the very information you normally send them by mail. Tell them over and over, on every press release, publication, radio, and television program you produce. Capitalize on your savings in postage and mailing costs. Cut back on the number of copies you print and mail out. At some point when you and your service are ready, take the big step: tell your clientele you won't be mailing information to them *at all* after a certain date.

Talk to your newspaper editors and editorial writers about it. Gain their understanding. Tell them where the money you'll save will be better spent.

When you're up and running

G ive yourself plenty of time to get the system running smoothly before you actually begin the regular release service. Conduct a "dry run" before you go live, just as Cable News Network did. Put your own organization on the system during the dry run. Complaints at this stage will help you spot problems.

The up-front costs of E-mail may cause resistance to the idea in your organization. Emphasize savings to your clients (or taxpayers if you are a public agency) as a reason for starting your service.

Effective communication: 19
Nine lessons from research

We are swimming in a daily sea of communication messages — mass media and interpersonal, intended and unintended. From this tide of messages, we select only a small fraction to which we pay attention. One estimate, for example, is that worldwide, fewer than one percent of messages on radio and TV are attended to by their potential audiences.

Of what we do pay attention to, we learn only a small portion. A study of TV news showed that only 30 minutes after viewing an evening newscast, one half of those surveyed could not recall a single thing they saw.

Finally, of those messages people pay attention to and understand, few result in any change in *behavior* or *attitudes*. Reaching an audience with a message that smoking increases the chances of developing lung cancer certainly has not resulted in any rapid or dramatic changes in behavior.

As communicators, these facts remind us of the difficulties we face in reaching audiences with information. The communication process is likely to fail for a number of reasons. These include:

Failure to share meaning. A few years ago a cartoon showed an educator opening the head of a student and pouring in the appropriate measure of knowledge. Such direct communication of knowledge would be nice, but it is simply not possible. Human beings must always communicate *indirectly* by first converting experiences or knowledge they

have into symbols (words or gestures). These must then be interpreted, or decoded, by the receiver of the message. Lack of clarity of language, an ambiguous gesture, or the absence of a shared culture can doom communication to failure. A "drinking fountain" in New York is a "bubbler" in Milwaukee. An "intestinal parasite" to an agricultural researcher is a "worm" to a farmer.

Failure of communication channels. There is always "noise" in communication, caused by anything from a smudge on the newspaper page to a lack of clarity in broadcast signals. Inability to hear or see at a meeting is another common reason for a lack of effective communication. However, there are also other problems brought about by the fact that people *expect* to receive certain things from media. We expect to be entertained by TV. How does this affect the use of TV as an educational medium?

Lack of attention to or lack of interest in the message. Researchers often assume that people who buy newspapers do so because they want news. Yet recent studies show that many other motives are involved (entertainment, to pass time, habit, etc.). Viewing TV is often done with other people or in conjunction with other activities. The typical TV news viewer is also reading a newspaper, is chatting with a spouse, and has children running through the room at the same time the broadcast is on.

This chapter presents nine "lessons learned" from research into the communication process

over the past 40 years. These lessons can help communicators better understand and use both mass media and interpersonal processes to reach audiences effectively. No attempt is made to be comprehensive; rather, the focus is on the practical implications of research results. A suggested reading list is provided at the end of this book for those wishing to read more in any of the nine areas.

Communication is a long and difficult process

In 1979, a project was undertaken to educate residents of three Wisconsin and two Iowa communities about energy topics, ranging

We are swimming in a daily sea of communication messages — mass media and interpersonal, intended and unintended.

from home energy conservation to nuclear power. Over a four-month period, major newspapers in each of the five communities printed 14 half-page articles on specific topics. The total number of words printed was approximately 50,000, or about half a small book. Results showed that knowledge about energy had increased over the period, but only by 2.8 percent. Such results are typical of single medium efforts to increase knowledge among general populations.

A more comprehensive effort is represented by a 1973-74 project of the Stanford Heart Disease Prevention Program in California. In one community, residents received an intensive

People learn at different rates, which has been explained by differences in such factors as education, income, and age.

two-year barrage of mass media messages in newspapers and on radio and television. A second community received the same intensive media coverage, but also included personal contact between health experts and community residents. Results showed that knowledge of heart risk factors increased by 26.5 percent in the first community and 36.0 percent in the second community.

Why is learning so slow and limited? We often imagine a public heavily tuned in to mass media. However, despite the fact that 70 percent of adults report reading a newspaper daily, the time they spend with it is 20 minutes or less. More than half of those age 44 or younger do *not* watch TV news between 5 and 7 p.m. on a typical day.

These results suggest that while increases in knowledge about most public issues are possible, intensive multi-media coverage over long periods of time is necessary. Although these figures can be discouraging to some, they must be kept in perspective. As compared to the number you might reach personally, mass media are still highly effective in reaching a large audience with information.

Two practical implications follow from this discussion. First, be realistic in setting goals for increasing knowledge among target groups. A 10 percent increase in knowledge in a community of 50,000 represents a substantial change. Second, use a multi-media approach. Because many people are not regular TV viewers, radio listeners, or newspapers readers, messages

must be repeated in different forms over time to be understood. Getting your news in a front-page story of your newspaper is an important step forward in effective communication, but it is not enough.

The rate of learning by an audience is *uneven*

Information offered by mass media or interpersonal channels does not diffuse evenly to audiences. Beginning with the classic diffusion study about hybrid seed corn in Iowa, and continuing through hundreds of other studies about the way new ideas and practices are adopted, there is clear evidence that some people learn well before others. The different rate of learning has been explained by differences in such factors as education, income, and age. Higher education encourages the gathering and processing of information. Younger persons are often more oriented to adoption of new ideas. And those with higher incomes are often in a position to act upon what they learn.

A second explanation was more recently offered for unevenness in learning. This explanation asserts that states, counties, and different organizations vary in their ability to deliver information. Organizations with large staffs have more ability to deliver information than those with small staffs. Thus, the rate of learning might have as much to do with whether a communicator can deliver as it does with whether an audience is receptive.

Limits to information delivery are also caused by geographic factors. Those who live near major roads get more visitors. Those who live near towns can get information more easily from there. A study by an Iowa state agency of the introduction of a new videotex system shows adoption of the system indeed differed by geographic region of the state.

A great majority of studies about how communities or farmers get information find that "gaps" in knowledge are created whenever new information arrives. An exception to this occurs only when the information is very important and when virtual saturation coverage of news about it occurs. In this case, those with the least information often catch up to those who already know. But this is usually only temporary. As the event dies down again, those who knew more originally again begin the process of moving ahead in knowledge.

Thus, when we think about communicating with audiences on most topics, we should expect that those who already know the most about it will be the first ones to learn more, and that unless heavy emphasis is placed on it, those with little knowledge will not learn much. This finding has important implications for those who are concerned about information equity.

Avoiding the creation of knowledge "gaps" requires a heavy investment in communication resources to reach older, more isolated, or other disadvantaged audiences. And invest-

ments in reaching these groups can be frustrating since members of these groups require more time to learn, and since they have fewer resources with which to *act* upon the information even if they receive it. If an extension agent is trying to increase corn yields in a county, a dollar's worth of time with more progressive farmers will get a much larger response than a dollar's worth of investment in less progressive groups. Finally, more advantaged groups often complain when they don't receive an agent's attention, while less advantaged groups don't.

We learn more from people we know *less* well

In a study of how people first hear about new jobs, it was found that the most valuable contacts came from those the job-seekers did not know well, rather than close acquaintances. This makes sense when we recognize that the information we get from groups with which we associate is often not new — we know much of it already. The main function of groups we belong to is to provide support and socialization rather than to learn new information. Thus, when we want truly new information, we are likely to get it from those we know less well.

More recently, researchers have become much more interested in the analysis of "communication networks" — the complex interpersonal communication links that connect individuals to groups and groups to one another. Research

indicates that much valuable and new information comes to groups through "bridge" roles — people who are members of more than one group and share information between groups. Also valuable are people who don't belong to groups, but relay information from one group to another by having contact with group members.

The practical significance of this finding for the communicator can be found both in information seeking and sending. When you want to learn what people in a community know or think about an issue, don't focus on contacting people you know. You are likely to be able to estimate what they know and think. Much more valuable knowledge will come from contacts with people you know less well and come into contact with less frequently. In terms of information sending, results suggest that communicators will have the most impact when they have contacts with new audiences, rather than those with whom they usually work. Thus, the common practice of building a list of clientele on whom one focuses tends to restrict total impact, even though it might focus on a highly receptive and supportive group.

Knowing what motivates people to communicate is important

Realization in the 1970s that people attend to media for many reasons other than to learn about what is going on in their world

led to research into why people use media and what they expect to find when they do use media. Researchers found that such motives as surveillance of one's environment, desire to escape, killing time, and entertainment could be used by different individuals to

Which medium is best for the following purposes?

- To keep up with the way the government is doing its job?
 Answer: Newspapers, magazines, commercial and public TV.
- To kill time? Answer: Commercial TV, magazines, radio, recorded music.
- To learn about myself?
 Answer: Friends, books.
- To obtain information about daily life?
 Answer: Newspapers, friends, magazines, books.
- To overcome loneliness?
 Answer: Friends, recorded music, radio.
- To get to know the quality of our leaders? Answer: Newspapers, public TV, magazines.
- To be entertained? Answer: Recorded music, film, radio.
- To feel I'm involved in important events? Answer: NONE BEST
- To release tension? Answer: Recorded music, radio, friends, film.
- To get away from usual cares and problems? Answer: Film, recorded music, friends, books, radio.

explain reading the same newspaper item. The motives also differ by age or maturation. A young child watches a television advertisement because of its bright colors, fast motion, and music. An older child watches the same ad to see an irresistible product he or she simply *must* have. An adult tunes in to the ad to see how an advertiser tries to persuade people to buy a product which they might not need.

Most of the time, we seek out media or interpersonal sources of information for entertainment, not to solve a particular problem. However, research shows that about 90 percent of adults conduct at least one learning project each year, spending anywhere from seven to 100 hours on the effort. The average adult conducts five learning projects in a year. Thus, when people do have specific problems, they are willing to seek out a considerable amount of information on that topic from many different sources.

One other aspect of motives for using media has to do with characteristics of certain media channels. One study found that certain media were preferred for specific types of information. For example, newspapers, magazines, and TV are the media of choice to keep up with government news. To kill time, commercial TV, magazines, radio, and recorded music were selected. These responses suggest that certain media may have an advantage in meeting specific information needs, either because of the nature of the medium or because of expectations people have developed about

what they will find in a particular medium.

Clearly, members of a communicator's audience do not all have the same motivations when they attend to media or interpersonal communications. To the extent that a communicator can anticipate people's motives, he or she can be more effective by supplying what is needed. Educators have long talked about finding the "teachable moment." Audiences are most interested in geology after an earthquake and in planting a garden on a beautiful spring day. If different motives and needs among audience members can be identified, media can be tailored to suit their varying needs.

Finally, studies of extension audiences reveal that *printed* materials are their best source of information from extension. This may be because the bulk of resources have been spent in the past on this medium. But, in part, it also may be that printed materials are sought out by people because they *expect* this medium to provide answers. They may not have the same expectations of radio or TV, even though those media could carry the same information.

Information seeking is *additive*, not *substitutive*

A well-worn saying about media selection, when considering new ideas and practices, is that mass media are most useful to make people *aware* of new ideas and give them *information* about those new practices,

but interpersonal communication channels are most important when *evaluating* a new practice or making a *decision*. The practical recommendation has been to use mass media in the early stages, and then switch to interpersonal channels. Recent adoption-diffusion research and re-analysis of older studies indicate that this saying needs to be modified.

The new research suggests that when people are just beginning to hear about a new practice, they do not actively seek much information about it. If mass media carry the message, they will likely hear about it from this source. If friends know, they will learn interpersonally. As a person learns more about an innovation and becomes seriously interested in the possibility of adoption, information-seeking tends to increase across *all* channels. That is, people tend to talk to friends, listen to media, and read all they can about it. Mass media's highest use comes at this point, as does the highest level of interpersonal communication. Thus, the use of media and interpersonal sources is *additive* across the adoption process, rather than *substitutive* (with one medium being the best at one point in time and other media preferred at other times).

What this means for communicators is that rather than using the mass media only to make people aware, the media have a continuing role across the adoption process. The medium one chooses to make people aware of a new idea should depend on how

the local communication system works. In Silicon Valley, for example, most people first learned about computers from other people, rather than mass media. This may be because computers were such an important part of the business and lifestyle of the region. For hybrid seed corn, the mass media were the first source for most farmers. No matter how people first learn about a new idea or innovation, once they become interested, they will search for relevant information from any available channel. This means information providers should be prepared to flood both mass media and interpersonal channels with information once an audience is interested.

Research also shows that at least for complex innovations such as computers, information seeking of all types continues at a high level after adoption has occurred. The same post-adoption need for information probably occurs in areas such as nutrition. Once a person has been convinced to alter his or her diet to improve health, there will be a high future need for information on nutrition. Thus, communication planners should consider the need to allocate substantial communication resources to post-adoption needs.

Knowledge, attitudes, or *behavior*: There is no set order in bringing about change

We often imagine that if we want to change people's agricultural, health, or other practices, we must start by giving them

information that causes them to have positive attitudes about the change, and that in turn results in a change in behavior. However, research suggests that *any* of these three — knowledge, attitudes, or behavior — may occur first. Psychologists have found that if one could change people's behavior, they would come to believe that what they were doing was right (behavior first; then information and attitudes). A study of farmers' adoption of computers in the 1980s showed that farmers tended to seek information first, then change behavior, and finally readjust attitudes (positively) to match what they had done.

No matter how people first learn about a new idea or innovation, once interested, they will search for relevant information from any available channel.

The implication of this is that, depending on the communicator's situation, flexibility is possible in bringing about change. When a communicator can change behavior directly (for example, by getting people to eat new foods at a demonstration), interest in information and attitude change may follow. In other situations, information may be delivered first. Changing attitudes, according to research, is generally a difficult process, although one can take advantage of attitudes that are already formed to encourage information seeking or changes in behavior.

How a person says something may be as important or more important than what is actually said. This is referred to as "non-verbal communication."

Learning information is often a group activity

While most communication models tend to assume one "sender" talking to one "receiver," it is common that other people and groups are involved. For example, when a family makes a decision about buying an expensive new car or about developing new eating habits, one person alone is unlikely to make the decision. A rather complex chain of communication messages is likely to occur.

Thus, communicators should consider whether a persuasive message is likely to result in communication by several individuals. Sometimes, the interrelationships that result are surprising. Nutritional communicators, for example, had focused on reaching the wife in a family, since they assumed that she traditionally took on the role of cook. However, research showed that it was the husband's nutritional knowledge, *not* the wife's, that made the difference in the family's overall nutritional pattern. Why? They found that the wife was serving foods that she knew her husband would like. Therefore, if he practiced good nutritional habits and ate a variety of nutritional foods, the family would have a good level of nutrition. If he had a low nutritional knowledge base, however, and ate only a few foods, the wife would not serve other foods even though she knew they would be good for the family. From a communication point of view, the failure to consider the need to communicate with the husband, as well as the wife, doomed much effort in this area to failure.

Recent research in the area of family decision making reveals that even in cases where one spouse tends to make a decision, some communication with the other spouse often occurs before or after making it. Even something as individually perceived as reading a newspaper, when placed in a household context, becomes a shared activity, with readership of a given newspaper item dependent not only upon the individual's area of interest, but also upon the knowledge that the spouse will be interested in a particular piece of information. The common practice of taking a particular section of the newspaper also may restrict the ability of others to read that same section. Recent studies of television viewing also suggest that what one member of the household is interested in influences what others watch.

Thus, communication planners need to consider who the important targets for information are, and how those target individuals are likely to interact (or not interact) with others. In several recent nutritional campaigns, for example, efforts have been made to design communication components to encourage spousal interaction and discussion (by requiring that both spouses fill out questionnaires or track diet over time).

Even when you don't communicate, you do

When we communicate, there are two elements to the message. First, there are the words or pictures that we use. Second, and less obvious to us, are the "rules" that go along with any communication message about how that message is to be valued and interpreted. For example, a large newspaper headline means "important story." When a teacher puts a transparency up on a projector, its content is seen as the main point (students begin taking notes at this time).

Imagine a large green interstate highway road sign that says, "Please disregard this sign." The *message* is to pay no attention to the sign, but the sign itself is based on a communication rule that says, "Big signs are important." This idea of rules about communication was used in research to make the point that in any communication situation, but especially in interpersonal situations, how a person says something may be as important or more important than what is actually said. Some refer to this as "nonverbal" communication. However, the fact that we develop "rules" about such behavior suggests that it is something more.

In mass communication research, these "rules" are often called "meta-communication," or communication about the communication process. Recent research on television suggests that technical editing, graphic display techniques, panning, or cutting from one part

of an interview to another may mean one thing to a journalist and another to an audience. To the journalist, cutting from one point in an interview to another is a necessary technique to focus a response. To a viewer, however, the perception may be that what was seen was the entire interview. A young child does not recognize what part of a TV segment is an advertisement and what part is program. The child has not yet learned the "rules" surrounding the advertisement — a sudden change in music, a change in who is portrayed, etc. Even the words, "We'll return to 'X' after these messages," may not be enough. Newspapers are not immune to this confusion either. While a journalist knows that

an editorial is the reasoned opinion of the editorial board of a newspaper, many readers believe letters to the editor, columns, and editorials to be the same thing.

These differences in perceptions of rules can generally be found between professionals of any type and the audiences they serve. When the communicators and audiences are of different cultural, age, or gender groups, the probabilities for miscommunication due to different rules increase.

Although communicators commonly pretest messages to see if they are clear, they less often check how audiences perceive the rules

Though the *message* is to pay no attention to the sign, the sign itself is based on a general communication rule that says, "Big signs are important."

governing communication channels. Given the increasing diversity of available channels, understanding what people expect from them is becoming more important.

New communication technologies pose difficult problems for communicators

Videocassette recorders, satellite receiving dishes, teletext, videotex, CD-ROM, electronic mail, and the microcomputer are some of the tools of a modern communication society. These tools both affect and are affected by the society into which they are

introduced. Some of the ways in which these new technologies affect communicators have nothing to do with the messages they carry. One major effect of television and computers, for example, has been that adopters of these technologies get less sleep than they did before. Many of the effects are complex and somewhat contradictory. Television is an impersonal mass medium, broadcasting the same message to millions. Yet studies show that this same medium often finds itself listed as a "companion" sitting across the table from someone while eating dinner. The microchip that frustrates ATM bank card users when they can't get the machine to do their bidding is the same chip that is permitting children to

discover themselves in the world of interactive computing.

One thing these new communication technologies have not done is to replace existing technologies. Despite dire predictions, radio did not replace newspapers. TV did not replace radio. And satellite receiving dishes are not likely to replace meetings either. New media struggle to find a niche, while older media adjust and redefine their uses.

Often, when new communication technologies are introduced, futurists talk enthusiastically about their vast potential and how they are likely to transform existing systems. It was predicted, you may recall, that microcomputers would lead to "the paperless office of the future." During this period, media are full of stories and examples of how the new technologies have been introduced and how they may improve communication. Later, media coverage declines, and articles become more realistic about what the new technology can do. Computers have become vitally important, but they have *increased* rather than decreased the amount of office paperwork.

The arrival of these new technologies pose some difficult problems for communicators. One problem has to do with equity. Slightly more than half the households in this country are now hooked up to cable television. This provides an attractive new channel for communicators. But sending a message on this channel leaves out the 47 percent of households that are not hooked up. Furthermore,

Though television is an impersonal mass medium, broadcasting to millions, studies show that this same medium often finds itself listed as a "companion."

the adopters and users of new communication technologies often tend to be those who are wealthier, better educated, and already relatively well-informed by existing media. One solution to the problem is to package and send essentially the same message along a variety of channels — new and old. Many communicators, however, are finding that they are spending more and more of their time adapting and rewriting their information to serve a number of different channels, and less time gathering and analyzing what is worth sending.

A second problem concerns the reliability and effectiveness of the new communication technologies. When a circular is mailed to a client, one can be reasonably confident that the client will receive it. But as is the case with any new technology, new systems don't always work as expected. A number of audiences gathered to watch a lecture via satellite may discover that due to a thunderstorm in the area, a pulled plug, or a switch flipped the wrong way, they are unable to see what they want. Electronic mail may be nearly instantaneous in traveling from one place to the next, but training receivers in how to use electronic mail and getting them used to the idea of checking their electronic mailboxes is another matter. Researchers studying the electronic delivery of news releases have found that, although the more rapid method of delivery has important advantages, new problems are also created. For example, whoever receives electronic news releases at a newspaper may not pass them along to the appropriate editor. Editors or reporters may not know how to access the releases even if they are routed to them. And power surges or automatic purging programs may wipe out news releases that otherwise would have been used. Many of these new problems are temporary. But they require communicators to spend more time checking to make sure their information is being communicated, and they force communicators to keep up to date on the new systems being installed by information recipients.

Conclusion

This is an exciting and challenging time for communicators. The body of research knowledge about the communication process is now large enough that it can be used as a base for understanding how communication works and making communication planning and strategy decisions based, at least in part, on research findings. At the same time, the new communication technologies are changing the way in which we relate to audiences. Although we cannot predict at this time exactly which of these new technologies will have the greatest impact on communicators in the future, we can with some confidence predict that some of them will.

Have you ever said something you thought was perfectly clear, only to discover later that you were completely misunderstood? Sure, it's happened to everyone. But how did you explain the misunderstanding? Did you blame it on the listener? The fault may well lie there, but the fact remains that you failed to communicate. Did you perform your half of the process in the most effective way possible?

Few people today have physical speech defects. More likely, the problem is how you're using what you were born with. Most people can improve their speech because, like good speech, poor speech is learned. If you practice poor speech, it becomes a habit. If you practice good speech, it too will become a habit. That's why it's so important to become "speech conscious," the first step toward better, more intelligible speaking.

Points for effective communication

Tune your ears to your tongue; really listen to what you say. You'll be surprised at some of the things you hear. A tape recording of yourself speaking will quickly reveal the gap between what you said and what you thought you said.

Successful communication requires a high level of attention, both on the part of the speaker and the listener. Without attention there's no communication. The attention a person pays to a particular communication is a function of three factors.

■ The effort required for comprehension.
■ The length of time attention is needed.
■ The listener's motivation.

Reduce the listener's effort. In spoken and written communication, you can reduce effort for the receiver by using shorter words and sentences, more examples and illustrations, and clear and logical expressions. In pictorial communication, you reduce effort for the viewer by clarity, sharpness, and simplicity of visual images. Make it easy to see at a glance what the message is all about.

New information is easier to grasp if it is presented a step at a time, with each point building on what has gone before. Relating unfamiliar concepts to things the listener knows about will reduce effort.

Spell out implications. People usually fill in the gaps left by vague or missing information — sometimes correctly, sometimes not. Sometimes they give up.

Redundancy can make comprehension easier, too. It reduces the chance of error and emphasizes important information. But redundancy can also make a story harder to listen to if it is monotonous or distracting.

Multiple media presentations can provide a redundancy that enhances comprehension. For example, a talk with slides, film, acetates, or real objects is better than a talk with no visual aids.

Remember your audience. Subject matter is the chief determinant of listener interest. People are generally more interested in and motivated to learn about matters that are physically and psychologically near to them. People accept a message more readily if they approve of the source and if the message coincides with their preconceptions, prejudices, or prior beliefs. Those who receive information tend to agree with a well liked speaker, and disagree with a disliked one.

People also tend to expose themselves to communications which agree with their existing opinions and interests, and they usually avoid unsympathetic material. They perceive what they want to perceive, have habitually perceived, or have been rewarded socially or physically for perceiving. They learn and retain information consistent with their own beliefs and forget what is not consistent more quickly.

Preparing a speech

Here are some guidelines for making a good speech:

■ Adapt the presentation to audience interests.
■ Determine in advance the reaction desired from the audience.
■ Prepare so that your remarks are effective, relevant, and valid.

Speak to the audience's needs and interests. When audience and subject have a real relationship, the speaker can be assured of a

favorable hearing. As a speaker, you need to show how your topic concerns each individual or the entire group. Try to find out characteristics of the audience ahead of time. Are they the same age? Do they work at the same sort of occupation? What are they most concerned about?

Material should relate to the purpose of the get-together. If the subject has been assigned, limit remarks to a particular aspect that fits the occasion and the audience. Try to learn when during the program you will be giving your speech and what else will be discussed. Adapt your remarks accordingly.

Suppose, for example, you've been asked to speak to three groups — a farmers' group, a city business club, and a homemakers' organization. It would be ineffective to give exactly the same speech for each group. Your remarks should be slanted to reflect the particular interests of your audience. Stress benefits, no matter who you are addressing.

Prepare with a purpose in mind. If you want to convince your audience, the reaction you seek is agreement. If you're planning to inform the audience, the reaction you want is clear understanding. Then, again, perhaps you want to stimulate action.

Each of these purposes demand slightly different strategies that should be targeted to the specific audience and its needs. Your basic goal, however, is to show proof of your statements by logic, reason, accurate and

When preparing a speech, adapt the material to audience interests, determine the reaction you desire, and plan to use remarks that are effective, relevant, and valid.

timely examples, recent statistics, and opinions of authorities. You would also want to demonstrate that your idea is the best available solution. And you would want to make that idea agree with what people feel is right or decent. Remember that persuasive speech containing sound evidence is more effective than speech without it.

Acceptance of the message is a critical factor in persuasive communication. The suggestion will be more likely accepted if is in harmony with group norms and loyalties; and if the source is perceived as trustworthy and authoritative. A suggestion made face-to-face and coupled with mass media reinforcement is more likely to be accepted than a suggestion

carried by either channel alone, other things being equal. To accomplish attitude change, you must make a suggestion for change which your listeners will receive and accept.

Change in attitude is more likely to occur if the suggestion is accompanied by other factors underlying belief and attitude. This refers to a changed environment which makes acceptable easier. There probably will be more opinion changes in the desired direction if conclusions are stated explicitly than if the audience is left to draw its own conclusion. Research has shown this is especially true in changing the opinions of the less intelligent members of the audience.

When the audience is friendly, when only one position will be presented, or when immediate but temporary opinion change is desired, it is more effective to give only one side the argument. Give pro arguments first.

When the audience disagrees, or when it is probable that it will hear the other side from another source, present both sides of the argument. For more change, place a message highly desirable to the recipient first, followed by the less desirable messages.

When equally attractive opposing views are presented one after the other, the one you presented last will probably be more effective. The audience will tend to remember the earliest and latest items in a series better than those in the middle.

Sometimes emotional appeals are more influential; sometimes factual ones are. It depends on the message and the audience. To induce desired opinion change, for example, a strong threat is generally less effective than a mild one.

The desired opinion change may be more measurable some time after exposure to the communication than right after exposure. There is a "sleeper effect" in communications received from a source some listeners regard as having low credibility. In some tests, time tends to wash out the distrusted source and leave information behind.

Prepare the talk. If you haven't time to prepare a talk, don't accept the engagement. Thorough preparation should extend over two or three days and longer, if possible. The speech should be entirely completed the day before it is to be given.

Keep in mind that thorough preparation is the best available fear remover!

Preparation also means analyzing the audience so that you'll be sure to choose the right subject matter, supporting material, and the proper approach to the topic. Keep the group's attitudes in mind; they will influence how your ideas are heard and accepted.

Preparation includes a thorough knowledge of your audience. There are several ways to get the audience information you need. The

group's officers and members can give you information, or you may attend one of their meetings. Literature or official publications also can help. Ask other professionals about the group, too.

Plan your speech to grab the audience's attention at the beginning. Ask a rhetorical question that everyone agrees with, or a question that makes people think. Make a startling statement of fact or opinion. Or use a quotation, a concrete illustration, a humorous incident, a reference to the occasion or the subject. The technique of "flogging a dead horse" often helps win over the audience on the major point (for example, praising academic freedom to a college faculty before getting to the real purpose of the address, which was to change opinions on tenure).

Divide your speech into two, three, or four main headings or points. Most listeners can't remember more than that. Adjust your language to the audience members' educational level and knowledge of the subject.

Your conclusion is your last chance to stress the purpose of your talk. You don't want anyone to leave with any doubt about what your tried to say. The end should focus on the central idea you've developed through your speech. Depending on your goal, you might end with a summary, a challenge, an appeal for action, a quotation, a story, an illustration, or a statement of personal intention. Or, you might finish with a question or problem to which you don't have an answer but want the audience to think about a solution.

The conclusion usually isn't the place for humor. But, if you can accomplish the purpose of your speech and still use humor, do so.

Title your speech after you've organized your talk. Then make it original, brief, relevant, and provocative.

Practice aloud. Don't practice so much that you get stale, but have material well in mind. Then don't read the speech, talk it. Many people prefer to speak from note cards that list the main points of the talk.

Finally, be succinct. There's nothing worse than a long-winded speaker.

Speech delivery

Very few people are able to get up before an audience without some nervousness and discomfort. A little fear and tension are normal, but too much can tie you in knots. To the extent possible, your voice, expressions, and posture should be warm, friendly, and relaxed. You can reduce nervousness if you know your topic and you are prepared. Display a positive attitude toward yourself, your topic, and your audience; and practice. Occasional failure and disappointment are inevitable parts of the learning process. But with experience, you'll soon gain the self-confidence and skill possessed by good speakers.

An effective speaker has something to say and the skill to say it. That person uses to best advantage the three main parts of speech delivery: voice usage, physical behavior, and mental attitude.

As mentioned before, an audience more readily accepts information if it likes the speaker and believes in the speaker's credibility. The audience develops attitudes about your sincerity, friendliness, and energy from your facial expression, the way you stand or walk, and what you do with your arms and hands.

Your mental attitude is important also. Think of your audience as you speak to them. Know the content of your presentation well enough to avoid using mental energy remembering what you want to say next. Be interested in the people you're talking to, and keep thinking of them as you speak.

Delivery may be broken down further into voice usage, body action, eye contact, and facial expression. Body action, such as your posture, gestures, and movement, vocal expression all are essential tools that enhance communication.

Voice usage

Rate or time. You need variety when you deliver a speech, and the rate, or speed of your speech helps provide it. Your speaking rate should reflect the mood of the material. It can help you convey meaning, too. Pauses, for example, are the punctuation marks of speech. Pause to let ideas sink in for meaning and emphasis.

However, when you do pause, do so in silence. Avoid vocalized pauses, such as "*uhs,*" "*ers,*" "*ahs,*" that only call attention to the fact that you're trying to think of what you're going to say next.

Pitch. A good speaking voice has range and flexibility of pitch. Pitch your voice so that you can easily raise and lower it for emphasis.

Force or loudness. Your voice must be loud enough to be heard. It should also be used as a tool for emphasis. Force and loudness should fit the mood of the material and the occasion.

Articulation. Distinctness of utterance is articulation. Don't mumble, mutter, run words together, or go back over words. Use your teeth, tongue, and lips to enunciate words.

Body action

Follow these guidelines to make your body work for you when you speak.

Posture. Posture should never draw attention away from your message. It's best to remain relaxed, but not slumped; erect, but not stiff. Be comfortable without being sloppy.

Gestures. Movements of any part of the body can reinforce your oral presentation. Know the difference between meaningful gestures and a case of the fidgets. Gestures help convey meaning, and they increase your own energy and self-confidence.

They help hold attention, too. The eye instinctively follows a moving object and will focus upon it. Movement can rouse a sleepy audience, but your movements should be natural and easy. Hands at your side or clasped behind your back are not effective. Use your hand gestures to reinforce your ideas. They can describe the size, shape, or motion of an object through imitation or help you emphasize a point.

Aside from universal hand gestures, gestures of the head and shoulder are the most common. You may shake your head or shrug your shoulders, as if to agree or disagree with a point.

Make your gestures strong. Avoid those that are half-hearted, weak, wishy-washy, or apologetic. A relaxed body will help to prevent stiff or awkward gestures. Make positive gestures, but vary their intensity to suit the point.

Timing of the gesture is important, too. A gesture should come with, or slightly before, the words it is intended to support. Never gesture after you have said the word or phrase.

Gestures and other movements can help reduce nervousness as well as reinforce what you say. A few moments of vigorous exercise, even a couple of deep breaths immediately before your presentation, will help relax you and reduce nervousness.

Movement of the body as a whole.
Movement can indicate transitions between thoughts, but avoid the undesirable types, such as shuffling feet, shifting weight, or fidgeting with the microphone or other equipment.

Forward or backward movements are often associated with how important a point is. A step forward indicates a more important point, while a step backward says, "Relax. Think about that last idea."

Movement and gesture can be combined in explaining visual aids. In fact, they *are* visual aids.

Eye contact and facial expression

Look at and talk to your audience. It makes your listeners feel you're interested in sharing information as well as feelings with them, as indeed you should be. Be sure that your facial expression, as well as your voice, reflects your own interest in your speech and in sharing it with your audience. Avoid the "poker face" approach to public speaking.

Because your face reflects your attitude, you can use it effectively to emphasize or support your message. Concentration tends to bring a frown to the face. Know your presentation well enough to able to avoid concentration too heavily on it. Or learn to concentrate with a pleasant expression. Take time to get comfortable before speaking. Don't suddenly relax at the conclusion of your talk. This

indicates to your audience that you are relieved your "ordeal" is over.

Ralph Waldo Emerson once said, "What you are thunders so loudly I can't hear what you say." Be sure the things you do with your body as well as your voice help rather than hinder in getting your message across.

Physical aspects of speech

The most powerful words in the English language are the short ones, such as live, love, hate, die, war, etc. People learn monosyllabic words earlier and use them more often. Since short words have more "sound-alikes" and alternate meanings, they are often mispronounced and misunderstood. Polysyllabic words, on the other hand, have more acoustical cues that help listeners discern meaning.

Test the principle of sound-alikes for yourself. Read aloud the following word groups: forge, forage; 4-H, forehead; shell, shelf, self; leave, leaf, left; cook, crook; brook, book.

Say them again; this time hold your fingertips lightly to your lips and face. Feel the different lip, mouth and jaw movements, and the resulting puffs of air. Each word has a different feel and speech mechanism requirement.

To help you become more aware of your speech mechanism and what it is or is not doing well for you, read rapidly and loudly the following word sets. Listen and look at

20 Speaking effectively

Physical aspects of speech

yourself carefully. Is each word clearly distinguishable? Are parts of your mouth making the necessary movements? Listen as you look and feel with your fingers. Be especially sensitive. Notice the differences:

cave	bridal	pure	quarter
pancake	final	poor	porter
cage	vital	tour	water
case	title	two	order
tack	yes	cracker	left
tact	jet	chatter	list
pact	get	shatter	lisp
pack	yet	shadow	lid

Your mouth, tongue, jaws, and teeth all play roles in physiological phonetics. A major cause of unintelligibility, for example, is not articulating consonant sounds. For example, in the word "notice," the "t" often sounds like a "d." In words like "hunting," the "t" often degenerates into a grunt.

Acoustical phonetics involves the speech sound after it has left the mouth. The strength of this sound is measured in decibels. Ordinary conversation at a distance of three feet is about 60 decibels of sound.

Awareness of loudness, pitch, and rate can improve listening ability as well as intelligibility. Also, when speaking before groups, try to get a feeling of "side tones," so you can make adjustments in your voice appropriate for the size of the room, size of the audience, and

acoustics of the room. If you are on radio or television, it is sometimes a good idea to use a little more force in your speech.

The context within which words are used is sometimes sufficient to give meaning to poorly pronounced words. But a wise communicator/educator avoids the risk of relying on context by developing intelligible speech and by seeking constant improvement.

The following points are worth repeating and remembering.

■ Sound is energy; it passes through the air in different wave lengths. The faster the puffs, the shorter the wave lengths, and the higher the pitch. Vary pitch, loudness, and speed; it is speech variability which adds interest and understandability to what is said. A soft monotone speech often leaves the impression that the speaker is uncertain or unprepared.

■ Listen to yourself. Acoustical feedback from the inner and especially outer ear can help you modify the voice and make necessary adjustments. A keen awareness of these "side tones" is essential for good speech. This is why a radio or TV announcer sometimes wears a headset or cups a hand between the mouth and ear to catch more of what is being said.

After you've practiced, rate yourself. You may want to record your practice sessions. Listening to the tapes will give you a good feel for your

strengths and weaknesses. If possible, videotape and critique your practice sessions.

Any efforts to improve your speech must begin with an honest and critical self-appraisal. What are your speech faults? The following list several common ones.

Do you:

Slur words?
Mumble?
Grunt sounds?
Swallow sounds?
Whisper rather than speak out?
Talk too fast?
Talk too slowly?
Talk in a monotone?
Have lazy lips?
Talk with your lips closed?
Have noisy lips?
Speak through your teeth?
Articulate poorly?
Need to speak more forcefully?
Let your breath out too quickly?
Sound unenthusiastic?
Speak in a halting, hesitating manner?
Give the impression of uncertainty?

Practice is the best remedy for these speech ills. Participate in toastmasters and speech clubs, as well as in courses if you have the chance.

234 The Communicator's Handbook

Phonetics and intelligibility

*P*honetics is the science of speech sounds. There are two types: physiological and acoustical.

Physiological phonetics is concerned with speech energy made through the lungs. The stomach muscles force the air from the lungs upward to the vocal cords, allowing the muscles pressing on the lungs to control loudness. As sound moves from the vocal cords it moves into the resonant track of the throat.

Like a fingerprint, the voice resonance of each person is unique. One person is a clarinet. Another is a trombone. Although a person cannot substantially change this resonance, he or she can make the best possible use of it.

■ Pace your pauses. Pauses can add dramatic impact and understandability. However, when they are heard as a halting, uncertain delivery, pauses can reduce speaker credibility and confidence. Remember that the average speed of delivery is about 150 words per minute. Fast talkers who deliver about 180 words per minute are more highly regarded, more persuasive, preferred, and can communicate more in less time. With speed usually comes enthusiasm.

■ Think and speak in units of thought. Poor readers tend to speak each word in the same way. The more adept you become at expressing thought units, rather than mere words or lines, the more interesting and distinct you will be. Vary the sound to suit the meaning of the words being read or said. Loudness, pace, and word stress reveal attitude as well as prevent misunderstanding. Example: " I *favor* the idea!"

■ Concentrate on using your entire voice tract. Practice breathing with your abdominal muscles rather than the diaphragm and upper chest to provide a steady breath stream and the power needed for good speech. Throat and neck muscles should be relaxed. Your lips, tongue, and jaw, however, should be mobile and active in shaping each puff of air or syllable clearly and distinctly.

If someone says you sound breathy, speak louder. If your voice sounds thin, open your mouth and lower the pitch when you speak. If your voice sounds harsh, don't lower pitch and lose your breath support at the end of sentences.

■ Watch the internal consonants. Don't replace the "t" in words like "quantity" with a sloppy "d." With the retroflex "r" as in "carry," "terrible," or "current," it helps to think of the word as being divided between the "*r*s." A slight pause between the "*r*s" helps. Don't let triple consonants throw you. Words like "wasps," "wisps," "lisps,"

are mostly tongue-and-teeth words. Make sure you use both when you pronounce them.

■ Avoid slurring that creates such sloppy words as "whatchdoin," "goinfishin," or "whatchagoinado."

Introductions

*W*hen you introduce a speaker, remember that you are introducing the person, not giving the speech. Your objective is to introduce the speaker as a person who has something important to say, who can say it with authority, and who has the ability to inspire confidence in the audience. Sell the speaker and the topic. Stimulate a desire to hear what will be said. Establish the basis for speaker-audience rapport. Everything done and said should contribute to the speaker's effectiveness.

The introduction doesn't have to be long to do this; it simply turns the spotlight of audience attention on the speaker. Try to limit your remarks and don't spotlight yourself.

Basic points

*Y*ou can create interest in the speaker and the subject by answering questions the audience is asking.

Who is the speaker? If the speaker isn't familiar to the audience, give his or her name twice: once at the opening of the introduction

and again at the end. If you have doubts about how to pronounce the name, check before the meeting to make sure you know how to say it. The audience will also be interested in the speaker's occupation, title, or position.

Where is the speaker from? Listeners want to know where the speaker came from originally and the current residence and position. Although these facts may seem insignificant, audiences like to hear them.

How is this person qualified? Point out the speaker's qualifications, such as experience, writings, or background. Give interesting data, achievements, and the fields worked in, especially those areas relating to the topic.

Why should the audience listen? Emphasize the importance of the subject. Show a need for information and tie it to the interests of the audience. Bring out universal needs and personal values of the audience.

End the introduction by formally presenting the speaker to the audience, giving the name once again: "May I present a friend of Hale County, Mary Jane Farrell."

Your previous remarks should have been directed to the audience. Now, and only now, do you turn to recognized the speaker. Remain standing as the speaker comes forward; lead the applause; and then sit down.

When the speaker finishes

You need to add only two or three sentences at the end of the speaker's talk. These should include a brief and sincere thanks, which should be addressed both to the speaker and to the audience. After the meeting, add a few private words of thanks.

Avoid the temptation of summarizing the talk, taking issue with any remarks, or adding items. It is all right to underscore briefly an important point by stressing its relevance to the audience.

Formal or informal

A formal introduction has dignity as well as interest. An informal introduction relieves tension and sets the tone of the meeting. Whether the introduction is formal or informal depends upon the prestige of the speaker, the occasion, or on the extent of your acquaintance with the person. In general, the better known the speaker, the briefer your introduction should be. The more unknown the speaker, the more you will have to arouse interest.

There are four necessary elements in introducing any speaker: tact, brevity, sincerity, and enthusiasm. These suggestions should help you plan your introduction. Using them will help, but you must supply the rest.

When you introduce a speaker:

- Be brief.
- Use humor only if it suits the occasion, is in good taste, and creates friendship.
- Speak loudly and clearly enough to be heard easily.
- Check the introduction you plan to make with the speaker.
- Be sincerely enthusiastic — but don't overdo.
- Suit the nature of the introduction to the tone of the speech.
- State the subject of the talk correctly.
- Practice your introduction.

Some important "Don'ts."

- Don't talk about yourself and how you felt the last time you spoke to a group this size.
- Don't emphasize what a good speaker or witty person the speaker is. Let the performance speak for itself.
- Don't give your views on the subject of the talk.
- Don't give committee reports, meeting announcements, etc., with the introduction.
- Don't apologize because the speaker is a substitute or not a known figure.
- Don't use trite remarks, such as "Our speaker tonight needs no introduction."

Presentation and acceptance speeches

Although you probably present more awards and honors than you receive, it is good to know how to be a gracious receiver

as well as a thoughtful giver. Whether you're presenting or accepting, observe all the rules of common courtesy and public speaking.

The presentation speech

A well-given presentation speech adds to the honor or award. It publicly expresses the recipient's merit and the donor's appreciation. Therefore, what is said should be appropriate to the occasion.

Name the award. The audience wants to know who the donor is and why the award is being given. If the award is a memorial, give all the reasons.

Give the reason. Explain why the recipient is receiving the award. State specific accomplishments. Be accurate and complete, but don't exaggerate. The audience is interested only in the achievements directly related to the award.

Explain the relevance. Tell how this person's work will influence the accomplishments of others, but avoid comparisons that might embarrass either the receiver or someone else who might have won the award. If the recipient is an organization, stress the principles it stands for.

Tell why the particular award was selected if it has a special significance to the receiver. Explain any symbolic nature of the award. Avoid mentioning the cost or the difficulty in deciding what to select.

Deliver it smoothly. Practice the speech so that you can deliver it well without reading it. Be brief, but complete. Be genial, but not humorous. Be sincere and enthusiastic; if your heart is not in it, let someone else make the presentation.

When you hand the award over, give it up. Don't make the honoree reach for it. After you've handed over the award, stop speaking.

Your speech should have ended the moment you released the award. If photographs are being taken, you may have to re-enact the presentation. Do this slowly. You and the recipient should face each other but turn slightly toward the camera, stand close to exchange until all photographs are taken. Then you should move aside so the recipient can have access to the microphone to make an acceptance speech.

You can deliver an effective speech without reading it. Be brief, but complete. Be genial, but not humorous. Be sincere and enthusiastic.

Give credit. Share the honor with others whenever possible. Show how the donor made it possible for you to receive the award. Without giving too much background, pay tribute to associates who helped you. Describe the work of others specifically.

Be modest. Minimize, but don't deprecate, your own merits. Attribute whatever you should to the cooperation of others and to favorable circumstances.

Compare what you have done with what is yet to be done — but don't tell the audience what others should do. Describe a humorous or interesting experience involved in the achievement. But don't embarrass anyone or get so personal that the audience can't enjoy it too.

Be appreciative. Make the group feel that you're pleased with the award without referring to its monetary value. Indicate its significance, the responsibility it puts on you, and your determination to live up to the honor. Avoid leaving the impression that it's something you've "always wanted."

Be brief. Don't lapse into personal conversation or comments with the giver or co-workers. End your acceptance with a brief statement of sincere appreciation. Then sit down, and don't disrupt the proceedings by talking further about the award with persons seated nearby.

The acceptance speech

In an acceptance speech, you must feel and show appreciation. Face the giver as you express thanks; call the giver by name. Also, thank the donor, using the person's or the organization's correct full name.

Often a sincere "thank you" is sufficient. But at other times, more may be necessary, especially if you know about the award in advance. Never begin an obviously planned acceptance speech with, "I really don't know what to say."

Tips for good telephone communication

Follow these tips in making your telephone time more productive and economical:

Every time you make or receive a call, you represent your organization and yourself — favorably or unfavorably.

■ Avoid long, detailed, technical communications or complicated figures and data. They can become garbled and misunderstood, and there is no written record for verification or future reference. If possible, arrange for your party to have technical material, lists, and figures beforehand so they can be referred to during the call.

■ Save up messages so that more business may be conducted in one call.

■ When possible, make an appointment beforehand for an important call.

■ Call different time zones during early morning or evening hours to avoid the high long distance rates between 8-5 working hours.

Voice is the key

Every time you make or receive a call, you represent your organization and yourself — favorably or unfavorably. The other person or persons can't see you, so the impression you give depends on your voice and telephone manners.

Here are some suggestions for developing a pleasing and effective telephone personality:

■ Identify yourself, your office, or your department in a few words. Try as quickly as possible to learn who you are speaking with, too.

■ Maintain a cheerful and considerate attitude toward each telephone call.

Boredom and discourtesy are easily recognized and give a poor impression. Strive for these six qualities: alertness, expressiveness, naturalness, pleasantness, distinctness, and helpfulness.

■ Use the instrument properly. Keep your lips ½ to 1 inch from the mouthpiece. Pronounce letters, numbers, and names clearly. Spell out names if they could be misunderstood.

■ Return calls. If you must leave the telephone during a conversation and won't be able to return immediately, say that you will call back and then follow through.

■ Say "goodbye" pleasantly and replace the receiver gently. The person making the call should end it.

Handling the "request" call

The request call sometimes requires some reference work. If you must hunt for information, handle the call in one of the following ways:

■ "Just a minute, please. I have it right here."

■ "Excuse me a minute while I look up that information."

■ "I find that it will take a few minutes to locate that material. May I call you back?"

Increase your listening power

A person is communicating seven out of every 10 minutes of every waking moment: 9% writing, 16% reading, 30% speaking, and 45% listening.

It has been estimated that about 98 percent of all learning occurs through the eyes and ears. Given that fact, it's easy to see why listening is a critical factor in human development. A person who is listening deeply actually undergoes physical changes as electrical activity of parts of the brain connected to the internal ear shows a "choppy" activation pattern characteristic of alertness and attending.

There is a galvanic skin response in the listener. Blood flow to the head increases, while that to the fingertips decreases. Body temperature may rise. Eyes are bright; posture is expectant. Effective listening is an active, responsive experience.

A person normally listens three times faster than the rate of speech. That means the average person speaks at the rate of about 120 words per minute but can listen at 400 words per minute. Comprehension is little affected by the faster speech rate.

Sensitive listening is an effective agent for individual change as well as for group development. Listening at a highly conscious and emotional level helps both

listener and speaker to become more mature, more open in their experiences, more democratic, less defensive, and less authoritarian. Listening is a growth experience.

Most individuals attend to only about 50 percent of what is said in their presence, no matter how carefully they thought they had listened. And research shows that two months later they will remember only 25 percent of what was said. Why? Partly because of poor listening habits.

A test of listening skills

Determine your listening habits by taking the following test. In each of the following pairs, check the listening habit which best describes yourself.

1. (a) I call the subject uninteresting. I take "target practice" at the topic. How dull can it get?

(b) I'm selfish. I sift, screen, and winnow, always looking for something worthwhile or practical that I can store away for future use.

2. (a) I criticize the delivery, overlooking the message in the process.

(b) I say, "This person's not great as a speaker, but I'll invest my time and try to dig out the message."

3. (a) I get excited, overstimulated and I want to comment or rebut the speaker when points are made that I don't agree with.

(b) I hear the person out before I make a judgment.

4. (a) I listen for the facts in a speech. Generalizations aren't of much value.

(b) I try to get the gist of the speech. Principles and concepts are the main thing.

5. (a) The position of my body helps me listen better. I lean forward with my chin resting in my hand, look at the speaker, and stay relaxed.

(b) I keep my body a little tense. My breathing and hearth rate are faster, and I don't make an effort to look at the speaker.

6. (a) Noise, movement, and other distractions in the room bother me; however, I'm sometimes guilty of disturbing others.

(b) I don't create or tolerate distractions. I mentally try to block out everything except what the speaker is saying.

7. (a) I avoid like poison any communications which are tough, technical, or expository in character. I don't like to be exposed to subject matter in unfamiliar areas. I stay away from the "deep stuff."

(b) I accept difficult and unfamiliar material as a challenge. I enjoy technical presentations; they sharpen my listening skills.

8. (a) I am influenced by emotion-filled words; they throw me out of tune with the speaker. Certain words destroy my listening efficiency for several minutes.

(b) I refuse to let "loaded" words become barriers to listening. I discover which words disrupt my listening efficiency, and learn to disregard them.

9. (a) I tend to listen for only a few seconds, then go off on a mental tangent.

(b) I stay tuned to the speech. I try to anticipate the speaker's next point.

The second item in each question depicts active and effective listening skills. If you fit the second description in each question you're a great listener and certainly a rare person. Anyone scoring less than 5 should work harder at developing better listening skills.

Remember, communication is a two-way process. Both sender and receiver of messages share important roles. The burden can't rest solely on the speaker. The listener must engage actively in the process. This is essential to achieve understanding. The speaker is merely the initiator of the process; the listener sustains and completes it.

any different
. Early usage
bartering a
e taking of
ket." Businesses
ng to include
ers wanted, in
sinesses) wanted
broader usage
ncludes references to a "marketing
to problem-solving encompassing
the selling of programs, services and ideas, as
well as products. And it works equally well for
non-profit organizations and individuals as
well as those with profit motives.

What is marketing?

Marketing today has become synonymous
with selling, promotion, and advertising.
But they are not the same. Nearly all business-
es and organizations sell, promote or advertise,
but they may not be marketing. What they
may be missing is a formal process that takes
into account the desires of the intended
audience.

Two definitions of marketing will help you
understand it better. The first says that market-
ing is "a formalized system or process of
organized thought and action that helps you
achieve product or organizational goals." It's a
process, not a product or goal in itself. When
applied to selling, marketing becomes "a
process of developing products or services

the consumer desires, and providing those
products or services in a place and at a price
the consumer will accept."

Foreign automobile manufacturers took over a
large share of U.S. sales when they found that
Americans wanted smaller, high-performance,

Marketing Tactical Plan Form

Plan Title:

Messages: Target Audience(s):

Activity	Responsible Person	Date Due	Date Done	Evaluation

Example of a marketing tactical plan form used to organize the process of developing a product or service the con-
sumer desires and will accept.

low-priced cars, instead of full-sized, high-priced, gas guzzlers. American manufacturers were *selling* their products, *not marketing* them.

Public relations practitioners use a marketing approach in "selling" an organization to its many publics. The goal is to create an image that appeals to the interests and desires of certain key audiences. Then, when the audiences are looking for products or services offered by the organization, or when the organization needs support on an issue, the audience will respond favorably.

Those who do advertising and promotion — tools used in sales and public relations — use a marketing approach to determine the motivation of potential audiences that may include consumers, clients, or viewers. Much research goes into learning about consumer preferences and interests, likes and dislikes.

The common thread in effective sales, public relations, advertising, and promotion is the attention paid to the market of potential consumers, clients, audiences, viewers, listeners, or readers, for example. Most businesses and organizations exist only because of their markets.

Organizational and program marketing

The techniques and tools described in this chapter are equally applicable for marketing a product, a program, an idea, a service, or an organization (both for profit and non-profit). From this point on, however, the discussion will be specific to organizational and program marketing in a non-profit setting.

Organizational marketing

Every organization, regardless of its mission, must have the support of its many audiences if it is to survive. Marketing audiences, or markets, for an organization may include: its own staff of employees, volunteers, directors, potential clients, taxpayers, opinion leaders, decision makers, and, in some cases, the news media.

Marketing goals for an organization usually involve creating visibility or awareness of the organization, or developing understanding and support for the organization's mission and accomplishments. The Red Cross, for example, wants people to be aware of its organization and participate in blood drives. It also wants people to understand and value its work, and to support it with their donations.

Passive marketing. Marketing an organization can be done passively or actively. *Passive marketing* includes those things that are a part of regular activity of the organization. And it can be *incidental or opportunistic.*

People, that is, your market, formulate an opinion of an organization based on such things as the way the telephone is answered, the appearance of an office or employees, the way they are treated by employees, the quality or lack of quality of the organization's products; and the effectiveness of the organization's communication pieces. These are *incidental* marketing opportunities.

To evaluate this aspect of your passive marketing, list all the ways you interact with your market. Then, evaluate each item and identify ways to improve. Develop a system for regular feedback from your markets. Ask clients or customers to fill out a form that evaluates items you identified earlier and leave room for comments on things you may have missed. Everything about an organization can influence the way people feel about it, in either a positive or negative way.

Passive marketing also means looking for ways to increase organizational visibility and support by taking advantage of opportunities created as part of normal activities. This is *opportunistic* interaction. Does your organization have educational materials that can be handed out when employees or volunteers are dealing with client audiences? Do you have printed signs that can be used by employees or volunteers when giving a talk or conducting a program? Are you taking advantage of every opportunity to get your organization's name and mission before your client markets? Are you getting credit for your organization's successes?

Logos and *slogans* are one way an organization markets itself passively. The goal is to create a visual or verbal identity for the organization that people will remember.

Logos are distinct visual elements that can be a graphic design or symbol, a name, or the two combined. They should be simple, uncluttered, and designed for use with a variety of media, such as letterhead, flyers, television, publications, or business cards. It's important that logos be used in a consistent manner. That is, the elements in the logo should be kept in the same order. Also, select a color and stick with it. Otherwise, the logo can become unrecognizable.

With repeated use, logo symbols can stand alone, without the name of the organization. Good examples are the golden arches of McDonald's, the Texaco star, Apple Corporation's multi-colored apple with a bite out of it, and the familiar clover of the Extension 4-H program. Logos can be printed on a variety of materials, such as coffee cups, pens and pencils, rulers, and t-shirts as well as on all official organizational materials such as signs, publications, newsletters, and stationery.

Slogans and jingles are brief statements that tell you something about the organization. Usually not more than three to five words, slogans can be used with logos. The advantage of slogans, however, is that they don't have to be seen. They are especially valuable for radio advertising, and if catchy enough, they will be repeated by consumers. And like logos, if repeated enough, slogans do not have to carry the organization's name. Good examples are "You deserve a break today," by McDonald's, "Where's the beef," by Wendy's, and "It's the real thing," by Coca-Cola.

The Cooperative Extension System is one organization that benefits from slogans that *describe* the product. Two slogans being used by state Extension Services are "Helping You Put Knowledge To Work," and "Education That Works For You."

Slogans can help create an image for an organization, but the organization must be prepared to live up to the image created. If the slogan implies your organization is friendly, then make sure your staff behaves that way. Remember, it's easier to build an image than to change one.

Active marketing. *Active marketing* is more involved than passive marketing. In an active marketing program, you develop a plan for carrying out specific marketing activities. The plan described below forces you to identify target audiences or markets and messages, and develop a strategy for reaching those audiences.

An active marketing program may include such things as a speakers' bureau, a news media campaign, direct mail, exhibits, advertising, events such as an open house, and promotional materials. Each employee or volunteer will be responsible for carrying out specific activities.

Program marketing

An effective effort to market the organization will be of little value if the programs or products of the organization are poorly determined, developed, packaged, or delivered. Stated another way, an organization is only as good as its programs.

It's important here to emphasize that program marketing is not the same as marketing a program. Program marketing is a process designed to make sure your programs are well planned. Don't confuse that with the idea of promotion of or selling a specific program, which is only one element of a marketing plan.

In most cases, your programs will be based on the desires of the market, assuming you do your homework to find out what the market wants. In some cases, however, your programs will be based on what someone has determined the market *needs*. An example would be an educational program on planning for retirement that you design for your target market of young married couples. You know they need the program, but the market doesn't sense a *need* or have an expressed interest. Your marketing job will be much more difficult.

Developing a marketing plan

As you identify organizational goals and objectives or problems and opportunities that can be addressed by a logical process of

analysis and strategy, you have started the marketing process.

Marketing plans seldom follow steps as closely as you might follow a recipe. There are, however, certain activities that, if accomplished, will help ensure a successful marketing effort.

Sometimes you might start with a formal or informal survey of your market to determine what they want or need. Or, you may already know what the market wants, and you have what they want, but you aren't getting a positive response from the market. Perhaps you haven't even determined who your market is.

How do you know where to start and who to involve in the process? You start by getting organized.

Getting organized

Let's assume somebody in the organization has identified a need to develop a marketing plan. You have a product or program or

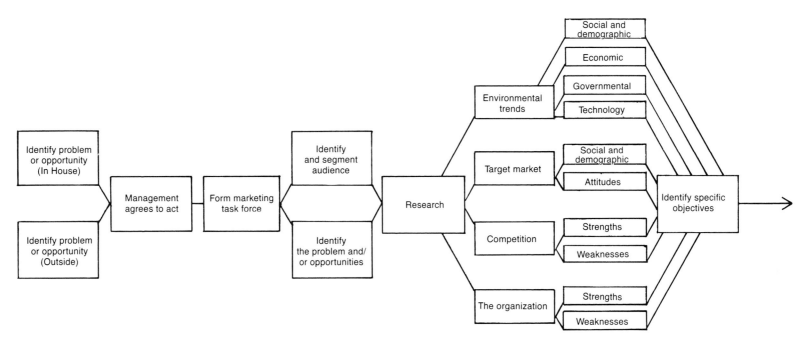

This organizational chart shows steps that can be used in developing a marketing plan. The important thing is that you understand the value of thoroughly analyzing your situation and base marketing decisions on sound data.

the organization itself is in need of a market. The first thing you do is form a team or a task force. It helps to have more than one person develop the plan. The team should be appointed by top management to give it credibility. You should also have a representative of top management on the team, and the promise of a budget that will allow you to do the job.

The team should represent staff at all levels of the organization who will ultimately be involved in carrying out the marketing plan. At some point, additional staff can be involved in marketing through sub-committees that are given specific responsibilities.

A team or task force leader should be appointed from among those staff who have

skills in group process, analysis, and communications. He or she should also have the time to carry out the responsibilities of the position.

If the team is also responsible for overseeing the plan's execution, each member should have a specific assignment and be given the authority to carry it out. If this is a long-term activity, agree on how long members are expected to serve.

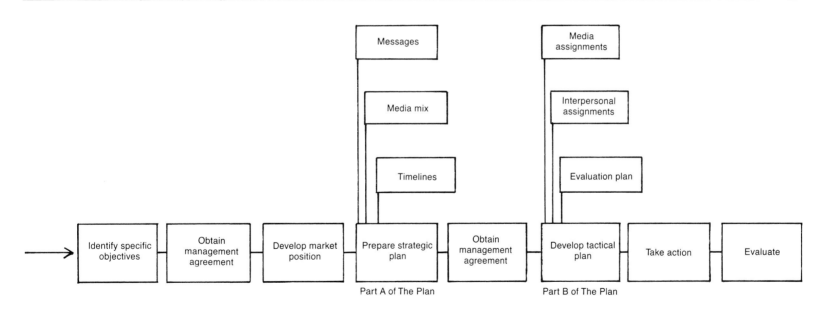

Set regular meeting dates for the team. Look for opportunities for team members to participate in staff development activities such as workshops in marketing and strategic planning that strengthen their contributions to the marketing effort.

Now that the team is formed and ready to begin marketing, it's time to start developing the marketing plan. The steps described here are designed to force you to consider all aspects of a marketing approach. In some cases, you will not need to carry out each step, nor will you always follow the steps in the order presented. The important thing is that you understand the value of thoroughly analyzing your situation and base marketing decisions on sound data.

The value of group brainstorming in developing your plan cannot be overstressed. Take advantage of this process whenever possible. If you have a group of ten or more, break into smaller working groups and share your ideas frequently. Develop a form based on the steps described below and keep detailed records.

A seven-step marketing model

Prepare a goal statement

State clearly and concisely the problem, opportunity or need this plan will address.

Prepare a goal statement that all participants in this planning process can agree with. At this point, don't worry about quantifying the results you hope to achieve. And don't spend much time identifying and describing the market you want to address; that comes later. If your goal is organizational marketing, your statement might relate to the image you want the public to have of the organization or a problem with the current image. If you're marketing a program or other product, you might make a goal statement that describes the expected outcome. For example, let's say you want an educational program on teen pregnancy to have an impact on the problem. It is in this step that you describe the problem. Make sure you're not relating to a symptom of the problem instead of the problem itself.

Once you are satisfied with the goal statement, evaluate it against your organization's stated mission. If you don't have a mission statement, have the group attempt to write one. The statement should be less than 25 words and should be clear enough that someone unfamiliar with the organization can understand what you're about. Your goal statement for this marketing plan should clearly fit within the organization's mission.

Identify and segment your market

Identify the audiences, or markets, you want to address. For each market you identify, break the group into smaller groups that have common identifiable characteristics. Then, put these segmented markets in a priority order for addressing, or targeting, in this plan. For each target market, list those people who influence the market. These influencers may be valuable in your strategy for reaching the target group.

Summary:
A seven-step marketing model

1) Prepare a goal statement. State clearly and concisely the problem, opportunity, or need this plan will address. Do not list specific objectives.

2) Identify and segment your market. Identify the audiences (markets) you want to address. For each market you identify, break the group into smaller groups that have common identifiable characteristics. Then, put these target markets in a priority order for addressing in this plan. For each target market, list those people who influence the market. These influencers may be valuable in your strategy for reaching the target group.

3) Research your information needs. There are three sets of data you need to accumulate to help you develop a marketing strategy. You'll have to learn all you can about your *target market,* the *environment* in which you'll be marketing, and the *competition* you'll have for your target market. Obtain as much information as is practical/feasible in the time you have available.

About the target market: Do a demographic and geographic profile of the target audience. List everything you learn about them.

About the environment:

■ What are the *social and demographic trends?* Are there patterns — other than those you already outlined for your target market — in the way people interact.

Is the population aging? Are there more working mothers in the job market?

■ What are the *economic trends?* What's happening to incomes, spending patterns, employment, credit availability, public attitude toward funding social services, etc.?

■ What are the *governmental trends?* Any changes in local, state, or federal laws? Political trends (which party controls government spending)? What are the "hot" or "in" programs that seem to get government support?

■ What are the *technological trends?* What impact on your target market (and your ability to deliver your programs or products) do you see from such technologies as satellite communications, home video, office automation, desktop publishing, computer-related technologies? Who controls this technology? Who has access to it?

■ How does the price of your product or service affect audience acceptance? What can you do about it? What are your resource limitations in people and budget and what can you do about that?

■ What other trends should you be aware of if you are to compete for your market share?

About the competition. Do you know who your competition is? Who has a product or service similar to yours? Who else is trying to reach your target market(s). What do you know about your competition? What are their strengths and weaknesses, and how do they compare with yours? How is the competition positioning itself to the market? How does the price the competition charges for their product/service compare with yours?

4) Identify specific objectives. Develop a series of statements that are very specific in defining what it is you want to accomplish with your target market. One way to write your specific objective would be to complete the statement, "This program is a success if. . ." It's important to be realistic in your objectives. Make sure they are achievable.

5) Develop your market position. "Positioning" is a marketing term that refers to how you set yourself apart from the competition. In what way is your organization or your product unique? What advantage does your organization or product have over the competition? Positioning also describes how you want to be perceived by your target market. Does your organization or product meet a perceived need of your target market? Are you perceived as a credible source of the product? *List those things* about your organization, or product, that could be used to position it effectively. What audience needs do they meet? What does it have that the competition doesn't have or isn't utilizing?

6) Prepare strategic and tactical plans. Now it's time to develop your *marketing strategy.* This is the heart of your marketing plan. It's here you will develop the messages, select a mix of media for delivering the messages, and devise a game plan that will help you achieve your objectives. Develop here your strategy (in broad terms) for how you will go about reaching your target audience(s). On another form, list the specific tactical plan that indentifies *who* will develop *what messages* for *what media* on *what time line.*

7) Make evaluation part of your plan. This is where you build into your plan a means of evaluating how well you've done. At some point you will be able to look back at your specific objectives, and determine if they have been met. But you also need to have several checkpoints where you ask yourself if things are going according to plan. These check points might be in the research stage (where you're learning about the target market, the environment, and the competition) or during the time the strategic and tactical plans are being executed. If you developed a form for your tactical plan, include spaces (with deadlines) for checking on your progress. Be prepared to make changes in your plan based on what you learn from the evaluation.

21 Marketing your organization

This step is called *market segmentation.* Brainstorming can be a valuable tool here. The goal is to target a market that has common interests, behavorial patterns, motivations, etc. Correctly segmented, you will have less trouble developing a strategy for reaching this target market. For example, "voters" become "male" and "female" voters; or "low income" and "high income" voters; or "male, low income" or "male, high income" voters.

In another example, let's say you teach a home economics class, and enrollment is dwindling. You want to recruit more students for the class. Your target audience, then, is potential students from among those in the school. Those students are male and female, and your approach to them would be different, so now you have two groups to address. Among the males, one group that might be motivated to get into home economics is athletes because nutrition and health relate to athletic performance. So now, you have segmented the group further.

After segmenting the groups, analyze where you might be most effective, that is, have the greatest impact. For example, if athletes take home economics, it might encourage other males to take it also.

Influencers of your target markets can be valuable resources for getting the markets to behave in a certain way. In the previous example, athletic coaches are influencers of the athletes' behavior. So are other respected athletes, for example, the star of a college team. Thinking about these influencers might help you to put your market segments in a priority order.

(NOTE: From this point on you will be addressing your highest priority target market. After you complete the process for one market, you likely will come back and take the second priority market and follow through with the same process.)

Market segmentation

The (global) market Segmented market Target market

The goal of market segmentation is to target a market that has common interests, behavioral patterns, motivations, etc. When correctly segmented, you will have less trouble developing a strategy for reaching the specific target market.

Research your information needs

There are three sets of data you need to accumulate to develop a marketing strategy. You'll have to learn all you can about your *target market, the environment* in which you'll be marketing, and the *competition* you'll have for your target market. Obtain as much information as is practical/feasible in the time you have available.

This is the section where you do the research. The more successful you are in getting appropriate information, the better your strategy will be. Some of the data will come

from a market audit where you gather existing information about the target market and the environment in which you'll carry out the marketing plan; other data will require opinion/attitude or behavior surveys.

Surveys can be formal, carried out with a tested questionnaire in a personal, telephone, or mail survey of a representative sample of the target audience; or informal, accomplished by asking a few questions of the target market over the telephone or in person. An example of an informal survey would be to ask every fifth caller to your office where they heard about your organization, how often they call or use your product, and if they are satisfied with what they got. Informal surveys can be good indicators, but the results likely are not reliable data. Your sample of clients may not represent the entire group. Check with a professional survey researcher before attempting a formal survey.

About the TARGET MARKET: Do a demographic and geographic profile of the target audience. Describe it in terms of their age, sex, race, education, marital status, employment status of one or both spouses, religion, family/household composition, income, location of residence, and any other category you think appropriate. Look at lifestyle characteristics: Do they eat out? How often? Do they volunteer? Where and how often do they take vacations? What news media do they use? Do they have a satellite dish? A VCR? What magazines do they read? etc.

If you want to know what the target audience knows and thinks about your organization and its products/programs, you'll need to do an opinion survey.

About the ENVIRONMENT: An environmental assessment will identify those things over which you seldom have control, but which may influence your ability to market to your target audience. This function is considered important enough by many companies that they have a full-time manager for environmental analysis. It's unlikely that all of the categories listed below will be important to your marketing plan. For those that are, be as thorough as possible given the time you have to devote.

■ What are the *social and demographic trends?* Are there patterns — other than those you already outlined for your target market — in the way people interact socially? Is the population aging? Are there more working mothers in the job market?

■ What are the *economic trends?* What's happening to incomes, spending patterns, employment, credit availability, public attitude toward funding social services, etc.?

■ What are the *governmental trends?* Any changes in local, state, or federal laws? Political trends, including which party controls government spending? What are the "hot" or "in" programs that seem to get government support?

■ What are the *technological trends?* What's their impact on your target market and your ability to deliver your programs or products through such technologies as satellite communications, home video, office automation, desktop publishing, computer-related technologies? Who controls this technology? Who has access to it?

■ How does the price of your product or service affect audience acceptance? What can you do about it? What are your resource limitations in people and budget and what can you do about that?

■ What other trends should you be aware of if you are to compete for your market share?

About the COMPETITION: Do you know who your competition is? Who has a product or service similar to yours? Who else is trying to reach your target market(s)? What do you know about your competition? What are their strengths and weaknesses, and how do they compare with yours? How is the competition positioning itself to the market? You will learn later in this chapter what "positioning" means. How does the price the competition charges for their product/service compare with yours?

NOTE: At this point you may find that the competition can serve the target audience better than you can. If you don't have the edge or think you can carve out a niche, you might want to find a different target audience, change your product, or change your goals.

One rental car company faced this prospect and decided to change their approach; they indicated that since they were second, they would try harder to win your business.

Identify specific objectives

Develop a series of statements that are very specific in defining what it is you want to accomplish with your target market.

In this section you will quantify your goals. Be very specific. Indicate *how much* or *how many*. For an organizational marketing plan, for example, you might want to specify the percentage of your market you want to be aware of the organization's mission. You could then formally evaluate the importance of your organization to that group. For a program, product, or marketing plan, you likely would want to set a goal of a certain number of people who would change their behavior or purchase the product because of the program. Again, you could use a follow-up survey to determine your success.

One way to write your specific objective would be to complete the statement, "This program is a success if..." It's important to be realistic in your objectives. Make sure they are achievable.

Develop your market position

Positioning is a marketing term that refers to how you set yourself apart from the competition. In what way is your organization or your product unique? What advantage does your organization or product have over the competition? Positioning also describes how you want to be perceived by your target market. Does your organization or product meet a perceived need of your target market? Are you perceived as a credible source of the product? *List those things* about your organization or product that could be used to position it effectively. What audience needs does it meet? What does it have that the competition doesn't have or isn't utilizing?

Positioning is one of the most important elements of your marketing plan. It is the centerpiece for your marketing strategy, which is described later in this chapter. Positioning usually is based on what you learn about your target audience. Understanding human behavior and motivation helps also. If you want to project a certain image to your target market, make sure that image is valid. As was the case in developing a slogan, you had better be able to deliver on what you say. If you position your product, for example, as being ideal for the health conscious, then you should be able to stand behind that claim.

The market position of an organization or product usually is reflected in its promotional materials, including advertising. For example:

- A new California winery, trying to compete against the existing, large wineries, positions its product as being the one to buy "for special occasions, such as anniversaries, birthdays, weddings, and christenings." This company carved its niche in the market-place and became successful in a very competitive business.

- An insurance company makes you feel *safe* with television spots showing that "You're In Good Hands With Allstate."

- You don't want to *miss* out on being a part of "The Pepsi Generation."

- There's one diet soft drink that is made for men, too. Showing a heavyweight boxing champion drinking the product proves it.

- Cooperative Extension Services at many of the land grant universities around the country position themselves as a part of their universities to lend *credibility* to their educational products. That sets them apart from their competition.

- You want to *trust* products you buy, so many companies use that theme in their products. One tire company positions itself as being the one to buy to make sure your family is safe from harm. A battery company uses the same theme in their advertising.

- Many companies position themselves as providing something you value, such as youth, upward mobility, and power.

Usually, you will position your organization or product differently to different target markets. For example, the same wood stove might be marketed to lower-income consumers as being the one stove that can really save you money on heating bills. For higher-income consumers, you might position your stove based on its aesthetic or status qualities.

The key to getting your market share is to carve out your niche. Find something about your organization or product that can't be or hasn't been utilized by the competition. Think about how you want the market to perceive your organization or product, and use that to develop your market position.

Prepare strategic and tactical plans

N ow it's time to develop your *marketing strategy.* This is the heart of your marketing plan. It's here you will develop the messages, select a mix of media for delivering the messages, and devise a game plan that will help you achieve your objectives.

Start by listing the messages or themes, not the ultimate wording, that will be used in your media plan. Remember, what you're offering is the benefit, not the product or service. Consider your positioning statement(s), and target market motivators.

Next, list the media mix. Consider the media and informal communication networks your target audience might use; you probably developed a list of them when you were researching your target audience.

Finally, develop an informal time line. Later, you will need to become more specific in your planning by developing a tactical plan that includes a list of assignments and deadlines. The tactical plan will specify who prepares what communication products, by when, and for what delivery time.

Your *marketing strategy* will influence the degree to which you are successful in your marketing efforts. Keep your target market in mind as you develop your strategy. Identify those people who influence your target market, and market *through* them. A good example would be to reach state legislators or U.S. Congressmen by directing your message to the appropriate aides who propose action for the lawmakers to take.

Existing communication networks often are more credible to your target audience. Analyze where they go for information. If your target market is the building trade, for example, then get your message in building trade magazines and newsletters.

Your media mix may include the news media, where you can purchase space or air time for advertising. Or you might try for free space with news or feature articles, or air time with public service announcements. Learn what to expect from the news media. They can be effective in creating awareness and interest, but they are less effective than other media in changing attitudes or behavior. The media mix may also include the use of direct mail such as newsletters or flyers; meetings, workshops, and demonstrations; publications; videotapes; a speakers bureau; exhibits; and any other media discussed in this handbook. Personal, one-to-one contacts called "relationship marketing" is effective if you have the people resources to make it happen.

Your *tactical plan* will be much more specific. You'll list all the releases, advertisements, exhibits, direct mail pieces, and other communication materials you'll produce for this marketing plan. After each item, you should list who is responsible, when it is due, and when it should be released. If you develop a form for this, leave a column for indicating the date an assignment was completed. You might even go so far as to have gold stars on the form to show that an assignment was done on time. Your tactical plan can change as the situation warrants, so be prepared to take advantage of opportunities that arise.

Make evaluation part of your plan

T his is where you build into your plan a means of evaluating how well you've done. At some point you will be able to look back at your specific objectives, and determine if they have been met. But you also need to have several checkpoints where you ask yourself if things are going according to plan. These check points might be in the research stage where you're learning about the target market, the environment, and the competition or during the time the strategic and tactical plans are being executed. If you developed a form for your tactical plan, include spaces with deadlines for checking on your progress. Be prepared to make changes in your plan based on what you learn from the evaluation.

As you develop an evaluation plan, it helps to understand the stages involved in the *life cycle* of a program:

■ The first stage, *development*, is the time it takes from the inception of an idea to the point where you're ready to execute the plan; this can take anywhere from several days to several months.

■ The second stage, *introduction*, is the period where you are delivering the program, but there has been little time for response; this could last from several weeks to several months.

■ The third stage, *growth*, is the time when the program is maturing and reaching its zenith; this is a major phase of the program and takes anywhere from several months to a year or more.

■ The fourth stage, *leveling*, is the point where interest in the program has peaked and will start to decline unless you introduce some new life into it.

■ The final stage, *decline*, is pretty much defined by its name; the program is winding down and will soon end unless you decide, as in the leveling stage, to introduce some new enthusiasm. The total time for these stages can be less than a year to several years, depending on the nature of your program. If you think about these stages when you plan your evaluation, you'll be ready to take the necessary action to achieve your goals.

The means you use to evaluate your progress or success depends on the resources you want to put into it. As discussed earlier in this chapter, formal evaluations using surveys can be time consuming and expensive. Informal surveys and other feedback can be valuable, but not always reliable.

The value of using a marketing plan like the one above is that it forces you to analyze all those things that can influence how well you market your organization or its products. You may stop with a plan that addresses one target market, or your overall plan may be a compilation of plans developed for several target markets.

Marketing limitations

M any things can limit the effectiveness of your marketing efforts. Among them are:

■ A *lack of leadership* for marketing. Someone has to have the responsibility and the authority for carrying out a marketing program;

■ A *lack of credibility* for the marketing effort. It has to be clear that the marketing effort is supported at the highest levels of the organization;

■ A *lack of resources* to carry out the marketing plan. You need sufficient people and budget; and

■ A *lack of staff support* for marketing. Everybody in the organization must em-

brace the marketing concept and be prepared to do their part.

Staff support for marketing will come when they become aware of the benefits to the organization, and ultimately to themselves. They need to realize that marketing isn't an add-on, but a part of everything they do. It makes what they do and the organization itself more effective and successful.

A final note: Don't forget the market

In the final analysis, no amount of marketing will ensure organizational success unless everyone in the organization is market-oriented. Your customers, clients, readers, listeners, supporters, etc. have to be considered your top priority. Without them, the organization likely will cease to exist.

It's essential that you consider your customers/clients when developing programs and products, and at any time anyone in the organization interacts with them. All the planning in the world will fail if the customer/client is turned off by someone in any level of the organization. One negative interaction, even one so seemingly trivial as a customer on the telephone being left on hold too long, can offset a well-designed marketing plan. Check out your organization, and see if you're really market-oriented.

Publicizing the event: The multi-media approach 22

To publicize an event like a field day or a meeting, first consider who you want to attend. If the potential audience is small, talk to each member personally, call, or write a letter. You can't beat the personal approach.

Let's say your potential audience is too big for the personal approach. How do you let people know about the event? How do you get them to come?

First of all, the event has to be worthwhile. Nothing will hurt your credibility with your audience and the media more than a highly publicized event that just doesn't amount to much.

All right. You've got an upcoming event, such as a field day, and a good sized group to tell about it. First, look over the checklist below, then flip the page for a plan of action. In general, plan your media campaign at least three months in advance if you wish to use magazines as part of your publicity effort. Determine items and people you want featured. It's a good idea to follow through on one theme. For example, the same picture used on your flier could also be used on posters, in the field day report (proceedings publication), and with a news release.

Publicity checklist

Here are some methods to consider:
- Personal contact.
- Advance news releases.
- Fliers, posters.
- Radio tapes.
- Radio scripts.
- Brochures/programs.
- Proceedings publication.
- Photographs.
- Loudspeakers.
- Caps, name tags, and other identifications.
- Television for public service announcements and news clips.
- Follow-up news releases.

General rules of publicity

Only publicize events that deserve publicity. Pomp without substance is not appealing to media people. And it won't do your credibility any good, either.

Put someone in charge. Publicity by committee can be a mess.

Make a plan. You can almost never plan too far ahead. Decide what you want to publicize and how you plan to do it.

Consider the media options and pick those most appropriate. (See publicity checklist.) If you have only a small audience, you might just speak or write to each person personally.

Make a calendar. This will be your schedule of publicity activities.

Be accurate. Clearly establish the 5 Ws and the H: Who, What, When, Where, Why, and How. (See news release sample at the end of this chapter.)

Be brief. Short, tightly written stories announcing an event have a much greater chance of being used and read.

Use a local angle. Involve local people in planning your event. Localize press releases. Involve local news sources. They can help make contacts with media and clientele you wish to attend your event.

Focus on the right audience. This may be the most important rule in communicating: Know your audience and write or talk to them.

Decide what is news. What is it about your event that makes it unique or newsworthy?

Establish media contacts. Be open. Let them know who you are and what you have to publicize. Learn their deadlines and other expectations. Do they want typed stories or is a phone call enough? Do they want only that information that relates to readers or listeners in their area?

Be business-like but friendly in your dealings with the media. Editors and broadcasters have busy schedules, deadlines, and profits to make. They consider themselves professionals, experts in their business, and don't like to be told, "You have to run my story."

Don't cajole or beg. "Sell" your story on its own merit. That's why the first rule is so important: Make sure you have something to sell in the first place.

Say "thank you" to the media when they help you publicize an event. I seldom do this directly to the editor or broadcaster, unless I know them fairly well or otherwise have a chance to do this without being ostentatious. But a letter to the editor, say, from you or someone who attended the event, is always nice.

Follow up. For goodness sake, if an event was worth publicizing, it should be worth a follow-up story(ies) on what happened. This could be in the form of information called or delivered to the media before the event ends. Here again, knowing media deadlines will help you get information to media in time.

Start planning for the next event before this one ends. You may want to shoot pictures or videotape to use in promoting next year's event. Keep track of what happened and learn from your mistakes. Keep records or notes. Have a discussion immediately after with those involved on what went right and how you might do better next time.

Media calendar for a field day

This sample calendar is designed to help publicize a field day, but it can also be applied to most other events:

- Plan the media effort. You should work directly with person(s) in charge of the field day or other event who, in turn, should keep event participants informed.

- Send a first release announcing an event like a field day at least eight weeks in advance, or at least soon enough to meet magazine deadlines.

- Write and design fliers announcing the field day. Printing shops need time. Check with them to see how much lead time they need to get the job done. Work with persons in charge of the event to determine number of fliers and distribution.

- Have posters printed (optional) for posting in the field day area. Also, remind the field day representative that he or she will need directional signs, caps, name plates, and loudspeakers.

- Take photos two to four weeks ahead of the field day. You need them recent enough to be timely, but you also need lead time to get them printed and distributed to newspapers. Past years' files can help.

- Make radio interviews with participants and/or give scripts to radio people for their radio services. Again, figure a two to three week lead time to allow time for editing and distribution.

- Edit, lay out, and distribute "field day report," a printed publication on what is presented at the field day.

- Send another more detailed advanced story to newspapers two weeks ahead of the event. If possible, that should be accompanied by a photo.

- Write stories from information presented at the field day. Do these a week or two in advance so they can be released the day of or the day following the field day.

- Contact TV station one or two weeks ahead of the field day. Arrange for advance filming and/or coverage of the actual event. Prior to this, determine "highlights" and possible TV "stars" who are willing to be

interviewed and filmed. (Optional: Produce public service announcements and distribute them at least three weeks ahead of the field day.)

■ Hold a "news conference" (optional) to give editors and broadcasters a "preview" and a chance to interview, take photos, and prepare stories. This is usually done the day before the field day.

■ Cover the field day. Be available to help visiting editors and broadcasters cover the field day. Take pictures. Make radio tapes. Information gathered at the field day can be used to write follow-up features (without field day tie) for magazines, to provide timeless interviews for radio service, to document the field day, and to build a photo file.

The press release

Think of the audience. Will the information do them any good? Know the media. What do they want/use?

Press releases should include the date and the name, address, and phone number of the person to contact for more information.

The following story is a good example of a press release:

Big soil conservation
'action' field day set

The largest soil conservation field day in mid-America — including action demonstrations of the latest in soilsaving techniques — has been set for July 26 and 27 near Weston, Mo., just north of Kansas City.

During the two-day event, 7,500 feet of broad-base, narrow-base and grass backslope terraces will be constructed, said Don Pfost, University of Missouri-Columbia agricultural engineer.

"This will give farmers a chance to see these new terraces which are especially well suited for steep slopes," Pfost said.

About 3,500 feet of underground outlets will be installed. In addition, two large waterways, a 650-foot diversion and an 8,000-cubic-yard dam for a lake will be built.

The field days are free and run from 8 a.m. to 5 p.m. both days. Food will be available.

Details are available from ASCS, SCS, Missouri Department of Conservation and extension offices. Rain dates for the event are August 2 and 3.

This news release features the five Ws and the H:

What - The largest soil conservation field day.
When - 26 and 27.
Where - Near Weston, Mo.
Who - Who says so? (Don Pfost); Who's it for? (farmers); Who's involved? (ASCS, SCS, etc.)
Why - "To give farmers a chance to see..."
How - Action demonstrations.

Be brief. Use short sentences, short paragraphs, simple words, active verbs. And get to the point — fast! Short, tightly written stories have a much greater chance of being used and read.

Beware of jargon. Send releases to the editor or broadcaster who decides what will be used. If you don't know the person's name, address information to "editor" (in the case of print media) or "news director" (in the case of broadcasters).

■ **Dealing with the media**

The ability to effectively deal with the media is a valuable skill within any organization. It is based on two rules: Always return phone calls and always tell the truth. This chapter presents an overview of how to effectively relate to the media and will prepare you to execute better interviews.

Dealing with the media

Reporters seldom forget the person who does not return their phone calls or tell them the truth. Therefore, to maintain your credibility with the media, you must make yourself accessible and you must be truthful. How you deal with the media is a reflection of the organization you represent. The function of the media in holding public officials accountable, in digging for details, and occasionally being skeptical, is one that should be respected.

Always respond to reporters as quickly as possible. Remember they generally work on deadlines and appreciate a prompt response. You can be certain reporters will remember slow responses to their inquiries. Your credibility is built day by day and could be your most precious commodity.

What can you do when reporters call and you aren't prepared to talk about the issue at hand? Or if reporters surprise you, waiting outside your office when you come to work? You don't have to stop and talk at that point; you can say you are busy and can't reply at

this time. But you must tell them when they can expect an answer.

As a media relations specialist for your organization, it is sensible to follow these two rules:

Call reporters back. Your boss is not always required to talk to reporters. A returned call, however, proves that your organization is cooperative.

Maybe your boss is not an expert on the subject. In that case, recommend another source. If your boss is indeed an expert on a particular subject, and you think this is a good

opportunity to get this expertise before the public, agree to an interview. But be sure you tell the reporter the interview will be conducted under specific guidelines.

Set the guidelines. The reporter should only have a set amount of time with your boss. Your boss' time is valuable. Note that you, not the reporter, set the time limit of the interview. You can make it as long or as short as you like. Tell the reporter ahead of time how much interview time to expect. Keep the total time short, but allow your boss to delay ending the interview if things are going well.

Assume that reporters will be prepared to conduct a thorough interview occasionally asking extremely difficult questions. Keep on point and stay in control.

Before granting an interview, you have the right to know the subject and scope of the interview. If your boss is to appear on a talk show, you also have a right to know the identity of the other guests and what topics will be discussed.

Arrange for the interview to take place in your boss' office. You will be there to tape record the interview for your records. Let the reporter know this beforehand.

How much time should you allow? Fifteen minutes should be long enough for radio; 30 minutes for television, including time for equipment set-up and break-down. You might want to schedule 45 minutes to an hour for a print reporter. Any longer than that and your boss may say too much and get into trouble. By keeping time short, reporters are forced to keep their questions on point.

Don't forget there are a number of built-in inequalities in the interview situation. Reporters have the right to cancel at the last minute. If you cancel, you must provide a substitute. Reporters can be late, you can't. But, if they are late, you *can* cut back their total time allotment.

Let them know up front that your boss will only discuss the particular subject at hand. If a reporter asks a question on a subject you agreed would not be discussed, you should respectfully suggest that you stick to the original subject of the interview. You might offer to find the answer for the reporter after the interview, recommend another person to

interview on that subject, or arrange another interview with your boss at a later date.

Whether the interview is to clarify your organization's position on an issue or to provide expertise in a certain area, the media exposure should be used to your advantage. If you deal effectively with the media, your organization may gain credibility and public support. Considering the cost of advertising, this can be a golden opportunity. Your interview should be regarded as free broadcast time or column inches to talk about the subject you know best.

Assume that reporters will be prepared to conduct a thorough interview, occasionally asking extremely difficult questions. Keep on point and stay in control.

Preparing for the interview

Do your homework. You and your boss should study the subject thoroughly, checking the latest facts and figures. Try to anticipate questions. It is foolhardy to meet with a reporter when you are unprepared.

Think it through. Work with your boss to think through the positive points you want to make, and practice answering difficult questions that could be asked. Type these on 3x5 cards and make them available for your boss to study. You can almost always use the message you would like to get out as the foundation for the questions you answer.

Get involved. Encourage your boss to practice for the interview with your assistance. You can set up one-on-one practice sessions to suggest changes or improvements on how to respond. Tell your boss not to memorize, but to be very familiar with the positive points. Generally, try to have three points ready for each sub-topic. These points should be prepared in short sentences, stated simply and clearly. If this is a broadcast interview, answers should be limited to 20 seconds. Remember the average broadcast story is 90 seconds long — three 20-second segments and an introduction and close.

Prepare show-and-tell material. Your boss' latest book will do, or a simple graphic to illustrate a complex statistic, or maybe a model of the plant you are planning to build.

Brief your boss on the reporter's background. What is the reporter's reputation for fairness? What prior stories has the reporter done about your agency? Don't hesitate to call friends or associates to get their opinions if you don't know the reporter.

The interview

The reporter is knocking on the door. You're ready and have prepared your boss with the following tips:

- During the preliminaries, smile and enjoy yourself. Try to relax your interviewer and you will relax too. Let it be known that you are looking forward to the interview. The

■ The interview

best way to diffuse a hostile situation is to be warm and accommodating.

■ Once the interview begins, adopt a more serious tone. Assume the role of the expert. Don't smile and nod your head while the reporter is asking you a question; just look interested. It is important to get your correct response on tape so there is no doubt about your position on any matter.

■ Stop talking when you've made your point. Many people say things they didn't mean to say after they've made their major point. Don't worry if there is a silent, awkward pause. A reporter will often use this pause as a technique to get you to volunteer information.

■ If the reporter asks three or four questions consecutively, pick the one you want to answer. If the reporter interrupts you before you finish your answer, pause, let the reporter finish, and then continue your answer.

■ Don't let the reporter put words in your mouth. If the reporter uses inaccurate facts when asking a question, don't allow the inaccuracy to go unchallenged. In other words, beware of the leading question that requires confirmation or denial.

■ If the situation becomes difficult for you, make the reporter repeat or clarify the question. Put the pressure of the situation back onto the reporter while you consider your answer. Don't get flustered.

■ At the end of the interview, tell the interviewer you appreciate the oportunity to clarify your position or speak on the subject. Watch the TV news that evening. Listen to the radio news. Time how long each story runs and note the amount of air time for the interviewee and the anchor.

Some helpful "nevers"

Advise your boss to:

■ Never say "No comment." Handle this type of question by saying, "That's not the critical issue, this is..." Then go on to explain what *is* critical. Or, "That's not right. These are the good things we are doing..." Or, "That's under litigation now. Our policy is not to discuss ongoing litigation..." Or, "We will have an announcement about that later this week."

■ Never say anything "off the record." Never say anything to a reporter you wouldn't want to see on the six o'clock news or the front page of tomorrow's newspaper.

■ The interview is never over until the reporter leaves the office. A TV reporter will often ask to shoot "B-roll," sometimes called "cutaway footage" or "cutaways." These are used to fill in the interview and make it more visually interesting. Camera technicians leave the sound on while taping the B-roll, and the reporter may ask you something like, "Well, how do you really feel about this issue?" Make sure you repeat only what was said earlier.

The same rule applies to radio or press reporters, who sometimes leave their tape recorders on to capture any off-the-cuff remarks that you wouldn't make if you suspected you were being taped.

If you are giving a phone interview, assume the reporter is taping the conversation. This assumption can save you many regrets later on.

■ Never lie to a reporter. This point cannot be overemphasized. As a spokesperson, you are delivering your organization's official policy, not necessarily a personal view.

Make sure your body language and speech patterns back up your sincerity. To combat nervousness that an audience may interpret as insincerity or untruthfulness, sit up straight and take deep breaths. Don't make excessive movements with your head. Be conscious of speech habits too, especially "uhs."

■ Never lose your temper. Because of television's visual impact, emotional responses can seem magnified. It is important to stay in control. The tips already mentioned may help you relax. And remember, you are not being interviewed to merely answer questions but to get your own points across. Keep thinking of the interview as an opportunity, a way of using free time to tell your story.

23 Media interviews

What to wear?

The key to dressing for an interview is that you want to be remembered for what you said, not what you wore. Dress conservatively and simply.

For TV, men should wear a solid light blue shirt and a dark colored suit in blue or gray. Don't wear a plaid sports jacket and loud contrasting tie. Don't wear striped or white shirts, jeweled tie tacks, gold chains, bulky ID bracelets, or wild ties. Over-the-calf dark socks are essential, and check that the soles of your shoes don't have holes. Few things look worse on television than skin showing when a man crosses his legs.

Women interviewed on television should wear a solid, light colored blouse and a dark, plain suit or blazer. Avoid sparkling jewelry, distracting bracelets, large earrings, ruffles, narrow or short skirts, and deep necklines.

Practice sitting quietly in a chair. Don't lean on the arm or constantly move from side to side or forward and backward.

If the television producer offers make-up, consider using it. TV can make you appear heavier and older than you actually are.

Conclusion

You probably realize by now how important your relationship with the various media can be. Following the guidelines in this chapter will help you use the media to your best advantage, but a great deal will depend on practice. Remember the two basic rules: Always return the calls of reporters and always tell the truth. Your organization can truly benefit from the way you deal with the media.

■ **Direct mail is popular**

A longside all of the new communications technology, direct mail — through post-age, penalty mail, or electronic mailboxes — remains a significant educational channel. The oft-labeled "junk mail" advertising in letters, packets, catalogs, and specific offers is a powerful sales method. The U.S. direct mail industry continues on an upward growth and learning curve.

Direct mail is successful because the medium allows you to direct the right message to the right reader at the right time. Selection and maintenance of target mailing lists is critical in successful direct mail — whether marketing products, services, or educational ideas.

Direct mail is popular

A dvertisers spend over $130 billion, or 1.5 percent of aggregate U.S. sales, every year. One of six advertising dollars is spent for direct mail, placing this sales method second behind newspaper advertising. While there's concern about the "junk mail" image reflected in the U.S. mass media, most people in the direct mail industry feel that its self-policing has earned public confidence in mail sales.

Consider these facts:

■ Every two weeks about one American in ten orders something from a catalog, brochure, or leaflet received in the mail.

■ Annual mail order insurance sales alone are nearly $7 billion.

■ Two of every three magazine subscriptions in the United States are sold by direct mail.

■ Mail sweepstakes have been an important aspect of direct mail.

■ Cable direct mail channels have moved direct mail sales into a new medium.

■ Telemarketing often is supplemented by mail. Just before the 1984 election, telemarketers netted the Republican National Committee pledges of more than $450,000 and collected over 91 percent of it.

■ One company surveyed had 40 percent repeat sales for selected mailed coupons.

As an educator or public relations professional, your major efforts are in "selling ideas" through the mail box. What you "sell" doesn't really matter. Direct mail can still be a solid media choice for you to persuade and to convince people of the value of your organization's services.

To use direct mail most effectively, you must consider it as the newest, practical yet exciting, medium to deliver your message.

The audience comes first

N ever forget that the reader's interests and needs always come first in any successful direct mail effort. This consideration is easy for advertisers to remember because income from readers is their survival. Educators, serving the needs of administrators and institutions, are too often tempted to develop and mail a sender-oriented message.

Direct mail offers you a way to reach many people, one at a time. Always keep your audience or reader in mind as you tailor your message to reach each individual one-on-one. Show your readers a benefit, and they will serve your needs, too.

IDEAS → AUDIENCE

Purchasing and evaluating mailing lists is a significant industry budget item. Target mail lists are so critical that list brokers are a big part of the direct mail industry. It is important that you have target mailing lists, but you must practice economic efficiency.

Modern technology is vital in today's direct mail medium. Minicomputers are used to generate text and graphics through desktop publishing to produce a quality letter. Available programs can even help with spelling, grammar, or writing format. Computers are used to target letters and prepare envelopes for a specific reader. Since the first mailgram (next day delivery) in 1970, letters have been sent electronically and this is most effective through selected computer networks.

Other chapters in this handbook that deal with desktop publishing, publication design, and graphics can help you improve your direct mail efforts.

Direct mail advertisers have their own associations for education and exchange. Anyone heavily into direct mail should consider membership. Monthly magazines such as *Direct Marketing* and *Target Marketing* provide many ideas and references.

What is direct mail?

The term "direct mail" usually evokes images of advertising pieces sent unsolicited to an address or person. Actually, direct mail is much more diverse. It can be a postcard, a newsletter, a publication, or a reminder about a meeting.

Direct mail can come in the form of a postcard, newsletter, publication, or reminder about a meeting.

In simple terms, direct mail is a message directed to a specific audience to accomplish a specific purpose. The size of the audience doesn't affect whether or not the message is direct mail, nor whether the message is a one-time event or a regular newsletter.

The biggest advantage of direct mail is that you can single out your audience and send it your message in the form you choose. You

decide who receives the message, what the message contains, how it is presented, and when it is sent.

If you want your readers to take action, direct mail is one of the best media you can use. Direct mail is an action medium. You can use it to get people to try out an idea. Industry uses direct mail to sell products and services. You should use it to "sell" ideas.

You can come closer to getting desired action with direct mail than you can with any other medium. If you send your message via the newspaper, the editor may not use the story or may bury it on a page where your intended readers won't see it. With radio or TV, any number of your intended audience may not be listening or watching.

Now let's look at some of the jobs for which direct mail is best fitted. Research has shown that mass media are most effective in creating awareness of, and interest in, an idea. The same studies have shown that personal contact is one of the most effective ways of getting people to try out or to adopt an idea.

That's where direct mail fits into educational communications. Direct mail is a personal contact. It's the next best thing to a personal visit or phone call. With direct mail, you can make contact with a far larger number of people than you can through visits and phone calls. Audiences scattered over a wide area can be pulled together through the mail.

Suppose, for example, you have a water or energy conservation message for home-owners. You want to make sure they get it. You can't possibly visit or phone all of them or get them all to a meeting. So the next best way to make sure they all get the message is to mail it (even cooperatively as an enclosure with electric bills) directly to them.

Direct mail may also be defined as the "paratrooper" of communication. It drops its message onto a specific target. And just as it takes teamwork to win battles, a paratrooper can't accomplish all of the goals of winning at communications, either. Like other media you may use, direct mail has its strengths, too. When all methods are fitted together — when each is used for its particular job — they accomplish effective communication.

Make sure you select the communication tool or method best suited for the job you have in mind. If you have a message for a large audience, perhaps one of the mass media is your best channel. But if you want to pinpoint an audience, direct mail may be the logical tool to use.

What makes direct mail effective?

Three things make good direct mail: a good idea, a good mailing list, and a good approach in presenting that idea.

A good idea. A good idea is one the audience wants, needs, or can use when the message is sent. It's possible that a need can be created by playing up a want or some unfulfilled wish. You may have to create the want. You have to show a benefit to your readers—in terms of more income, more leisure time, or more of something else that appeals to them.

A good mailing list. You can be sure of reaching your audience if you select the audience you want to reach. But you must send it to the right people. A good mailing list is based on audience interest. It is accurate, complete, and up-to-date.

Mailing lists contain names of real people. People move, sell businesses, farms, and homes. They buy new ones, go out of business, retire, and die. Merchants drop old itmes, add new ones; individuals may shift interests to learn about new subjects or new products.

If you want your direct mail to hit a bulls-eye every time, you must keep your mailing list as up-to-date as this morning's newspaper. A simple way to check your mailing list for "deadwood" is to send a questionnaire or card to each person on your mailing list. Ask if he or she wishes to continue receiving your direct mail pieces. Include a few select questions to help gear your future efforts even better to reader needs. Do this once a year. Be sure to save purged addresses for awhile. Check with local postal authorities on your survey approach.

You also may secure information on removals and corrections from your local post office. Use returned envelopes to purge and correct your mailing lists. Ask your postmaster for available materials to keep your mailing list active.

Be sure to add zip code numbers to your list.

A good mailing list and knowledge of postal regulations are essential for success.

A good approach. A good approach encompasses copy and format that relate to the interest, needs, or wants of the audience. Having a good approach means that your message is written in the readers' language — in terms they understand — and that it stresses benefits to them. Your message should have an easy-on-the-eye layout. Perhaps you need a simple illustration or a big headline to catch their attention or to drive home a point. There are hundreds of ways you can dress up your message, at little or no cost.

Know postal regulations

K nowledge about the latest postal regu-
lations is vital to anyone using direct
mail. Changes in penalty mail regulations for
government employees make it even more
critical to know what you can and can't do
with this type of mail. Ask about the Postal
Service centralized database National Change
of Address (NCOA) program if you use direct
mail frequently.

You can save money by keeping up on the
new laws and new rates. The easiest way to
do this is to check with your local postmaster
while your mailing piece is in the planning
stage. They can tell you if your proposed direct
mail piece will conform to bulk mailing
regulations and can advise you on the most
economical way of mailing it. Don't wait until
the piece is ready to mail. Check with the
postmaster as you plan it.

Building a new list

I t's likely that you already have a mailing list
in your office. But if you're starting from
scratch or wish to enlarge your direct mail
business, here are some ideas.

Check your office letter files. The best
place for names is often your own office letter
files. These will give you names and addresses
of people interested in your products and your
organization. Also, check local stores selling
specialized goods to the people you want to

reach. Your local library has state and national
directories listing names of people active in
certain businesses and organizations.

Keep names of people who write to you for
educational or promotional publications. The
publications requested will tip you off as to
the individuals' interests so you can put their
names on the right mailing list.

Include media. If you wish to use direct mail
as a part of your educational program, make
sure that names of radio and TV stations, daily
and weekly editors, magazine editors, and
other media outlets are on your list.

Think users. Depending of course on the list,
names of your local dealers, leaders, and
cooperators may work well for you. Contact
these same people for names of customers,
neighbors, and friends who might be added
to your lists. Check membership rolls of service
clubs; business groups; farm, home, and
youth organizations. Try county clerks for lists
from tax records, birth registrations, marriage
licenses, building records, and the like.

Use a "giveaway." Many businesses use
giveaway publications and "sign-up" prizes at
public gatherings just to collect these names
for their promotional mailing lists.

The telephone directory. A rundown of the
Yellow Pages will remind you of business
people who should be added to your lists. Do
a quick run through the regular section of the
telephone book, too.

Target lists — one or many?

S ome people favor having one grand list
and mailing everything to everyone. Others
divide their lists into interest groups and select
the groups to receive a certain newsletter,
card, or promotional piece.

Since many communicators are converting to
computerized mailing lists, keeping readers
categorized by one or more interest group is
the best approach. Budget cuts and changes
in penalty mail have caused many educators
to look for ways to reduce expenditures, and
targeting your audience to save money can
get better results, too.

Costs and time for mailing are causing many
offices to use generalized monthly newsletters,
with inserts for specific reader interests often
sent in the same envelope. This prevents you
from flooding your audience with all of the
pieces of direct mail you produce. You reach
well-identified audiences, thus gaining
readership.

Remember to code your mailing lists by topic
and date. When you need to revise or remove
an address you'll know just where to look.
Thus, SBED88 might mean "small business
interested in economic development —
added in 1988" and GVT86 might mean
"Vermont garage owner — added in 1986."

Planning direct mail letters

Your choice of words when you write is termed "style." For effective direct mail you should develop a style based on two factors. First, use words and terms familiar to and popular with your readers. Second, say things in your own personal way. Don't mimic someone else's style.

If you want a direct mail letter to get results, some hard work and planning is definitely required. Effective letters don't just happen. They are designed, planned, written, rewritten, revised, and worried over.

What's your goal? As with any other piece of writing, it's best to set down the goal of your letter first. Write down this objective and how you plan to reach it. Then take a long, hard look at your audience. Is it composed of parents, volunteers, teenagers, retirees, business persons, teachers? You'll need to know all you can about your readers so you can write in their language and appeal to their needs.

What's the benefit? Think about how you can aim your letter so it will show a benefit to this audience. This will be the starting point of your letter, so pick the best benefit you have to offer. This could be a free publication, an opportunity to "test" your product free of charge, a financial savings, a way to become more popular, or a method of saving time in work. Always write in terms of your readers and their benefits, not yours.

Remember that people are motivated by certain "drives." Among these are the urges to have financial security, good health, leisure time, popularity, good looks, praise from others, and business and social success.

Notice how the professionals go about pointing out reader benefits:

■ "Here are two tried and true methods of making money at home."

■ "Would you like to trade your worries for greater security and happiness?"

■ "We are offering you an exclusive free gift in order to introduce our new line."

■ "Open an account and enjoy a new kind of credit shopping. Accept this invitation and get a copy of our catalogue absolutely free."

■ "Here's how to put extra money in your wallet."

■ "It's your money that's involved, and the stakes are high!"

While you are thinking about benefits to your readers, also consider some of their objections to the product or idea you are trying to "sell" them. Figure out how you can counter these objections in your letter and build their confidence in you and your organization.

Your style shows

Develop a practical, not literary, style. The manner in which you put words together should result in a clear and readable message. Here are some tips.

Don't take your readers for granted. Things are clear to them only if they understand them. Never pass over a complicated sentence just because you (the writer) know what you mean.

Be sure your readers get the meaning you intend. If clarity is in doubt, try the sentence or idea on a friend who doesn't have your technical knowledge of the material.

Even simple things sometimes have to be made clear. If your readers understand what you're saying without having to reread or study phrases, you're more apt to keep them with you. If they can't follow your writing, you can be sure they'll "put it aside to look at later on." And it will never be read.

Use words you are sure your audience would use or at least understand. Then your message will be clear to them. Use specific words that carry an exact meaning for your readers. Although your readers' vocabulary may be as good as, or better than yours, it may also be different.

24 Direct mail

Don't go the long way around. Use the active voice. Write: "This workshop gives you the answers you need," not, "The answers you need can be obtained at the workshop."

The more direct you are, the easier it will be for your readers to follow your thoughts, grasp the message, and take the action you want them to. "Talk" to specific readers. Use words and references with which they are familiar.

Get in step with your reader. How many times in the past few months have you started a direct mail letter with these uninspiring words: "A meeting about _____ will be held at _____ in _____ "? Ever figure out how many people read no more of your letter than that?

What did you do wrong? You never got in step with your reader. When writing direct mail, try to forget your problems and think of your readers. Put yourself in their shoes — and keep them in mind throughout your letter. Use an opening paragraph that promises to benefit your readers: Save them time, trouble, and/or money; help their families; solve their problems; etc. Always sell them benefits.

Make the opening count. Remember that, except when you are writing to someone who knows you, the opening sentence is vital. Some direct mail specialists say that, in importance, the opening carries 90 percent of the weight of the letter.

Don't be discouraged if an opening doesn't come easily. Write a half dozen or more; then pick the best. Keep the opening short, to no more than two or three sentences. After you've written that important first paragraph, test it on yourself by asking, "Is this what I'd say to a person I'd just met?"

Besides offering a benefit, two other effective ways or writing an opening are:

■ Ask your readers a question in such a way that they will mentally agree with you.

■ Include a recent news happening in your lead paragraph and tie it in to your readers' interests.

Get to the point. Come to the point of your letter quickly. Don't waste your reader's time with a story or attempted humor. Remember, readers don't know they want what's in your envelope. The competition for attention is stiff in this age of information explosion.

Anticipate that your direct mail reaches a reader at the worst possible moment — the children are fussing, a dog is in the flower garden, golf partners are waiting, it's bill-paying time, or the family is ready to head for the beach. Can your letter be understood between mail box and kitchen?

Be enthusiastic and sincere. If you don't show your enthusiasm for your own idea your reader won't either. You'll build confidence naturally if you don't exaggerate or oversell. But if you meet the challenge of sincerity and enthusiasm in your writing, your letter won't be tiresome or boring. Stimulate your readers to jump out of their boredom.

Aim for appealing copy. You're ahead in successfully reaching your readers when you write your own copy. Following are seven reasons why, adapted to educational goals:

■ Copy is genuinely sincere.

■ Words are personal; you know most readers.

■ Your copy almost always tells a story; testimonials are easy.

■ You stand behind your information with a personal guarantee.

■ It's your job to know your information inside out.

■ You're enthusiastic and your copy shows it.

■ Your words are natural, not self-conscious, and emphasize knowledge.

Understand what your copy says to the reader.

Let your script cool; then re-read it. Pre-test it with an audience sample. Rewrite it until you're sure it will answer your reader's questions. That may be up to five times. You waste effort on direct mail unless you can be sure it is helping you reach your goals.

The "hurry" action. If you want your readers to take action as a result of your letter, you must show them some good reason why they should act today and not next week. This can be done by setting a deadline, indicating a limited supply if there is, or explaining other advantages of quick action.

Do you want them to return a post card or a coupon, ask for a publication, telephone you, send you a check, attend a meeting? If so, carefully explain why that action is important. And make it easy for them to take that action.

Study the experts. Each day you receive several pieces of direct mail. Keep the best for ideas on layout, writing, action, and appeal.

Layout for direct mail letters

Now that you've planned your direct mail letter, your next step is to figure out how you'll catch your reader's attention. After all, you can't sell your idea if your letter isn't read. And you've got to get their attention or they won't read. Competition at the mail box puts your message against big business.

A good layout of direct mail letters enables you to catch the reader's attention.

This is where a good layout can help. With very few exceptions, it's the written part of your letter that gets top billing in your layout. Arrange your layout to complement the message.

Too often the layouts of amateur letters are too cluttered and complicated. Because you'll tend to try too hard, the tendency is to over-experiment and create a confusing circus of words and concepts. However, sometimes an educational letter is just "thrown together." Either extreme is bad for the reader and counterproductive for you. Keep your layout design simple; A complicated design will steal from your words.

Many times a lettered heading is all that's needed to get attention. A drawing or a photo, if well done and in tune with your message, also can catch the reader's eye and lead into your letter.

Clip art. Clip art books are one of the best sources of illustrations to dress up direct mail, If you or your staff lacks artistic ability, you can use the talents of professional artists at little cost. A selection of these books can be well worth your investment. A wide variety of images is grouped under useful topics, and an inexpensive purchase of previously used illustrations gives you an art file at your fingertips.

Addresses of clip art firms can be found in such magazines as *Direct Marketing* and *Target Marketing*.

Remember that the major function of the layout isn't to win an art contest, but to gain and hold the reader's attention. A good heading or drawing is interesting to look at and moves the reader's eye down into your

printed message. Beware of overprinting copy on illustrations because reading is difficult. A drawing or heading, like your copy, can hold promise of something the readers want, or create and stimulate an urge.

White space. Watch the work of professional designers who do make-up for magazines, direct mail, and advertising. Notice how they use white — or open — space. When designing your letters, remember that such openness is inviting.

Effective letters without headings or illustrations are possible with only extra wide margins and double or triple spaces between paragraphs. Since readability is the key, double columns and narrow single columns are favored over full-page lines. Research indicates that an alphabet-and-a-half (40 characters) is a legible line length.

Some tips for effective design include:

■ Use readable typefaces, with serif types.

■ Consider larger type for older audiences.

■ Avoid reverse type in body copy.

■ Investigate potentials for self-mailers with address surfaces planned in layout.

■ Remember that photographs provide credibility.

Pre-printed mailers. When looking for ways to add color and zip to your letters without straining your pocketbook, try pre-printed mailing pieces. These are "tailor-made" letter-sized paper, envelopes, or post cards with art work and headings already printed. There are many firms that supply these items at a reasonable cost. The drawings and captions are designed by skilled artists and printed in four colors. Usually these pre-printed items can be run on any standard office duplicating machine. Again, refer to *Direct Marketing* and *Target Marketing* magazines for vendors.

Colored paper. Color adds appeal to almost any written material. The simplest way to add color to your direct mail letter is to use light-colored paper. When sending out a series of letters or newsletters, you might print your masthead in one or two colors and on a colored paper.

Like everything else in direct mail, the design and the choice of a color or no color will depend on your audience. Make certain that the paper you select will have the right effect on your readers.

Newsletters

Newsletters are the most popular form of educational direct mail. Studies show that not only are newsletters read, but about one in four readers file them for future use. They have shown steady gains in importance

in the teaching and promotional programs of many organizations. For example, The California Cooperative Extension Service issues over 300 different newsletters from its farm and home advisors' offices. Many go out monthly; others at varying intervals.

Newsletters are the most popular form of educational direct mail that have gained importance in teaching and promotional programs.

Newsletters are becoming more popular with educational groups facing a budget crunch because they can serve a variety of interests in one mailing. The same is true of churches, service clubs, and manufacturers. All find that a regular letter with a newsy approach provides effective communication.

Newsletters are diverse

Every newsletter is different. In general, they tell of recent developments in the subject-matter field, report research and other findings of interest to the readers, carry success stories of individuals, promote upcoming products or events, and relay useful ideas. Others answer frequently asked questions, condense or extract material from important legislation, speeches, or current events articles. Usually the subject matter is well diversified.

Writing patterns vary from newsletter to newsletter, too. Most follow a free, less formal writing style. Many combine the chatty style of a personal letter with the brevity and "get-to-the-point" punch of a news story.

The writer usually assumes that the readers know something about the subject and can build on that knowledge from one issue to another. New or uncommon terms should be defined quickly or used so that their meanings are clear.

Writing your newsletter

The same rules of capturing your audience quickly applies to newsletters, too. One easy way to do this is to place the most important, interesting, or timely items first in the letter. Longer multi-item newsletters often have a brief table on contents at the start. If appropriate, this might include a teaser capsule that sums up important topics discussed inside. For overly long articles, consider pulling them from newsletter copy and enclosing as a separate piece with your newsletter.

■ Start with a brief, to-the-point paragraph. Vary the length of your opening sentences, but generally speaking, keep sentences and paragraphs short for easy reading and more attractive appearance.

■ Get to the point. Avoid long introductions. Use familiar words. Speak the language of your readers.

Headings and illustrations

Use brief and lively headings. Allow plenty of white space around the headings. You may need to use subheads for a few longer articles. Remember that verbs add spice and interest. You can either allow the head to stand alone, or you can actually use it to lead into the main body of your text. Whichever style you choose, however, be consistent.

You can add sketches, simple charts, and graphs to your newsletter, but only if they add meaning to your story and save words.

The picture story makes a good device to engage reader interest. If your newsletter is duplicated by the offset printing process, pictures aren't too expensive. Make your photo selection very carefully, though. Faced with the choice of using a bad photograph or none at all, choose to go without and change your picture story to another format.

Appearance

Naturally, you'll want a neat, attractive newsletter. Consider these ideas.

■ Have an easily remembered title and heading design, with a simple, clean-cut illustration of a product, outline of your state, or other emblem that means something to your readers and to your organization. Use the services of a staff or commercial artist for this since the design of a masthead or heading can make or break your newsletter. Good graphic design may cost you money up front, but spread out over several years and thousands of readers, the fee is low indeed.

■ Add color by printing your newsletter on colored paper. The difference in cost between this and white paper is very little. Using the same color for each issue will help your readers to identify the newsletter.

■ If you print or duplicate on both sides, use a paper with enough weight so that there will be no "show through."

■ Use a two- or three-column format for easy reading. If your must use a one-column layout, have extra wide margins and short paragraphs.

■ You can break the monotony of the column by occasionally indenting statements or other material you'd like to have stand out.

■ Make good use of white space by not cramming too much on one page.

Be a good editor

Your extra effort in writing, editing, and rewriting your manuscript will mean less effort for your readers. Make clarity the main goal of your editing, and your readers will stick with you through many newsletters. For more advice on writing, and a more detailed discussion on newsletter design, refer to Chapter 4, "Newsletters."

Business letters

Business letters qualify as direct mail pieces. How much does each letter you write cost your organization? Research by a well-known corporation shows that the price tag averages nearly $20. This figure is based on a medium-range salary for the letter writer. The higher the salaries involved, the greater the costs to your business.

Obviously, wordiness and unclear thinking or writing push this cost even higher. Imagine the money wasted when a reader can't easily understand a letter. Unfortunately, this is true of too many business letters.

"The difficulty is not to write, but to write what you mean; not to affect your reader, but to affect him precisely as you wish." This quotation by Robert Louis Stevenson sums up why it's important to write good letters. Yet, how many people can honestly say that their letters convey the exact meaning or affected readers exactly as they intended? Chances are the percentage is low.

Letters are usually written for two reasons: to ask for information, or to give information. Neither is difficult to do. But sometimes even the simplest task becomes drudgery if you don't enjoy doing it. And it's only human nature not to enjoy doing something if you don't know how to do it well. Here are a few tips to help you write a better direct mail business letter.

Be yourself. Too often the writer of a business letter believes the occasion deserves a change of personality. Instead of being friendly and cheerful, cold and formal becomes the order of the day. This example illustrates the urge to overdo.

> "We beg to advise and wish to state that your letter of recent date has arrived. We have noted its contents and herewith enclose the information you requested."

Don't fill your business letters with phrases like "regarding the matter," "due to the fact," "I beg to remain," and so on. Just be yourself.

Think before you write. Analyze what you want to say in your letter before you sit down to write it. You might ask yourself these questions as a starting point:

■ What am I trying to accomplish in this letter?

■ How can I best accomplish it?

There may be other questions to ask, too, but these are the most important.

Divide the letter into parts. A letter should have an opening for the reader, a middle for the message, and an ending for the writer. The opening belongs to the readers because it plays the same role as the lead in a news story. It must catch the reader's attention, indicate what the letter is about, and set up a friendly and courteous tone for the whole letter. It should link up with previous correspondence by mentioning the date or subject. The opening paragraph should be short, and it should say something. Here are some examples:

> "Thank you for your request for information about water conservation."

> "Here is the bulletin you asked us to send."

> "Congratulations on the fine progress your annual report shows."

"I would certainly appreciate having a copy of your report about the new program."

The middle of the letter contains the "meat" of your message. It elaborates on the opening paragraph, as shown in the abbreviated example which follows.

Dear Mr. Jones:

We are happy to send the booklet you requested. As a small business owner, you will be especially interested in page 14. It summarizes a report of current trends in employment for small businesses in our state.

Please write us again if you would like more information.

Stop when your message is complete.
Many letter writers repeat the same ideas in different words. They are as annoying as the visitor who says, "Well, I've got to leave. . ." and then sits and talks for another hour.

Speak in an active voice. Direct statements with active verbs are the most effective endings to use. Participle endings, such as "Thanking you in advance," or "Trusting you will take care. . ." are the least effective. They are weak, hackeyed, and incomplete in thought. Such endings are as bad as opening statements that say, "We have here before us your letter of recent date" or "As per your recent request. . ."

Here are a few examples of direct, effective closings.

"If I can help you in any way, won't you please let me know?"

By asking a question, you invite the receiver to write again. By saying ". . . please let me know," you merely give the receiver permission to write again.

"I would appreciate knowing by June 6 so that the committee can plan the remainder of the program."

Consider whether you want to open up opportunities for further correspondence. A pen pal may be the last thing you need.

Improving your direct mail

Be goal oriented. Know exactly what you want your mailing to do. What are you trying to accomplish? Are you alerting your readers to some new research development which may interest them? Would you like them to try a new product or service? It's surprising how many mailing pieces keep their objectives hidden. These mailings often are prepared by people who know what they're trying to do, but who keep their goals secret from their readers.

Handle one goal at a time. If you want your readers to do several different things, use a continuing series of letters. Sell them one idea at a time.

Write benefits. Let your readers know what your idea will do for them. Appeal to the things they are interested in. Give them all the information they need in order to take the action you want them to take.

A direct mail specialist for a lawn seed company has written in one short phrase a complete definition of copy that sells. She says, "In our copy we must never forget for an instant that people are interested in their lawns, not in our seed."

Let layout enhance your message. Make the layout and format of your mailing tie in with your overall plan and objective. Have you used black-and-white when color printing would have been more useful? Have you used color when black-and-white would have done as well? Have you used duplicating when the image you project calls for a more polished product?

Mail it to the right person. Effective direct mail pieces must be mailed to people who can use your idea. Obviously, your first job here is to compile a complete, accurate mailing list, with names spelled correctly. After you have the list, you must keep it up-to-date.

Help the reader. Make it easy for your readers to take action. If you want them to send for a publication, give them all the details of where to send and what to ask for. Take all the guesswork out of the letter for your readers. Put yourself in the reader's shoes and ask, "Now what do these people want me to do about this?" Then make it easy for them to take action.

Tell your story over again. Few salespersons make a sale on their first call. Even the best of them call back many times before turning a prospect into a customer. And it isn't reasonable to expect one mailing to produce a large return. If your objective is sound and your mailing list is good, you'll get more results from a planned series of mailings than from a single attempt.

Appearances count. Avoid misspelled words, poor grammar, incorrect punctuation, trite expressions, substandard usage, and slang or jargon. Remember that your credibility is at stake in each letter you write. Handwritten letters should be done neatly, or not at all. And, most important of all, answer letters promptly. Someone cared enough to write. The courtesy should be returned.

Research your direct mail. Is your direct mail reaching the right people? Does it contain ideas they need or can use? Are your messages being read, understood, and acted upon? A follow-up evaluation is an integral part of successful direct mail.

Count on it. A crisis is almost guaranteed to happen at the most inconvenient times, from the first day of vacation to Friday at 4:30 p.m. Most people who work with issues that affect the public have received the dreaded phone call, read a damaging headline or been surprised by a negative video bite that can turn even Mother's Day into a bad horror movie.

Why be surprised? After all, it's your job to handle crises, isn't it? Or does a crisis handle you?

What is a crisis?

From an institutional viewpoint, a crisis is anything that threatens the stability of your organization. One can erupt from a negative perception about an event or statement, an exaggerated claim of a disgruntled employee, or a valid claim by a so-called "whistleblower." A crisis can be anything from a mere nuisance to a bona fide donnybrook registering 10.0 on your personal "Richter Crisis" scale.

All crises share several common characteristics. First, they are nearly always negative. They distract you from important daily tasks, divert your focus from your job, its mission, goals and purpose. They create negative feelings between employees and managers within the organization. They cast shadows of doubt about the worth or credibility of your organization in the eyes of the public.

A crisis can also create improper or distorted perceptions. It may involve allegations that tell only part of the story and stimulate negative impressions by the public about your organization. Unfortunately, in an age of snap judgements, perception is too often reality. Management must therefore be prepared to deal decisively with erroneous or improper viewpoints.

A crisis tends to polarize and divide an organization. More often than not, it causes employees and management to choose sides, not necessarily based on fact or the best interests of the organization. Again, management should recognize early signs of polarization and take steps to maintain organizational integrity and unity.

Crisis situations are almost always disruptive. They place an organization's work on hold until the crisis is resolved. An important facet of crisis management is identifying how a crisis is likely to disrupt your organization so that you can strike a balance between handling the crisis and maintaining your normal work load.

Except in situations where you have taken a calculated risk, a crisis generally takes you by surprise. In most cases, a crisis will produce a situation to which you must react. While the prudent manager may not always be able to predict a crisis, he or she can understand the elements that comprise a crisis and develop a plan to deal with it when it happens.

Panic can be the immediate reaction to a crisis. But remember that effective crisis management can be learned.

Types of crises

Each crisis you encounter will be different, of course. But crises come in four basic forms, listed below. Knowing with which type you are dealing is imperative for effective crisis management. However, keep in mind, that a crisis can be a combination of types, each of which must be addressed.

Disgruntled Joes. Every organization has its share of Disgruntled Joes. They like to create a lot of smoke, and occasionally they can set off a five-alarm fire. The key to handling a Disgruntled Joe is to uncover the truth and use it to rectify the misdeed or put a rumor to rest.

Speak carefully, and remember that all comments made to the media are potentially "on the record."

Foot-in-mouth. Statements taken out of context or made in haste trigger a foot-in-mouth crisis. People guilty of foot-in-mouth fail to properly evaluate the consequences of their comments. They may speak to a reporter without realizing that their comments are always "on the record." They may say more than they can comfortably support with facts or research, then be placed in a position where words become the rope that hangs them — and you. Foot-in-mouth must either be disclaimed, explained, or qualified.

Charted minefields. Organizations run the risk of crisis by engaging in controversial practices or by espousing controversial viewpoints, activities, or policies. The very nature of their work exposes them to potential crises. Research projects using animals, radioactive materials, or chemicals are examples that illustrate the charted minefields principle.

In all such instances, potential landmines are out there waiting to be exploded by a misstatement, a careless act, or a misdeed. A crisis manager's job is to know about these landmines and chart the organization's path through the minefield in advance of the crisis. Charted minefields allow you to positively frame policies, attitudes, and practices to avoid incorrect perceptions and damaging public opinion.

Uncharted minefields. The most dangerous and potentially damaging crisis of all is the uncharted minefield. This crisis takes you completely by surprise. Disclosure of problems triggers explosion after explosion with each new fact that surfaces. The explosions are likely to occur in all directions. You have no clues about what mines are likely to explode, much less where they are buried.

The key to managing the uncharted minefield crisis successfully is to gain control through systematic but rapid fact-finding. Your organization should have in place a means to separate truth from fiction. Utilizing accurate information, you may be able to quickly correct the uncharted minefield into a predictable situation and so control the intensity, frequency, and direction of the explosions.

Plan Ahead

One of the best tools in your managerial bag of techniques is a well conceived, ready-to-go plan you can activate when a crisis occurs. This plan should address several key issues.

Identify crisis points. Every organization has crisis points. Controversial personnel, products or services; internal philosophical conflicts; weak managers; known instances of communication breakdowns; and changing public attitudes in relation to your organization are all areas to examine carefully.

"What if?" is a valuable question to ask in crisis management. Futuristic scenarios and model solutions based on your organization's vulnerable spots can remove surprises as an element in the next crisis and give you a head start in dealing with it.

Fact-find during non-crisis periods. As you identify crisis points and construct scenarios, you should be routinely gathering, sorting, and classifying known information relevant to your organization — including rumors.

Classify the information into categories, such as facts and myths. Facts should be routinely updated; rumors should be verified or exposed as myths.

Select your team. Your organization needs a crisis management team, a group of pivotal players that performs key functions during a crisis. Pivotal players must be prepared to work around the clock, if necessary, for successful crisis management. Their identity should not receive a high profile within the organization lest they become compromised before, during or even after a crisis. Each member should receive routine crisis management training and should be updated regularly on potential crisis points, facts, and myths.

Many times, the organization's chief officer also serves as chief spokesperson during a crisis. Sometimes, however, that person may be absent or may need some behind-the-scenes maneuvering room to end the crisis.

In addition, several spokespersons may be needed in a given situation. By developing a list of qualified personnel in different areas of your organization who could serve in this role, you have improved your flexibility to respond to a crisis. You also benefit from a good list of resources who can be called on to respond to a wide variety of issues to prevent crisis.

Fine-tune your communications networks. Keeping internal and external lines of communications open in your organization and maintaining their integrity, especially in times of non-crisis, is probably one of the best ways to prepare for — and prevent — crises.

Externally, continue to stroke cooperative reporters and work to establish a rapport with difficult or skeptical ones. You must strive to enhance your reputation as a straight-shooter, a person on whom a reporter can depend as an accurate source of facts or tips.

Your external communication networks — how you maintain dialogues with your public and/or clientele — should also be tested routinely to be sure that:

■ All your links are functioning properly.
■ Information you want passed gets passed without distortion of facts and manipulations of meaning.
■ Accurate feedback flows into your organization from your audiences and/or clientele.

You must also fine-tune your internal tools and networks for effective communication. Will today's tools and methods for disseminating information be effective in the future? Can you depend on the internal links of your organization to reflect accurately the true attitudes and opinions of employees? Are your personnel rosters up to date? Are you sure that all your internal newsletters are reaching their audience?

Prudent crisis management teams will routinely test all networks, evaluate tools, and fine-tune relationships to ensure that in periods of crisis they can guarantee an effective dialogue with the people the organization serves.

Surviving a crisis

However unpleasant a crisis may be, it will eventually end. Your hope, of course, is that it will end quickly with a minimum of damage to your organization. In fact, a crisis can actually have a positive outcome for your organization. Effective crisis management can legitimize the mission of an organization or clarify its role. It can provide a fresh start or a

Keeping internal and external lines of communications open is an effective way to prevent many crises.

25 Crisis management

new opportunity for your management team or your organization. And, because top management is willing to deal with it openly, how the crisis is managed can often promote positive opinion about your organization in the minds of the public and among your organization's employees.

How do you survive a crisis and profit from the experience? How can you control the crisis and take a proactive role in managing events to foster positive public opinion?

First, realize that the immediate goal of any crisis management plan should encompass rapid resolution. In ending a crisis as quickly as possible, an organization must seek to diffuse it and maintain integrity and credibility. If possible, the crisis should be turned from a negative into a positive experience for your organization.

In dealing with a crisis, an organization will typically engage in various combinations of four basic strategies. You may:

■ Do nothing.
■ Stonewall.
■ Respond and defend.
■ Take the offensive.

Do nothing. Some organizations refuse to admit that a crisis exists. By their non-action, they let the crisis take its toll and run its course. Such organizations are generally well insulated from public opinion; public and employee sentiments do not concern management. A do-nothing approach is the least

desirable of any alternative, since repeated crises will ultimately divide an organization, disrupt its integrity and cause it to erode from within.

Stonewall. In a stonewall strategy, management refuses to respond externally to the crisis on the basis of not wanting to dignify what it considers erroneous or improper allegations.

An organization using the stonewall approach runs the risk of negative public attitudes and trial by media. Often, the public interprets silence as an admission of guilt, an act of arrogance, or an unwillingness to compromise on an issue.

However, in a limited number of instances, the stonewall is not only acceptable, it is the only desirable course of action. Such instances include personnel matters involving disciplinary action deemed confidential under state or federal laws, or a situation to be resolved in a court of law.

Respond and defend. Organizations that face a crisis head-on and work positively and aggressively for a rapid resolution enjoy a higher survival rate than those that either do nothing or stonewall. Respond and defend is a successful crisis management technique. Keys to developing a response and preparing a defense include communicating factual information and selecting the proper spokesperson(s) to represent the organization.

Take the offensive. This strategy involves developing an offensive of your own and

taking advantage of an opportunity for creating positive public opinion. An effective offensive includes responding to the crisis and projecting an organizational posture or position that demonstrates solutions of benefit to the organization, its employees, and the public at large. In other words, by taking the offensive, you may treat a crisis as only a part of a much larger issue, and take advantage of the chance to advance a positive perception of your organization.

Be warned, however. In taking the offensive, you may unwittingly prolong a crisis or risk losing control when it could have been handed quickly and quietly with a simple response.

Developing facts and sources to state your case

Whether you decide to respond and defend or take the offensive, your best weapon is accurate information. As you develop your response to accusations, prepare a rebuttal to a negative event, or plan your offensive, remember that reporters and members of an informed public who ask questions may well have the answers before they ask.

Your first defense, therefore, are facts and a factual response. An organization that tends to stretch the truth when developing and issuing responses to a crisis will lose credibility and heighten the crisis. Only truthful statements, unclouded by value judgements and emotional provocation, are acceptable.

You must also utilize a spokesperson who can effectively communicate your facts in a credible manner. The ability of your spokesperson to remain calm is also critical. When choosing a spokesperson, try to avoid four types of personalities. The following labels are generalizations and do not diminish the overall value of these types of people to an organization in other capacities.

Shrinking Violets. Some personalities aren't meant for the spotlight, even though they are some of the nicest folks you know. Shrinking Violets feel intimidated by close questioning or confrontations. They act nervous and upset; they may even feel guilty. They do not make an effective or credible spokesperson.

Egotrippers. You know the type. Egotrippers thrive on the spotlight, but not for what can be done for the organization. Instead, they use the forum for their own agenda. An Egotripper displays the "Big-I-Little-You" attitude in dealing with the public and with the media, injecting value judgements and resorting to emotional provocation during a crisis.

Loose Cannons. The general sense of disorganization typical in a Loose Cannon tends to heighten in crisis situations. A Loose Cannon exhibits no sense of direction and can project an insensitivity to the real crisis issues. They are unpredictable, regardless of the amount of preparation you invest to help them respond to the crisis. Since you are never sure what Loose Cannons may say under stress, it is best to keep them out of the spotlight.

Honest Abes. Honesty is the cornerstone of effective crisis management, and these people have their heart in the right place. An Honest Abe feels compelled to tell the truth, the whole truth, and nothing but the truth in the most sincere possible way. However, an Honest Abe may fail to understand the importance of the proper response at the proper time, expressed in the proper manner. In that way, they resemble the Loose Cannon.

An Honest Abe will unlock to the world the most confidential of organizational files and may miscommunicate ideas and concepts through revelations taken out of context. An Honest Abe will almost always try to answer the expected final question of a reporter: "Is there anything *else* you would like to add?"

When a crisis erupts

Effective crisis response is based on several common principles that apply, no matter what the particular type of crisis. Dealing with a crisis depends on the management team's ability to:

- Get the facts.
- Develop a position and agree on strategy.
- Keep internal and external lines of communication open.
- Deal with the media.
- Plan for the next one.

Make sure your spokesperson can effectively communicate calmly and with credibility, without injecting their own egos.

25 Crisis management

Get the facts. Miscommunication heightens crisis and can result in exaggerations, half-truths, distortions, and negative perceptions. The first step in crisis management is to get the real story and understand the elements of the crisis. Remember that in most crises, accurate information is an effective weapon. It is the responsibility of the management team to have all the information at hand. They must then develop the strategy for dealing with the crisis, including timing and manner of communicating factual information.

Develop a position and agree on strategy. Once the facts are known, then — and only then — can a management team develop a position and agree on a strategy to handle the crisis. The key to successful crisis management is to base your position and strategy on facts. In every instance, the team should take care to ensure accurate, consistent and relevant statements.

Where crisis management involves response strategies, the organization's spokesperson must be well prepared to face the media and respond to the public. In crises dealing with only one or two issues, a single, well prepared spokesperson is usually the most effective tool to deliver responses.

Good internal communication is a given for the success of the spokesperson(s). Everyone involved must know the identity of the spokesperson(s) and be willing to allow the spokesperson(s) to assume that role.

Personality limitations aside, everyone involved in the crisis should receive the same education and information about the crisis. When pressed, anyone involved tells the same story. It is very important that the organization has its story and strategy straight — no matter who is speaking.

Keep communications lines open. Awareness, flexibility, and dialogue form a critical triad for crisis management. If you are central to the crisis, stay in touch and stay informed. During crisis, you may need to shelve ongoing projects and devote your full attention to crisis management. Furthermore, one central individual must remain aware of all conditions at all times and keep the rest of the team properly informed, hourly if need be.

During a crisis, if something can go wrong, it will. Flexibility is important if you would avoid Murphy's Law. By staying informed and involved, the crisis manager is in the best position to respond to changing conditions as quickly as possible. An inflexible mindset or an inability to respond can create another, even more serious crisis by inhibiting concessions or blocking compromise.

Effective dialogue in as many directions as necessary is critical for successful crisis management. You must be skilled at accurately expressing a viewpoint in a manner consistent with the needs and characteristics of differing audiences or clientele. All too often, crisis spokespersons deliver the proper message in the same form to all audiences. A variation of

the message may be required to effectively communicate the message's meaning. However, exercise care to ensure that a change in form does not change the overall meaning of the message.

You must also be a skilled listener to effectively hear and understand your progress — or lack of it —in a crisis. Crises can easily be prolonged because the crisis team fails to understand that the crisis was ready for resolution and did not take steps needed for closure.

Deal with the media. The job of a reporter is to get a story. While some are more eager than others and may use techniques that might be considered a bit deceptive, remember that no reporter likes to stand empty-handed before an editor.

Your relations with the media must be open and aboveboard. You must be available to a reporter, and you must tell the truth. Return phone calls even when you have nothing to say. A firm, "No comment at this time," is more effective than a stonewall.

When your spokesperson makes a statement to the media, prepare the statement in writing and provide it to the reporter. Written statements formally put you on record and signal that you are prepared. Before facing the press interview, work on your statement so that you can express it accurately and conversationally.

If you grant an interview beyond delivering the basic statement, remember that you run the risk of a statement taken out of context

■ When a crisis erupts

You can use a crisis to your advantage — to hit your own "home run" within your organization.

since you have no control over which quote or bite will be used. Your best defense is to develop a few summary statements based on your prepared statement. Each should last no longer than 20 seconds. Know them cold. Try to include catchy phrases, but avoid being cute. Use everyday language that is easy to understand.

Practice so you can repeat your statements without unnatural pauses. Repeat the central phrases often during the interview. Do not allow the interview focus to shift from your central theme; keep realigning the discussion with your statements. You have now imposed some degree of control in the interview.

Plan for the next one. When the dust clears and the crisis is over, it is important that the management team does more than simply sit back and wait for the next one. An astute review of why the crisis occurred, an evaluation of the way it was handled, and discussion about how it could have been avoided will be effective exercises for future crises. A reevaluation of crisis points, developed

scenarios, the fact-finding process and your communications networks will help you gauge your success level in dealing with past crises and your state of readiness for the next one. You should also insist that the performance of each member of the crisis team be evaluated to continuously strengthen your ability to respond to crises.

During your career, your organization will very likely experience a crisis. Crises do not have to rage out of control; they can be managed. You can even use a crisis to hit your own "home run" within the organization.

Remember that crisis management is more than a dream; there is no magic or voodoo involved. Effective crisis management is built upon openness, honesty and a set of principles and techniques that you can learn and apply for the benefit of you and your organization.

The word "strategic" derives from Greek and Latin roots associated with planning and leading military operations. The stratagems are designed, of course, to tilt the odds in favor of troops against an enemy. Military tacticians have long attempted to gain the advantage using processes such as mapping and scanning the environment, positioning troops, and specifying targets and timing.

The concept has translated easily into the arena of sports, another two-sided team activity. Coaches develop game plans and scouts search out potential talent far in advance of the playing season, studying re-runs of past games as a general would scrutinize a battle terrain map. Teams watch their competition play, practice various formations, and work on timing and surprise maneuvers.

During the past decade strategic planning has entered the workplace, too. The most promising uses have blended military and gaming theory with management theory. Experts agree that it is the *process* of strategic planning — not the *product* of a strategic plan — that assists organizations in improving performance.

What is strategic planning?

Simply stated, strategic planning is a *systematic process* that management teams use to scan the environment, analyze trends, set medium- and long-term goals, and adjust near-term goals. The process can position the organization economically, politically, and socially to achieve improved results. For communicators and educators, strategic planning encompasses an in-depth understanding of social psychology and knowledge about how clients and/or users learn.

A number of models for strategic planning can be adopted. All require team leadership, solidarity, commitment to goals, and a willingness to be flexible when goals must change. Depending on individual personalities and strengths, each team member may play a slightly different role. The process relies on some team members, for example, to be able to read future trends and communicate them to co-workers. Other team members may be better at translating these predicted trends into action plans.

The components of strategic planning:

- Agree upon and commit to a mission.
- Develop a futuristically oriented vision.
- Establish priorities.
- Articulate broad goals and specific program objectives — targeting audiences, learners, and other users.
- Agree upon norms or standards of behavior and practice these within the organization.
- Establish individual and team roles.
- Define standard operating procedures.

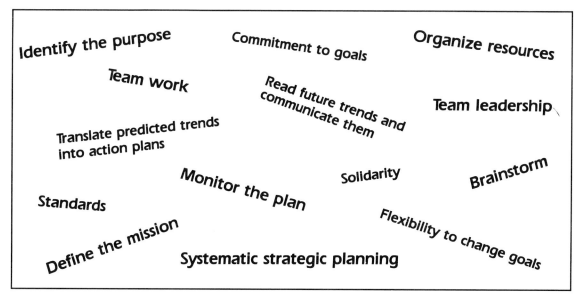

Your strategic plan will consist of several standard components, requiring team leadership, solidarity, commitment to goals, and a willingness to be flexible when goals must change.

- Develop flexible, innovative, change-oriented methods for positioning, changing course, and redirecting efforts.
- Attract and develop the best possible human talent.
- Balance goals and resources.
- Ask "what if" questions and develop alternative scenarios.

The need for strategic planning

Why use strategic planning? The general says, "Do it, or die." The football coach declares, "Nobody wants to be a loser," while the business entrepreneur states, "To stay ahead of the competition." How would you as a communicator respond to that question?

Many educators and communicators are trained to see their jobs in individual terms. That is, their educational backgrounds emphasize the importance of knowing the audience or the learner. While they relate well to the individual or the group they wish to communicate with, they may neglect to examine how their particular job integrates with or influences the goals of the entire organization.

They perceive that their "message" flows from the source (the communicator) through a channel (such as a publication or a television show) to a receiver. The transfer notion assumes that if the communicator or teacher understands the audience, has something to

transmit, and can design an attractive message or lesson, the effort will succeed. This works much of the time, but unfortunately this can also result in "doing things right, rather than doing the right things."

Use of a strategic planning process can assist educational communicators to place their designs in context. It can help assure that what is conveyed or taught addresses future needs, as well as those in the present and past. It also recognizes that communicators and educators work in organizations which must be linked to local, national, and global environments and to developments within these environments.

Who should be involved in strategic planning?

Groups of all sizes and types can apply the principles of strategic planning. The dimensions of the process will vary with the complexity of the mission, organization, and breadth of the external environment. These efforts are usually undertaken by an organizational system such as a work unit, an academic department, a university system, a county staff, or a local community agency. For the purposes of this chapter, an imaginary boundary line separates members of the group — the internal organization — from those outside it.

All levels of the internal organization should be involved in the planning effort. A design must be developed for leading and initiating the process. At this stage, private facilitators or consultants are often used to help the internal organization analyze itself, learn to work together as a team, and define the mission and purpose.

The internal organization, with or without outside help, must decide who should be involved from the external environment. Normally, data collection, ideas for the tasks, goals, and methods of the organization will be collected from users of the organization's services and those who are important to the system politically, economically, technically, and socially.

Sometimes a subgroup of the organization is given major responsibility for ongoing scanning of the external environment. This scanning may include a review of futuristically oriented literature and forums that interact with others outside the normal scope of the organization.

The key words when scanning are: wide and broad. Individuals should be encouraged to read and interact outside their own specialities, acquaintances, communities, cultures, and countries.

When to do strategic planning

Most healthy organizations periodically undertake major strategic planning efforts. One shot, quick fixes usually fail. Healthy organizations assure that ongoing strategic planning is maintained. They are always ready to alert the team when it is time for another more intensive planning period.

To use the football analogy, a team will engage in intensive strategic planning during the pre-season. If the plan is working well, that is, the team is winning, only minor modifications and adjustments are likely to be made. Attention will be given to tactics, maintenance, and staying on course with the game plan.

The team, however, does not compete in a static environment. The competition is watching its performance, learning from it, and planning strategy it hopes will result in an upset. When performance slips, or if the team loses, it returns to a more intensive period of planning. A major slump will usually require a return to strategic planning as well. In other words, the intensity of strategic planning varies. Particularly in today's times of rapid change, it is extremely dangerous to shut down the process entirely.

How can strategic planning be used?

Non-profit agency and educational communicators should remember that their clientele do not live in universities or government buildings. They are in the real world, making a living, raising a family, managing local communities, and debating local, state, and national public policy. The strategic planning process can be an excellent tool for creating natural interfaces of knowledge between users and service providers. It can help you reach your clientele in the most efficient and effective way possible.

Practically speaking, strategic planning can and should be used for many tasks at many levels. For the communicator working in education in any technical field, the strategic planning process is an essential tool for bringing together scientists, educators, communicators, and users.

When undertaking any major educational and communication program, project, or campaign a communicator should consider integrating systematic strategic planning efforts. All projects should be seen within a larger context that addresses the needs of the unit as a whole. Thus, the first attempts of implementing individual projects using a strategic planning approach may require more time. After some practice, however, most teams find their creativity and work efficiency exceeds previous individual efforts.

By engaging in a strategic planning process, interdisciplinary teams can be helped to agree upon purpose and priorities. For almost any research community, the process is proving useful for developing an improved agenda and for interacting with people and organizations with a vested interest in this agenda.

Educational communicators can introduce strategic planning immediately to their programs and projects. Small teams can engage in discussion of the planning components suggested. Even individual communica-

Remember, the communications team does not operate in a static environment. The competition is watching your performance, learning from it, and planning its own strategy.

tion products can usually be improved by a wider scan of the environment prior to writing, a clearer statement of expectations of the reader, and feedback before publication.

How to get started

A s with all things new, introduction of strategic planning requires leadership and risk-taking. In addition, for other than individual or small team efforts, the use of a trainer or consultant experienced in strategic planning and team building is essential. Persons with expertise in this area are much more widely available today than just a few years ago. Most universities, community colleges, public and private organizations and businesses can recommend people to help get the ball rolling. Also, there are many excellent books and periodicals that can assist both new and experienced facilitators to develop or fine tune their skills.

16 steps to strategic planning:

1. Identify the purpose of the program or project.
2. Formulate a list of specific objectives.
3. Use identifiable performance indicators. (How you will know if objectives achieved?)
4. Evaluate present level of performance.
5. Discuss problems and constraints to overcome.
6. Organize resources that can be mobilized to reach objectives.
7. Brainstorm action ideas.
8. Organize and brainstorm best possible ideas.
9. Set team expectations and roles.
10. Describe things that could go wrong and discuss contingencies that could be used — play out "what if" scenarios.
11. Negotiate any necessary issues with critical players within and outside the organization.
12. Prioritize action agenda.
13. Establish timetable and individual responsibilities.
14. Describe monitoring, feedback, and communication process (internal team, external cooperators).
15. Put plan into action.
16. Monitor the plan: revise, adjust, or start again.

Bibliography and suggested readings

Chapter 1 The art of good writing

Suggested readings:

The Written Word II, based on the New American Heritage Dictionary, a guide to writing, style, and usage.

Lewis, Norman. *Word Power Made Easy*, a handbook for helping you build vocabulary.

Provost, Gary. *100 Ways to Improve Your Writing*, a guide to all phases of writing.

Strunk, William and E. B. White. *The Elements of Style*, a classic contribution to the art of writing.

Cook, Claire Kehrwald. *Line by Line*, a guide to editing your own writing.

Bremner, John. *Words on Words*, a must for beginners or veterans.

Zinsser, William. *On Writing Well*, an example of sound journalism.

Chapter 2 Producing effective publications

Suggested readings:

The Associated Press Style Book and Libel Manual. New York: The Associated Press, 1982.

Beach, Mark. *Editing Your Newsletter*. Portland, OR: Coast to Coast Books, 1988.

Beach, Mark, Steve Shepro, and Ken Rosson. *Getting It Printed*. Vancouver, WA: The Printing Buyer's Bookshelf.

Bernstein, Theodore M. *The Careful Writer*. New York: Atheneum, 1980.

____. *Watch Your Language*. New York: Antheneum, 1976.

The Chicago Manual of Style. Chicago: The University of Chicago Press, 1982.

Craig, James. *Production for the Graphic Designer*. New York: Watson-Guptill, 1980.

The Government Printing Office Style Manual. Washington, D.C.: U. S. Government Printing Office, 1984.

Hurlburt, Alan. *The Grid: A Modular System for the Design and Production of Newspapers, Magazines, and Books*. New York: Van Nostrand Reinhold Company.

____. *Layout: The Design of the Printed Page*. New York: Watson-Guptill Publications.

Judd, Karen. *Copyediting: A Practical Guide*. Los Altos, CA: William Kaufmann, 1982.

Miller, Casey, and Kate Swift. *The Handbook of Nonsexist Writing for Writers, Editors, and Speakers*. New York: Harper and Row, 1988.

Parker, Roger C. *The Aldus Guide to Basic Design*. Seattle: Aldus Corporation, 1987.

Pocket Pal: A Graphic Arts Production Handbook. New York: International Paper Company, 1983.

Rodale, J. I. *The Synonym Finder*. Emmaus, PA: Rodale Press, Inc.

Skillin, M. E., R. M. Gay, and others. *Words into Type*. New York: Appleton-Century-Crofts, 1964.

Strunk, William, and E. B. White. *The Elements of Style*. New York: Macmillan Publishing Company.

The Ventura User's Guide to Basic Design. Rochester, NY: Xerox Corporation, 1987.

Webster's New Collegiate Dictionary. Springfield, MA: G. and C. Merriam Co.

White, Jan V. *Editing by Design: A Guide to Effective Word and Picture Communication for Editors and Designers*. New York: Bowker, 1982.

____. *On Graphics: Tips for Editors*. Chicago: Lawrence Ragan Communications, Inc., 1981.

Chapter 3 Writing for newspapers and magazines

Suggested readings:

The Written Word II, a guide to writing, style, and usage.

Bibliography
and suggested readings

Word Power Made Easy, a handbook for helping you build a vocabulary.

100 Ways to Improve Your Writing, a guide to all phases of writing.

A Pocket Guide to Correct Grammar, a mini-course in writing.

Chapter 6 Graphic Design

Suggested readings:

Vierck, Charles J., and Thomas E. French. *Graphic Science.* New York: McGraw-Hill Book Co., Inc., 1963.

Craig, James. *Production for the Graphic Designer.* New York: Watson-Guptill Publications, 1974.

Baroui, Daniel, Edward Booth-Clibborn. *The Language of Graphics.* New York: Harry N. Abrams, Inc., Publishers, 1980.

Munce, Howard. *Graphics Handbook.* Cincinnati, OH: North Light Publishers, 1982.

Chapter 9 Photography

Bibliography:

Cole, Stanley. *Amphoto Guide to Basic Photography.* Garden City, New York: Amphoto Books, 1979.

Editors of Eastman Kodak Company. *The Joy of Photography,* 1979.

Hedgecoe, John. *The Photographer's Handbook.* New York: Alfred A. Knopf, Inc., 1977.

Lefkowitz, Lester. *The Manual of Close-up Photography.* Garden City, New York: Amphoto Books, 1979.

Minor, Ed, and Harvey Frye. *Techniques for Producing Visual Instructional Media.* McGrall Hill Book Co., 1977.

Nibbelink, Don D. *Picturing People.* Garden City, New York: Amphoto Books, 1976.

Rosen, Marvin J. *Introduction of Photography: A Self-directing Approach.* Boston: Houghton Mifflin Co., 1976.

Upton, Barbara, and John Upton. *Photography.* Boston: Little, Brown & Co., 1976.

Chapter 11 Radio

Suggested readings:

Ries, Al, and Jack Trout. *Positioning: The Battle for the Mind.* McGraw-Hill, 1981.

Metzler, Ken. *Creative Interviewing, The Writer's Guide to Gathering Information by Asking Questions.* Prentice-Hall, 1977.

Lyons, Christopher. *Guide to Better Audio.* Shure Brothers, 1989.

Chapter 12 Video and television

Bibliography:

Bensinger, C. *The Home Video Handbook.* Indianapolis, IN: Howard W. Sams & Co., Inc., 1982.

Clark, J. "How do interactive videodiscs rate against other media?" *Instructional Innovator,* September 1984, 12-16.

Heller, N. "Camera operation and adjustment." *Video Systems.* September 1987, 501-58.

Huges, J. E. "Getting the right reading." *A. V. Video.* November 1978, 50-56.

Hussey, G. Art. "Electronic technology: impact on extension delivery systems." Washington, D.C.: USDA, Electronic Technology Task Force Report, 1985.

McQuillin, L. *The Video Production Guide.* Indianapolis, IN: Howard W. Sams & Co., Inc., 1983.

Musburger, R. "Technical self-education." *Corporate Television.* 1987, 81-84.

Naisbitt, J. *Megatrends,* New York: Warner Books, 1982.

Soseman, N. "Making a list and checking it twice." *Video Systems.* September 1987, 22-32.

Toffler, A. *The Third Wave.* New York: William Morrow, 1980.

Utz, P. "For home use only." *A. V. Video.* November 1987, 39-40.

Zettl, H. *Sight Sound Motion.* Belmont, CA: Wadsworth Publishing, 1973.

Chapter 13 Interactive video

Bibliography:

Gates, W. *CD-Rom—The New Papyrus,* Redmond, WA: Microsoft, 1986.

Iuppa, N. *A practical guide to interactive video design.* White Plains, NY: Knowledge Industry Publications, Inc., 1984, p.5.

Miller, R. "Discs and the USDA: helping people help themselves." *The Videodisc Monitor, 8.* August 1987, 14-15.

Parsloe, E. *Interactive Video.* Cheshire, United Kingdom: Sigma Technical Press, 1985.

Spritzer, D. R. "Megatrends in Educational Technology." *Educational Technology.* September 1987, 44-47.

Chapter 15 Desktop publishing

Bibliography:

Adams, Eric J. "Piecing Together the Desktop Publishing Puzzle." *Business Software.* February 1988, 6:1:24-33.

Bee, Harry. "Publish It on a Desktop." *PC Resource.* October 1988, 58-68.

Bican, Frank. "Black and White Monitors: The Designer Collection." *PC Magazine.* March 29, 1988, 7:6:147-197.

Crider, Bill. "Just Add Postscript." *Publish!.* February 1989, 4:2:70-72.

Desktop Publishing and Office Automation Buyer's Guide and Handbook, No. 10. New York: Computer Information Publishing Inc., 1988.

"Desktop Publishing Users' Report." Concepts Report No. 9, 1987. Communications Concepts, Washington, D.C.

Hannotte, Dean. "WordPerfect on the Move." *PC Magazine.* November 29, 1988, 117-134.

Heid, Jim, and Paul Kahn. "Interleaf: Revisions Made Easy." *Publish!.* May 1988, 3:5:56-62.

Jerome, Marty. "Extra Memory." *PC/Computing.* May 1989, 2:5:283.

Magid, Lawrence J., and Marty Jerome. "IBM vs Apple." *PC/Computing.* August 1988, 1:1:70-77.

Manes, Stephen. "Desktop Publishing: Can You Justify It?" *PC Magazine.* November 29, 1988, 85,86.

Mendelson, Edward. "Interleaf: The Industrial-Strength Publisher." *PC Magazine.* December 27, 1988, 7:22:139-146.

Rosch, Winn L., and Kellyn S. Betts. "Multiscanning Monitors for VGA and Beyond." *PC Magazine.* May 16, 1989, 8:9:94-147.

Saffo, Paul. "Desktop Publishing: The Joy of Installation." *Personal Computing.* March 1988, 63-66.

Seymour, Jim, et al. "Word Processing: Fast, Flexible, and Forward-looking." *PC Magazine.* February 29, 1988, 7:4:92-345.

Simone, Luisa, et al. "Power Publishing." *PC Magazine.* December 27, 1988, 7:22:88-135.

Sutton, Jane. "Ventura Publisher Proves a Complex Design Tool." *The Editorial Eye.* January 1988, 11:1:1, 8.

Watzman, Suzanne. "Visual Literacy and Document Productivity." Proceedings, 34th International Technical Communication Conference, 1987, Society for Technical Communication, Washington, D.C. pp. ATA-48 - ATA 50.

Wallia, C. J. "Desktop Publishing Training." *Technical Communication: The Journal of the Society for Technical Communication.* August 1988, 35:3:231, 231.

Will-Harris, Daniel. *WordPerfect 5: Desktop Publishing in Style.* Berkeley, California: Peachpit Press, Berkeley, 1988.

Suggested readings:

PC/Computing. Ziff-Davis Publishing Company, One Park Avenue, New York, N.Y. 10016. Subscription services: P.O. Box 58229, Boulder, Colorado 80321-8229.

Bibliography and suggested readings

PC Magazine: The Independent Guide to IBM Standard Personal Computing. PC Magazine, P.O. Box 51524, Boulder, Colorado 80321. Subscription services: P.O. Box 54093, Boulder, Colorado 80322.

PC Resources. IDG Communications/Peterborough Inc., 80 Elm Street, Peterborough, New Hampshire 03458. Subscription services: P.O. Box 58724, Boulder, Colorado 80322-8742.

PC World. PCW Communications, Inc., 501 Second Street, San Francisco, California 94107. Subscription services: P.O. Box 55020, Boulder, Colorado 80322-5029.

Electronic Publishing & Printing. Maclean-Hunter Publishing Co., 29 N. Wacker Drive, Chicago, Illinois 60606. Circulation department, same address. Complimentary subscriptions may be available.

Personal Publishing: The Magazine for Desktop Publishers. Hitchcock Publishing Company, Geneva Road, Wheaton, Illinois 60188. Circulation department, same address.

Publish! PCW Communications, Inc., 501 Second St., San Francisco, California 94107. Subscription services: P.O. Box 55400, Boulder, Colorado 80322.

Lichty, Tom. *Design Principles for Desktop Publishers.* Scott Foresman and Co., Glenview, Illinois 60025.

Miles, John. *Design for Desktop Publishing.* Chronicle Books, 1988.

Parker, Roger. *Looking Good in Print.* Ventana Press, 1988.

White, Jan. *Graphic Design for the Electronic Age.* Watson-Guptill, 1988.

Chapter 19　Effective communication: Nine lessons from research

Suggested readings:

Abbott, Eric A. "Differential Learning from Daily and Weekly Newspapers: A Field Test in Five Communities." Paper presented to Newspaper Division, Association for Education in Journalism Annual Convention, Boston, August 1980.

Brown, Lawrence A. *Innovation Diffusion: A New Perspective.* New York: Methuen, 1981.

Festinger, Leon. *A Theory of Cognitive Dissonance.* New York: Row, Peterson, 1957.

Inose, Hiroshi, and John R. Pierce. *Information Technology and Civilization.* New York: W. H. Freeman and Co., 1984, Ch. 7, 193-229.

Katz, Elihu, Jay G. Blumler, and Michael Gurevitch. "Utilization of Mass Communication by the Individual." Ch. 1, 19-31, in Jay G. Blumler and Elihu Katz (eds.) *The Uses of Mass Communications,* Sage Annual Reviews of Communication Research, Vol. III, Beverly Hills, 1974.

Lichtenstein, Allen, and Lawrence Rosenfeld, "Normative Expectations and Individual Decisions Concerning Media Gratification Choices," *Communication Research* 11(3), July, 1984, 393-413.

Maccoby, Nathan et al. "Reducing the Risk of Cardiovascular Disease: Effects of a Community-Based Campaign on Knowledge and Behavior." *Journal of Community Health,* 3(2), Winter 1977.

Neuman, Russell W. "Patterns of Recall Among Television News Viewers." *Public Opinion Quarterly,* 1976, 115-123.

Rogers, Everett M. *Diffusion of Innovations,* Third Edition, New York: The Free Press, 1983.

Tichenor, Phillip J., Jane M. Rodenkirchen, Clairce N. Olien, and George A. Donohue. "Community Issues, Conflict, and Public Affairs Knowledge." Ch. 2, 45-80 in Peter Clarke (ed.) *New Models for Communication Research.* Sage Annual Reviews of Communication Research, Vol. II. Beverly Hills, CA: Sage Publications, 1973.

Tough, Allen. "Major Learning Efforts: Recent Research and Future Directions." *Adult Education,* 28(4). 1978, 250-263.

Watzlawick, Paul, Janet Helmick Beavin, and Don D. Jackson. *Pragmatics of Human Communication.* New York: W.W. Norton & Co., 1967.

Authors, reviewers, and credits

In Print

Chapter 1 The art of good writing

Author:
William S. Sullins
Specialist, extension communications
Kansas State University, Manhattan

Reviewer:
Janet Rodekohr
News editor
College of Agriculture
University of Georgia, Athens

Illustration, design, and layout:
John Potter

Chapter 2 Publications

Author:
JoAnn B. Pierce
Associate professor
Institute of Food and Agricultural Sciences
University of Florida, Gainesville

Reviewers:
Thomas W. Knecht
Coordinator, publications unit
North Carolina State University, Raleigh

Evelyn Liss
Section coordinator
Oregon State University, Corvallis

Terry Meisenbach
Assistant professor
University of Nebraska, Lincoln

Illustration, design, and layout:
Kai S. Toh

Photography:
Palma Ingles Stafford

Chapter 3 Writing for newspapers and magazines

Authors:
William S. Sullins
Specialist, extension communications
Kansas State University, Manhattan

Susan O'Reilly
Coordinator, educational media
Institute of Food and Agricultural Sciences
University of Florida, Gainesville

Reviewers:
Janet Rodekohr
News editor
College of Agriculture
University of Georgia, Athens

Illustration, design, and layout:
John Potter

Chapter 4 Newsletters

Author:
Linda Benedict
Specialist, extension communications and
instructor, agricultural journalism
University of Missouri, Columbia

Reviewer:
Judith Bowers
Specialist, public affairs
USDA extension
Washington, D. C.

Illustration, design and layout:
Kai S. Toh

Chapter 5 Writing skills shortcourse

Author:
Joseph J. Marks
News director and professor
College of Agriculture
University of Missouri, Columbia

Design and layout:
Kai S. Toh

Visuals

Chapter 6 Graphic design

Author:
Gary Hermance
Head, graphics and print services
Institute of Food and Agricultural Sciences
University of Florida, Gainesville

Reviewers:
Frankie Gould
Specialist, extension assistant graphic
design
Louisiana State University, Baton Rouge

Authors, reviewers, and credits

Ashley Wood
Coordinator, educational media/
communications
Institute of Food and Agricultural Sciences
University of Florida, Gainesville

Illustration, design, and layout:
Ralph Knudsen

Chapter 7 Exhibit design and production

Authors:
Harry A. Carey Jr.
Specialist, extension exhibits
The Pennsylvania State University, University
Park

Ashley Wood
Coordinator, educational media/
communications
Institute of Food and Agricultural Sciences
University of Florida, Gainesville

Reviewer:
Ralph Knudsen
Graphic artist
Institute of Food and Agricultural Sciences
University of Florida, Gainesville

Illustration:
Peter A. Kauffman
Ralph Knudsen

Design and layout:
Ralph Knudsen

Chapter 8 Posters

Authors:
Harry A. Carey Jr.
Specialist, extension exhibits
The Pennsylvania State University, University
Park

Ashley Wood
Coordinator, educational media/
communications
Institute of Food and Agricultural Sciences
University of Florida, Gainesville

Illustration, design, and layout:
John Potter

Chapter 9 Photography

Authors:
Jeanne Gleason
Associate agricultural editor
New Mexico State University, Las Cruces

Don Breneman
Specialist, communications
University of Minnesota, St. Paul

Reviewer:
William E. Carnahan
Retired, USDA Extension Service
Washington, D. C.

Illustration, design, and layout:
David Miller

Photography:
Fritz Albert, Victor Espinoza, Bill Carnahan,
Jeanne Gleason

Chapter 10 Slidetape production

Author:
Marshall Breeze
Associate professor
Institute of Food and Agricultural Sciences
University of Florida, Gainesville

Illustration:
Marshall Breeze, Meryl Klein

Design and layout:
Meryl Klein

Photography:
Marshall Breeze, Palma Ingles Stafford

Electronic Media

Chapter 11 Radio

Author:
David A. King
Specialist, electronic media
Oregon State University, Corvallis

Reviewers:
Jeanne Gleason
Associate agricultural editor
New Mexico State University, Las Cruces

Cordell Hatch
Information transfer advisor, USAID
Washington, D. C.

John Sulzmann
Coordinator, audio production
Oregon State University, Corvallis

Illustration, design, and layout:
 Kai S. Toh

Photography:
 Ron Matason, Vellie Matthews, Palma
 Ingles Stafford

Chapter 12 Video and televison

Author:
 Jeanne Gleason
 Associate agricultural editor
 New Mexico State University, Las Cruces

Reviewer:
 David A. King
 Specialist, electronic media
 Oregon State University, Corvallis

Illustration, layout, and design:
 Helen K. Huseman

Photography:
 Ron Matason, Victor Espinoza, Jeanne
 Gleason

Electronic Hybrids

Chapter 13 Interactive communications technology

Authors:
 Jeanne Gleason
 Associate agricultural editor
 New Mexico State University, Las Cruces

 Mary G. Miller
 Extension specialist, instructional design
 Virginia Polytechnic and State University,
 Blacksburg

Reviewer:
 Cathy Selberg
 Specialist, public affairs, USDA extension
 Washington, D. C.

Design and layout:
 Yaeko Egashira

Photography:
 Victor Espinoza, Jeanne Gleason, Mary
 Miler, Virginia Tech University photo staff

Chapter 14 Computer graphics

Author:
 Harry A. Carey Jr.
 Specialist, extension exhibits
 The Pennsylvania State University, University
 Park

Reviewers:
 Frankie Gould
 Specialist, extension assistant graphic
 design
 Louisiana State University, Baton Rouge

 Ashley Wood
 Coordinator, educational media/
 communications
 Institute of Food and Agricultural Sciences
 University of Florida, Gainesville

Illustration, design, and layout:
 Audrey S. Wynne

Photography:
 Palma Ingles Stafford

Chapter 15 The basics of desktop publishing

Author:
 Mary L. Cilley
 Associate professor
 Institute of Food and Agricultural Sciences
 University of Florida, Gainesville

Reviewer:
 David Cochrane
 Center for instructional and research
 computing activities
 University of Florida, Gainesville

Illustration, design, and layout:
 Donna Wernersback

Keystroke communications

Chapter 16 Computers in communications

Authors:
 David G. Rice
 Specialist, computer applications
 North Dakota State University, Fargo

 Eldon Fredericks
 Head, agricultural communications
 Purdue University, West Lafayette, Indiana

Illustration:
 David Rice

Design and layout:
 Ronald Stephens

Authors, reviewers, and credits

Chapter 17 Teleconferencing

Authors:
Harlan C. Lynn
Specialist, electronic media
University of Missouri, Columbia

Ed Vernon
Specialist, electronic technology
University of Illinois, Urbana

Betty Fleming
Formerly specialist, public affairs, USDA
Washington, DC

Reviewers:
Larry Quinn
Chief, video and teleconference section
USDA extension
Washington, D. C.

Larry Whiting
Head, information and applied
communications
The Ohio State University, Dublin

Design and layout:
Meryl Klein

Photography:
Palma Ingles Stafford, The Ohio State
University photo staff

Chapter 18 Electronic news

Author:
Russell T. Forte
Public affairs specialist, USDA
Washington, DC

Design and layout:
Ronald Stephens

Photography:
USDA photo staff

Marketing the message

Chapter 19 Effective communication: Nine lessons from research

Author:
Eric A. Abbott
Professor, Department of Journalism and
Mass Communications
Iowa State University, Ames

Illustration, design, and layout:
John Potter

Chapter 20 Speaking effectively

Author:
J. Cordell Hatch
Information transfer advisor, USAID
Washington, DC

Design and layout:
Donna Wernersback

Photography:
Palma Ingles Stafford

Chapter 21 Marketing your organization

Author:
Ken Kingsley
Associate director
Agricultural communications
Oregon State University, Corvallis

Reviewer:
Meg Gemson Ashman
Head, office of information,
extension
University of Vermont, Burlington

Illustration:
Meryl Klein, Ron Thomas

Design and layout:
Meryl Klein

Chapter 22 Publicizing the event: a multimedia approach

Author:
Joseph J. Marks
News director and professor
University of Missouri, Columbia

Illustration, design,and layout:
John Potter

Chapter 23 Media interviews

Author:
Marcella M. Hilt
USDA office of information, news division
Washington, DC

Reviewers:
 Denise Miller
 Media services coordinator
 National 4-H Council
 Chevy Chase, Maryland

 Diane O'Conner
 Public affairs specialist, USDA
 Washington, DC

Illustration:
 John Potter

Design and layout:
 Donna Wernersback

Chapter 24 Direct mail

Author:
 Glen W. Goss
 Retired, The State University of Pennsylvania,
 State College

Illustration, design, and layout:
 Kai S. Toh

Photography:
 Palma Ingles Stafford

Chapter 25 Crisis management

Authors:
 Don Poucher
 IFAS Information
 Institute of Food and Agricultural Sciences
 University of Florida, Gainesville

Julia C. Graddy
Head, news and information section
Institute of Food and Agricultural Sciences
University of Florida, Gainesville

Illustration, design, and layout:
 John Potter

Chapter 26 Strategic communications planning

Author:
 Janet Poley
 Director, communications, information and
 technology, USDA extension
 Washington, DC

Illustration, design and layout:
 Donna Wernersback

Miscellaneous

All chapters were edited and reviewed by Patricia Calvert, deputy director, communications information and technology, USDA extension, Washington, D. C.

Cover design: Ashley Wood, Audrey Wynne

Book design: Ashley Wood, Ronald Stephens

Typesetters: Billie Basinger and Renea Bohannan

Index

Index

Index

Index

All product names mentioned are trademarks for registered trademarks of their respective holders.

Mention of these products does not necessarily constitute an endorsement.

Adobe Illustrator, *Adobe Systems, Inc.*
Aldus PageMaker, *Aldus Corp.*
Byline, *Aston-Tate*
Corel Draw, *Corel Systems*
.Final Word II, *F W Corp.*
Fujichrome, *Fuji Corp.*

Gem Desktop Publisher, *Digital Research*
IBM VGN, *IBM Corp.*
Interleaf, *Interleaf*
Kodachrome, *Kodak Corp.*
Ektachrome, *Kodak Corp.*
Laser Jet, *Hewlett-Packard*
Laser Writer, *Century Software*
Mac Draw, *Macintosh; Apple Computer, Inc.*
Macintosh, *Macintosh; Apple Computer, Inc.*
Martin Marietta, Data Systems, *Martin Marietta Corp.*
MS-DOS, *IBM Corp.*

Multi-Mate Advantage II, *Aston-Tate*
NotaBene, *Dragonfly Software*
PFS: First Publisher, *Software Publishing*
Publisher's Paint Brush, *Mediagenic*
Ready Set Go, *Letraset*
Unix, *Santa Cruz Operation*
Ventura Publisher, *Xerox Corp.*
Word Perfect, *Word Perfect Corp.*
Word Star 2000 Plus, *Word Star U.S.A.*
Xy Write III Plus, *XY Quest, Inc.*